CW00747276

FABERGÉ

Romance to Revolution

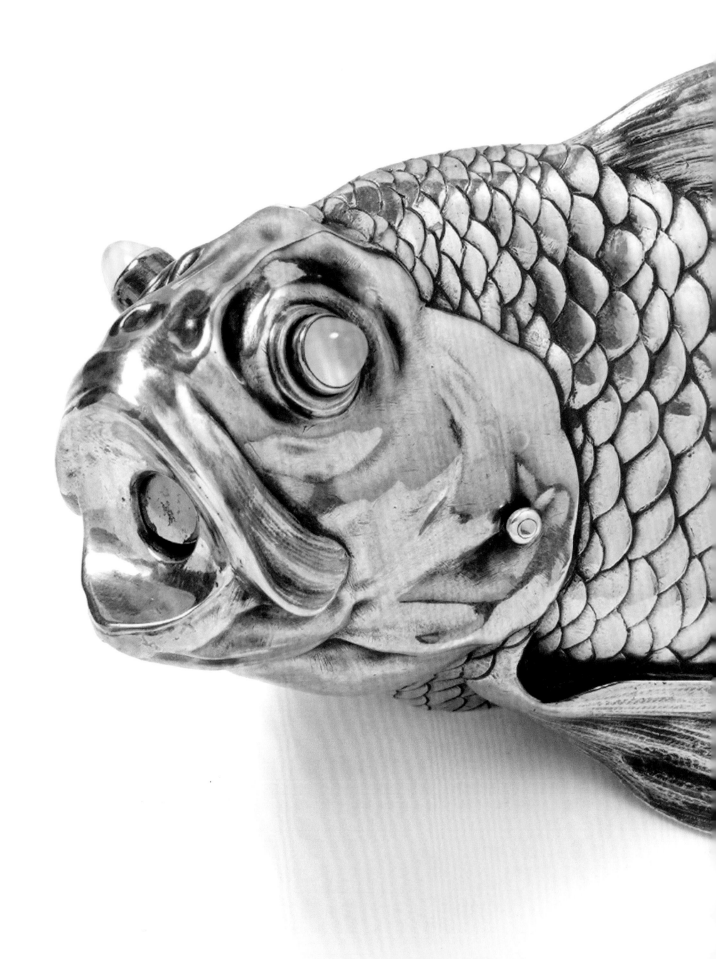

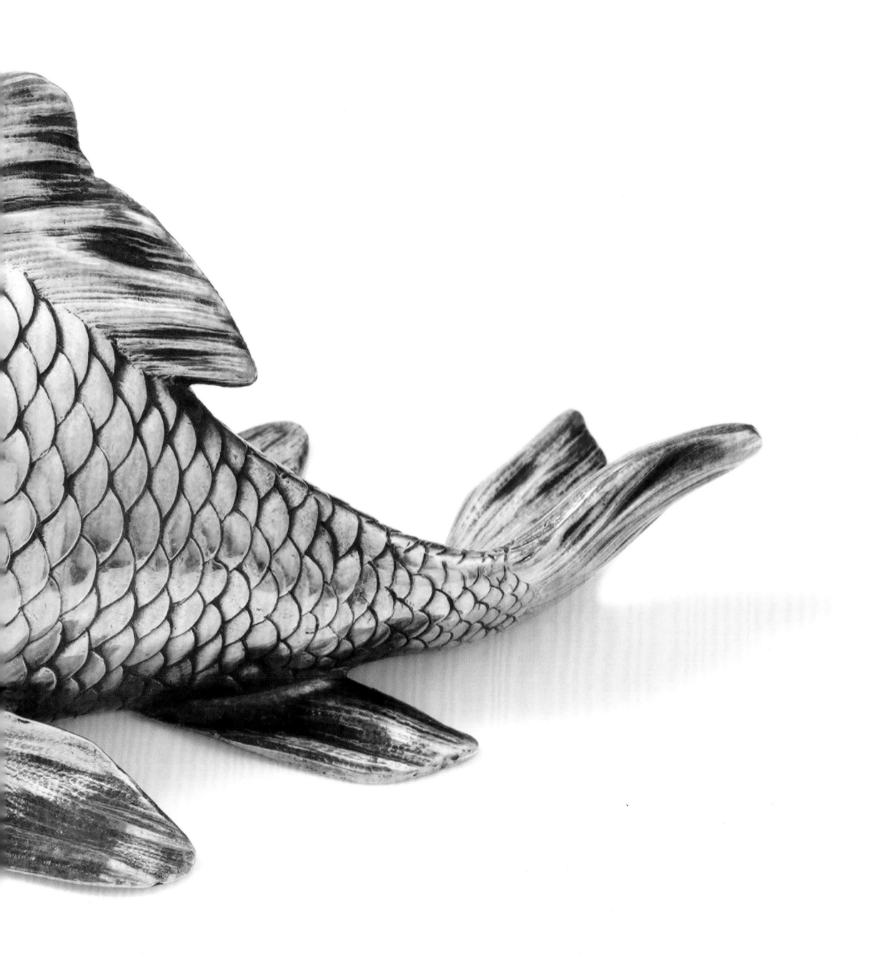

Published to accompany the exhibition *Fabergé in London: Romance to Revolution* at the Victoria and Albert Museum, London, from 20 November 2021 to 8 May 2022.

Supported by

PAN PACIFIC
LONDON

First published by V&A Publishing, 2021
Victoria and Albert Museum
South Kensington
London SW7 2RL
vam.ac.uk/publishing

Distributed in North America by Abrams, an imprint of ABRAMS
© Victoria and Albert Museum, London
The moral right of the authors has been asserted.

ISBN 9781 83851 0145

10 9 8 7 6 5 4 3 2 1
2025 2024 2023 2022 2021

A catalogue record for this book is available from the British Library.

All rights reserved. No part of this publication may be reproduced, stored in a retrieval system, or transmitted in any form or by any means, electronic, mechanical, photocopying, recording or otherwise, without the written permission of the publishers.

Every effort has been made to seek permission to reproduce those images whose copyright does not reside with the V&A, and we are grateful to the individuals and institutions who have assisted in this task. Any omissions are entirely unintentional, and the details should be addressed to V&A Publishing.

Extract from *The Edwardians* by Vita Sackville-West reproduced with permission of Curtis Brown Ltd, London, on behalf of the Beneficiaries of the Estate of Vita Sackville-West. Copyright © Vita Sackville-West, 1930

Designer: Daniela Rocha
Copy-editor: Denny Hemming
Index: Nic Nicholas
Map p.70: ML Design
Origination: Altaimage
Printed in China

V&A Publishing

Supporting the world's leading museum of art and design, the Victoria and Albert Museum, London

Publisher's notes
All works are by the firm of Fabergé unless indicated otherwise.
Focus spreads and captions authored by Kieran McCarthy unless indicated otherwise.

Frontispiece
CIGAR CUTTER, MODELLED AS A CARP IN THE JAPANESE TASTE, 1903–8

Chief workmaster Henrik Wigström (1862–1923), St Petersburg
Silver, gold, stained chalcedonies; l. 13.3 cm
Purchased by 4th Earl Howe, 24 November 1908
The Woolf Family Collection

Opposite contents
MATCHSTAND WITH MANDRILL, 1899–1909

Workmasters Anna Ringe (1840–1912) and Julius Rappoport (1851–1917), St Petersburg
Silver, enamel; 8.2 x 7.8 cm
Purchased by Lady Paget, 1 December 1916
The Woolf Family Collection

Opposite foreword
FRENCH BULLDOG, c.1914

St Petersburg
Petrified wood, gold, enamel, diamonds; h. 9 cm
Sold by Fabergé, London, in November 1916 to Mrs Mango, a Turkish shipping heiress
Private Collection

FABERGÉ

Romance to Revolution

EDITED BY KIERAN MCCARTHY & HANNE FAURBY

V&A PUBLISHING

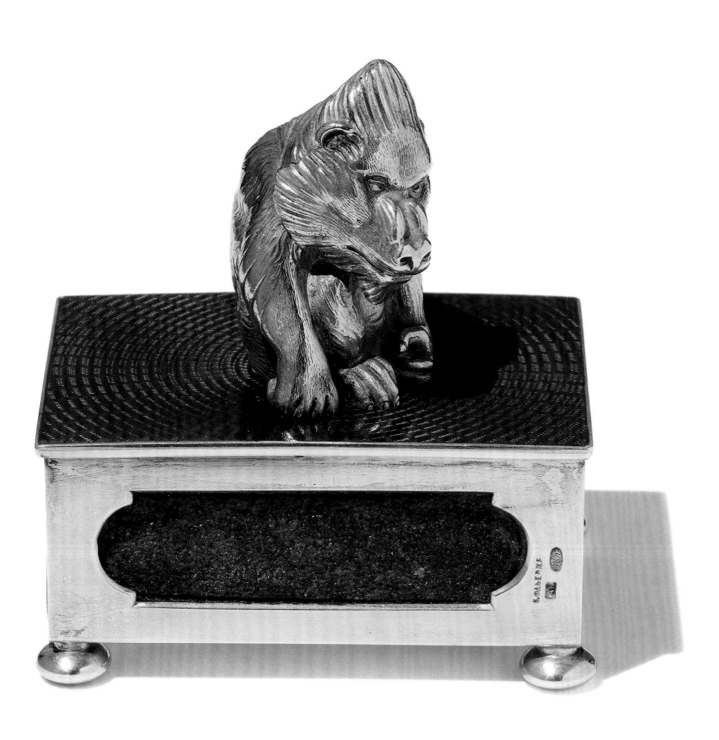

CONTENTS

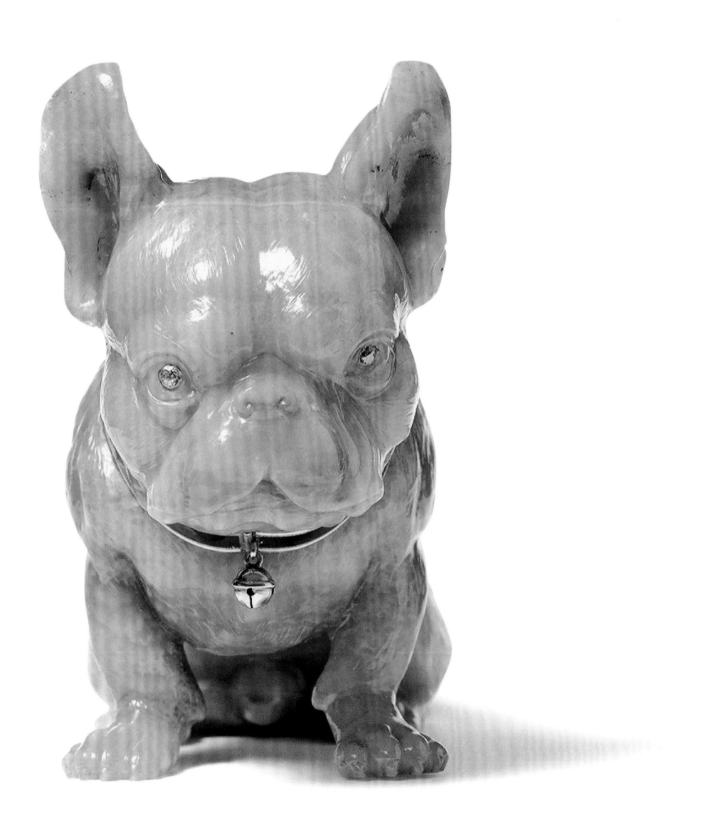

FOREWORD

TRISTRAM HUNT
Director, V&A

PETER CARL FABERGÉ'S LEGENDARY CREATIONS
are as inspirational and desirable today as when
they were first conceived. His art was visionary,
his creativity seemingly boundless. His success was
rooted in his ability to perform at the highest level,
not only as a creator but also as an employer and
entrepreneur – a necessity that rings true for artists
and craftspeople today. His enlightened system of
outsourcing production to affiliated workshops
of the most skilled artisans, keeping management
separate; his philosophy of staff welfare (at its height
the House of Fabergé employed 500 staff); the
relationships he cultivated with his customers,
all characterized Fabergé as someone with
exceptional business acumen, and the company
as a new and very modern type of enterprise.

The V&A is proud to host *Fabergé in London:
Romance to Revolution* – the museum's third exhibition
dedicated to the Russian goldsmith since 1977. Then,
it was the first major exhibition on Fabergé to be
staged by a national museum in the United Kingdom
and formed part of the Silver Jubilee celebrations
for Her Majesty The Queen. It was organized by
Kenneth Snowman of Wartski, whose family later
generously gifted to the museum nine pieces of
Fabergé, now on display in the permanent jewellery
gallery, which complement the loans in the V&A's
Snowman Collection. The second Fabergé exhibition,
staged in 1994, was co-organized by the Fabergé Arts
Foundation in Washington, D.C.; the Hermitage
in St Petersburg; the Musée des Arts Décoratifs in
Paris; and the V&A in London. Since glasnost new
opportunities for international collaboration and
scholarship have produced a golden age in Russian
artistic research. For 2021 we have chosen to focus
upon the importance of Fabergé's little-known
London branch, the only one to operate outside
the Russian empire, and its international reach.
The House of Fabergé was very much an Anglo-
Russian enterprise and took Edwardian Britain by
storm. While royalty, aristocrats, American heiresses,
exiled Russian grand dukes, maharajas and financiers
flocked to the Fabergé branch in London, it was
from London that Fabergé would plan the company's
overseas sales trips to Europe and the Far East.

The V&A, situated as it is in this capital city,
with its strong links to works by Fabergé and its
continued mission to inspire the creative industries,
is the perfect place to stage *Fabergé in London: Romance
to Revolution*. In addition to a glorious selection
of Easter Eggs, the exhibition aims to expand
our visitors' appreciation of Fabergé creations.
From animals carved in hardstone and guilloche
enamelled boxes to stunning jewellery, visitors will
be immersed in Fabergé's evocative world.

My sincere thanks go to Kieran McCarthy of
Wartski, without whom this exhibition would not
have been conceived. It is his in-depth research of
Fabergé's London branch that laid the foundation
for this display and his extraordinary network has
enabled us to show many rarely seen pieces, now
held in private collections.

My thanks also go to the recently retired V&A
Senior Curator of Jewellery Richard Edgcumbe,
who identified the potential for this exhibition. An
enormous debt of gratitude is also due to Dr Genevieve
Davies, whose support has been truly invaluable.

According to Fabergé's London agent, H.C.
Bainbridge, 'The coming of Fabergé flashed like a
comet through the black firmament of over-seriousness
everywhere and with such unmistakable brilliance'. We
hope that the return of Fabergé to the V&A will re-ignite
this flash of brilliance and joy in the capital once again.

INTRODUCTION

Kieran McCarthy

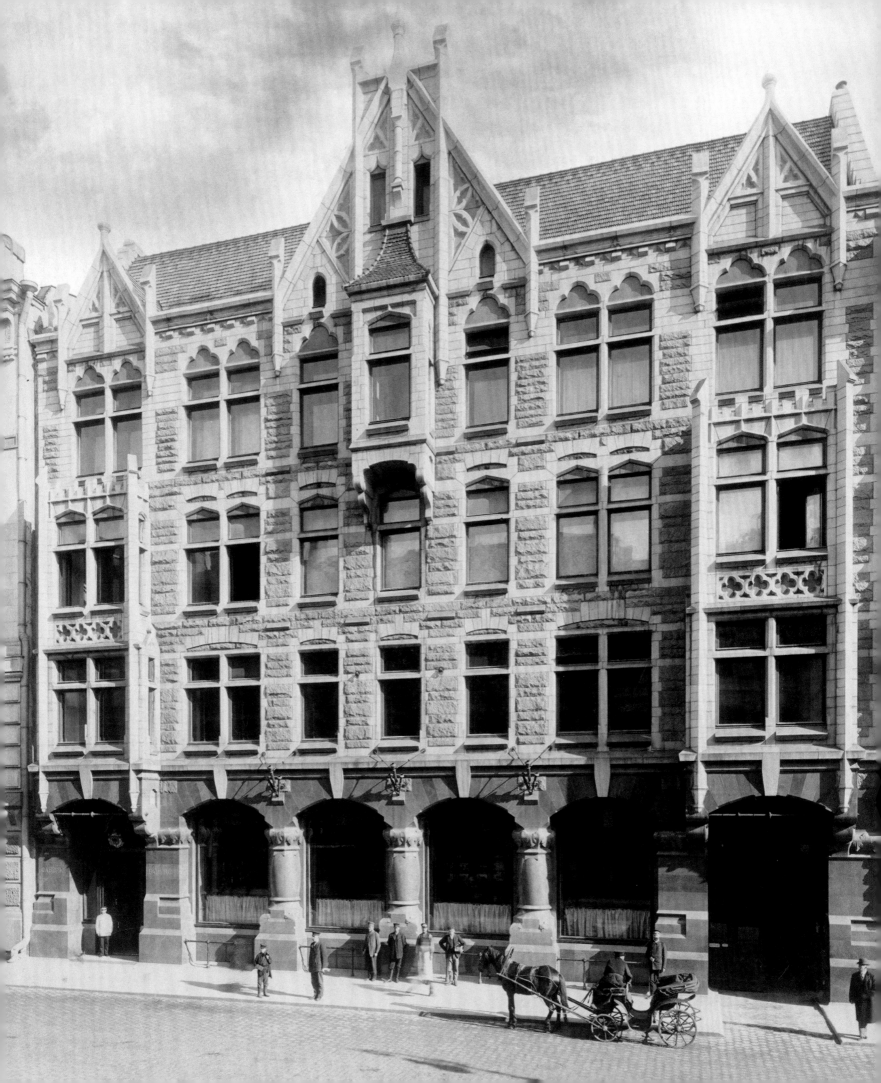

Chapter opener

I

BEAR, ST PETERSBURG, c.1909

(detail; see also p.40)

The coming of Fabergé flashed like a comet through the black firmament of over-seriousness everywhere and with such unmistakable brilliance.

HENRY BAINBRIDGE, 1949[1]

The name of Peter Carl Fabergé (1846–1920), the Russian goldsmith and jeweller, conjures up images of imperial Russia and flamboyant jewelled works of art, especially Easter eggs. It has become a byword for luxury in popular modern culture. Businesses routinely exploit the goldsmith's fame by claiming their products to be the 'Fabergé egg' of their wares and for filmmakers the eggs have become a staple plot device when a priceless treasure is needed, often to be stolen. The history of the House of Fabergé is inextricably woven into that of the dying days of the ill-fated Romanov dynasty and a doomed Emperor. Fabergé's works were the joyful and luxurious diversions of Russia's ruling elite as they raced to a violent revolutionary end. Comprising his most significant customers, its members expressed their love for each other through the exchange of Fabergé gifts. But Fabergé was not solely a Russian business; its works bewitched an audience far beyond the borders of the Emperor's empire, largely served by an office Carl Fabergé opened in London in 1903. It attracted a glittering clientele and his creations became as fashionable in Britain as they were in Russia. This transformed the company from a solely Russian enterprise into an international, and especially Anglo-Russian, affair.

The British royal family were Fabergé's foremost customers in London, having been introduced to the goldsmith's work by virtue of their close kinship with the imperial Russian family. Queen Alexandra (1844–1925), wife of King Edward VII (1841–1910), and Maria Feodorovna (born Princess Dagmar of Denmark; 1847–1928), wife of Emperor Alexander III (1845–1894), were sisters while Alexandra Feodorovna (born Princess Alix of Hesse and by Rhine; 1872–1918), who married Emperor Nicholas II (1868–1918), was King Edward VII's

2

Fabergé's premises at 24 Bolshaya Morskaya, St Petersburg, with its façade of Finnish marble in the Anglo-Gothic taste. It housed a showroom on the ground floor, while on the floors above were account offices, designers' and sculptors' studios, apartments and a large library. The firm's principal workshops were arranged around a courtyard to the rear.
Wartski, London

niece. Empress Maria was particularly enamoured with Fabergé's works and her affection for the firm is evident in a letter she wrote to Queen Alexandra describing him as 'the greatest genius of our time'.[2] The Queen regularly received Fabergé gifts from her Russian relations and in 1894, when her birthday fell during a visit to St Petersburg, the Duke of York, later King George V (1865–1936), recalled she was given 'half of Fabergé's shop'.[3] The Empress liked to surprise her sister with the firm's newest creations and was displeased by the company's expansion. She complained, 'Now that that silly Fabergé has his shop in London, you have everything, and I can't send you anything new, so I am furious'.[4]

Fabergé arrived in Edwardian London at a time of joyful and conspicuous consumption. Life in the capital city for the upper classes was characterized by unrestrained *joie de vivre*. Released from the twilight of Queen Victoria's reign they indulged in lavish lifestyles, led by the new King, Edward VII; a bon viveur who eagerly pursued the pleasures of wine, women and food (the last of which led eventually to a waist measurement of 122 centimetres, or 48 inches). The King surrounded himself with a court of similarly minded people. He enjoyed the company of the rich, beautiful or witty, and many of his companions possessed all three attributes. Their ancestry, occupation and creed were irrelevant to the cosmopolitan King. American heiresses and Jewish businessmen were as welcome in his circle as the landed aristocracy.

Into this hedonistic world entered Carl Fabergé, a goldsmith who would become famed for his artistry and meticulous craftsmanship. Carl was born in May 1846, the son of Gustav Fabergé, a jeweller of Huguenot descent who had settled in St Petersburg and established a business there. It was modestly successful but unremarkable, producing standard jewellery that was largely indistinguishable from that of its many competitors. Gustav recognized potential in his son and encouraged him to enter the family business. Under the supervision

of his father's colleague in St Petersburg, Peter Hiskias Pendin, he was instructed in the mysteries of goldsmithing. Carl's artistic education included a lengthy Grand Tour of Europe. He travelled throughout England, France, Italy and Germany, where he was apprenticed to Josef Friedman, a master goldsmith in Frankfurt am Main. There he learned the delicate techniques later employed in his creations. On his travels he immersed himself in the goldsmith's art. By visiting museums, libraries and private collections he was able to study both antique and contemporary styles, carefully examining their forms and execution.

In 1864 Carl returned to St Petersburg to join the family business and put his knowledge of the history of goldsmithing to work. As a result of his remarkable talent, the business evolved quickly and its standing grew. Under his keen tutelage it evolved to produce jewellery, silverware and works of art of the highest calibre. In 1866 it started supplying the Imperial Cabinet with official gifts. A year later Carl was invited by the Hermitage Museum to assist in the study of gold artifacts unearthed during archaeological excavations. He was entrusted with the delicate task of reassembling pieces from the fragments found and diplomatically never charged for his services. Working in the museum afforded him the opportunity to access the treasures it contained and school himself further as a goldsmith. In 1872 Carl took complete control of the Fabergé company. He organized it as a hierarchy of workshops specializing in different areas of production, each run under the supervision of a workmaster. He sought and nurtured the very best talent, while creating a familial atmosphere. Carl and his brother Agathon (1862–1895), who designed for the firm until his death, plundered decorative cultures past and present for inspiration, synthesizing these influences to create a unique Fabergé style. The focus was on craftsmanship and artistry, rather than the precious content of the materials used.

The elegant creations of the House of Fabergé captured the spirit of the final days of imperial Russia and the imagination of its customers. By 1900 Carl was the pre-eminent jeweller in Russia, with 500 employees, additional branches in Moscow and Odessa, and new imposing granite-clad premises on Bolshaya Morskaya in the heart of St Petersburg. The St Petersburg shop was a short walk from the Winter Palace and a mecca for high society. Carl's workshop manager Franz Birbaum recalled: 'Every day from 4 to 5 all the St. Petersburg aristocracy could be seen there'.[5] Lady Sackville recorded in her diary when she visited the city that 'you meet just everyone at Fabergé'.[6] With ceaseless attention to detail he ensured expansion did not diminish standards. He was at the centre of this creative whirlwind, moving between customers, designers and craftsmen. Henry Charles Bainbridge, who would become the Fabergé agent in London, wrote: 'Fabergé worked at great strain. Creator, Artist, Salesman and Controller, he was always up to concert pitch'.[7]

Having conquered the world of Russian goldsmithing, Carl Fabergé tentatively looked to prove himself abroad. In 1900 he travelled to Paris to exhibit at the Exposition Universelle. The Exposition revealed his creations to a rapturous new audience and was a huge success. The appetite for his works in Paris encouraged him to open a branch in Western Europe. In 1903 he decided on London as its location and it occupied discreet premises before moving in 1911 to New Bond Street, the most prestigious retail thoroughfare in the country. His choice of London over Paris was certainly influenced by his existing relationship with British royalty. He was, however, also drawn by the greater potential London offered for business. It was a thriving and cosmopolitan city at the heart of a trading empire that embraced the globe.

Fabergé's move to London coincided with a wave of Russophilia in Britain. The mutual threat posed by expansionist Germany, under Kaiser Wilhelm II,

3
Peter Carl Fabergé (1846–1920)
sorting gemstones, *c.*1905.
Wartski, London

led to a thawing of relations between the British and Russian empires. Memories of the war in Crimea just a short while before were fading. Simultaneously there was an increased fascination with Russian arts and culture. Russian diplomats took advantage of this and distributed Fabergé gifts among influential members of society, using the firm's refined works to promote a positive view of the country. The Ballets Russes, which premiered at Covent Garden just before Fabergé opened the New Bond Street shop, strengthened the love for all things Russian. Fabergé on New Bond Street and the Ballets Russes

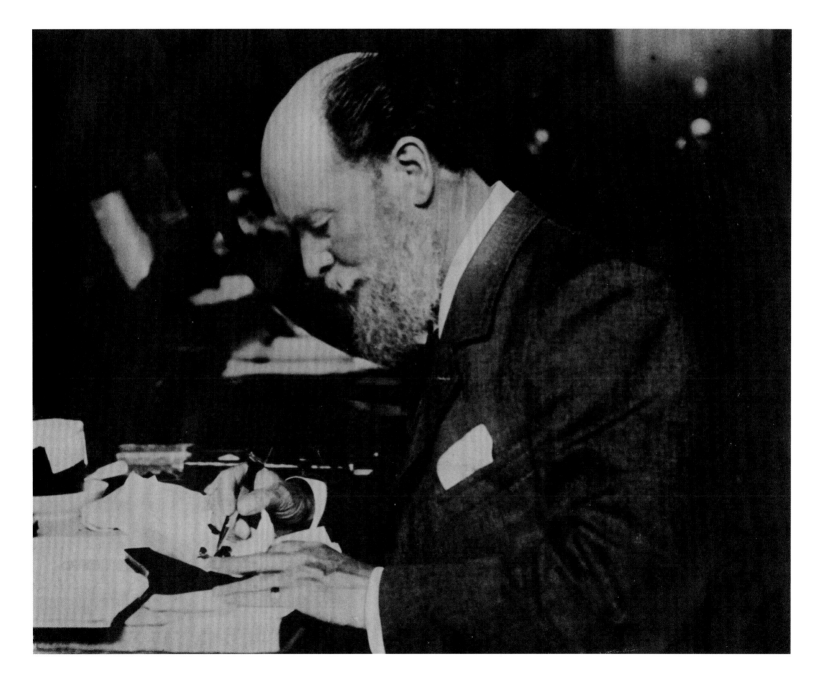

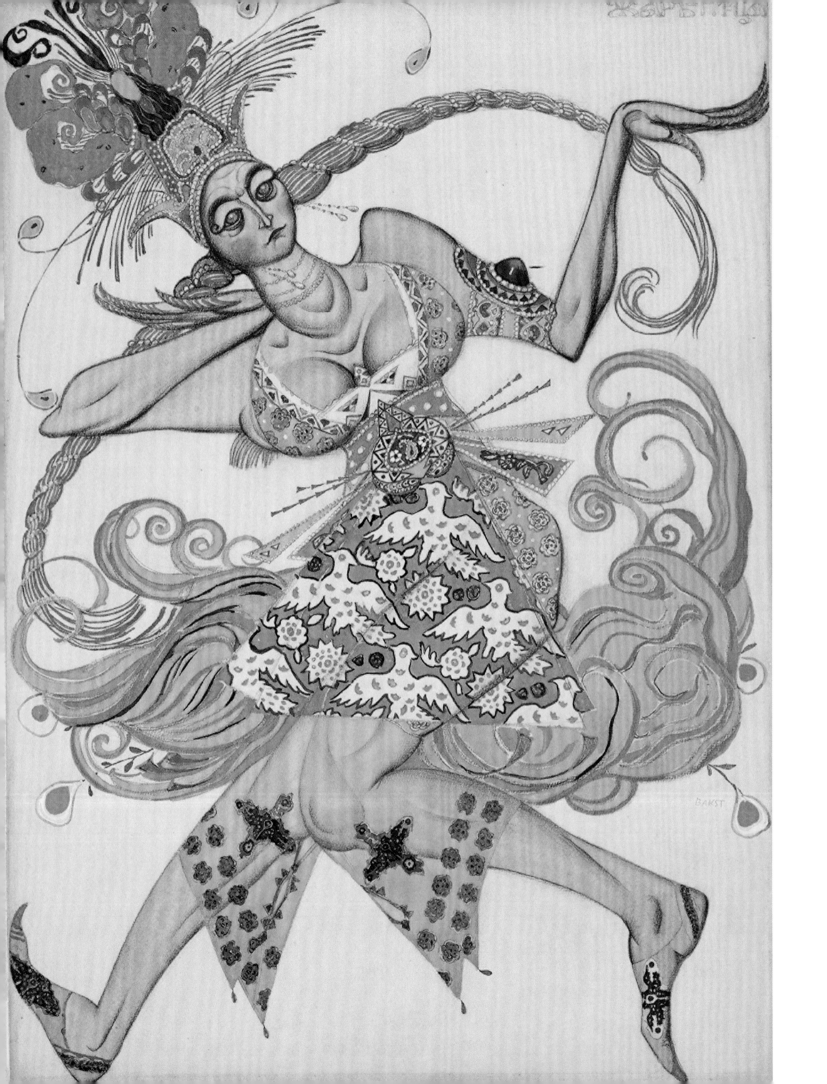

in Covent Garden combined to convey a highly aesthetic view of a Russia, populated by seductive dancers and gifted goldsmiths producing lavish works of art.

Fabergé's presence in London is well documented; the branch's later sales ledgers survive and the memoirs of Henry Bainbridge, Fabergé's London agent, give detailed information about branch activities. The ledgers contain over 5,500 entries recording items purchased, the name of the buyer, and the sales price in sterling, as well as the production cost in roubles. Bainbridge fleshed out the information in the ledgers with colourful accounts of Fabergé's customers and activities in London in his autobiography *Twice Seven* (1933) and, later, a book devoted solely to the business, *Peter Carl Fabergé, His Life and Work* (1949). He presents Fabergé as a restless genius on the edge of Europe, tirelessly serving a discerning and noble clientele. Bainbridge's books have shaped the art historical appreciation of his achievements and helped to create the 'cult of Fabergé', in which the firm's works are venerated as the last flowering of court art. To these primary sources can be added a recently discovered archive of material belonging to Bainbridge, containing detailed information dating from the time he was working at the firm to the subsequent period when he was researching his books. These Bainbridge Papers dramatically improve the understanding of the business in both Britain and Russia.[8] They offer an insight into the inner workings of the London branch and the close relationship between its international customers and the workshops in Russia.

Unlike contemporary collectors who primarily acquire works to add to their own collection, Fabergé's Edwardian customers visited the shop to buy gifts for each other. Exchanging gifts was an important protocol in Edwardian society and Fabergé offered his customers a supply of fashionable and royalty-endorsed presents. The focus on artistry rather than intrinsic value in Fabergé's works made them ideally uncompromising gifts. Henry Bainbridge was an astute observer of Edwardian high society and studied it closely. He regularly visited his customers' homes and filled notebooks with details of their likes, dislikes, pastimes and relationships with one another. He used this information to tailor Fabergé's works towards their interests. At his instigation, the workshops in Russia modelled his British customers' pets in Siberian hardstones and Fabergé's artists produced finely painted enamel scenes of their stately homes and palaces. Horse racing was a passion for British royalty and high society in the Edwardian era. Lord Northcliffe declared Edward VII to be the greatest king Britain ever had, before mischievously adding 'on the racecourse'.[9] To cater for the interest in horse racing Fabergé's enamellers supplied the London branch with works decorated in the racing colours of his British customers and modelled the prized horses of King Edward VII and his friend the banker Leopold de Rothschild.

Fabergé's works thus offer an insight into the lives of his gilded clientele and are closely identified with the Edwardian era during which the business flourished. It is romantically perceived as a golden age, a time of peace and prosperity when Britain dominated the world. The poet Philip Larkin wrote of 1914 that there was 'never such innocence, never before or since'.[10] This believed innocence was ensured by the benevolent rule of a cultured elite, who indulged themselves shopping at Fabergé. The writings of those who enjoyed the pleasures of Edwardian Britain reveal Fabergé's presence in their lives. Sonia Keppel, the daughter of the socialite Alice Keppel, in her memoirs described the time as 'an age of chivalry, of putting women on pedestals', adding that her mother's pedestal could have been 'made by Fabergé'.[11] Sonia's sister, Violet, the lover of the novelist Vita Sackville-West, considered gifts of Fabergé items to be so personal that she equated them with receiving lingerie; as a sign a relationship was 'in danger of becoming serious'.[12]

4
COSTUME DESIGN FOR THE
BALLET *THE FIREBIRD*, 1913

Léon Bakst (1866–1924)
Metallic paint, watercolour, pencil, charcoal and wash; 67.3 x 48.9 cm
The Joan and Lester Avnet Collection, Museum of Modern Art, New York
(4.1978)

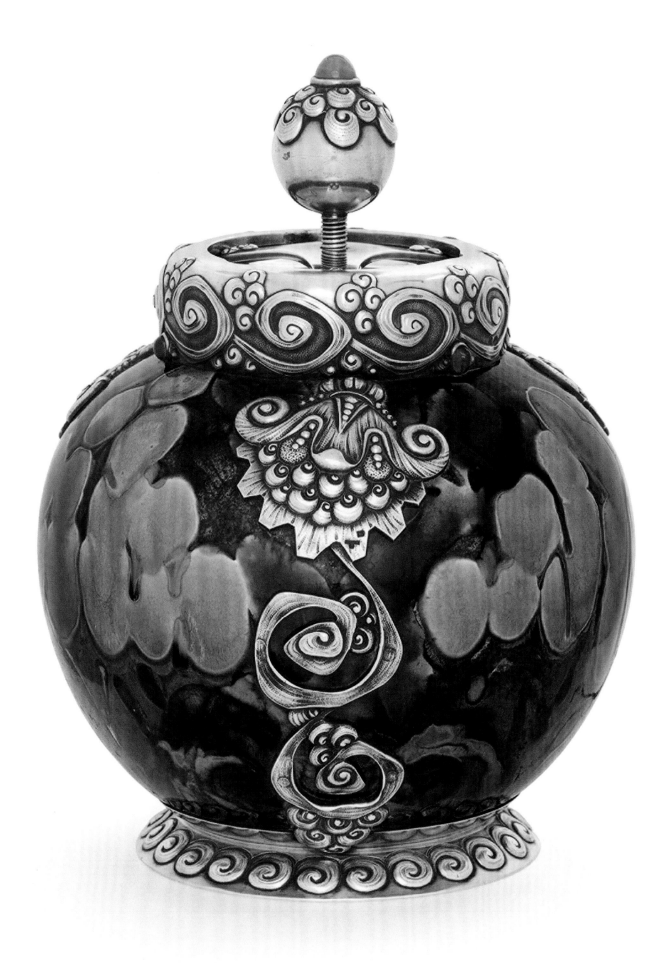

5

**TOBACCO HUMIDOR IN THE
'OLD RUSSIAN TASTE'**

Moscow, *c.*1910
Glazed earthenware body by the
Imperial Stroganov School, silver-gilt
mount with amethyst and chalcedonies
by Fabergé; h. 21 cm
Purchased by Robert Younger, later
Baron Blanesburgh, heir to the George
Younger & Son brewery fortune, on 18
June 1910
The Woolf Family Collection

6

Ledger entries from Fabergé's London
branch, recording the purchase of the
tobacco humidor, 1910.
Tatiana Fabergé Archive

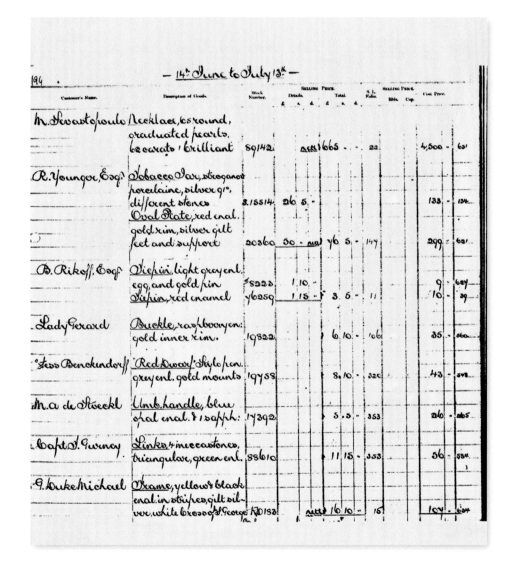

The joyful world in which Fabergé's British venture thrived came to an end with the outbreak of the First World War. When the guns began firing, his jewelled confections became inappropriate indulgences and trade faded away. War and revolutionary tension simultaneously undermined the business in Russia. The workshops were conscripted to make munitions and the supply of jewels to London ceased. The London branch continued operating in ever-reducing circumstances until it finally closed in early 1917. Fabergé's creations were anathema to the Bolsheviks – the politically valueless possessions of the despised classes – and they closed the branches in Russia the following year. Fabergé himself fled the country; he never recovered from the destruction of his life's work and died broken-hearted in Lausanne, Switzerland, in 1920.

The war and political upheavals of the early twentieth century swept away many of the European monarchies and elites that Fabergé served. In Britain and America, the change in fortunes was less dramatic and the demand for Fabergé's creations survived. Indeed, in the decades following the war, it was heightened by their association with the carefree days before 1914. Led by Queen Mary (1867–1953), connoisseurs began to acquire his works on the secondary market. They were aided by the new communist government selling Fabergé treasures they had confiscated from the Russian imperial family and aristocracy. The most sought-after of the treasures emerging from post-revolutionary Russia were the firm's imperial Easter Eggs. These extraordinary and complex works were commissioned by Emperors Alexander III and Nicholas II as gifts for their wives and close family members at Easter. Since the death of Fabergé the imperial Eggs have grown in stature to become the highest possible expressions of luxury and craftsmanship.

GOLDSMITH TO
ROYAL DYNASTIES

BRITISH

Queen Victoria
1819–1901

Prince Albert
1819–1861

Prince Alfred
1844–1900

Princess Louise
1848–1939

Prince Leopold
1853–1884

Princess Helena
1846–1923

Prince Arthur
1850–1942

Princess Beatrice
1857–1944

PRUSSIAN

Emperor
Frederick III
1831–1888

Empress
Victoria
1840–1901

Princess Alice
1843–1878

Grand Duke
Louis IV
1837–1892

issue 7 including

King Edward VII
1841–1910

Queen Alexandra
(Princess of Denmark)
1844–1925

Emperor Wilhelm II
1859–1941

Prince Albert
1864–1892

Princess Louise
1867–1931

Princess Victoria
1868–1935

Princess Maud
1869–1938

Prince Alexander
1871–1971

King George V
1865–1936

Queen Mary
1867–1953

King Edward VIII
1894–1972

Princess
Mary
1897–1965

Prince Henry
1900–1974

Prince George
1902–1942

King George VI
1895–1952

Queen Elizabeth
1900–2002

Queen Elizabeth II
1926

Princess Margaret
1930–2002

DANISH

King Christian IX
1818–1906

Queen Louise
1817–1898

King Frederick VIII
1843–1912

Prince George
1845–1913

Princess Thyra
1853–1933

Prince Waldemar
1858–1939

RUSSIAN

Empress Maria Feodorovna
(Princess Dagmar of Denmark)
1847–1928

Emperor Alexander III
1845–1894

Grand Duke Alexander
1869–1870

Grand Duke George
1871–1899

Grand Duchess Xenia
1875–1960

Grand Duke Michael
1878–1918

Grand Duchess Olga
1882–1960

Empress Alexandra Feodorovna
1872–1918

Emperor Nicholas II
1868–1918

Grand Duchess
Olga
1895–1918

Grand Duchess
Tatiana
1897–1918

Grand Duchess
Maria
1899–1918

Grand Duchess
Anastasia
1901–1918

Tsarevich Alexei
1904–1918

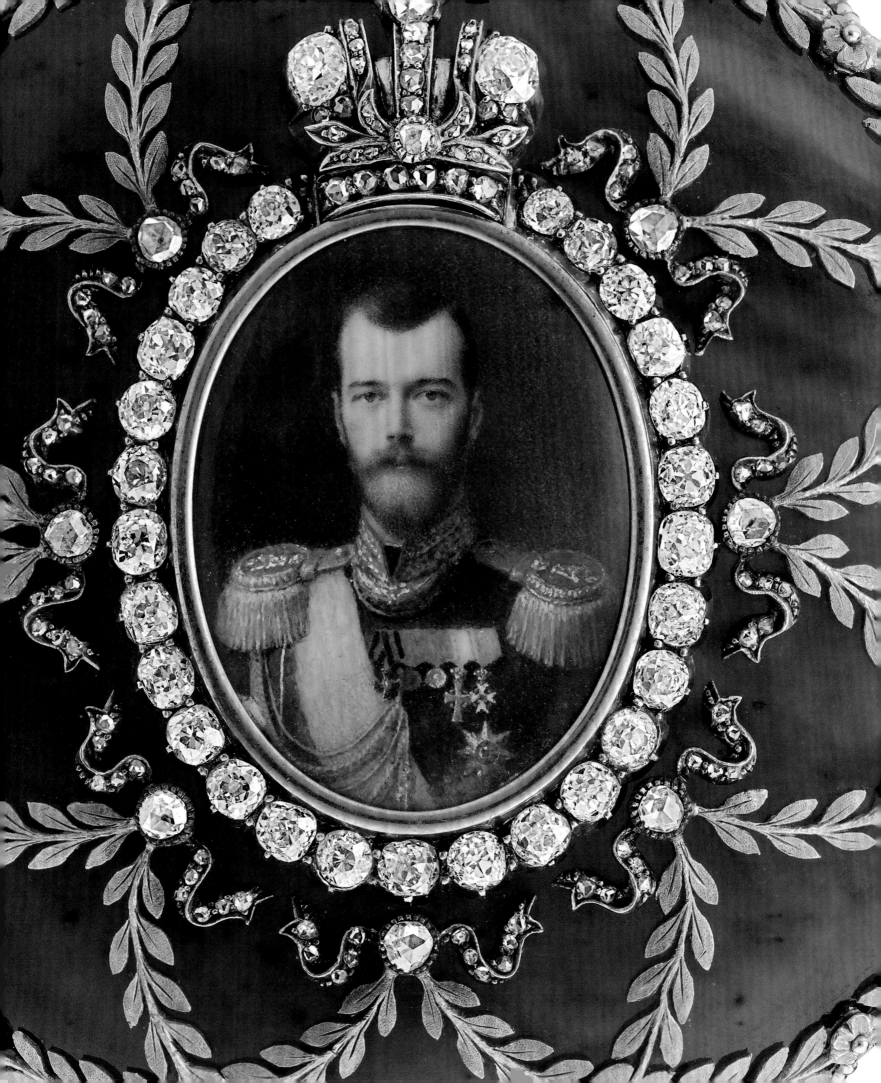

I

FABERGÉ
IN
RUSSIA

Tatiana Muntian

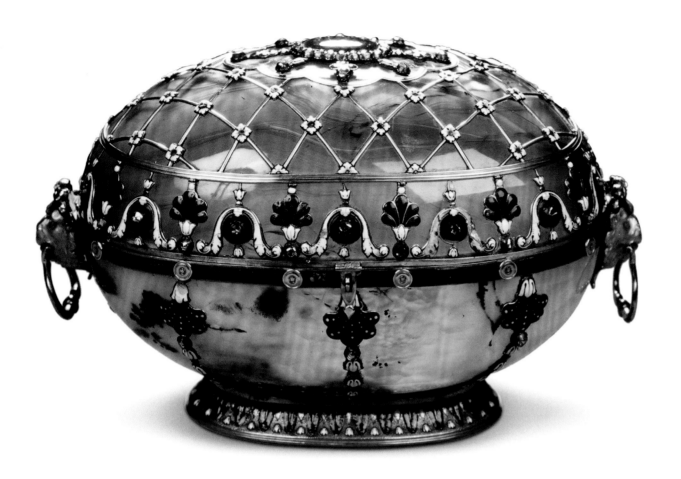

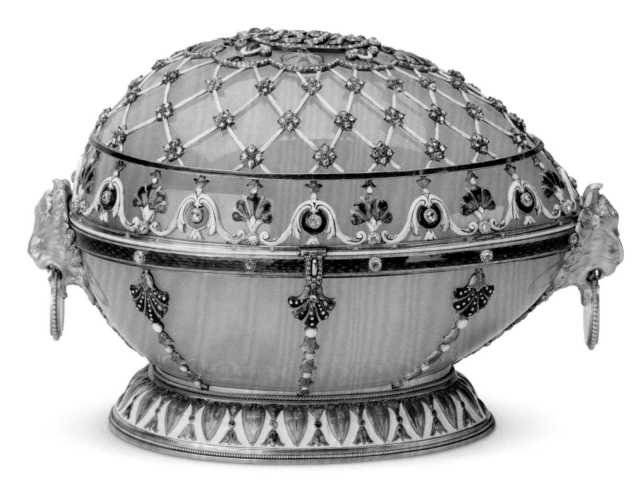

THE FIRM OF FABERGÉ WAS FOUNDED IN 1842 BY Carl Fabergé's father, Gustav Petrovich Fabergé (1814–1894). The Fabergé family was descended from French Huguenots, who had fled religious persecution in France following the Revocation of the Edict of Nantes in 1685. In the years that followed, they settled first in Germany before moving on to Pernov, in the Russian Baltic province of Livonia (now Pärnu, Estonia). The cosmopolitan outlook of Peter the Great (1672–1725) had made Russia an attractive country for artisans; religious tolerance was later enshrined in law and the language of the imperial court was French. This was the context in which Gustav grew up. Gustav reached the guild title of craftsman (*tsekhovoi*) and from Pernov hurried on to the jewellery mecca of the empire, the city of St Petersburg. There he achieved his greatest goal: he won enrolment in the St Petersburg guild of merchants and opened a store located for a time at 11 Bolshaya Morskaya Street selling gold and gem-set jewellery in the northern capital's aristocratic Admiralty region.

Gustav married the Lutheran Charlotte Maria Jungstedt (1820–1903), the daughter of an artist, and in 1846, the couple's first son was born: Peter Carl Fabergé. Gustav ensured that Carl received a diverse education, first attending the fashionable Gymnasium of St Anne's. Aged 18, Carl then travelled extensively, visiting the famous museums of Florence, Paris and Dresden whose collections would later serve as inspiration for the firm's works, and studying the techniques and history of goldsmithing. In Dresden he was a regular visitor to the Green Vault, the Treasury of the Saxon Electors. More than once the company would turn to the masterpieces in Dresden, reinterpreting historical works such as a casket by the jeweller Le Roy (pl. 9) or the cup with the figure of a female Moor by Benjamin Thomae (1682–1751) and Johann Melchior Dinglinger (1664–1731). In St Petersburg, Gustav's friend and colleague, the talented goldsmith Peter Hiskias Pendin (1823–1881) became Carl's mentor.

Carl Fabergé returned to St Petersburg and joined the family business. He and his colleagues devoted time and energy to studying the forms and ornaments of the art of earlier eras. They drew constantly from this inexhaustible source, particularly because it held an obvious attraction for clients steeped in the nineteenth-century preoccupation with historicism. It was believed that only a deep understanding of the art of the past made it possible to 'skilfully apply its motifs in the recreation of ever more ingenious items'.[1] It was not enough simply to copy the past; rather, it was the artist's ability to make a 'sophisticated choice' from the myriad examples available that resulted in the best work. The seeds were thus being sown for using the past as inspiration for the exquisite contemporary *objets de luxe* that would follow from the House of Fabergé.

In 1872 Carl Fabergé began to manage the family business entirely on his own, his father having retired to Dresden. That year also saw his marriage to Augusta Jakobs (1851–1925), the daughter of the manager of the imperial furniture workshops, with whom he would have four sons. Jewellery and the decorative arts of the day had previously been valued by the size and weight of the precious stones and metals used. In a departure from such traditions, and with the help of his younger brother Agathon (1862–1895), a talented designer and valued advisor who joined the business some ten years later, Fabergé eagerly formulated a new aesthetic, that of the design-led artist-jeweller, a marriage of design and craftsmanship, which would capture the attention of the Russian aristocracy and make his works irresistible – the ultimate objects to own or the gifts of choice.

Carl, the 'young, but already quite mature first-class jeweller',[2] found success and recognition through his entries in the 1882 All-Russian Art and Industrial Exhibition in Moscow. The firm was awarded a gold medal for a group of copies of ancient Greek gold items. As the expert commission

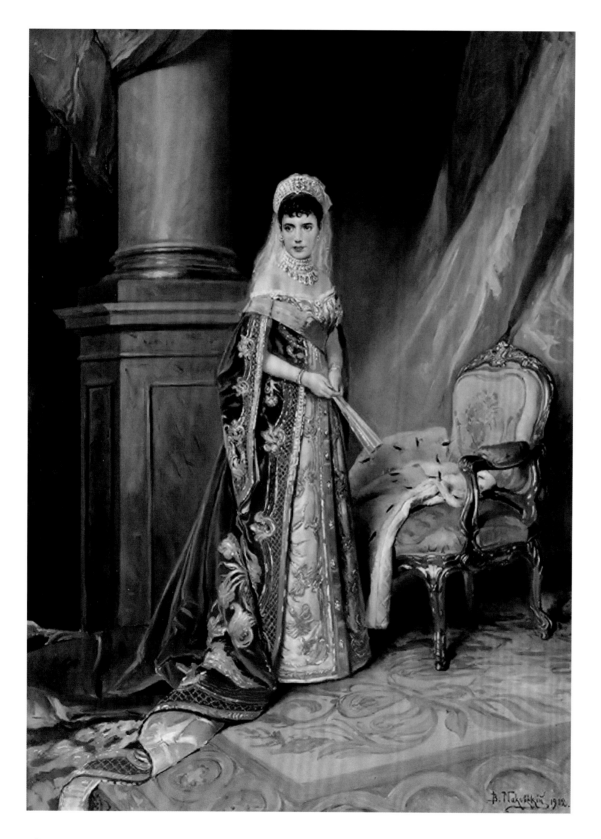

11
PORTRAIT OF EMPRESS MARIA
FEODOROVNA, PRINCESS
DAGMAR OF DENMARK
(1847–1928), 1912

Vladimir Makovsky (1846–1920)
Oil on canvas; 267 x 192 cm
The State Russian Museum,
St Petersburg

Empress Maria Feodorovna of Russia,
wife of Emperor Alexander III and
sister of Queen Alexandra of England.
The Empress was one of Fabergé's
most influential and supportive
customers. Her admiration for the
firm is evident in a letter she wrote to
Queen Alexandra describing Fabergé as
'the greatest genius of our time'.

noted, 'his works are distinguished by their fineness, not inferior to the originals and works in the same style as the famous Castellani in Rome'.[3] These pieces garnered important attention. Fabergé was delighted when Empress Maria Feodorovna purchased 'a pair of cicada cufflinks from him, which, according to the ancient Greek belief, brought happiness'.[4]

After his success at the 1882 All-Russian Exhibition, Carl Fabergé made his international debut at the 1885 International Exhibition of Works made from Precious Metals and Alloys in Nuremburg, where his entry was rewarded with a gold medal and 'very flattering reviews'.[5]

Further exhibitions established his reputation: the Nordic Exhibition of Agriculture, Industry and Art in Copenhagen (1888), at which Fabergé was also awarded a gold medal, and the Stockholm Exhibition (1897) at which the title of Court Jeweller to His Majesty the King of Sweden and Norway was conferred upon him.

However, the most important date in the company's history was 1 May 1885; on that day, Carl Fabergé was granted the status of Supplier to the Imperial Court and was given the right to include the state emblem (or coat-of-arms) of the double-headed eagle on stationery, advertisements and other public materials. Five years later, he personally was granted the status of Hereditary Honorary Citizen and the title of Appraiser of the Cabinet of His Imperial Majesty, which gave him the right of unhindered entry into the imperial palaces. Records indicate that he 'was repeatedly invited for personal meetings' with the Emperor, Empress and other 'august persons'.[6] Fabergé increasingly began to supply items to the imperial family, who gradually began to give him preference over his competitors.

It was Alexander III who initiated the famous series of Imperial Easter Eggs, to which the jeweller devoted more than 30 years of his life. The Emperor's first such commission was an Easter gift for his wife Maria Feodorovna. Outwardly, it

resembles an eighteenth-century egg that belonged to her mother, Queen Louise of Denmark (1817–1898).[7] Alexander was not only the commissioner but also, one might say, Fabergé's collaborator. The egg created by Fabergé, unlike the European ivory prototype in Denmark, was made of gold covered with white opaque enamel. Opening it revealed a miniature chicken made of coloured gold with ruby eyes; the little hen itself concealed a diamond crown. The third and final surprise, a 'precious keepsake', again deviated from that within the egg belonging to her mother. Through his brother, Grand Duke Vladimir Alexandrovich (1847–1909), who oversaw the order, Alexander conveyed a request to the jeweller asking him 'to replace the last surprise [a diamond ring] with a small pendant egg made of some precious stone' as 'it could be very nice'.[8] A delicate chain was attached to the gift so that 'Minnie', as she was known within the family, could wear it separately. The Emperor declared the order to be a 'great success' and that it had the desired effect on the recipient.[9] From that date forward (with a few exceptions), Fabergé fulfilled an annual order of an imperial Easter gift, each of which invariably delighted the couple with its original design and delicate work.

After the death of his father in 1894, Nicholas II ordered two jewelled eggs each year, one of which was intended for the Dowager Empress Maria Feodorovna, and the other for his wife the young Empress Alexandra Feodorovna. From 1885 to 1916, 50 eggs were created. Seven of those once belonging to Maria Feodorovna have been lost. The location of the eggs presented to her in 1886, 1888, 1889, 1897, 1902, 1903 and 1909 remains unknown (the 'surprise' within the 1897 egg, however, has survived).

Some of these Easter gifts are the last Russian autocrats' wordless declarations of love for their wives and can say as much about their personal relationship as do letters and memoirs. They are adorned with Cupid's arrows in diamonds, portraits

of their children or images of the palaces in which they carried out their private, daily lives. A number of the imperial eggs were dedicated to important political events in the life of the empire, including the construction of the Great Siberian Railway, the 300th anniversary of the founding of the Romanov dynasty, and the First World War.

Imperial clients had no use for duplicates, so each subsequent egg had to be different from the previous one. It was very difficult to create a new, completely original Easter gift from year to year, endlessly playing with the shape of an egg. Nevertheless, the firm's artists and craftsmen were honoured to be given this difficult task. 'What a gift for invention, what artistic skill', Maria Feodorovna wrote about Fabergé in a letter thanking her son for another 'marvellous egg'.[10] Indeed, Fabergé's imagination when creating these *objets de fantaisie* knew no limits. From the first egg concealing a hen, he moved on to create intricate jewelled designs. Easter eggs were made, for example, in the form of the Moscow Kremlin or a classical colonnade, a bay tree with tiny white flowers, jewelled fruit and a singing mechanical bird, or a basket of wildflowers in diamonds and platinum.

The artistic style of each Easter egg was selected to harmonize with the theme and, as Franz Birbaum testified in his memoirs, Fabergé had complete freedom to choose both the style and theme. Easter eggs were made in the manner of Louis XV and Louis XVI, Empire or the Renaissance. Fabergé and his artists, accustomed to 'a certain artistic discipline',[11] particularly favoured classical French art of the eighteenth century. Empress Alexandra Feodorovna had some interest in the most recent fashionable style known in Russia as the *stil' modern*, in part because her native Darmstadt was home to an important group of Jugendstil artists patronized by her family. Thus, this style, too, found a place in Fabergé's work. When creating the Lilies of the Valley, Pansy and Clover Eggs (1898, 1899, 1902 respectively) Fabergé turned to nature for

inspiration, while still avoiding the romantic liberties and eccentricity inherent in the work of French jewellers. He preferred modest flowers such as lilies of the valley, wild pansies and daisies to the 'trembling and delicate' orchids and other rare, 'exiled' flowers.[12]

The clockwork surprises hidden within some of the Easter eggs were mechanical wonders: an enamelled peacock proudly walked while revealing a fan of iridescent feathers; a gilded silver swan glided as if on the surface of water; while a miniature train with golden carriages and inscriptions that are legible only with a magnifying glass ('ladies only', 'smoking', 'non-smoking') ran for several metres with sparkling diamond headlights. The surprise within the Catherine the Great Egg (1914) was an automaton of Catherine II, carried in a sedan chair by two Moors and valued at 26,800 roubles. Dowager Empress Maria Feodorovna declared it 'a marvellous work of unimaginable and inimitable beauty'. The tiny masterpiece so impressed her that she called Fabergé 'the true incomparable genius of our time'.[13]

A number of the Imperial Easter Eggs were loaned by the Romanovs to be exhibited at the 1900 Exposition Universelle in Paris. Carl Fabergé showed his work *hors concours* (that is, exhibiting but not competing) as he served as a member of the jury for gem-set as well as artistic jewellery. His fellow jurors included the Russian court jeweller Friedrich Koechli (1839–1909) and his well-known French competitors, the jewellers Louis Aucoc (1850–1932), René Lalique (1860–1945), Henri Vever (1854–1942) and Frédéric Boucheron (1854–1942). The exhibition featured Imperial Easter Eggs loaned by the imperial family, miniature copies of state regalia (pl. 12), jewellery, carved hardstone items and flower studies made of precious stones and gold set in vases made of rock crystal. Despite some negative reviews from adherents of the Art Nouveau movement, the firm's works were a success among both Parisians and visitors who had come from all over the world. For his skill, Fabergé was awarded

12
MINIATURE REPLICA OF THE
IMPERIAL REGALIA, 1900
Workmasters August Holmström
(1829–1903) and Julius Rappoport
(1851–1917), St Petersburg
Gold, silver, platinum, diamonds, pearls,
spinel, sapphires, velvet, rhodonite
7.3 x 5.4 cm; 3.8 x 2.9 cm; 15.8 cm;
6.7 x 4.2 cm
Made by permission of Emperor
Nicholas II for Fabergé to exhibit at the
Exposition Universelle of 1900, Paris
The State Hermitage Museum, St
Petersburg (Э-4745)

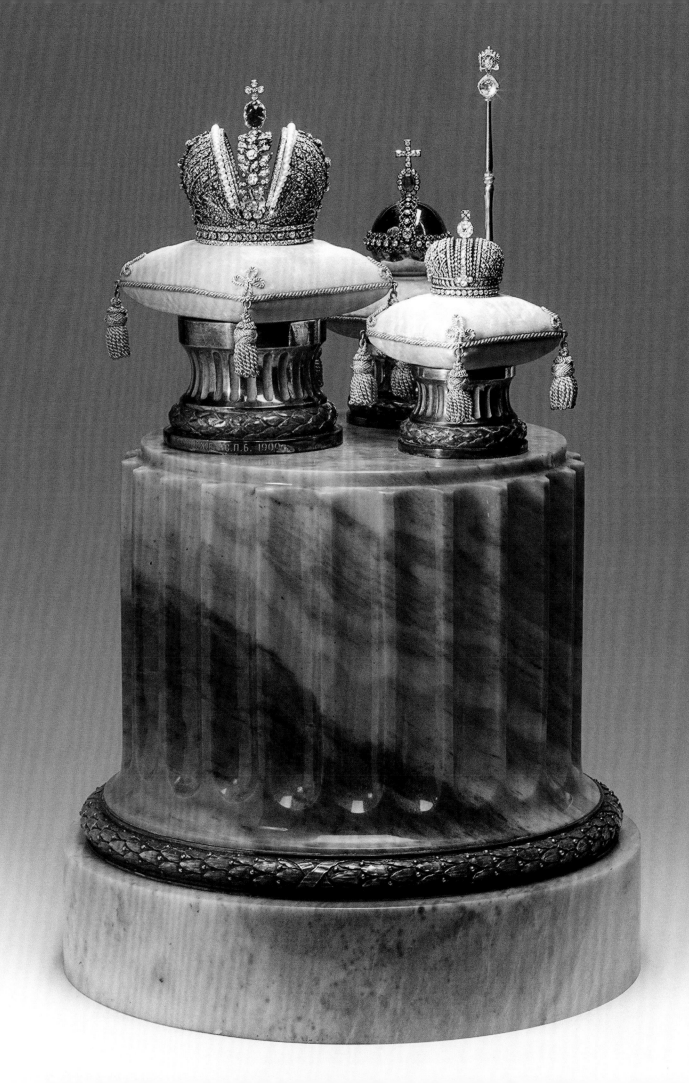

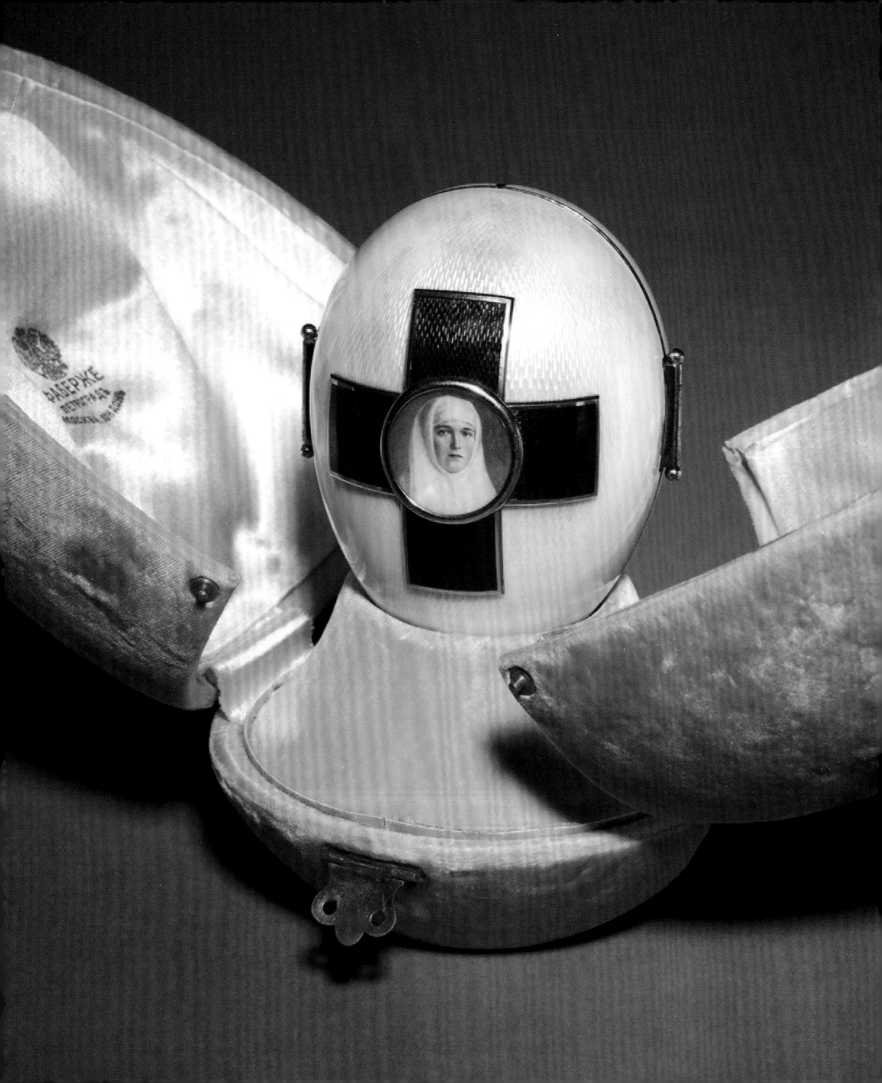

the highest French accolade, the *Légion d'honneur*, and a commemorative medal.

The eggs made during the First World War, conversely, were austere and completely devoid of gems. The Emperor may have considered it inappropriate to present luxurious, expensive gifts during these difficult years; in addition, the Emperor's family was devoting significant personal funds to set up hospitals and medical trains. Many of Fabergé's craftsmen who had worked on important imperial commissions were drafted and sent to the Front. The 1915 eggs were dedicated to the work of the female members of the Romanovs as Russian 'Sisters of Mercy', which is why they are now both known as the Red Cross Eggs. Their cost was almost seven times less than the eggs of the previous year, the last Easter in peacetime. The 1915 egg for Alexandra Feodorovna, made in the traditional form of an egg-shaped frame with two doors opening to reveal an icon, cost 3,600 roubles, while that for the Dowager Empress, which included as the surprise a folding screen with five portraits of the Sisters of Mercy by the miniaturist Vasilii Zuev (1870–1941), cost 3,875 roubles.[14]

Russian Grand Dukes and Duchesses, Princes and Princesses followed in the Emperors' footsteps and became devoted patrons of Fabergé. The firm had the 'good fortune' to number among its customers 'all the august members of the Imperial family'.[15] In March 1902 the personal Fabergé collections of the Empresses and other members of the imperial family, the nobility and the cream of Russian society, were shown in an exhibition held to benefit the Imperial Ladies Patriotic Society charity at the mansion of Pavel von Dervis in St Petersburg (pl. 14). Significantly, Fabergé's works were exhibited alongside antique miniatures and snuff boxes. The exhibition's organizers, all members of the elite of Russian society, rightly decided that his works were of equal value to recognized masterpieces of the past in terms of originality of design or virtuosity of execution.

The event was a tremendous success and enthralled the inhabitants of the city, allowing them a rare insight into the private lives of the imperial family. For the family, Fabergé's works 'had no equal in the world in their perfection and subtlety of execution',[16] they adorned everyday life and were full of 'joyful, sometimes fervent, always refined creativity'.[17] The Grand Duchess Olga, when thanking her sister Xenia and brother-in-law Grand Duke Alexander Mikhailovich for a charming box from Fabergé, exclaimed in delight that it was 'extraordinarily appetizing!'.[18] The epithets 'appetizing' or 'tasty', both terms taken from the jargon of the *Mir iskusstva* (World of Art) circle, characterize the work of Fabergé in the best possible way, as objects in which there was much of the 'beautiful, dexterous, sometimes exquisite, [or] funny'.[19]

According to his contemporaries, Fabergé's work represented the standard for elegance and refinement. It was said that when the Grand Duke Dmitry Pavlovich (1891–1942), a cousin of Nicholas II, paraded in the white uniform of his Horse Guards Regiment, he appeared as graceful as if he had been made by the jeweller Fabergé.[20] Nicholas, who collected carved hardstone figurines of soldiers in the 'uniforms of different regiments' made in Fabergé's workshop, prized their quality and grace. When his son Alexei appeared dressed in the uniform of an officer of one of the imperial family's Rifle Regiments, the Emperor was so proud of him that he could only compare him to a figurine by Fabergé.[21]

The company also counted among its extensive clientele prominent industrial titans and cultural figures. The oil baron Emmanuel Nobel (1859–1932) and business heiress Barbara Kelch (née Bazanova, 1872–1959) were notable clients. Fabergé created for each of them Easter eggs complete with surprises that were not inferior to the imperial Easter gifts in luxury. The influential prima ballerina Matilda Kshesinskaya (1872–1971) was another regular

13
THE RED CROSS WITH TRIPTYCH
EGG, 1914–15
Chief workmaster Henrik Wigström
(1862–1923), St Petersburg
Gold, silver, enamel, glass, portrait
miniatures; 8.6 x 6.4 cm
Presented by Emperor Nicholas II
to Empress Alexandra Feodorovna,
Easter 1915
The India Early Minshall Collection,
The Cleveland Museum of Art,
Ohio (1963.673)

14

Two views of the charity exhibition *Fabergé Artistic Objects, Antique Miniatures, and Snuff Boxes*, held at the Von Dervis mansion on the English Embankment in St Petersburg, March 1902. The showcase (left) contains works by Fabergé from the personal collection of Empress Alexandra Feodorovna; the view on the right includes the two showcases containing the Easter Eggs of Dowager Empress Maria Feodorovna and Empress Alexandra Feodorovna.

Photographs by Carl Carlovich Bulla's studio, 9–15 March 1902

The Moscow Kremlin Museums

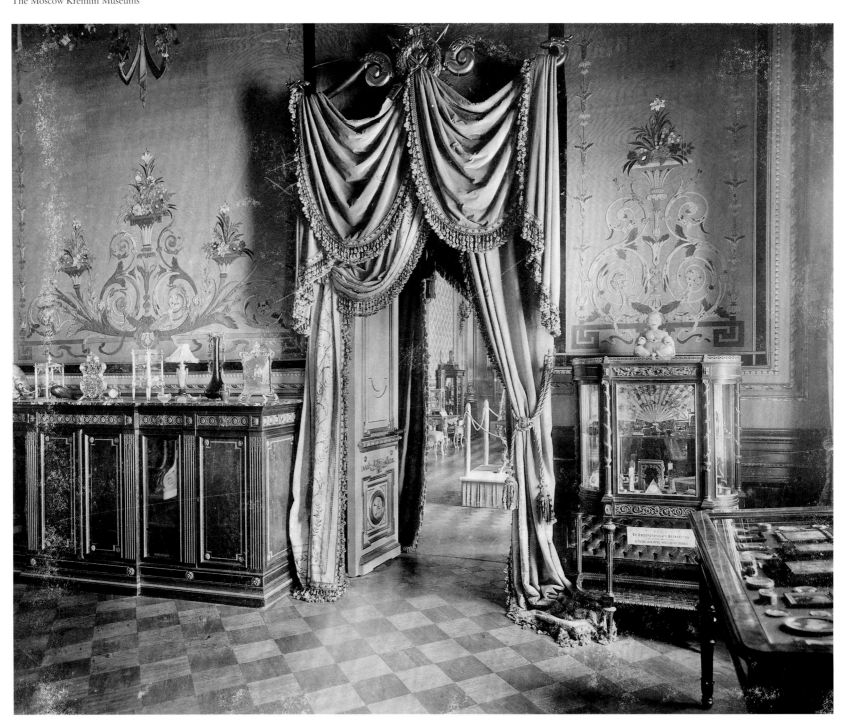

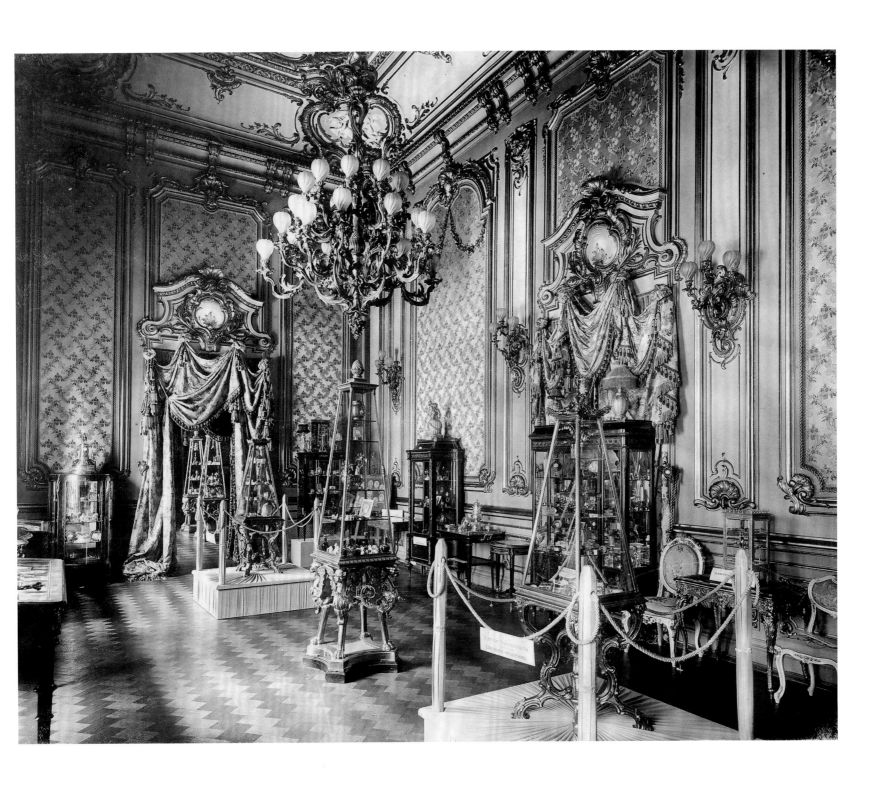

purchaser and recipient of gifts from the House of Fabergé. Grand Duke Andrei Vladimirovich (1879–1956), son of Grand Duke Vladimir and a close friend of the ballerina, presented her with a large straw egg of deceptively inexpensive appearance, stuffed with numerous small packets wrapped in paper, for Easter 1904. Among 'simple little things' such as pencils, ashtrays and 'other trifles', the ballerina found 'wonderful things from Fabergé and a pair of diamond buckles for shoes'. The ballerina, in turn, invited friends to her home at Christmas and handed out 'gifts, usually things from Fabergé'.[22]

Kshesinskaya owned a large collection of luxurious jewels by Fabergé, which she sometimes wore on stage. In her memoirs she recalled they were kept in Fabergé's shop on Bolshaya Morskaya. When she travelled abroad on foreign tours the firm also couriered and safeguarded them for her. In 1911 the ballerina arrived in London, her

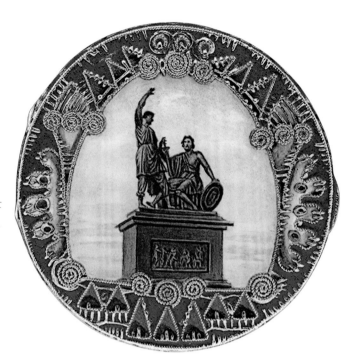

15
BOX, IN THE 'OLD RUSSIAN TASTE', c.1910

Workmaster Feodor Rückert (1840–1917), Moscow
Silver-gilt, enamel; diam. 4.5 cm
The Beilin-Makagon Art Foundation

The lid is set with a view of the monument in Moscow's Red Square to Minin and Pozharsky, the merchant and the prince, who led the liberation of the city from Polish invaders in the 17th century.

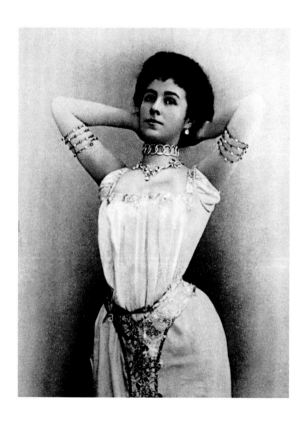

jewels having already been delivered to the British capital and safely stored at Fabergé's London shop. Two numbered catalogues had been made of her jewels; she held one copy and the firm the other. Kshesinskaya would telephone and, for security purposes, give only the catalogue number of the item she wanted to wear at that evening's performance or event. One of Fabergé's employees would then bring the necessary jewel to the hotel or theatre, and would remain nearby throughout the evening.[23]

Thanks to 'the refined artistic taste and astonishing energy of [Carl Fabergé], the firm developed its activities significantly',[24] becoming the largest jewellery enterprise in the empire with 500 employees and prestigious purpose-built premises. While St Petersburg was, according to the jeweller's grandson Oleg Fabergé (1923–1993), the 'soul of the firm', a second branch was opened in Moscow in 1887, and it thrived. A silver factory and workshops were established and their output included works

16
Matilda Kshesinskaya, the *prima ballerina assoluta* of the Imperial Russian Ballet and lover of Emperor Nicholas II before he was crowned. She is shown here in the role of Princess Aspicia in the ballet *The Pharaoh's Daughter*, 1898.

Opposite
17
Fabergé's Moscow branch on the corner of Kusnetsky Most and Neglinnaya Street in the centre of Moscow's luxury goods district. The business opened in 1887 as an equal partnership between Allan Bowe and Carl Fabergé. Allan and his brother Arthur went on to open Fabergé's London branch in 1903.
Wartski, London

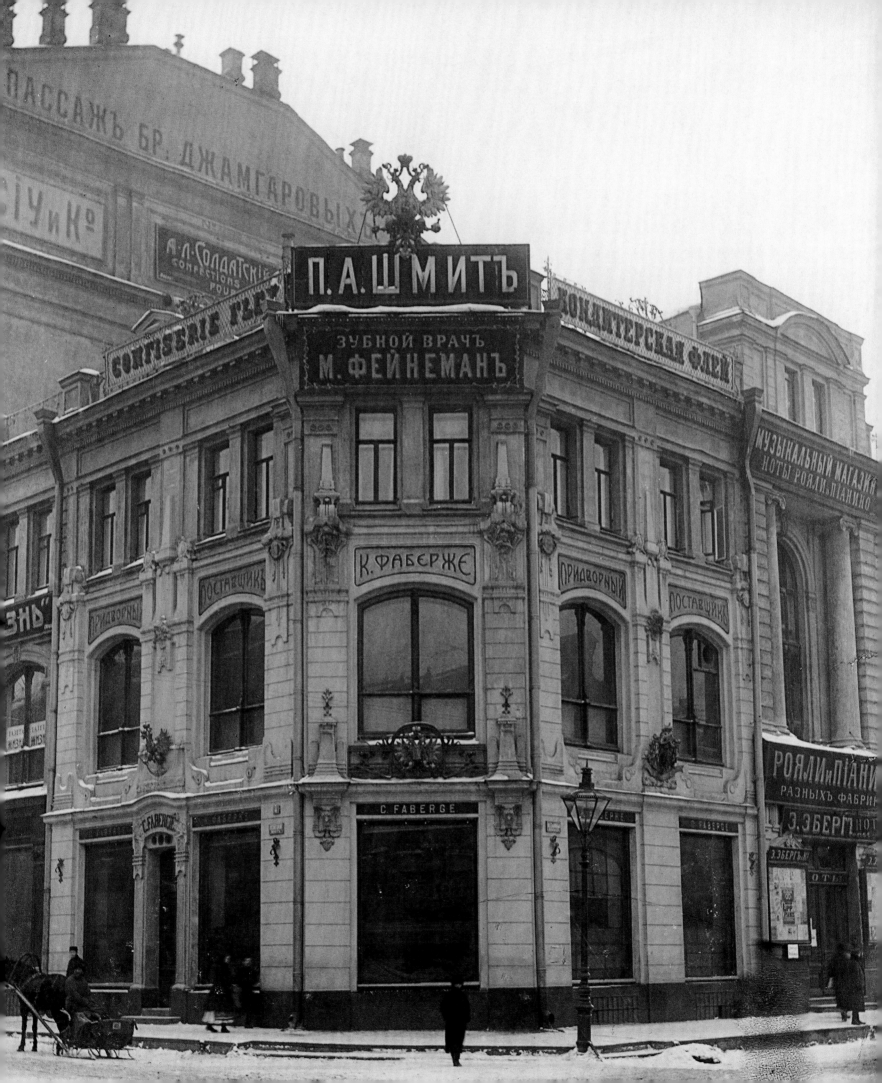

in the 'Old Russian taste', which was popular in the city. A subsidiary of the Moscow branch opened in Odessa in 1900 and another operated in Kiev between 1905 and 1910. In addition to representatives of the financial, industrial, government and artistic elite, the clientele of the Moscow branch also included members of the nobility. The memoirs of Lidiia Mitkevich-Zholtko, daughter of Artur Mitkevich-Zholtko, who was the head of the jewellery department of the Moscow workshops from 1902, mentions the famous ballerina Yekaterina Geltser, a soloist of both the Bolshoi and Mariinsky theatres. For one benefit performance, the firm's jewellers created a diamond and emerald necklace and tiara, the colours of which were intended to enhance her red hair.[25]

Grand Duchess Elisabeth Feodorovna (1864–1918), sister of the last Empress Alexandra Feodorovna and wife of Grand Duke Sergei Alexandrovich, Governor-General of Moscow, was also a client of the Moscow branch. The couple highly valued the firm's creations and often advised their nephew, Tsarevich Nicholas, to pay attention to them, even before he ascended the throne. On 14 August 1894, Grand Duke Sergei wrote to the future Emperor: 'We saw lovely things at Fabergé's and advised him to show them to you, as one of these days such things will be yours. We embrace you'.[26] Sergei Alexandrovich often chose works from Fabergé as gifts for those close to him. In the summer and autumn of 1899, Vladimir Feodorovich Dzhunkovsky (1865–1938), adjutant to the Grand Duke, was invited to stay at Ilyinskoe, the couple's country estate near Moscow. During his visit, he accidentally killed a cat while hunting, an act for which he 'suffered terribly from the Grand Duchess'. Vladimir Feodorovich recalled:

She uttered a lot of unpleasant words and did not speak to me for three days, only silently greeting and bidding me farewell. I wasn't able to prove that I had mistaken the cat for a hare, a fact that angered her still

18
A monumental silver kovsh, mounted with cabochon stones, depicting boyars, medieval Russian warriors, in the 'Old Russian taste', Moscow, c.1900.
Private Collection

19
Grand Duchess Elisabeth Feodorovna, a frequent visitor to the Moscow branch of Fabergé, 1882.
Russian State Film and Photo Archive, Krasnogorsk

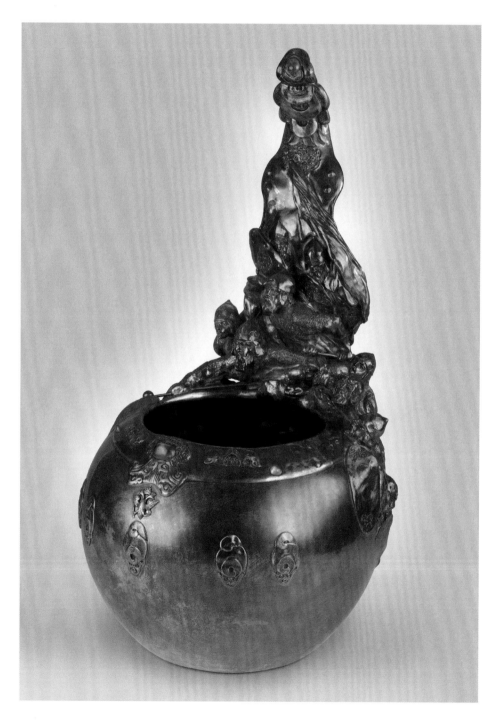

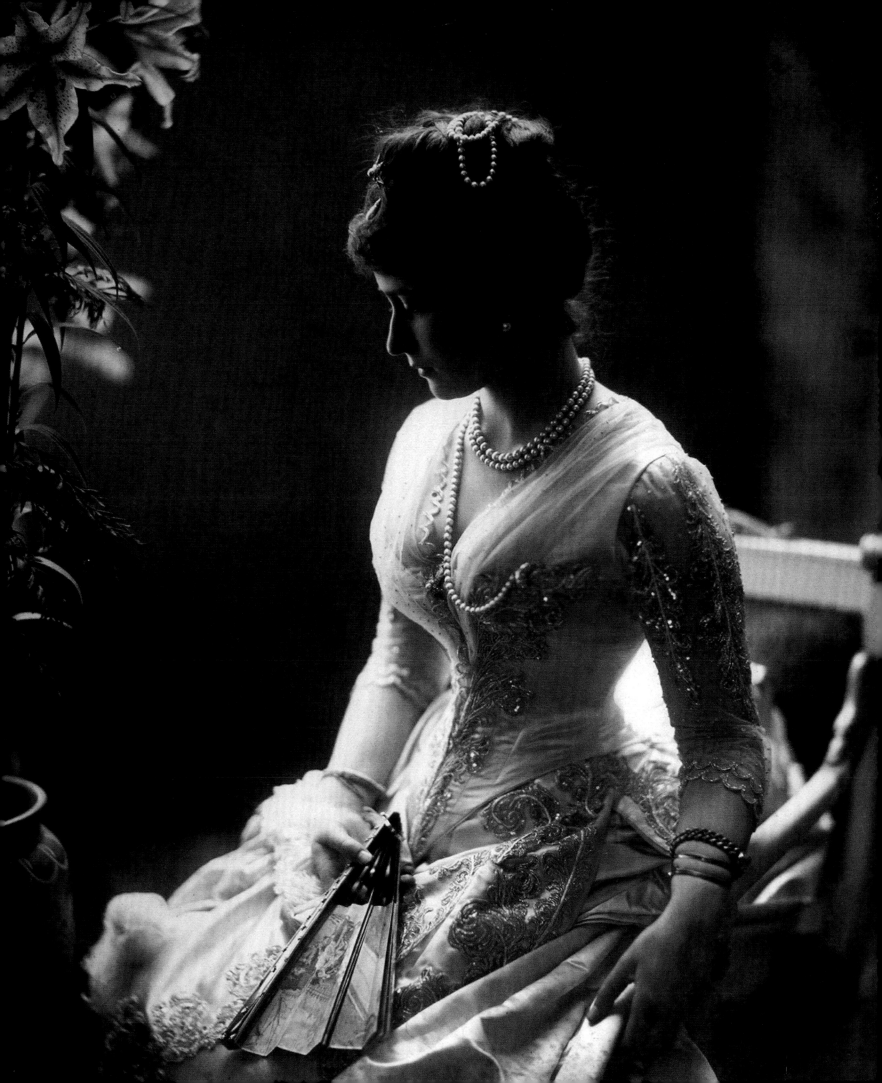

more ... At Christmas I received a present from the Grand Duke: a silver hare by Fabergé in memory of the hunting trip to Ilyinskoe. Someone noted that I should have been given a cat rather than a hare. But this suggestion was not successful, and the Grand Duchess' anger flared up again as she recalled the incident. Everyone fell silent.[27]

Beginning in 1901, the company expanded its international distribution via trade trips to London, where a branch was finally opened in 1903. From 1908 the company arranged commercial trips outside Europe, namely to Asia, especially to China and Siam (Thailand) where Fabergé was the first Russian trading company.[28] As a result, a synthesis of European and Asiatic styles was reflected in Fabergé designs. Eugène Fabergé (1874–1960), Carl's eldest son, wrote that 'many magnificent works by Fabergé decorate the palace of the King of Siam, the palaces of the Siamese nobility and Indian maharajas in Nepal'.[29] The company's employees carefully studied the drawings and photographs sent from Siam. As a result, in addition to works in European styles, new objects were made in the Siamese style. A traditional gift for the Lunar New Year in Siam was a figure of the animal corresponding to that year in the zodiac. In 1913, the year of the pig, for example, clients at the Siamese court ordered a large series of objects and pendants in the form of pigs.[30]

When describing his company, Carl Fabergé emphasized the family-run nature of the enterprise.[31] His younger brother, Agathon (1876–1951), made a great contribution to artistic strategy, creating the designs for many of the firm's most important works. His eldest son, Eugène, joined his father's business in 1894; they headed the St Petersburg branch together and he oversaw participation in international exhibitions. Carl's second son, also Agathon, joined his father's business in 1895 and was a gifted gemmologist. Alexander Fabergé (1877–1952), Carl's third son, served as the firm's director and trustee as well as acting as a designer for

20
Fabergé design, from the workshop of Henrik Wigström, for a jewelled, gold-mounted nephrite and red agate representation of a *chedi*. These are monuments built over receptacles containing sacred relics of the Buddha. The corresponding *chedi* is in the Thai Royal Collection.
Image courtesy of Ulla Tillander-Godenhielm

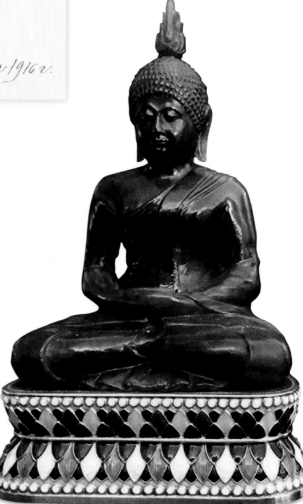

21
BUDDHA, *c.*1908
Chief workmaster Henrik Wigström (1862–1923), St Petersburg
Nephrite, gold, enamel; h. 9 cm
Private Collection

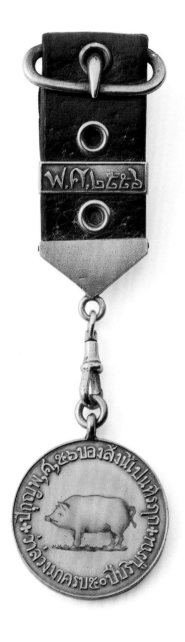

22
MEDAL, COMMEMORATING THE
YEAR OF THE PIG, 1913

St Petersburg
Silver, enamel, leather; h. 6 cm
The Woolf Family Collection

the Moscow workshop. The youngest son, Nicholas
(1884–1939), worked at the firm's London branch.

A similar dependence on family members
distinguished some of the company's St Petersburg
workshops. For example, Fabergé's primary
workshop, making jewellery with diamonds and
other precious stones, was first headed by August
Holmström (1829–1903), who, in addition to
luxurious ornaments, was entrusted with creating
some of the Imperial Easter Eggs. His son Albert
took over after his death in 1903 while his elder
daughter Fanny married the jeweller Knut Oskar
Pihl, who had begun his career in Fabergé's Moscow
workshops in 1887. Their daughter, Alma, in turn
became one of the firm's most important artists.
The workshop of Stefan Wäkevä (1833–1910),
which specialized in the production of silver utensils,
similarly grew when his sons joined the business.

Fabergé employed a broad cross-section of
craftspeople, many of them 'immigrants' from
Finland, a Grand Duchy within the Russian empire.
In 1903, when Fabergé's second chief workmaster
Michael Perchin died, he was succeeded by his
favourite student and apprentice, the Finnish-Swede
Henrik Wigström (1862–1923). We might presume
that had the Russian Revolution not intervened,
Henrik would have been succeeded by his son,
also named Henrik. In addition to the Wigströms
and Holmströms, the Finnish contingent included
among others Fabergé's first chief workmaster
Erik Kollin (1836–1901). According to Agathon,
Carl Fabergé's second son, 'the high level of
professionalism of [Fabergé's] craftsmen and their
total honesty was largely due to the fact that so many
had Finnish origins'.[32]

In response to a growing demand among his
clientele, Carl Fabergé opened a lapidary workshop
making carved hard- and gemstone sculptures in
St Petersburg at 44 Angliiskii Prospect. The Ural
mountain range was regarded as a treasure box
of mineral resources, which formed the basis for
Russia's extensive industrial development in the

eighteenth century and contributed significantly to the Russian economy. It stretches for 2,500 miles from the Arctic Ocean to the deserts of Kazakhstan and runs through nine Russian regions. In addition to iron and copper, the Urals were a source of gold, precious and semi-precious stones, such as emeralds, amethysts, aquamarines, nephrite, rhodonite, malachite and other gems, which were duly transformed by the court jeweller – Fabergé.

Many of the firm's employees were from what was called Russia's 'stone belt'. Peter Kremlev (1888–after 1937), a peasant from the Perm province who graduated from the Yekaterinburg Art-Industrial School, headed the workshop. Fabergé noted that the training of qualified stone carvers lasted at least five years, and only then could they be trusted with the execution of important orders. Such craftspeople 'were the exception rather than the rule'[33] and it was not easy to find new specialists.

One such exceptional talent was Petr Derbyshev (?–1914), who, after graduating from the Yekaterinburg School, journeyed to St Petersburg from the Urals on foot, arriving 'dressed in rags and shod in *lapti* [woven bark shoes]'. Recognizing his talent, Fabergé nurtured the young craftsman and he joined Kremlev's workshop, where he produced some of Fabergé's most sophisticated lapidary works. He studied in the German city of Idar-Oberstein, the centre of the stone-carving industry. From there, Derbyshev moved to Paris, where he worked with the famous firm of Lalique. As Birbaum wrote in his memoirs, Lalique, being delighted with his abilities, wanted to make the young man from the Urals his successor by marrying him to his daughter. Derbyshev chose instead to return to his homeland early in 1914. At the outbreak of the First World War, he was mobilized and perished in the earliest days of the conflict.[34]

The lapidary workshop created amusing and sought-after carved animal studies. The Russian aristocrat Prince Felix Yusupov (1887–1967) wrote that 'they seemed to be alive.'[35] Desirable as gifts,

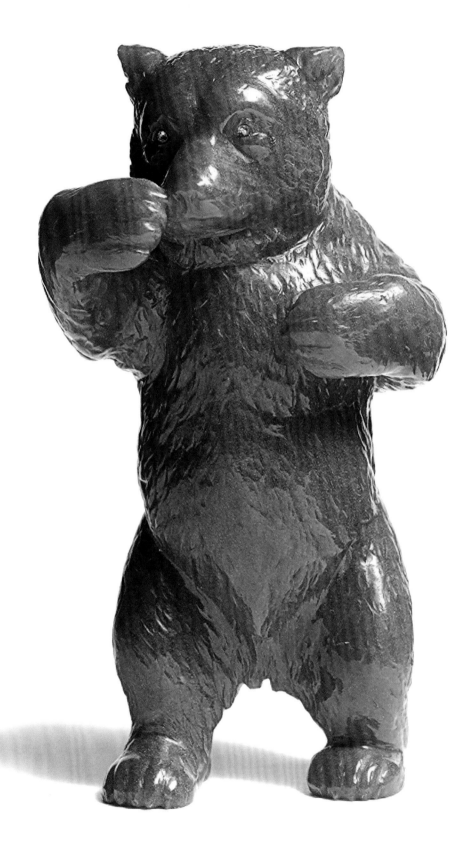

Opposite
23
BEAR, *c.*1909

St Petersburg
Brown jasper, diamonds; h. 8.7 cm
Private Collection

Art dealer Albert Stopford
purchased a matching brown
jasper bear from Fabergé's London
branch, November 1909.

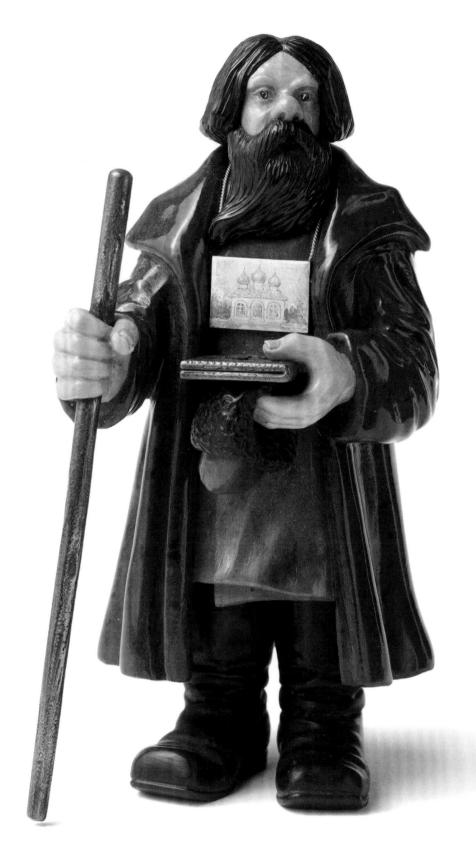

24
RELIGIOUS PILGRIM OR
*BOGOMOLETZ, c.*1908–14

St Petersburg
Jasper, flesh-coloured quartzite,
sapphires and nephrite; h. 13.5 cm
Wartski, London

they were sometimes presented with a hint of the recipient's appearance or character; one might receive a majestic bear (pl. 23) while a timid rabbit or a graceful cat would be more appropriate for another. Fabergé's figurines were no less valuable than his gold jewellery, so the presenters' generosity would not go unnoticed, but at the same time did not place the recipient under obligation. Dmitrii Ivanov (1870–1930), Director of the Kremlin Armoury Palace, wrote that the fashion for small, carved elephants, which were given for good luck, was partly the impetus for the carving of hardstone animals. 'The Grand Duchesses began to collect them, and fashionable society followed suit'.[36]

Compared to the animal carvings, mostly made from a single stone, the studies of people, assembled from different pieces of carved semi-precious stones, were the most difficult to make. Fabergé's sculptors and stone carvers succeeded in creating a vivid gallery of portraits of traders, artisans and peasants, all of which were enormously popular with the noble clients of the court jeweller. They were amused by the exotic and, to them, unknown lives of the common people, depicted by Fabergé with his characteristic elegance and lightness of mood, which gave an impression of innocence. Nicholas II and members of the Romanov family were touched by these little cameos in stone, showing the cheerful and sentimental side of everyday life.

The most charming and touching perhaps of all Fabergé's creations are his flower studies: flowers and berries on golden stalks, sitting in vases of rock crystal that appear to be filled with water; nephrite cacti with golden needles in pots of semi-precious stones; and carvings of bonsai in the Japanese style. In these works, the company's craftspeople were able to reveal the true qualities of gems from the Urals, Siberia and the Altai. True, to those of a pragmatic mindset, the purpose of the flowers, which could be called 'cabinet pieces', might not be clear.[37] Other critics considered the flowers too fragile and expensive. The author of an article in the magazine

Town and Country (*Stolitsa i Usad"ba*) in 1914 asked, 'Who buys such things? It's a waste of money!' To which Fabergé replied, '[T]here are people who long ago grew tired of diamonds and pearls and yes, it is sometimes awkward to make a gift of jewellery. In this case, these pieces fit the bill!'[38]

The early works in this genre were indeed made mainly of gold and enamel set with diamonds and pearls. Then the company's craftspeople turned to nephrite, or Siberian jade, to represent the leaves. Semi-precious hardstones were employed to make delicate petals and berries. Birbaum singled out for special mention the floral studies of dandelions, whose fluffy white seed heads were made, according to him, from 'natural [dandelion] down being attached to gold hair-like lengths of wire with tiny diamonds'.[39] A technical examination of an example from the Armoury collection, made on the eve of the 1917 Russian Revolution, confirmed that Fabergé had indeed used natural dandelion seed heads.[40] His craftspeople succeeded in capturing the light, elusive quality of the natural world in this astonishing image of a moment frozen in time.

Owing to the mood of what was a deeply troubled period of the early twentieth century, this study of a flower proved extremely popular. Dandelions have been compared to human reveries, dreams of happiness, which were indulged in everyday prose. In the work of the Russian Symbolist poet Konstantin Bal'mont (1867–1942), the 'grey-haired dandelion' represents 'the whole world, round like the earth', a symbol of frailty, precariousness and the fragility of being.[41] But suddenly these dreams vanished, shattered by the blows of fate. Soon, indeed, the world of imperial Russia would also disappear, and the renowned jewellery firm of Fabergé would cease to exist. Its multi-national tribe of artists and craftspeople, imbued with 'modern culture and the Russian creative spirit', had succeeded in creating a unique style that remains synonymous with beauty and perfection.[42]

25
DANDELION, 1914–17

St Petersburg
Gold, silver, nephrite, rock crystal, dandelion seed tufts, diamonds; 21.5 x 5.5 cm
The Moscow Kremlin Museums
(MP-12013/1-3)

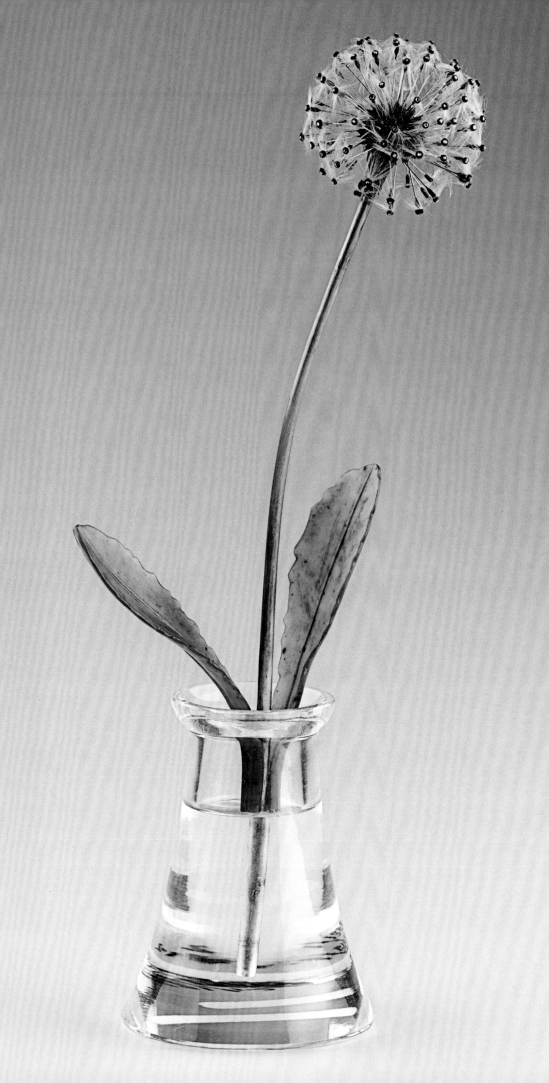

THE ST PETERSBURG WORKSHOPS

Ulla Tillander-Godenhielm

By the late 1880s Carl Fabergé had become the most important goldsmith and jeweller in St Petersburg, with the imperial court, the Russian aristocracy and the city's wealthy bourgeoisie at his feet. His remarkable path to fame and fortune began the day he hatched his ingenious idea of creating a completely new line of luxury gift items: a fabulous array of objects in precious metals, decorated with enamel and beautiful hardstones, in designs drawn from a seemingly bottomless well of imagination.

Fabergé's concept was neither a one-man stroke of invention, nor was it an overnight success, achieved by waving some magic wand. It was the fruit of a lengthy process that lasted nearly two decades, during which Fabergé established a cadre of immensely talented and progressive craftsmen and designers, all eager to take part in something utterly new.

Success brought challenges in its wake. To meet the ever-expanding demand for this innovative range of works, much needed to change within the firm, which hitherto had worked in cramped premises, with the workshops scattered around St Petersburg. Manufacturing processes had to become more efficient in order to increase the volume of production. Designers had to be inspired to surpass themselves. The various 'core functions' of the company had to start communicating with each other, to work closely together, and to understand their respective problems. It was essential to put the entire organization on a new footing.

Carl Fabergé took the decision to construct new headquarters for the firm, situated at 24 Bolshaya Morskaya. Completed in 1901, the purpose-built property was the first commercial complex of its kind anywhere in Russia. It introduced a totally novel approach, with most of the company's core operations working under the same roof. But there was more: long before the advent of the modern concept of industrial democracy, its prototype now came into play at the House of Fabergé. Curiously enough, it bloomed during the reign of the greatest autocracy the world has ever seen.

The ground floor of the building was laid out as a large showroom, with counters and glass display cases around the walls (pl. 26). Here, the greater part of the stock was placed, resplendent in fitted presentation boxes. The space was designed with display in mind, so that the customer could see all the latest wares at a glance. Carl Fabergé's own office was directly adjacent to the main showroom. The floors above contained all the company's offices and the studios of the artists and designers, with an adjacent reference library of works on the decorative arts in general and jewellery in particular. Nearly every volume written about the goldsmith's trade and the cutting and polishing of gemstones could be found on the shelves, and the library was naturally at the disposal of the employees. In line with the 'pedagogical practices' for staff, designers and craftsmen, a small greenhouse was built on the flat part of the building's roof. Plants and flowers, including tropical varieties, were grown here during the summer months. These were used as models for the flower studies created by the House of Fabergé.[1]

Four central workshops were housed in the five-storey courtyard wing of the building. Connecting passages between the office building and the workshops facilitated the daily contact between the various company units.

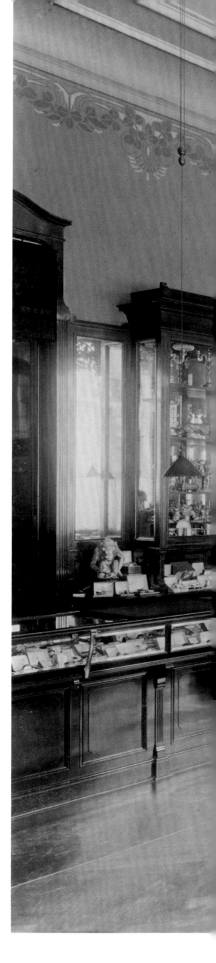

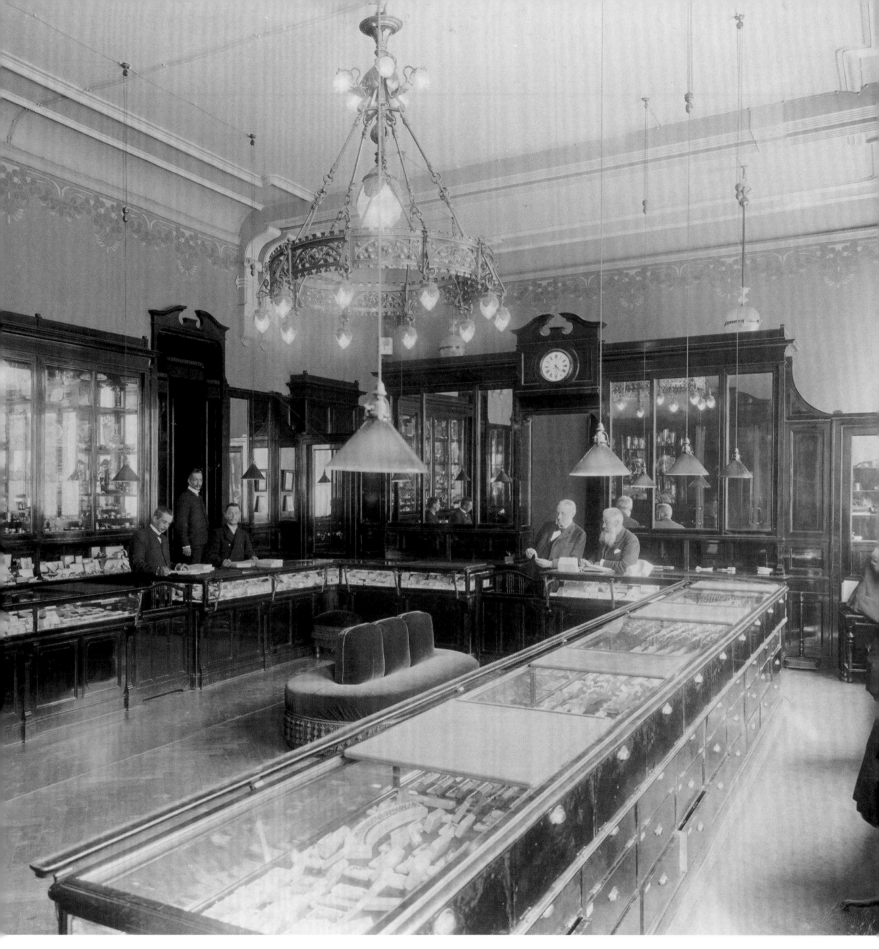

26
The interior of Fabergé's ground-floor
showroom at 24 Bolshaya Morskaya,
St Petersburg.
Wartski, London

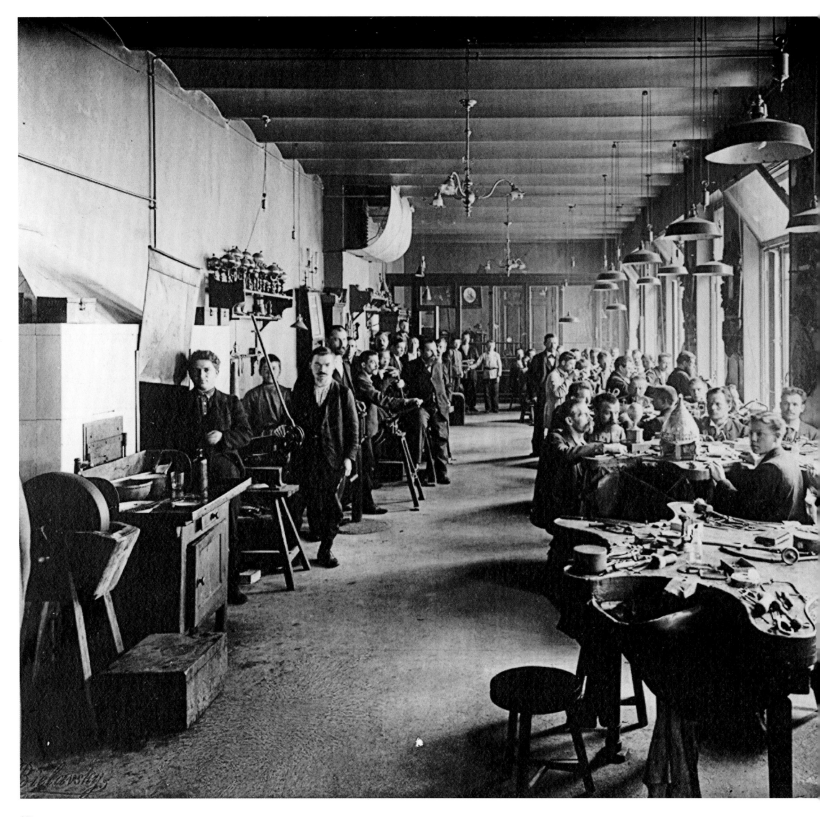

27
The workshop of Fabergé's chief workmaster
Michael Perchin and later his successor Henrik
Wigström. It was located on the second floor of
the building behind Fabergé's shop on Bolshaya
Morskaya in St Petersburg.
Wartski, London

The principal workshop occupied the second floor (pl. 27). It was headed by Michael Perchin (1860–1903) until his untimely death, and thereafter by Henrik Wigström (1862–1923). The third floor was the domain of the master of fine jewellery August Holmström (1829–1903), succeeded in 1903 by his son, Albert (1876–1925). The all-round master goldsmith August Hollming (1854–1913) was housed on the first floor. Underneath the eaves on the fourth floor were the quarters of the second master jeweller, Alfred Thielemann (1870–1909).

On the ground floor, also in the courtyard wing, was the workshop devoted to the making of the fitted cases. It was essential for these master casemakers to be adjacent to the production units, as they had to spend considerable time on the spot, measuring the objects and jewels for which the cases were being made.

At least a dozen other closely affiliated workshops were situated in nearby locations. These included the ateliers of the goldsmiths Viktor Aarne (1863–1934), Fedor Afanasiev (1870– after 1927) and Antti Nevalainen (1858–1933); the silversmiths Julius Rappoport (1851–1917) and Stefan and Alexander Väkevä (1833–1910; 1870–1957); the lapidary Peter Kremlev (1888–after 1938), and the master enameller Alexander Petrov (d.1904), aided by his two sons Nikolai (d.1918) and Dmitri. Nikolai became Fabergé's chief enameller on his father's death.

The administration, office clerks, sales personnel and designers were all on the firm's payroll. By contrast, the entire production arm was outsourced, but working under contract to and exclusively for Fabergé. The workshops were thus independent enterprises, owned and run by their individual master goldsmiths. Offering the masters ownership of their workshops within a system of close collaboration was a pragmatic arrangement and was typical of companies with artisanal production. The system afforded many advantages, both for

the House of Fabergé itself and for the individual workmasters. Above all, it secured long-term cooperation among the parties involved. For the master, there was also the assurance of a steady outlet for his production.

The workmasters were all hand-picked by Carl Fabergé. Most had worked earlier as young journeymen in ateliers already collaborating with the firm, and were thus very familiar with the requirements of the House. The workmasters were responsible for the quality of craftsmanship and for guaranteeing delivery schedules. In return, they were granted the right to mark their wares with their own initials.

Outsourcing meant that the House's creative energies could be focused on the products: management was spared the burden of irksome day-to-day headaches. These included difficulties in recruiting suitable apprentices and journeymen, and the eternal problem of keeping skilled staff on the roster. A Fabergé atelier was arguably the dream workplace for a goldsmith, but there were challenges nevertheless, both for the workmaster and the man at the bench. A goldsmith's work demands total concentration and unwavering precision of eye and hand. Distraction was an issue in the crowded cluster-seating at the workbenches. The tiniest slip of a tool could mean catastrophe. Working hours were long, while daylight was in short supply in the winter months. Lighting left much to be desired. Excessive use of alcohol was rife, with absenteeism one of the consequences. Finally, good workmanship was much in demand in St Petersburg: there was always the temptation of a change of employer.

The workshops had their own specialities, with production divided between them accordingly. The Perchin/Wigström workshop, being the 'senior' atelier, was allocated the most exacting commissions, especially those important pieces for the imperial family. Before he became chief workmaster in 1903, Henrik Wigström (pl. 28) assisted Perchin in making 26 of the Imperial Easter Eggs, and after his promotion he supervised a further 20.

The dazzling Easter eggs get the headlines, but the backbone of production at Wigström's workshop was formed by small utility items and decorative home accessories: cigarette cases, boxes, bonbonnières, bell pushes, clocks, decorative frames and desk sets, for instance. These were pieces that would be scattered around affluent homes in keeping with the taste and decor of the time, and they therefore made ideal luxury gifts.

An exploration of the pieces made in Wigström's workshop between 1911 and 1916 shows the breadth of production, which embraced some 50 different types of object.[2] As models were hardly ever repeated, this highlights the organizational genius of Fabergé's production methods. Looking through these pieces also reveals the importance of enamel, which featured in almost half of his creations, either as the principal decorative element or to highlight details in the design.

With its treasure trove of decorative minerals from mines in the Urals and beyond, Russia provided Fabergé with a veritable galaxy of hardstones. The importance of these in Fabergé's production can also be seen in Wigström's output during that five-year period: well over 30 per cent of the completed pieces included hardstones, Siberian nephrite being the most commonly used.

The hardstones were cut to precise designs supplied by Fabergé's designers. Collaboration in advance was paramount here: the hardstone parts of any item had to be cut and polished – and precision-drilled – to accommodate the gemstones and precious metals in the finished product, as well as mechanisms for bell pushes and clocks. Both of these items were Fabergé bestsellers.

The craftsmen in the workshops were a highly heterogeneous group, brought together from all corners of the Russian empire and representing its wide spectrum of different cultures, religions, and tongues. They also differed widely in age, from the very young to the very old. But despite all these differences, oral and written testimony from goldsmiths who worked there indicates that there were few problems among the staff at Fabergé. The

28
Henrik Wigström, Fabergé's third chief workmaster from 1903.
Collection of Ulla Tillander-Godenhielm

Opposite
29
Designs from the workshop album of Henrik Wigström.
Private Collection

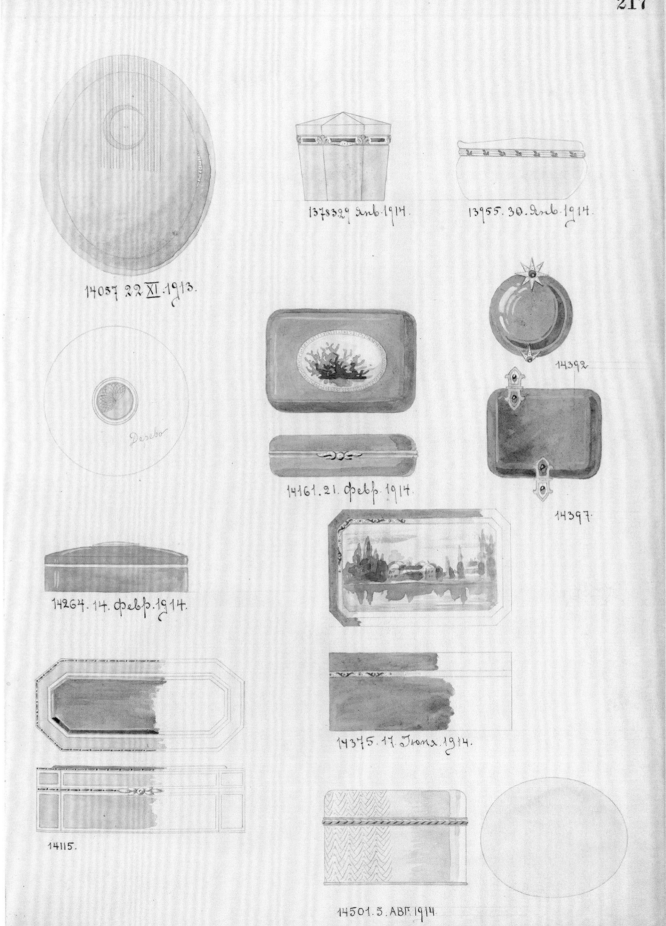

14057 22 XI 1913.

13783 29 Янв. 1914.

13955. 30. Янв. 1914.

Дерево

14392

14161. 21. Февр. 1914.

14397.

14264. 14. Февр. 1914.

14375. 17. Июня 1914.

14115.

14501. 5. Авг. 1914.

language question, for instance, was mitigated by a common trade jargon – a 'goldsmiths' Esperanto' of sorts – that outlasted the St Petersburg era and was still in use in Finland up until the 1960s.[3]

Good workplace morale and a high degree of motivation was largely due to the enlightened system by which the head of each workshop took a personal interest in every member of his staff, guiding them and discussing the work in hand. This philosophy of staff welfare pervaded the entire firm, creating a feeling that all the workers were members of an extended family.

The guild system was abolished in Russia at the end of the nineteenth century. Nevertheless, its traditions and working practices were by that time so deeply ingrained in the routines of workshops dependent largely on manual labour that they continued to be observed by the masters. An important legacy from the old system was the tradition of training apprentices. These young craftsmen-to-be were appointed to the workshops at a very tender age: an apprentice of a mere 10 or 11 years of age was not an unusual sight at a St Petersburg workbench. The boy would be seated at the bench next to his instructor, a master goldsmith or senior journeyman. This would be his place for the next six years, the average length of an apprenticeship in a goldsmith's workshop.

The teaching method was simple. From the outset, apprentices were expected to learn by watching their instructors at work and through making their own innumerable mistakes. It was a regimen that required a great deal of patience on both sides, as the instructors were inevitably concerned primarily with the work in hand, the teaching of their apprentices taking second place.

The Fabergé workshops were almost all a 'family affair'. The ateliers of Holmström, Hollming, Thielemann, and Väkevä all had family members on the roster, either two generations of the same family working together, or wives engaged in the running of the workshop. Sons were apprenticed with a view to taking over from their fathers. Daughters,

if so inclined, were employed as designers or clerks. Wigström's daughter Lyyli, a quick-witted and gifted young woman, was also employed in the workshop. She handled its day-to-day clerical tasks, and also had the significant responsibility of managing the workshop's stock of precious stones.

The Holmström workshop offers another example of how family members were brought in. On the death of his father August in 1903, Albert Holmström took over. Albert harboured dreams of becoming a concert violinist, but the only son of a master jeweller did not have a choice in such matters.

The Holmström workshop was unique in having two in-house designers, and both were talented women. Albert's sister Alina Holmström (1875–1936) was one, and the other was August's young granddaughter, Alma Pihl (1888–1976).

Alina Holmström was a graduate of Baron von Stieglitz's well-known Central School of Technical Drawing in St Petersburg.[4] Carl Fabergé was a firm advocate of studies at this establishment. The younger set of craftsmen and artisans at Fabergé was urged to take courses at the Stieglitz School, which had an impressive curriculum for preparing students in arts and crafts for the industry. Alina was a skilled jewellery artist with a talent for fashioning extremely small details. The 'garland style' or *style guirlande* was

Opposite
31
A page of jewellery designs in the 'garland style' from the Holmström workshop album, dated November 1912.
Wartski, London

30
Alina Holmström, designer at the jewellery workshop of her brother Albert Holmström, 1910.
Collection of Ulla Tillander-Godenhielm

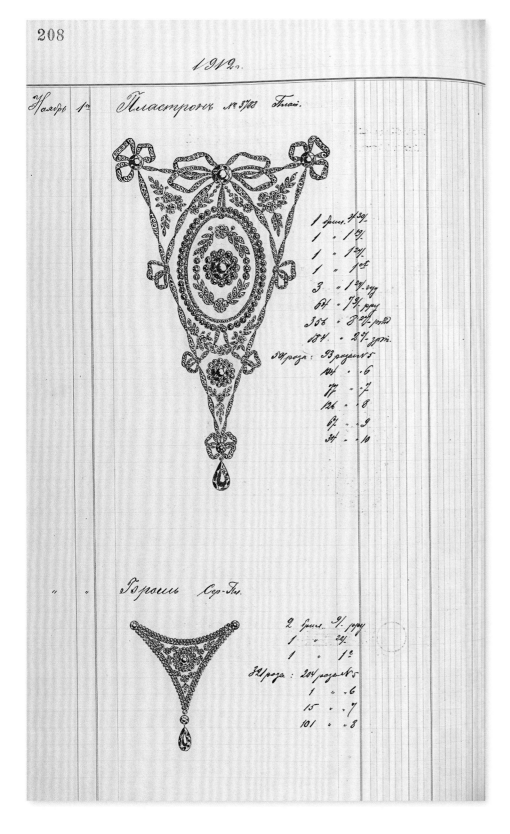

her preferred mode of expression. The two surviving Albert Holmström books of jewellery designs show a great number of refined, ethereal and stylish pieces in the 'garland style', which could very well have come from Alma's pen.[5]

In 1908 Alma, then only 20 years of age, was employed as an apprentice draughtsman. During rare moments of leisure, she tried her hand at designing. Uncle Albert saw her efforts and showed them to the sales department. They were much impressed. So began Alma's career as a self-taught assistant designer. Her breakthrough came with the design of 40 winter-themed brooches made for the oil magnate Emanuel Nobel in January 1911. These were so successful that Dr Nobel followed up with many similar commissions. She thereafter designed frost-flower bracelets, pendants (pl. 34), and more brooches, in platinized silver richly set with the tiniest rose-cut diamonds.

The next assignment was a huge step, by any measure, for in 1912 Alma was tasked with designing nothing less than an Imperial Easter Egg. This was to become the fabled Winter Egg (1913), an Easter gift to the Dowager Empress, Maria Feodorovna. The Melting Ice Pendant (pl. 44), crafted alongside the Winter Egg at the Holmström workshop, echoed the theme of the egg – winter giving way to spring.

We have no evidence of the Dowager Empress's reaction to her breathtaking gift. Suffice to say, however, Alma was asked to design an Imperial Easter Egg for Empress Alexandra the following year. The inspiration for this astonishing piece came from family evenings at home, as Alma watched her mother-in-law doing her needlepoint embroidery. Carl Fabergé approved the idea, and he charged the Holmström workshop with the project. The technique was new and absurdly difficult, and it required several prototype brooches (pl. 38) before the workshop felt equipped to embark on the egg itself. The result was a triumph of the collaboration between designers and artisans: the Mosaic Egg (1914), now in the collection of H.M. Queen Elizabeth II.

32
Alma Pihl, designer at the jewellery
workshop of her uncle Albert
Holmström, 1912.
Collection of Ulla Tillander-
Godenhielm

33
A page from the design album of the Holmström workshop, dated 27 June 1913, showing the sketch of the pendant.

34
ICE SHARD PENDANT, 1913

Designed by Alma Pihl (1888–1976), workmaster Albert Holmström (1876–1925), St Petersburg
Rock crystal, platinized silver, diamonds; 7.2 x 3.1 cm
Artie & Dorothy McFerrin Collection at the Houston Museum of Natural Sciences (McF 47)

Opposite

35
NECKLACE, *c.*1900

Workmaster August Holmström
(1829–1903), St Petersburg
Gold, silver, diamonds; 19 x 13 cm
Wartski, London

36
SNOWFLAKE BROOCH, 1913

Workmaster Albert Holmström
(1876–1925), St Petersburg
Gold, platinized-silver, diamonds;
2.5 x 2.5 x 0.5 cm
Private Collection

37
Design for the Snowflake brooch from
the album of the Holmström workshop.

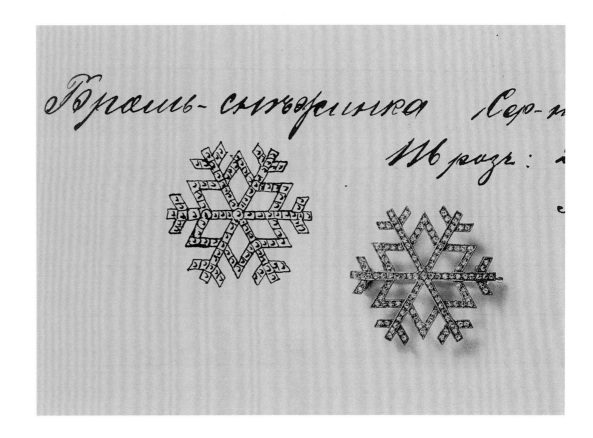

38
BROOCH, IMITATING PETIT-
POINT EMBROIDERY, *c.*1913

Designed by Alma Pihl (1888–1976),
attributed to the workshop of Albert
Holmström (1876–1925),
St Petersburg
Platinum, gold, diamonds, rubies,
coloured sapphires, topazes, demantoid
garnets, emeralds; l. 4.4 cm
The Woolf Family Collection

MATERIALS AND METHODS

Joanna Whalley

When viewing a work by Fabergé, the overall impression is often one of effortless perfection. This appearance is, of course, deceptive. The effect is the result of many hours of intense, highly skilled work by a team of the finest craftspeople, each specializing in a specific element of the work at hand, such as lapidary, goldsmithing, mounting, setting, engine-turning or enamelling; the whole process being carefully coordinated to ensure that the various elements come together seamlessly.

Russia has long been famed for its abundant wealth of mineral resources, which is naturally a source of great national pride. The unrivalled variety of materials has served as inspiration to a long tradition of lapidary, in which Russia excels. This art form was further refined by the most discerning businesses, such as Fabergé's, who employed the best lapidaries.

In choosing a material to carve, the lapidary has a number of considerations. They must first choose how best to express the subject matter, be that the soft downy fur of a dormouse, the waxy green skin of a frog, or even the sheen on the back of a sealion. Colour, translucency, lustre and natural inclusions are all of influence, but of primary importance is the material's suitability to carving. It must be hard, tough and free of natural internal fractures or disfiguring inclusions.

The most versatile gem materials for carving are those comprised of many minute crystals that are firmly interlocked and therefore generally tough and most able to take complex forms. The best known materials of this type are those of the quartz group, such as jasper, chalcedony and agate. These

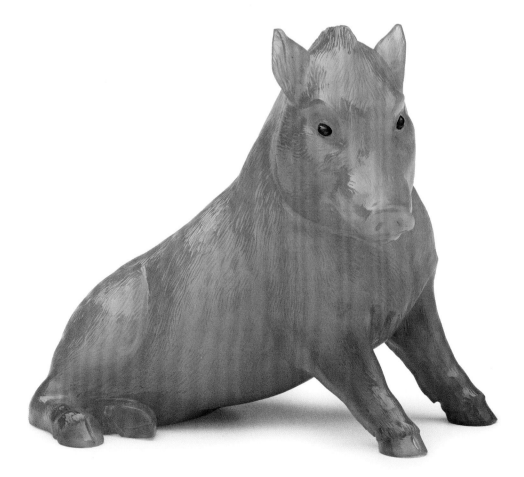

39
Wild boar, c.1908

Sculptor Boris Frödman-Cluzel (1878–1969), St Petersburg
Chalcedony, rubies; 6.7 x 8.6 x 5.0 cm
Purchased by King George V, when Prince of Wales, from Fabergé's London branch, December 1909 (£31)
The Royal Collection / H.M. Queen Elizabeth II (RCIN 40260)

The pose is reminiscent of the famous bronze boar in the Medici collection in Florence, with which Fabergé and his sculptors were likely to have been familiar.

56

40
SCOOP, c.1885

Chief workmaster Erik Kollin
(1836–1901), St Petersburg
Striated agate, gold, sapphires; w. 14 cm
Private Collection

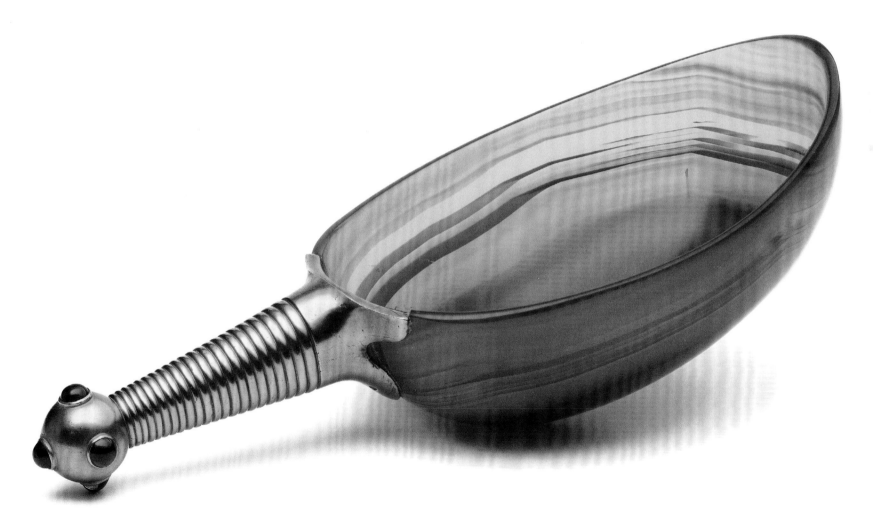

are the most abundant gem minerals on earth and were readily available to the lapidaries of Russia, occurring in a broad spectrum of colours, often in distinct layers or graduated zones. This inherent beauty may be experienced in the simplest of forms, such as Fabergé's agate Scoop, with its distinctive banded colours (pl. 40). In experienced hands, the distribution of hue can be positioned in such a way as to express, for example, the graduated colour seen in the Wild Boar (pl. 39), the darker tones of which have been carefully positioned in order to give the legs and the mane a deeper colour. This appears quite natural and lends the boar a certain realism.

Another popular choice of material is jade, of which there are two varieties: nephrite and jadeite, both of which can be sourced in Russia. The minute crystals of jade have a great tensile strength and are more fibrous than those of the various quartzes; hence it is the toughest known gem material used for carving. Fabergé's lapidaries often favoured the dark spinach-green variety of nephrite from Siberia for their work and the frog of the Desk Seal, thought to have been heavily inspired by a bronze designed by the animal sculptor Emmanuel Frémiet (1824–1910), utilizes its properties to the fullest extent (pl. 41). The surface of polished nephrite has a lustre that appears almost waxy and not dissimilar to that of an amphibian, making it the ideal choice. Aware of the extremely tough nature of the material, the carver has accommodated thin, out-stretched limbs with fine fingers and webbed toes, which, although vulnerable, are relatively resistant to damage during the rigours of carving and to subsequent handling. Bowenite, a variety of serpentine that often has a very pleasing pale apple-green colour with a soft translucent quality, is commonly mistaken for jade and was regularly used by Fabergé. The Budai figurine from around 1900 is a fine example (pl. 42). It is a more abundant material and is softer and therefore easier to carve than jade, although it does have advantages, too, being relatively brittle and susceptible to fracture.

Much of the carved work designed at Fabergé derived its inspiration from a collection of objects that were gathered for the purpose by Carl Fabergé himself. Within this collection was a large group of Japanese netsuke, acquired during the second half of the nineteenth century, a period when Japan had great influence over Western art. The small animals were intended to be viewed in the hand, with a continuation of the design through to the underside, their highly tactile forms often conveying the playful nature of the creatures portrayed.

Russia's long tradition of stone carving cannot be discussed without mention of the national stone, orletz, or as it was later known in the West,

Opposite
42
BUDAI, BEFORE 1903

St Petersburg
Bowenite, gold, enamel, diamonds, rubies, pearls; 11 x 10 cm
Private Collection

The articulated hands, head and tongue of this genial figure move at the lightest touch, as they are counterbalanced by internal weights. Fabergé was inspired by mechanical figures made by the Meissen porcelain factory in the 18th century. These derive from Chinese representations of Budai, a Buddhist monk associated with contentment. Fabergé would have had access to Meissen works during his stay in Dresden.

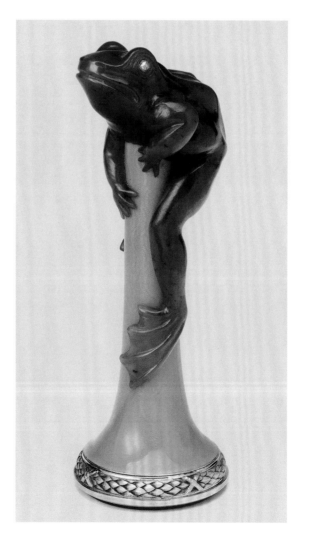

41
DESK SEAL, WITH FROG HANDLE, 1903–17

Chief workmaster Henrik Wigström (1862–1923), St Petersburg
Nephrite, silver, gold, enamel; h. 9.5 cm
The Royal Collection / H.M. Queen Elizabeth II (RCIN 100339)

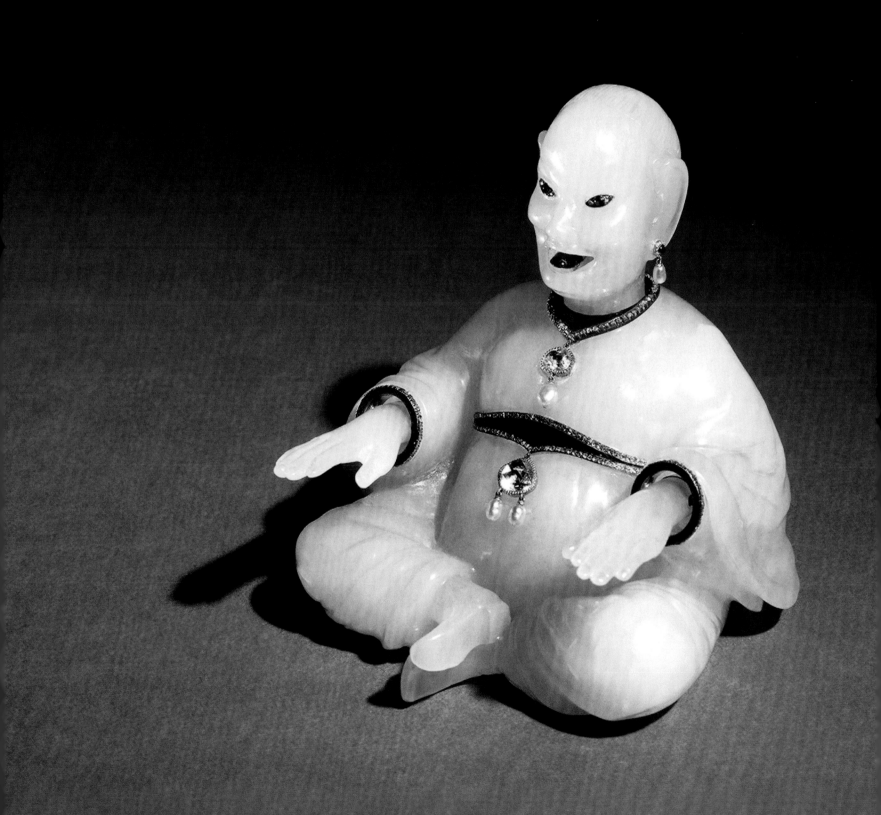

Opposite
43
KREMLIN TOWER CLOCK, *c.*1913

Moscow
Rhodonite, silver, enamel, sapphires,
emeralds; 29 x 14.6 cm
The India Early Minshall Collection,
The Cleveland Museum of Art,
Ohio (1966.477)

44
MELTING ICE PENDANT, 1912

Designed by Alma Pihl (1888–1976),
workmaster Albert Holmström
(1876–1925), St Petersburg
Rock crystal, platinized silver,
diamonds; 4.8 x 5.5 cm
Private Collection

45
A page from the design album of the
Holmström workshop, dated 1912,
showing the sketch of the pendant.
Wartski, London

rhodonite, after the Greek for 'rose'. Rhodonite
is most often found in the form of large rose-
pink masses with distinctive black veining, and
occasionally in the form of translucent pink or red
tabular crystals. It is relatively brittle and easily
fractured, so for this reason is usually cut into simple
solid forms. The material was first discovered
in the Sverdlovsk district in the Ural Mountains
of Russia in the 1790s, following Catherine the
Great's enthusiastic development of the country's
mining operations. Rhodonite was so highly valued
that it was officially named the National Stone of
Russia in 1913. This was the year that marked the
300th anniversary of the Romanov dynasty and the
associated celebrations were intended to highlight
its great achievements, the establishment of a
strong mining industry among them. The blush red
rhodonite of Fabergé's Kremlin Tower Clock (pl.
43), *c.*1913, aptly references the distinctive red bricks
from which the Kremlin's walls and towers are built,
but perhaps it was also employed in this context
because it so beautifully expresses a great pride in
Russia and its valuable resources.

In addition to the microcrystalline gem materials
used for this purpose, single whole crystals were
employed. Rock crystal is a colourless, transparent
form of macrocrystalline quartz, thought, up until
the Age of Enlightenment, to be a form of deeply
frozen ice that could not be melted, following Pliny
the Elder's erroneous observation that it was to
be 'found only in places where the Winter snow
freezes with the greatest intensity'.[1] This ice-like
appearance could not have been better explored
than in the designs of Alma Pihl, an extraordinary
young female designer working in a creative field
that was dominated by men. Pihl naturally chose
Siberian rock crystal as the ideal medium in which to
represent the melting winter ice, as illustrated by her
Melting Ice Pendant (pls 44–5) and the Imperial
Winter Egg (pls 187, 203). The egg is engraved
with dendritic crystals and frosted with a myriad
of glistening rose-cut diamonds, set in platinum.

Through this ice-cold shell can be seen tantalizing glimpses of a basket of white wood anemones, carrying with them the promise of spring and of rebirth, so appropriate for an Easter gift.

Macrocrystalline forms of quartz may also be coloured during growth by minerals present in the local environment. Iron compounds may lend a purple colour (amethyst), or a yellow hue (citrine), and if the quartz contains aluminium and has been subjected to natural radiation during growth, it may appear smoky grey to brown in colour. Macrocrystalline quartz is notoriously temperamental during carving. The crystals are often beset with inherent tensions created during growth and also invariably contain inclusions that render the material sensitive to the changes in pressure and temperature associated with the carving process. Rock crystal objects that survive this stage may later release their internal pressures unexpectedly in response to exposure to extreme display conditions, such as the direct, hot sunshine of a shop window.

Another highly distinctive decorative technique in Fabergé's works is the use of enamel, a form of glass to which additives are introduced to increase stability and reduce the melting range. It is modified with metal compounds, which lend colour and further influence the melting range, and may also be employed to alter the level of transparency. Fabergé enjoyed experimenting with enamel, so much so that Henry Bainbridge, Fabergé's British agent, described the workshops as 'research laboratories' with the aim of finding new colours.[2] The firm's chief enamel master was Alexander Petrov, who was assisted by his son and apprentice Nicolai. Nicolai was described by Bainbridge as 'a somewhat rough character, fully absorbed by his work'.[3]

The Fabergé firm employed many different styles of enamelling including cloisonné, where the enamel is contained within cells made from overlaid wire, and champlevé, where the cells for the enamel are created by cutting into the substrate metal. A fine

and highly traditional Kovsh, designed by Feodor Rückert (1840–1917) for Fabergé's London branch in 1911, is decorated with cloisonné enamel (pl. 46). These were the predominant techniques favoured in Russia until the arrival of the French Huguenot jewellers in the eighteenth century, which included the paternal ancestors of Carl Fabergé himself. The enamellers among this group brought with them the French technique of *guilloché*, an art for which the skilled craftspeople at Fabergé's workshops in St Petersburg were particularly renowned.

Guilloché enamel relies on the application of large, open fields of transparent or translucent enamel, a style known as *en plein*, to a metal substrate that has been prepared with a machine-engraved design. Often the effect is that of a lustrous watered silk, which is achieved by engraving a series of perfectly matched repetitive patterns, be they straight lines of varying depths, undulating waves, or even radiating starbursts. A variety of these patterns may be seen through the delicate lilac and peach translucent enamel of the Desk Clock (1908–17) designed by Henrik Wigström (pl. 47). These designs are usually only created satisfactorily by a process known as engine-turning. The engines, originating in the late seventeenth century, rely wholly on the skills of their operators – the engine turners (or guillochers) – by whom they are carefully maintained and operated to create precise light-reflecting patterns. The pattern was specified at Fabergé by the designers, who referred to a panel of engine-turned samples in order to select their choice. A set of the numbered samples used at the London branch survives and is believed to have been used to communicate finer specifications with the workshops in St Petersburg (pl. 48).

The exact metal alloy is selected with care. Metal oxides are produced at the interface between the metal and the enamel during the essential heating process. These oxides, particularly those of copper, have an unfortunate habit of reacting with the enamel to create some unexpected, and often unattractive, colours. However, an oxidation layer

46
KOVSH, 1908–11

Workmaster Feodor Rückert (1840–1917), Moscow
Silver-gilt, cloisonné and painted enamel; 14.4 x 18.2 x 11.0 cm
Purchased by Grand Duke Michael Mikhailovich, 31 May 1912
The Royal Collection / H.M. Queen Elizabeth II (RCIN 32475)

47
DESK CLOCK, 1908–17

Chief workmaster Henrik Wigström
(1862–1923), St Petersburg
Gold, silver, gilt, enamel, synthetic ivory
replacement; 11 x 11 cm
Private Collection

48
Fabergé's engine turning sample panel, from the London branch, front and back
Silver; 14.3 x 12.6 x 0.3 cm
Wartski, London

is essential to create good adhesion between the two materials. For this reason, enamellers usually rely on refined alloys of silver and gold. Even so, the more responsive enamels, such as the pinks and reds, remain highly susceptible to reaction and so in addition the metal is further prepared with a coat of colourless, transparent enamel called a 'flux' as an isolation layer.

Carl Fabergé is known to have used a palette of up to 130 enamels (pl. 49) including those with varying levels of opacity,[4] but sadly the exact formulations of these enamels were lost with the closure of the workshops in 1918. The colours could be further modified by the degree of heat and the duration of exposure to it. Many of Fabergé's enamels have a characteristic opalescent appearance, which is beautifully enhanced by their reflective engine-turned substrates. This property is achieved by the addition of an opacifier (Fabergé is likely to have used lead arsenate)[5] to create a mist of fine particles that diffuse the light. Careful control of the temperature is key and yet was made particularly difficult by the relatively unsophisticated kilns of the day, thus relying heavily on the judgement of a highly experienced eye.

Enamelling *en plein* is an extremely challenging technique to master. Not only does enamel respond to temperature in its depth of colour and level of translucency, but because enamel and metal expand and contract at differing rates, this can also introduce a strain between the two that may distort the metal and result in cracks or losses. A 'counter enamel' (a layer of enamel on the underside of the metal) is most often applied in an effort to reduce this strain. To make matters even more delicate, the finest enamel must usually be developed in four or five extremely thin, even layers, each fired and polished in succession in order to build up the enamel to the required depth of approximately 0.5 mm without risk of the enamel becoming unattractively cloudy.[6] The level of experience and skill required in this complex process cannot be overstated. The entire outcome

relies on a sound understanding of each colour and opacifier, and of how they react over an arc of temperatures, as well as how they best respond to the different metal plates in use.

Enamels are all too easily damaged and the material is made particularly vulnerable when applied in large planes without the protective walls provided in other styles of enamelling, such as cloisonné and champlevé. A satisfactory repair is almost inconceivable, as demonstrated by the surviving correspondence between Eugène Fabergé and Bainbridge between August and December 1935, regarding damage to the enamel plaques of an unnamed egg in the collection of Her Majesty the Queen. Eugène Fabergé made the interesting observation that 'enamel is a most capricious thing: sometimes an enamelled object falls down on the floor and nitchevo [nothing] – it does not break & sometimes it is laying calmly on the table untouched & breaks out by itself, nobody knows why.' He offered two alternative approaches to the necessary repair. The first was to remove the damaged plaque and to replace it. The second option offered was to re-enamel all six of the plaques so that they matched, whilst trying also to match these plaques to those of the top section of the egg. There were just three men deemed capable for such a job and one of them refused even to try as it was so complicated.[7] By 13 December the latter option for repair had been chosen and, after a period of materials-testing, the six freshly enamelled plaques were ready for reattachment by Eugène's Jewellery Master.[8]

Today there are two very different approaches to the repair of damaged enamel. One is to re-fire the plaque with fresh enamel as outlined earlier. This, of course, relies on the availability of a highly specialized enameller with immense skill. It is an option that is made even more elusive by the fact that often the original raw enamels can no longer be found. They regularly contained poisonous ingredients, such as those deriving from lead, cadmium, arsenic and even radioactive uranium,

which are now prohibited by the Health and Safety regulations of most countries. The other approach is a more conservative one and that is to retain all the original enamel, replacing the area of loss with a carefully matched resin.

A single object may combine a variety of different materials, including enamel panels, each with very different properties. This was a factor that had to be considered in the very early stages of design. Precious metal elements are usually joined together using solder (a metal alloy with a lower melting point), but this is a process that requires direct exposure to a flame at a very high temperature. As can be appreciated, once created, an enamel must not be subjected to extremes. Therefore, the framework of the object had to be designed in such a way that heat-sensitive elements may be added after construction. Methods of attachment included 'soft solder' (a lead-based solder that melts at a relatively low temperature), pins, rivets, or the use of serrated teeth that could be bent to secure parts.

Similarly, most gemstones must not be exposed to the jewellers' torch, as this may change the colour, burn, or even crack, the stone. So the mounts and the basic framework of the jewel were prepared by the goldsmith and mounter, before the setter was given the task of fitting the gems at the final stages.

Large gem specimens of Russian origin were often the predominant feature of Fabergé jewellery, frequently with a simple, exquisitely designed frame of rose-cut diamonds. The extraordinary mineral resources of Russia provided gems of the very finest quality: the unrivalled amethysts of Siberia, with their distinctive velvety red tint; aquamarines the true delicate greenish blue of the oceans; deep pink topazes and Siberian emeralds, too. All were shown to their best advantage in mounts that were comparable to those given to more humble gems, such as the 'mecca stone'. This was a simple pale, blue-grey chalcedony enhanced by a pinkish undertone that was said to take on the colour of a lady's flesh when worn.[9] The gem was greatly

49
A Fabergé enamel colour sample panel
Silver, copper, enamel; 27.0 x 30.7 x 0.5 cm
Collection Mirabaud, Switzerland
(Inv. 926)

favoured by Fabergé and in his hands considered so desirable that a brooch featuring a mecca stone was bought by Queen Alexandra (pl. 50).

Carl Fabergé's love of colour was not restricted to enamel and hardstones. He also incorporated a variety of coloured gold alloys into his designs following a style that developed in the eighteenth century and became known as gold *à quatre couleurs*. The purity of gold is typically measured in carats, that is, in parts of 24. Pure, 24 carat gold is very rarely used by goldsmiths because it is considered too soft and malleable to be of practical use, so it is almost always alloyed with other metals including silver and copper to make the gold harder and more durable. Fabergé preferred to use gold with a purity of 14 carats; that is, 14 parts pure gold to 10 parts other metals. In order to create colour, the proportions of alloyed metals were altered. A relatively high level of copper, for example, will produce a red alloy known as rose gold; if silver were more dominant, then green gold would be the result; should nickel or palladium be introduced, then the colour will be white. Traditionally these relatively subtle tones were used to evoke the natural colours of flowers and foliage, and this simple design conceit was continued by Fabergé in the floral swags and foliate borders of many of his designs. He also chose to showcase coloured gold in its own right in the form of elegant, simple designs that rely on contrast, such as the rose and yellow gold Cigarette Case (pl. 51).

Not only did Fabergé experiment with different alloys of gold, but he also worked with platinum in a similar fashion. Platinum had been discovered in the Ural Mountains, near Ekaterinburg, in 1819. However, it was not until the late nineteenth century that the technology was available to create the high temperatures needed in the manufacture of solid platinum jewellery. This changed the face of jewellery design. Unlike silver, platinum does not tarnish and its inherent strength is such that it may be used to create far finer, visibly lighter and therefore far more discreet settings, making it

the ideal choice of metal for delicate jewellery. In Fabergé's designs, the platinum all but disappears behind the subtle glitter of rose-cut diamonds in their millegrain settings, allowing the fine colours of the featured gems to be seen in their best light. Research has shown that Carl Fabergé used various unusual alloys of platinum from a near pure metal, to as little as 20 per cent platinum content by weight. He also used a white metal that comprised a 9 carat alloy of gold and silver that was then plated with platinum.[10]

It is clear that Carl Fabergé's choice of materials favoured the practical and meaningful rather than the intrinsically valuable, with the greatest emphasis on the rarely rivalled skills of his team of specialist craftspeople. Whilst maintaining an appreciation of traditional Russian styles, the designs were also open and progressive, and Fabergé freely exercised his love of experimentation in materials and techniques. These objects, of such fine quality and in new and exotic styles, held great appeal in the West. It is no small wonder, then, that Fabergé's London branch, its only location outside Russia, played such a vital role in the company's success during the Edwardian era.

51
FLAME CIGARETTE CASE, 1908–9
Workmaster August Hollming
(1854–1913), St Petersburg
Rose and yellow gold, diamonds;
7.8 x 3.9 x 2.8 cm
Purchased by R.C. Ashton Esq.,
23 December 1910
Private Collection

50
BROOCH, c.1906
Workmaster August Hollming
(1854–1913), St Petersburg
Mecca stone (stained chalcedony),
diamonds, gold, silver; 2.9 x 2.5 x 1.5 cm
Purchased by Queen Alexandra from
Fabergé in London, 29 October 1906
Artie & Dorothy McFerrin Collection
at the Houston Museum of Natural
Sciences (McF276)

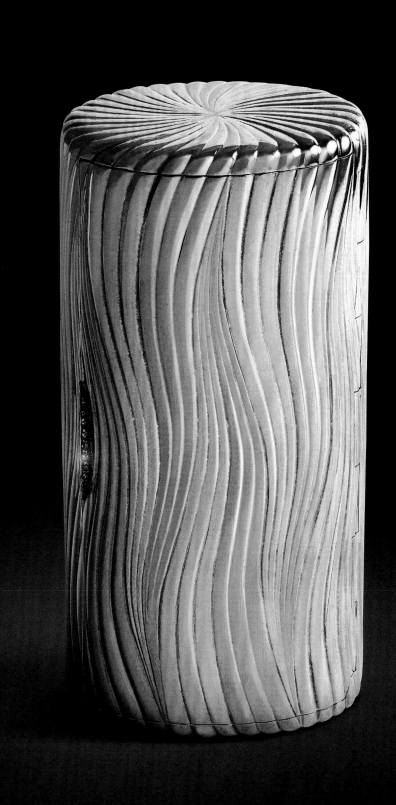

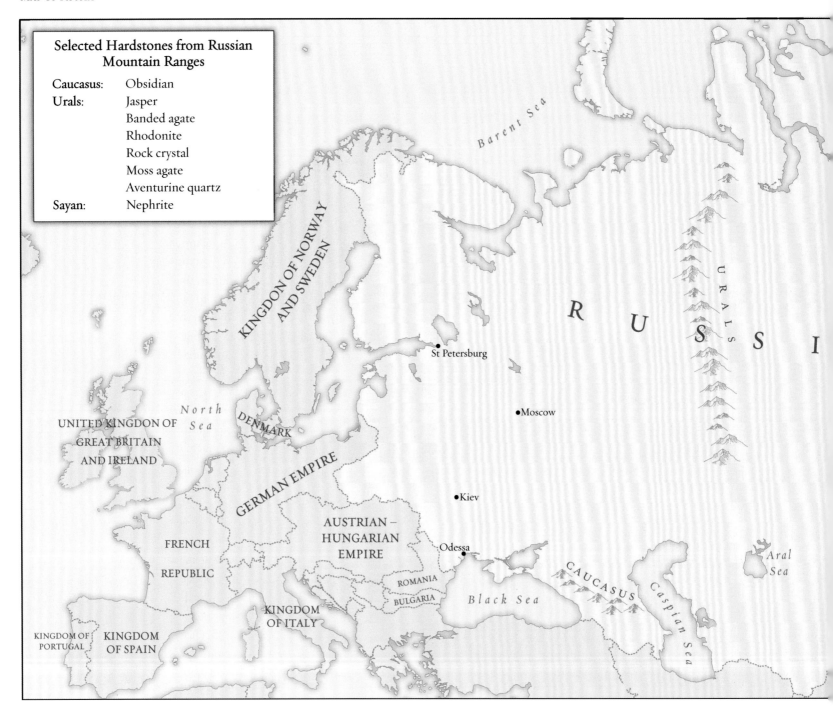

Selected Hardstones from Russian Mountain Ranges

Caucasus: Obsidian
Urals: Jasper
 Banded agate
 Rhodonite
 Rock crystal
 Moss agate
 Aventurine quartz
Sayan: Nephrite

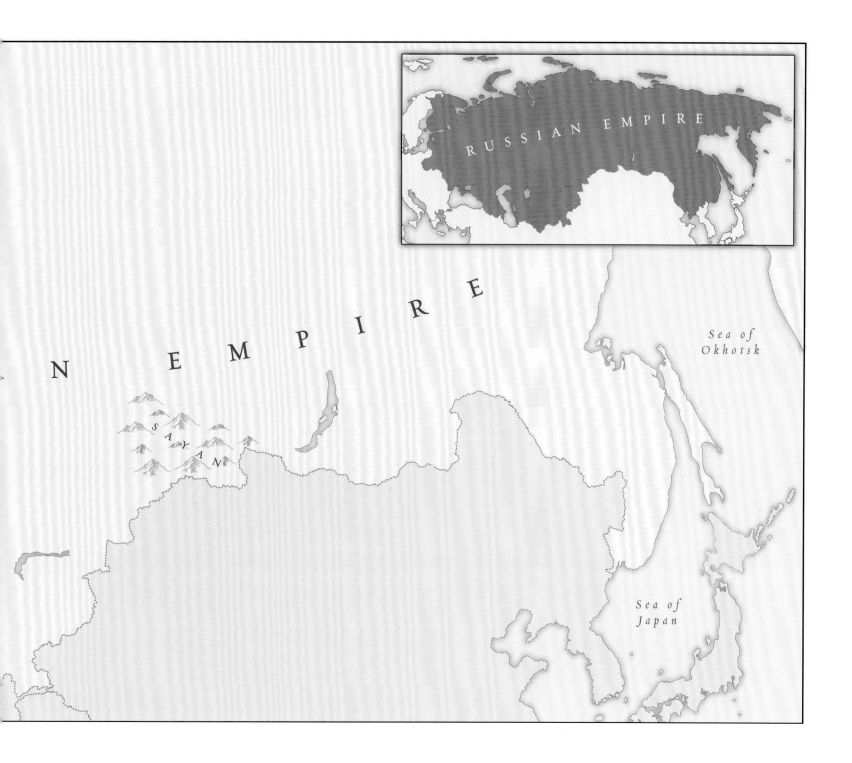

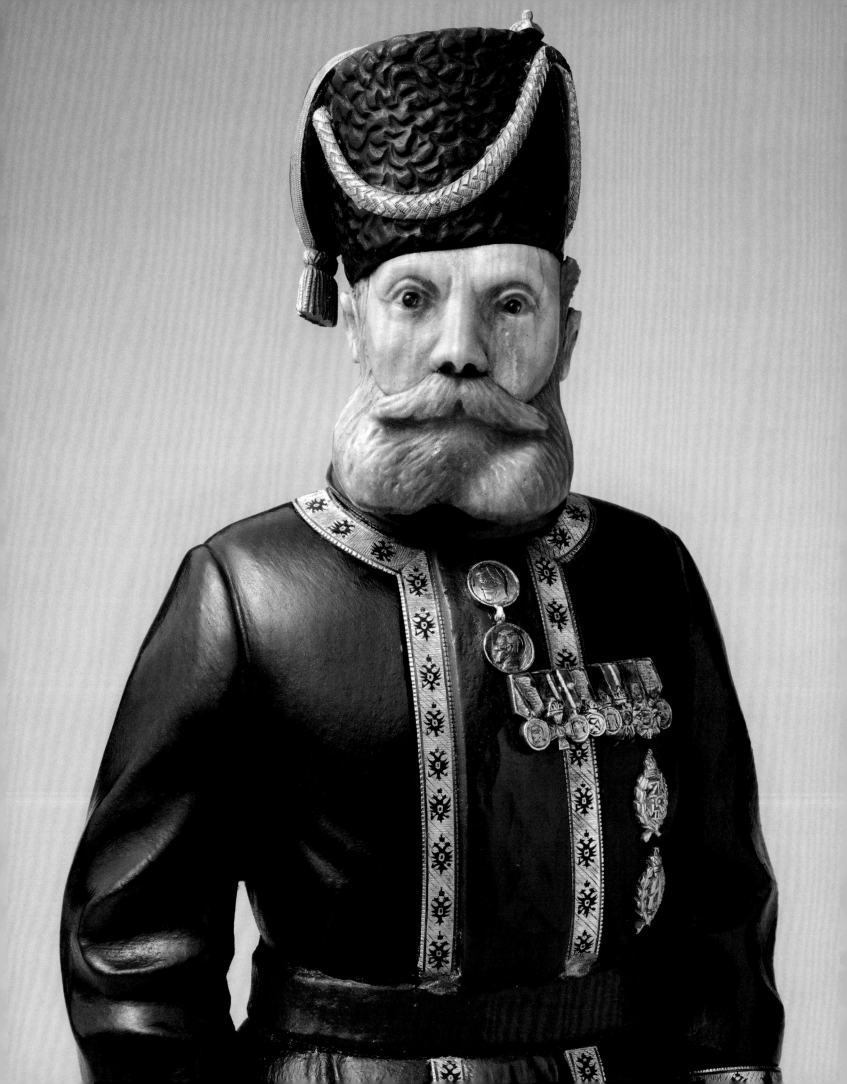

KAMER KAZAKS

THE HARDSTONE FIGURES PRODUCED BY THE HOUSE of Fabergé are works of sculpture that portray in a colourful mosaic the inhabitants of imperial Russia. They are among Fabergé's rarest creations, fewer than 50 are recorded, and after the Imperial Easter Eggs they are the firm's most valuable works. Two of the figures represent Nikolai Pustynnikov (b.1857) and Andrei Kudinov (1852–1915; not illustrated), the personal bodyguards or 'Kamer Kazaks' (Chamber Cossacks) of the Dowager Empress Maria Feodorovna and the Empress Alexandra Feodorovna.

The bodyguards were non-commissioned officers of the Cossack guard regiments. Kudinov was born in western Russia and assigned to the future Empress Maria Feodorovna in 1878. He was fiercely loyal to her and remained in her service until his death. Pustynnikov was born in the Cossack city of Novocherkassk, north-east of the Black Sea. He began his military service in 1876 and faithfully served Empress Alexandra from the time of her marriage to Emperor Nicholas II in 1894 until the Russian Revolution. Being appointed to attend a member of the imperial family was a great honour and brought tremendous privileges. Both were highly esteemed servants, who were closely identified with the Empresses.

The two figures were commissioned by Emperor Nicholas II in 1912 and the bodyguards were ordered to visit Fabergé's premises to be modelled. Both are posed standing to near-attention with their heels together and hands at their sides. Franz Birbaum, Fabergé's workshop manager, named Georgi Konstanovich Savitski and Boris Frödman-Cluzel as possible modellers and Peter Mikhailovich Kremlev and indirectly Peter Derbyshev as the master lapidaries responsible for cutting the stones. They were made in St Petersburg under the supervision of Fabergé's chief workmaster, Henrik Wigström. A drawing of the figure of Pustynnikov, dated 31 January 1912, is contained in one of the surviving design albums from Wigström's workshop.

The sculptures are three-dimensional jigsaws. Each of the differently coloured hardstones is cut to slot seamlessly into the next and they are invisibly secured with shellac. Fabergé's mastery of his materials is evident in his choice of stones for the Cossacks. Their woollen winter coats are carved from dark green nephrite. Fabergé's craftsmen have transformed this unyielding stone into a fabric that overlaps, billows at the hem and rumples up on the arms and chest. The Cossacks' coats were trimmed with otter fur and this is represented in speckled brown jasper. It is edged with a delicate yellow gold border embroidered with black enamel imperial eagles between translucent red enamel stitching. The medals and badges they wear are similarly worked in gold and enamel. Their trousers, boots and fur hats are carved from black onyx. The materials used for their hats and the small bags worn hanging from their belts differ. Those of Pustynnikov, made from purpurine (a lead oxide glass), correspond with the red livery of Empress Alexandra. Those for Kudinov are fashioned from lapis lazuli to represent the blue livery of the Dowager Empress. The faces and hands are worked from cacholong; also known as Kalmuck agate, this is an unusual form of opal named after the River Cach in the Bukhara province of Uzbekistan where it is found. The stone's relative softness and pale milky-white colour make it ideal for portraying Slavic skin and Fabergé's craftsmen used it perfectly to depict the Cossacks' proud features. Their striking full-

53
KAMER KAZAK, OR CHAMBER COSSACK, 1912
(detail; see also pl. 56)

flowing beards are carved from grey Kalgan jasper and their alert eyes are set with bright blue cabochon sapphires. The Emperor paid 2,300 roubles for each figure. They were the most expensive figures Fabergé made. The next most costly, also acquired by the Emperor, was of a Boyar, a Russian nobleman, wearing a purpurine coat, which cost 950 roubles.

Following the 1917 Revolution the figures, along with nearly all the imperial family's possessions, were confiscated. They were taken to the Pavlovsk Palace to the south of St Petersburg. The figure of Kudinov remains in the collection of the Palace. That of Pustynnikov was separated from his brother-in-arms some time before 1934 when, needing to raise funds, the Soviets sold seized works of art. Armand Hammer, the American businessman and agent of the Russian government, took it to New York, where it was bought by Mrs George Davis, one of the many wealthy American collectors who were captivated by the romance and tragedy of the Russian imperial family's lives. As the generations passed and the wealth of the Davis descendants dwindled, the figure lay wrapped in a blanket, forgotten, in the attic of the family's house in Rhinebeck, north of New York city. It was uncovered during a house clearance and subsequently sold at auction in 2013 for $5,980,000.

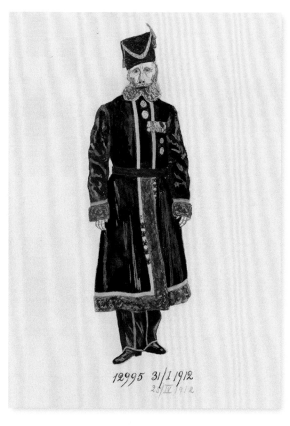

54
Drawing of Kamer Kazak, or Chamber Cossack, from the workshop album of Henrik Wigström, 1912
(Nikolai Nikolaievich Pustynnikov, personal bodyguard to Empress Alexandra Feodorovna)
Private Collection

Opposite
56
KAMER KAZAK, OR CHAMBER COSSACK, 1912
(Nikolai Nikolaievich Pustynnikov, personal bodyguard to Empress Alexandra Feodorovna)
Chief workmaster Henrik Wigström (1862–1923), St Petersburg
Siberian hardstones, enamel, gold, sapphires; h. 17.8 cm
Purchased from Fabergé by Emperor Nicholas II
Private Collection

55
Andrei Kudinov (left) and Nikolai Nikolaievich Pustynnikov in their ceremonial dress as Kamer Kazaks at annual military manoeuvres, presided over by Emperor Nicholas II, 1913

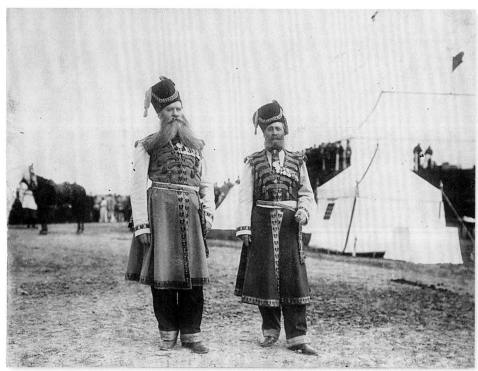

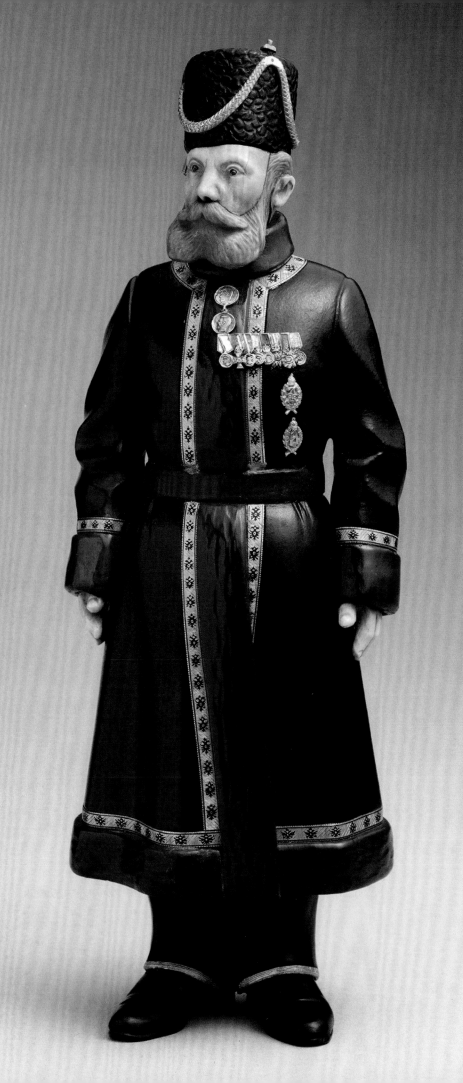

NEPHRITE LOTUS VASE

THE BODY OF THIS MONUMENTAL VASE IS CUT FROM a single piece of nephrite, a hardstone also known as Siberian jade. Nephrite was used extensively in Fabergé's work; it is a resilient stone formed from interlocking crystals and able to withstand carving well. Fabergé sourced nephrite from the wilderness outside Irkutsk, north of Mongolia, where it was found in vast boulders. Great efforts were made to transport the boulders from Siberia to St Petersburg; the first stage of the journey involved them being pulled on sleighs, floated down rivers and rolled on logs through the unforgiving Siberian landscape. When they arrived in the city, they were placed in the courtyard of Fabergé's headquarters at 24 Bolshaya Morskaya. The lapidaries in the surrounding workshops would then carefully cut pieces of the finest colour from the boulders to be worked upon.

The stone of this vase is of a scale not commonly found in Fabergé's *oeuvre* and it is one of the firm's largest lapidary works. It is modelled as an upright lotus flower with naturalistically tapering and overlapping petals; the finely worked yellow-gold mounts are elaborately enamelled and gem-set. The vase is accompanied by its original double-door holly-wood case, lined in silk and velvet, and its original price ticket of 3,250 roubles.

Fabergé studied contemporary and past cultures for sources of inspiration, which he fused together to create his own unique style. This vase is a synthesis of Asiatic and European influences. Lotus flowers are a common decorative device in Asiatic cultures and are particularly significant in Buddhist and Hindu art. Its jewelled gold mounts and their polychrome enamelling are inspired by sixteenth-century European works of art. Michael Perchin, Fabergé's second chief workmaster, was responsible for making the vase. Perchin studied the gold and lapidary works of Renaissance Europe and his workshop specialized in supplying pieces in the neo-Renaissance taste.

The vase was bought from Fabergé's St Petersburg branch by the American heiress Lydia Morris. Miss Morris was the daughter of John Morris, founder of I.P. Morris & Company, a successful iron manufactory in Philadelphia. She was a recognized botanist, who, with her brother (also named John), established a garden at their summer home, Compton, in Philadelphia. Inspired by Japanese and Chinese tastes, they transformed the surrounding land into one of America's finest gardens. Archival photographs reveal that its ponds were planted with lotus flowers. Lydia Morris was one of a considerable number of American customers who patronized Fabergé in both Russia and London. The United States' economy experienced breathtaking growth following the American Civil War (1861–5) and the nation's vast size and natural resources led to it becoming the world's dominant economic power. The resulting wealth of its citizens enabled them to make acquisitions such as this Fabergé vase, which at over 3,000 roubles was a considerable price.

58
LOTUS VASE, 1896–1903
Chief workmaster Michael Perchin (1860–1903), St Petersburg
Nephrite, gold, enamel, rubies, diamonds; h. 25.4 cm
Purchased from Fabergé by the American iron heiress Lydia Morris c.1899–1903
Private Collection

Overleaf
59
Photographs of nephrite mining in the Sayan Mountains, north-west of Irkutsk, the source of the hardstone used by Fabergé, c.1900.
Wartski, London

57
The satin interior of the case of the Lotus Vase, inscribed in Cyrillic 'Fabergé, St. Petersburg, Moscow' beneath the Imperial Warrant.
Private Collection

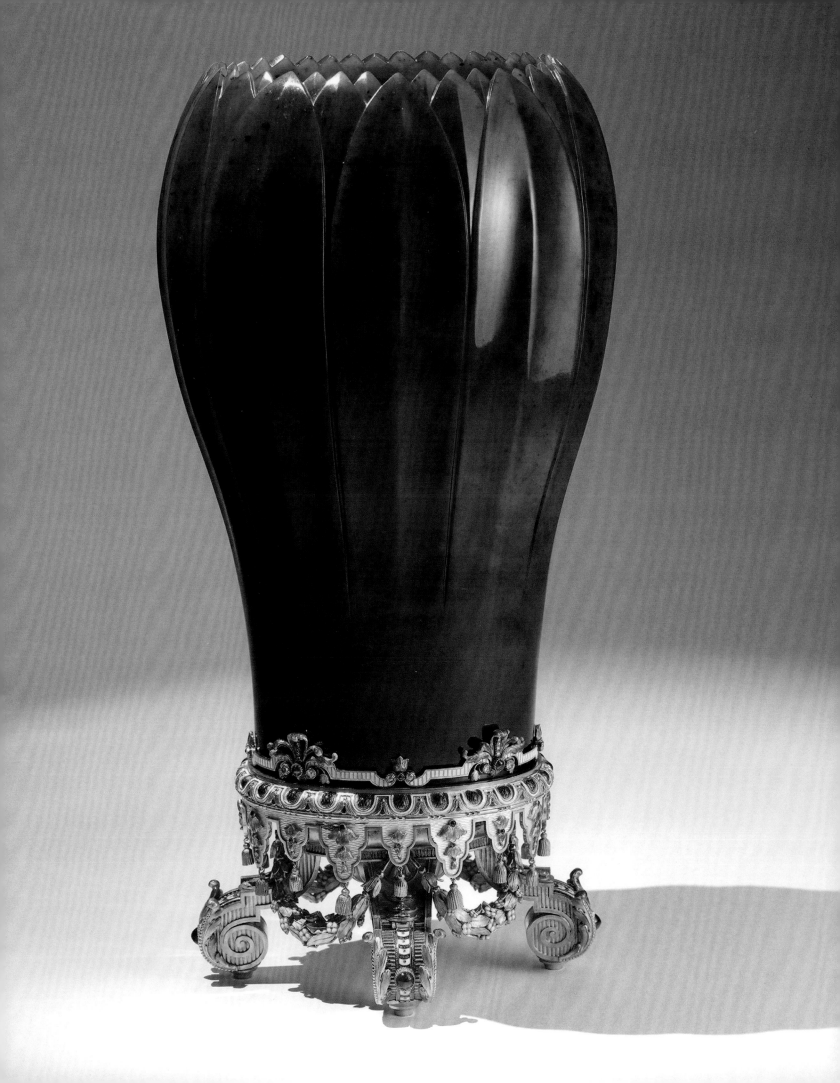

SELECTED WORKS

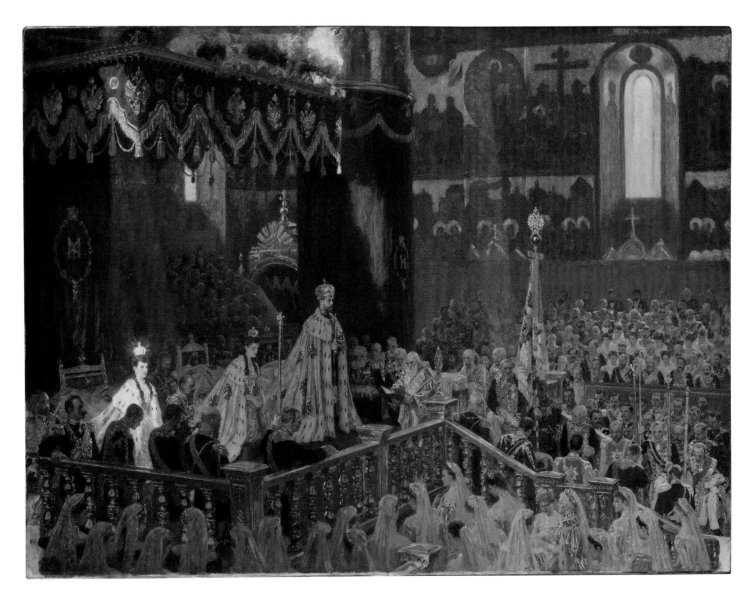

60

*THE CORONATION OF NICHOLAS II ON 14 [26] MAY 1896 IN
THE USPENSKI CATHEDRAL OF THE MOSCOW KREMLIN*, 1898

Laurits Regner Tuxen (1853–1927)
Oil on canvas; 66 x 875 cm
The State Hermitage Museum, St Petersburg (ЭРЖ-1638)

The coronation took place on 14 May (Julian calendar; 26
May in the Gregorian calendar). The Gregorian calendar was
implemented in Russia on 14 February 1918.

61

PRAYER BOOK OF EMPRESS ALEXANDRA FEODOROVNA, 1896

Cover: chief workmaster Michael Perchin (1860–1903), St Petersburg
Book: printed with chromolithographs, M.O. Wolff, St Petersburg, 1878
Nephrite, silver, leather, silk, paper; 16.5 x 14.5 cm
Given by Emperor Nicholas II to Empress Alexandra on the day
of their coronation, 14 May 1896
The Moscow Kremlin Museums (Кн-8)

The book contains an intimate dedication, handwritten in English,
by the Emperor, which reads: 'For my own beloved sweet wify with
every best wish on this day from her ever loving & devoted Nicky,
Moscow May 14/96'. The prayer book was one of the exhibits
loaned for the charity exhibition held at the Von Dervis mansion
on the English Embankment in St Petersburg, March 1902.

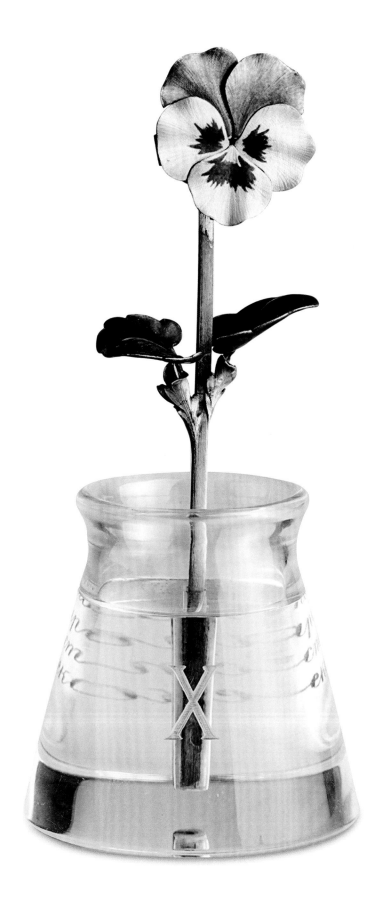

62
PANSY, 1904

Chief workmaster Henrik Wigström (1862–1923), St Petersburg
Gold, enamel, rock crystal, diamonds, ivory, watercolour on ivory;
h. of flower 14.5 cm, h. of base 6.5 cm
Given by Emperor Nicholas II to Empress Alexandra Feodorovna
on their 10th wedding anniversary, 1904
The Moscow Kremlin Museums (MP-564)

The pansy, which is an emblem of love, was given by Emperor
Nicholas II to Empress Alexandra Feodorovna for their 10th
wedding anniversary in 1904. The rock crystal vase is engraved
with the roman numeral 'X' and the petals unfold to reveal
portrait miniatures encircled with diamonds of their five
children: Grand Duchesses Olga, Tatiana, Maria and Anastasia
and son Tsarevich Alexei.

63
PANSY, ST PETERSBURG, 1904
(detail, showing work with petals unfolded)

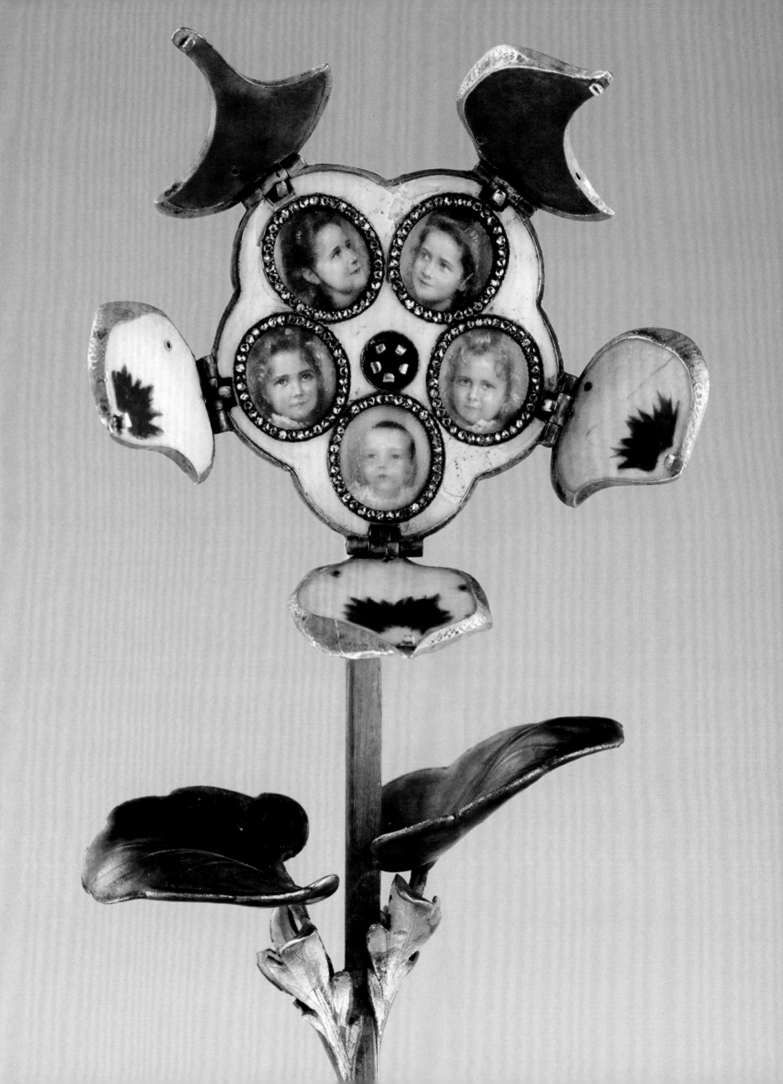

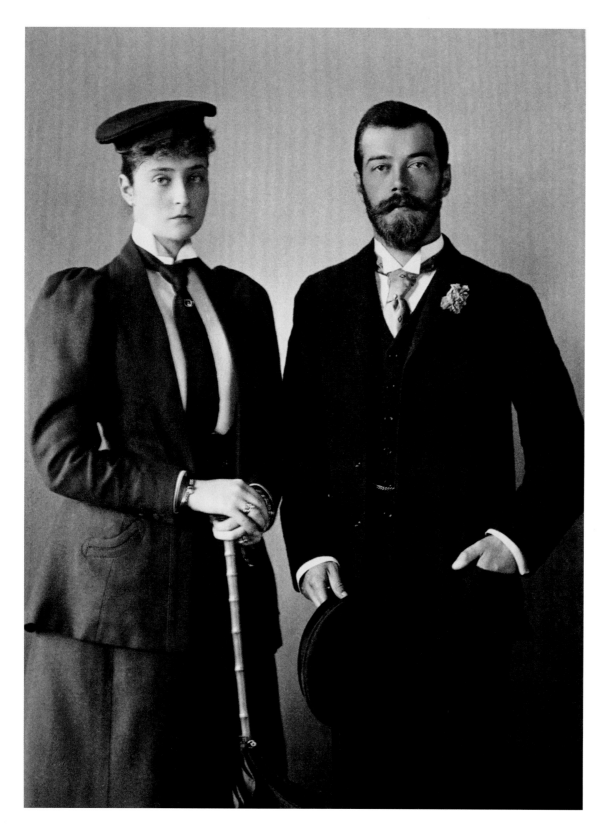

64
Betrothal portrait photograph of
Tsarevich Nicholas Alexandrovich and
Princess Alix of Hesse and by Rhine,
London, August 1894.

65
BROOCH, *c.*1894

Workmaster August Holmström (1829–1903), St Petersburg
Gold, silver, aquamarine, diamonds; 1.1 x 3.7 x 3.7 cm
Collection of Empress Alexandra Feodorovna
Private Collection, care of Wartski, London

The brooch, centred by a Siberian aquamarine within a sloping
trellis border of rose diamonds, was purchased by Tsarevich
Nicholas Alexandrovich, later Emperor Nicholas II, on
10 August 1894 as a gift for his fiancée, Princess Alix of Hesse
and by Rhine, later Empress Alexandra Feodorovna. The brooch
remained in the imperial couple's possession after Nicholas
II's abdication in 1917 and during their subsequent exile. With
the October 1917 Revolution the Bolsheviks seized power,
and valuables belonging to the imperial family – including this
brooch – were removed prior to their execution in July 1918.

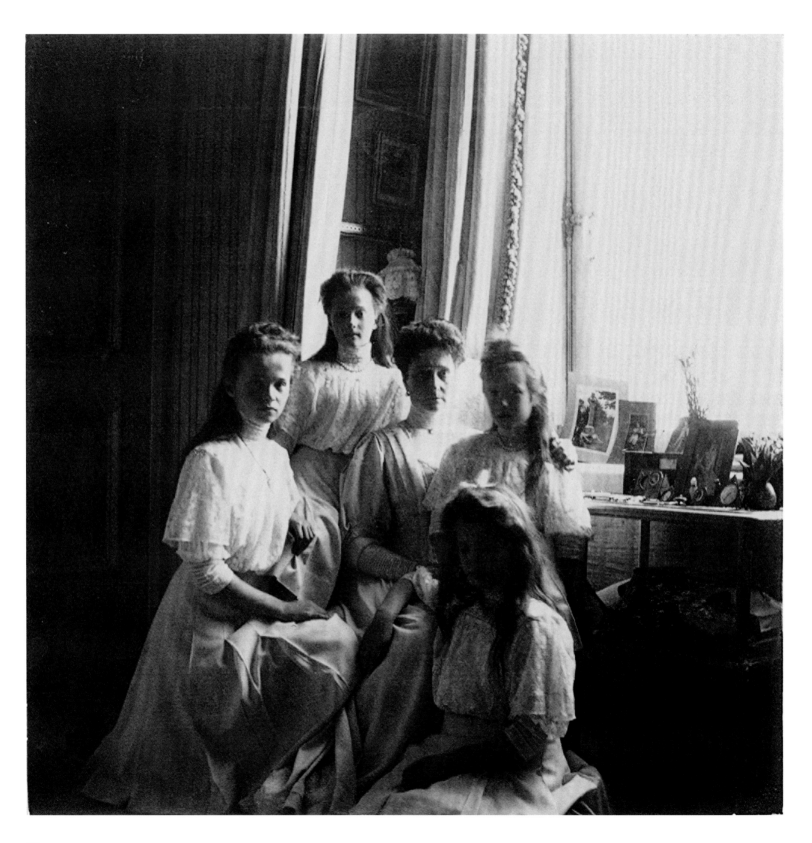

Opposite
66
Empress Alexandra Feodorovna and her
four daughters, Alexander Palace, Tsarskoe
Selo, south of St Petersburg, 1909. Due
to the privacy it offered, when officially
resident in St Petersburg the Alexander
Palace was the preferred residence
of Nicholas II and his family. The Mauve
Room was Alexandra's favourite and for
20 years it was the centre of family life in
the palace. The clock can be seen on her
dressing table (far right).

67
IMPERIAL CLOCK, 1896–1901

Chief workmaster Michael Perchin (1860–1903), St Petersburg
Gold, enamel, pearls, glass, ivorine; 9.5 x 10.5 x 3 cm
Purchased jointly by Emperor Nicholas II and Empress Alexandra Feodorovna on
4 December 1901 from Fabergé in St Petersburg for 215 roubles
Artie & Dorothy McFerrin Collection at the Houston Museum of Natural Sciences
(McF 92)

This boldly designed triangular, jewelled and enamelled gold
clock is centred with a large white enamel dial surrounded by a
gold bezel set with pearls. The three corners are enamelled in
translucent fuchsia over a sunburst engraving and handpainted
dendritic motifs, while the outer edge is decorated with a
border of alternating leaves and berries. It stands on two gold
ball feet, supported by a scrolled gold strut to the reverse. The
Empress placed this clock in the Mauve Room, her refuge in the
Alexander Palace.

68
BOWL, c.1913

Chief workmaster Henrik Wigström (1862–1923), St Petersburg
Lapis lazuli, gold; l. 10.8 cm
Private Collection

The bowl is carved from a single piece of richly coloured lapis
lazuli in the Renaissance taste. Fashioned as a fluted shell, it
is mounted in matt yellow gold and supported on four gold
feet in the form of stylized dolphins. The gold of 72 zolotniks
(equivalent to 18 carats) is the highest standard employed by
Fabergé. Like many Fabergé pieces in this style, the source of its
design was the richly mounted 16th- and 17th-century hardstone
works in Dresden's Green Vault, which Fabergé would have seen
during his travels in western Europe. Due its brittleness and
variable hardness, the carving of such large pieces demonstrated
incredible skill.

69
CIGARETTE CASE, c.1907

Moscow
Enamel, gold, silver, diamonds, crystal, ivory, watercolour on ivory;
portrait miniature of Tsarevich Alexei; 9.3 x 6.3 x 1.5 cm
From imperial apartments in Alexander Palace, Tsarskoe Selo
The Moscow Kremlin Museums (MP-657)

The birth of Tsarevich Alexei in 1904, a male heir, was met with
joy in the Romanov family. His arrival was thought to ensure the
continuance of their dynasty. Emperor Nicholas II owned this
jewelled, royal blue enamel case with triumphal gold laurels by
Fabergé, containing a portrait of the Tsarevich.

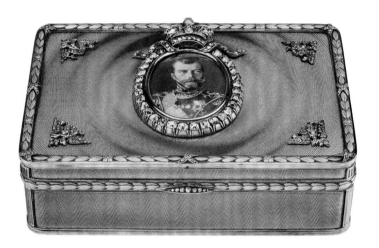

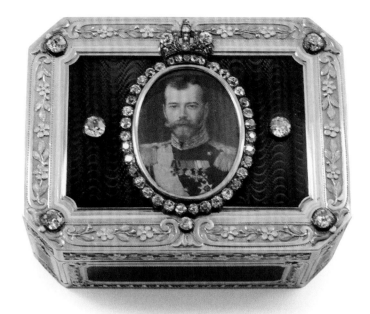

70
RAFFALOVICH IMPERIAL PRESENTATION SNUFFBOX, 1914

Chief workmaster Henrik Wigström (1862–1923),
St Petersburg; miniaturist Vasilii Zuev (1870–1941)
Gold, enamel, diamonds; 2.8 x 9.8 x 6.7 cm
Given by Emperor Nicholas II to Artur Germanovich Raffalovich,
Russian diplomat and financier, in 1915
The Royal Collection / H.M. Queen Elizabeth II (RCIN 100338)

This imperial presentation snuffbox, with its shimmering moiré
patterns and swirling concentric circles, constitutes one of
the finest examples of Fabergé enamel work. Its provenance is
intriguing. The Imperial Cabinet accounts note that the box was
completed in May 1914 and was duly presented the following
year by Emperor Nicholas II to the Russian diplomat Artur
Germanovich Raffalovich. Originally, however, the box was not
mounted with the imperial portrait but with the diamond-set
cypher of the Emperor. Boxes applied with the cypher were of
a lower category and more numerous (Raffalovich had already
received two). In April 1915 the box was returned to Fabergé's
workshops, where the cypher was exchanged for the portrait,
which shows Nicholas II in Preobrazhensky regimental uniform.

71
PËRMETI IMPERIAL PRESENTATION SNUFFBOX, 1908–13

Chief workmaster Henrik Wigström (1862–1923),
St Petersburg; miniaturist Vasilii Zuev (1870–1941)
Gold, enamel, diamonds; 3.5 x 7.8 x 5.9 cm
Given by Emperor Nicholas II to Turhan Pasha Përmeti,
Ottoman Ambassador to Russia, 1913
Artie & Dorothy McFerrin Collection at the
Houston Museum of Natural Sciences (McF 225)

Jewelled Fabergé snuffboxes with either imperial portraits or
cyphers were neither gifts as such, nor a personal expression
of the sovereign's generosity. Instead they represented either
official recognition of meritorious service to the Russian state
or a diplomatic gesture. Imperial presentation boxes were never
inscribed with a dedication as recipients had the option to
return their boxes to the Imperial Cabinet in exchange for cash.
Many were therefore 'recycled'. This work demonstrates the
revival of the Louis XVI style, the skills of the Henrik Wigström
workshop, and those of the miniaturist Vasilii Zuev.

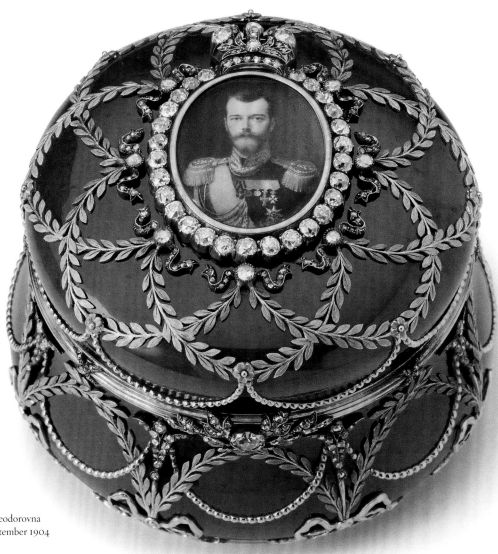

72
ORLOV-DAVYDOV IMPERIAL
PRESENTATION SNUFFBOX, 1904

Chief workmaster Henrik Wigström (1862–1923),
St Petersburg; miniaturist Vasili Zuev (1870–1941)
Nephrite, gold, diamonds; 6 x 8.4 cm
Given by Emperor Nicholas II and Empress Alexandra Feodorovna
to Count Anatolii Vladimirovich Orlov-Davydov, 26 September 1904
Private Collection

The unusual bun-shaped nephrite box is entwined with gold
laurels interspersed with diamond-set motifs. The lid is mounted
with a miniature of Emperor Nicholas II wearing regimental
uniform, held within an elaborate diamond frame surmounted
with a diamond-set Romanov crown. The box was presented
by Empress Alexandra Feodorovna to Lieutenant-General and
Grand Master of the Horse, Count Anatolii Vladimirovich
Orlov-Davydov. At the start of the Russo-Japanese War in 1904,
Count Orlov-Davydov gave one million roubles to the Red
Cross and another million roubles for the building of a warship
for the Russian fleet. The box was formal recognition of his
generosity to the charity and loyalty to the crown.

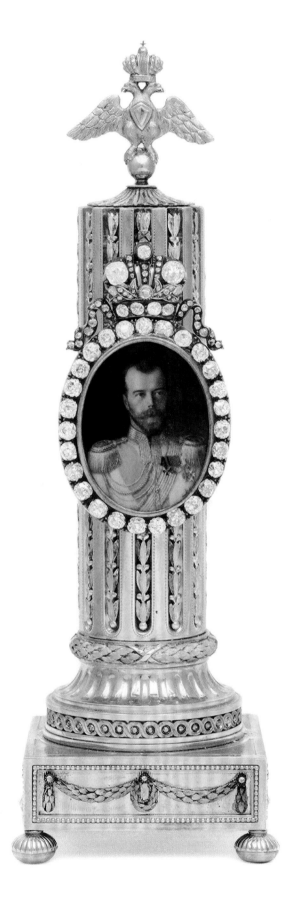

73
Zu Eulenburg imperial columnar table portrait, 1909

Chief workmaster Henrik Wigström (1862–1923), St Petersburg
Gold, diamonds, portrait miniature; h. 15.8 cm
Given by Emperor Nicholas II to Count August zu Eulenburg,
Grand Marshal of the German Court, 1909
Courtesy of A La Vieille Russie, New York

This jewelled table portrait of Emperor Nicholas II is mounted
on a fluted column of vari-coloured gold, inset with trails of
laurel leaves and berries, surmounted by a double-headed eagle.

The table portrait was another form of the imperial presentation
gift and marked the occasion when Nicholas II (on the yacht
Standard) met Kaiser Wilhelm II (on his yacht *Hohenzollern*) in the
Gulf of Finland in 1909. At a huge cost to the Imperial Cabinet
of 2,050 roubles, it was one of only three such gifts awarded
personally by Nicholas and one of only five such column portraits
known to have been made by Fabergé.

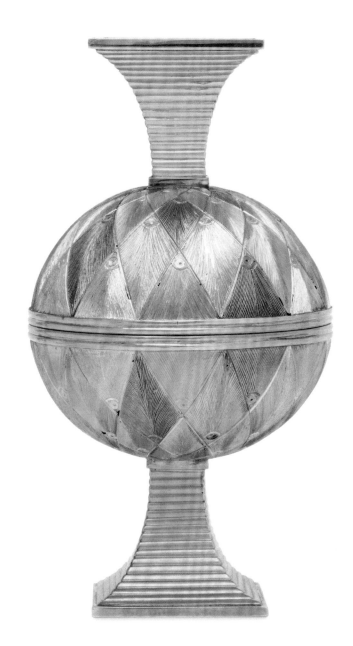

74
Loving cup, before 1896

Chief workmaster Michael Perchin (1860–1903), St Petersburg
Coloured golds; h. 9.21 cm
Courtesy of A La Vieille Russie, New York

This cup is an exceptional work employing four colours of gold,
inspired by the use of coloured golds in 18th-century French
goldsmithing. By adding various other metals to the gold alloy, its
colour changes. In this double, or loving, cup, Fabergé has used
the technique in a striking geometric design, the curved bowls
formed from alternating lozenges engraved with stylized feathers.

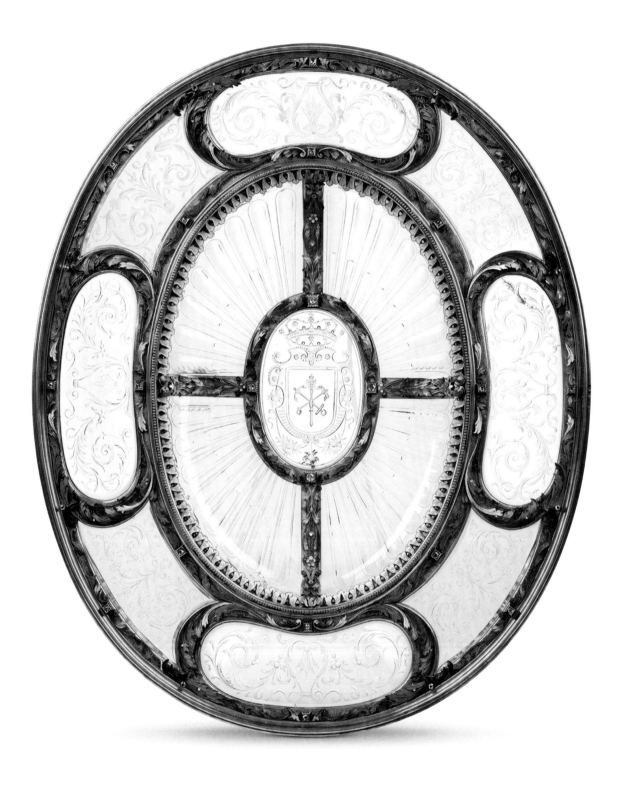

Opposite
75
PRESENTATION DISH, 1896

Chief workmaster Michael Perchin (1860–1903), St Petersburg
Rock crystal, gold, silver, enamel, diamonds; 39 x 33 cm
Engraved on the reverse in Cyrillic: 'From the nobility of St Petersburg 1896'
The State Hermitage Museum, St Petersburg (Э-18074)

A jewelled and enamelled rock crystal dish in the Renaissance
style, given by the nobility of St Petersburg to Emperor Nicholas
II after his return to the city following his Coronation in 1896.
Formed from 13 carved rock crystal panels, the central panel
is engraved with the coat of arms of the city, the gold mounts
elaborately enamelled opaque blue, white, green and red.
Rock crystal is an unpredictable material when carved, with
the potential to fracture. Franz Birbaum, Fabergé's workshop
manager, described the working of rock crystal as requiring a very
'particular skill'.

76
LETTER OPENER, c.1900

Moscow
Rock crystal, gold, diamonds; 19.5 x 2.5 x 0.8 cm
Given by Empress Alexandra Feodorovna to Margaret Hardcastle Jackson, 1900
Accepted under the Cultural Gifts Scheme by H.M. Government from Nicholas
Snowman and allocated to the Victoria and Albert Museum, 2017 (M.2:1,2,3-2017)

This rock crystal letter opener, encircled by a band of green gold
laurel leaves, tied with a red gold ribbon bow and mounted with
diamonds, was a Christmas present from Empress Alexandra
Feodorovna to her English governess, Margaret Hardcastle
Jackson, in 1900. The gift was accompanied by a handwritten
note in English, which read: 'For dear Miss Jackson, with loving
Xmas wishes from Alix 1900'. Following the death of the
Empress's mother in 1879, when she was aged six, Miss Jackson
became a maternal figure in her life, making monthly reports
to Queen Victoria on her granddaughter's progress. After she
retired, Miss Jackson and the Empress continued to correspond
by letter, making this gift particularly appropriate.

77
Grand Duchess Alexandra of Mecklenburg-
Schwerin wearing a Fabergé tiara.

78
TIARA, c.1904

Workmaster Albert Holmström (1876–1925), St Petersburg
Gold, silver, aquamarines, diamonds; diam. 29 cm
Collection of Her Royal Highness the
Grand Duchess Alexandra of Mecklenburg-Schwerin
Artie & Dorothy McFerrin Collection at the
Houston Museum of Natural Sciences (McF 590)

The aquamarine and diamond tiara is formed from nine
vertical diamond-set arrows with pear-shaped aquamarine
flights. The arrows, emblems of Cupid, are directed
towards the wearer. The tiara belonged to Her Royal
Highness the Grand Duchess Alexandra of Mecklenburg-
Schwerin, née Princess Alexandra of Hanover and
Cumberland (1882–1963), shown left. The Grand
Duchess was the first cousin of Emperor Nicholas II, and
niece of Empress Maria Feodorovna of Russia and
Queen Alexandra of the United Kingdom.

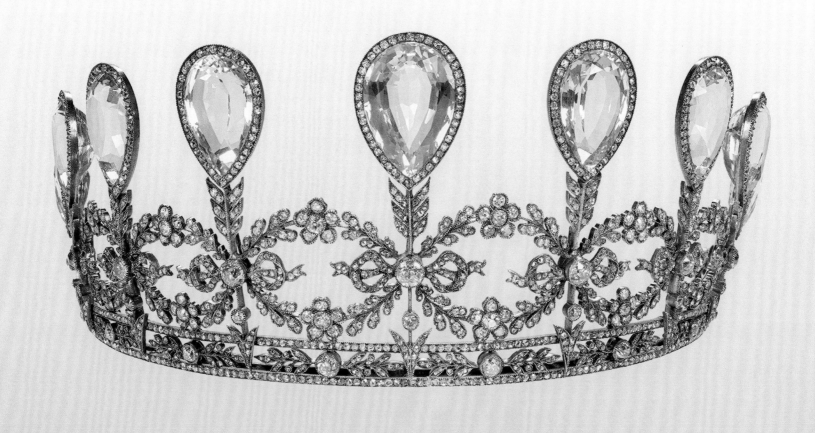

79
Miniature frame on easel, c.1910

Chief workmaster Henrik Wigström (1862–1923), St Petersburg
Silver-gilt, enamel, moss agate, foil; h. 13.97 cm
Courtesy of A La Vieille Russie, New York

80
A page from the design album of the Wigström workshop,
showing a sketch of the work.

A moss agate, framed as though a painting, stands on a gilded
silver easel. Fabergé was especially taken by the patterns that
naturally occur within moss agates. He knew the stone as Orskaia
jasper and his workshop manager Franz Birbaum wrote of
it: 'Thickets of trees, cliffs, valleys ... and the most varied and
unexpected motifs unfold before one's astonished eyes'. According
to Birbaum, Orskaia jasper was mainly used in thin sheets. A
large block would be cut into slabs, each carefully examined by
the craftsman, who would choose the most interesting motifs and
decide how the stone should be further cut. In this piece Fabergé
has foiled the moss agate to provide a horizon to the view.

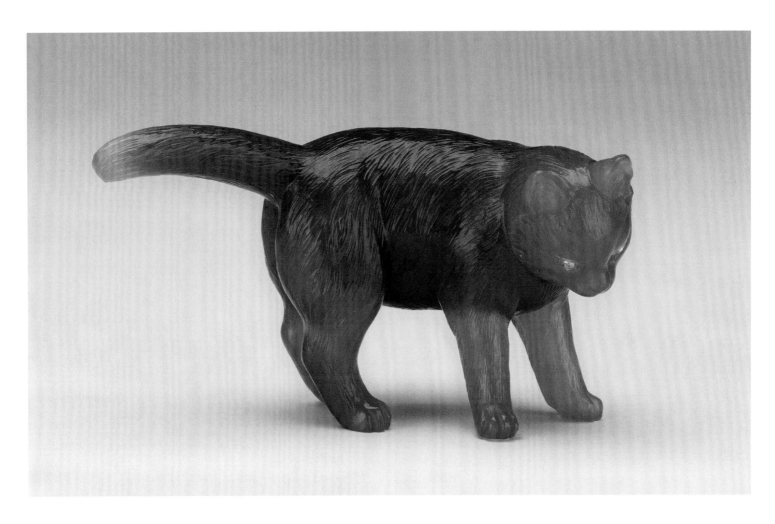

81
KITTEN, *c.*1914

St Petersburg
Brown and grey agate, diamonds; 2.7 x 5.0 x 2.3 cm
Purchased by 4th Earl Howe, Queen Alexandra's Lord Chamberlain,
29 November 1915
The Royal Collection / H.M. Queen Elizabeth II (RCIN 40037)

Richard Curzon, 4th Earl Howe and Queen Alexandra's devoted
Lord Chamberlain, bought a 'grey + brown agate' cat from
Fabergé's London showroom, at 173 New Bond Street, two days
before Queen Alexandra's birthday. It may be assumed that this
was his intended gift.

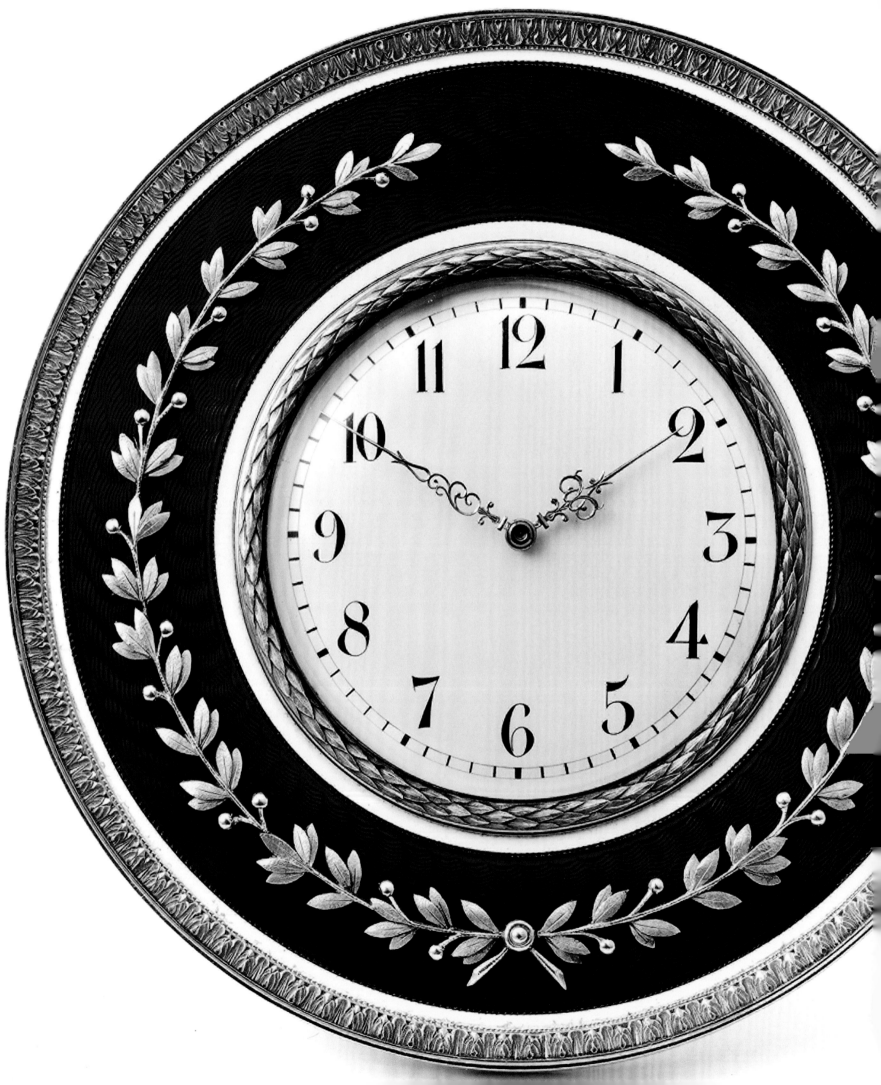

2

FABERGÉ
IN
LONDON

Kieran McCarthy

Chapter opener
82
CLOCK, 1903–8 (detail)
Chief workmaster Henrik Wigström
(1862–1923), St Petersburg
Gold, silver, enamel; diam. 9.8 cm
Purchased by Stanislas Poklewski-
Koziell, first secretary of the Russian
Embassy, 22 December 1908
Private Collection

HAVING WON THE PATRONAGE OF THE IMPERIAL
family and thereafter becoming the most celebrated
goldsmith in Russia, Carl Fabergé began to test
the quality of his work against that of his overseas
rivals. In 1900 he participated in the Exposition
Universelle in Paris, the spiritual home of high
jewellery. A thriving and long-established
community of craftsmen resided in the city. At its
pinnacle were the grand Parisian jewellery houses
of the calibre of Cartier, Boucheron and Vever.
A newcomer, arriving from Europe's eastern
margins, Fabergé wished to show that his work
matched, if not excelled, that of these celebrated
businesses. Great efforts were made in preparing
for the Exposition and to ensure that his finest
creations were shown he gained the permission of
the Russian Emperor to display Easter eggs from
the imperial family's private collection. He was
also allowed to produce and exhibit an intricate
miniature version of the Imperial Regalia. The
preparations were a success and the firm's work
met with great acclaim. The critic Victor Champier
wrote that Fabergé introduced 'a most ingenious
and artistic note'[1] to the event and the jury for
goldsmiths' work described the Easter eggs from
the Imperial Treasury as 'truly remarkable'.[2] Fabergé
was awarded the *Légion d'honneur* in recognition
of his achievements and his eldest son Eugène
(1874–1960) proudly deemed it his father's greatest
triumph. He later wrote in his faltering English of
the many customers it won in Paris: 'All the highest
visitors have passed at Fabergé's vitrine, purchasing
bibelots & jewels & giving orders'.[3]

The Exposition alerted Fabergé to the appetite
for his creations in Western Europe and the
desirability of opening a foreign division of his
business to cater to it. Although he had met with
success in France, Fabergé chose London over Paris
as the location of his new branch. The British royal
family were existing customers and undoubtedly
played a significant part in luring the firm to
London. Henry Bainbridge, Fabergé's British agent,

83
Premier House, 48 Dover Street,
London, the location of Fabergé's
London office from 1906 to 1911.
Fabergé occupied an office on the
first floor overlooking Dover Street.
Although there was a bell and a
commissionaire at the entrance,
most customers — whether King or
commoner — walked straight upstairs
and announced themselves simply by
knocking on the office door.

went as far as describing the expansion as a 'modest
gesture'[4] towards Queen Alexandra, sister of the
Dowager Empress of Russia and a devotee of the
firm's work. Sales trips to London began in 1901
and these demonstrated the royal family's appetite
for Fabergé. Prince George (later King George V)
noted one such trip in his diary in May 1903, writing
that Fabergé had 'just come over from Russia' and
'we bought about 43 of his lovely things'.[5] Fabergé
was also keenly aware of the possibilities London
offered for business beyond the royal family. The
city was wealthy and at the heart of a trading empire
that reached around the globe. London was a
cosmopolitan metropolis, where the international
patrons who sought his work regularly congregated.

Fabergé's London office opened shortly after the
sales trip of 1903: it was established and initially run
by Henry 'Allan' Bowe and his brother Arthur. The
Bowes, who were of English descent, were already
partners in Fabergé's business in Moscow, which
had opened in 1887. Allan had met Carl Fabergé by
chance while travelling on a train from Russia to
Paris the previous year. A capable young man, Allan
won his travelling companion's confidence as they
journeyed westwards. Fabergé asked him to run
the new Moscow enterprise, which operated as an
equal partnership between Bowe and Fabergé. It
flourished by serving the city's growing population
and led to the Bowes opening another branch
in Odessa in 1900. When the ambitious Bowe
brothers became aware of the demand for Fabergé's
creations in their homeland, Arthur travelled to
England to establish a new branch there.

The firm's first location in London was the
Berners Hotel at 6 & 7 Berners Street, north of
Oxford Street. Whether Arthur merely stayed at
the hotel on arriving in the city or actually opened a
showroom there is not recorded. Shortly afterwards,
he relocated to an office incorporating 'a private
reception room' in Portman House, 415 Oxford
Street, on the corner of Duke Street. Trading as a
'Representative' of 'C. Fabergé, Court Jeweller of

Russia', he built upon the firm's existing relationship with the British royal family and set about serving a wider clientele who shared the royal fascination for all things Fabergé. The Bowes's control of the London branch proved to be short-lived. Political instability in Russia, together with the ambitions of Carl Fabergé's second son Agathon (1876–1951), led to the Fabergé family ousting the Bowe brothers soon afterwards. Revolution erupted violently in Russia in 1905 and the Moscow business was all but closed in the turmoil. Accounts from its employees describe bullets hitting the shopfront and 'people being killed like rabbits' in the streets outside.[6] The danger led the Bowes to consider moving back to the safety of London. Simultaneously Agathon, who was increasingly controlling the business in Russia, wanted to dissolve his family's entire partnership with the Bowes. Agathon got his way and the partnership was terminated, rather acrimoniously, in March 1906.

Following the split Carl Fabergé took direct control of the London branch. In October 1906 he issued a notice to customers announcing he had 're-opened his branch establishment in England' under 'his personal control' and a choice of 'his newest productions' had been sent from St Petersburg.[7] To run the business, he dispatched his youngest son Nicholas (1884–1939) to London. To assist him, he appointed Henry Bainbridge as co-manager. Bainbridge, who had worked with the Bowes in London and was an engaging north country man, is a key figure in the history of Fabergé in London. Nicholas Fabergé took little interest in the role forced upon him by his family and the everyday running of the London branch fell to Bainbridge. He was at the centre of its activities, constantly liaising between Fabergé's customers and the workshops in Russia. He frequently travelled to St Petersburg, where he suggested new works and secured the finest pieces for sale in London. He was hugely gratified by his role at Fabergé and the entry it gave him into the gilded circles of its customers; being

pursued by kings, queens and business titans, all asking his opinion, was flattering. Bainbridge wrote two books that provided first-hand accounts of the inner workings of the House of Fabergé in London: an autobiography called *Twice Seven* (1933) and a study of Fabergé himself entitled *Peter Carl Fabergé, his Life and Work* (1949). He was a gifted author; using anecdotes and asides he effortlessly carries his reader through the golden age of Fabergé, painting a vivid picture of the firm's illustrious clientele and of Carl Fabergé as the gifted artist who served them.

Bainbridge and Nicholas Fabergé leased a rather ramshackle office on the first floor of Premier House, a commercial building at 48 Dover Street in the fashionable centre of London, close to Piccadilly and The Ritz, the newly built hotel. This discreet location was perfect for Fabergé's business, offering both him and his clients the anonymity they desired. The only hint at street level of the treasures above was the name 'Fabergé' in small letters, discreetly placed in the doorway. Customers were able to come and go unnoticed; Bainbridge watched even the Prince of Wales 'melt into the crowd' after leaving the office. The premises attracted a prominent clientele and was for Bainbridge an unassuming backwater in which,

> ... Kings put aside their crowns, ... ambassadors, maharajahs and magnets of all kinds, gay lords, grave lords, law lords and the lords of the Daily Press, together with the throng of Edwardian Society, cast off their chains of office, and leaving the main-stream of their activities for a while, spent a cool and refreshing half hour.[8]

Fabergé's principal customers in London were members of the courts of King Edward VII and King George V. The tastes and pastimes of British high society were essentially feudal and the royal family's endorsement of Fabergé's work made it highly fashionable. King Edward VII's court differed dramatically from that of his mother,

84
Henry Charles Bainbridge (1874–1954),
Fabergé's agent in London and his
biographer.
Wartski, London

85
Nicholas Fabergé (1884–1939),
youngest son of Carl Fabergé and
manager of the branch in London.
Following its closure in 1917 Nicholas
remained in London, working as a
photographer.

86
Card (front and back) sent by the
London branch of Fabergé to its
customers in spring 1907, announcing
the arrival of new stock.
Wartski, London

Queen Victoria. The barriers of class and creed, which had previously stymied royal live, were overcome. His circle included traditional aristocrats as well as the newly moneyed. Fabergé's primary British patrons came from both groups: bankers, brewers and entrepreneurs rubbed shoulders with members of the peerage at its London branch. The Rothschild family, led by Leopold de Rothschild, were particularly significant customers. Their patronage was second only to that of the royal family. Sir Ernest Cassel, a Jewish immigrant from Germany who became one of the most accomplished financiers of the age, was another of the firm's prominent newly moneyed patrons.

The *joie de vivre* of Edwardian London attracted members of an increasingly mobile international elite, who flocked to the city to share in the pleasures it offered. As it does now, the city hosted a large Russian émigré community, and many of its members viewed Fabergé's shop as an outpost of home. Grand Duke Michael Mikhailovich, grandson of Emperor Nicholas I, found solace in his exile from Russia in Fabergé's London shop. When he visited he saluted the portraits of the Emperor and Empress that hung on its walls. Americans were particularly welcomed in Edwardian London; over 100 American heiresses married into the British peerage between 1870 and 1915. The contemporary press jealously viewed the influx of brides as a form of 'gilded prostitution', where titles and social respectability were bought for large dowries.[9] These marriages were not, however, entirely mercenary, the American heiresses often sharing the tastes of their British hosts. Consequently a large proportion of Fabergé customers in London were of American origin. Americans were also among its most active patrons; the wealthy widow Mrs William Bateman Leeds, who was in her youth known as 'Pinkie' due to her rosy complexion, appears in the firm's sales ledgers 66 times.

The House of Fabergé's business in London was highly exclusive. Apart from circulars sent to

existing customers twice yearly, it did not advertise. Knowledge of the firm was limited to those who had been introduced to the company and it was near impossible to stumble upon Fabergé's Dover Street rooms and make a spontaneous purchase. Almost all its visitors were aware of its work and reputation beforehand. Most subsequently made repeated visits

K. ФАБЕРЖЕ

ПРИДВОРНЫЙ ЮВЕЛИРЪ.

С.-Петербургъ.

Москва. ❖ Кіевъ. ❖ Одесса.
Нижегородская Ярмарка.
Лондонъ.

C. FABERGÉ

JOAILLIER DE LA COUR.

St. Pétersbourg.

Moscou. ❖ Kiev. ❖ Odessa.
Foire de Nijny-Novgorod.
Londres.

LONDON, 48, DOVER STREET,
W..

SPRING, 1907.

Mr. Fabergé has the honour to inform you that he has sent from St. Petersburg a new choice. An opportunity to show you this he would esteem.

PLEASE TURN OVER

OBJECTS IN ENAMEL, GOLD, CHISELLED
SILVER, SIBERIAN STONES, ETC.

BONBONNIERES, ANIMALS, CLOCKS, FLOWERS IN VASES, FRAMES, PAPER KNIVES, SEALS, PENHOLDERS, GUM BOTTLES, BELL PUSHES, MECHANICAL BELLS, CIGARETTE LIGHTERS, CIGARETTE BOXES, ASH TRAYS, PENCILS, ETC.

FANS, LORGNETTES, HANDLES FOR UMBRELLAS, PARASOLS, STICKS AND WHIPS, HAT PINS, MOTOR PINS, TOILET BOXES, NOTE BOOKS, SMELLING SALT BOTTLES.

CIGARETTE CASES, MATCH BOXES, CIGARETTE HOLDERS (AND CASES FOR SAME), CARD CASES, ETC.

LINKS, BUTTONS, BUCKLES, CLASPS, FLOWER BROOCHES, LOCKETS, PENDANTS, NECKLACES, DIADEMS, TIE PINS, BROOCHES, BRACELETS, MUFF CHAINS, EASTER EGGS, ETC.

LARGE BOWLS (RUSSIAN STYLE) IN BEATEN SILVER AND IN ENAMEL.

Opposite
87
Fabergé's premises at 173 New Bond
Street, two shops along from Cartier's.
The columns to either side of the shop
front contained metal shutters that
extended across the building to provide
security at night.
Fersman Mineralogical Museum,
Moscow

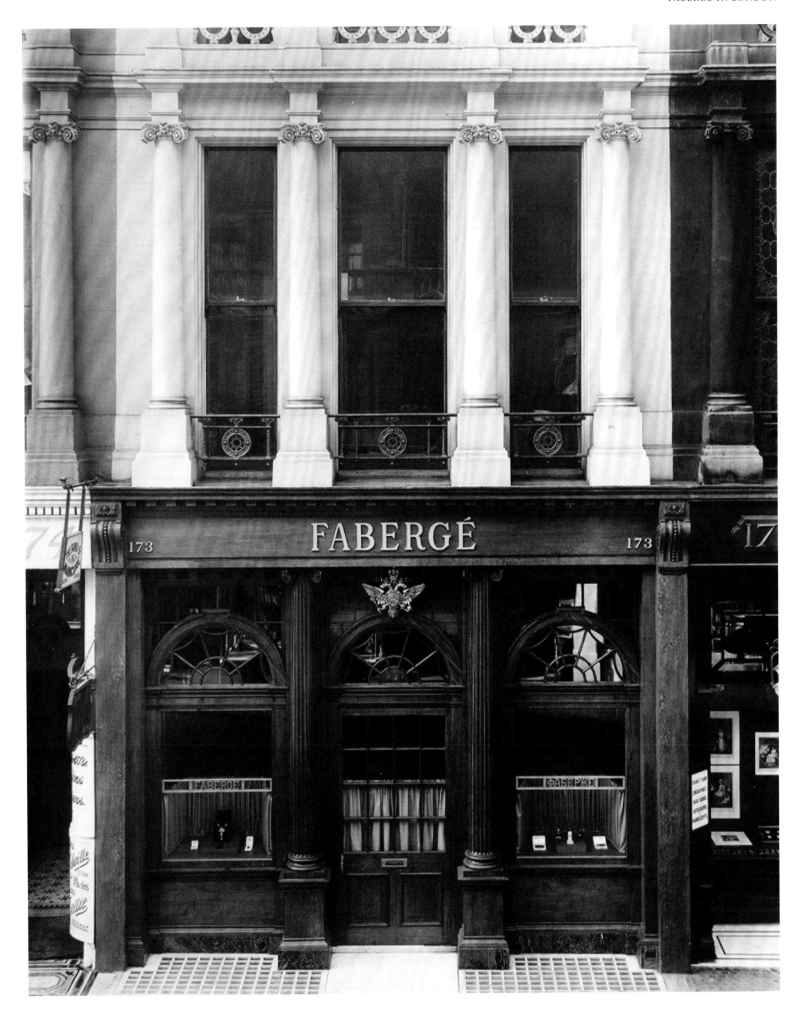

and remained customers over long periods of time; visitors making only a single purchase are rarely recorded. Cash sales and those made to an 'Inconnu' or unknown visitor were exceptional. The branch's exclusivity and knowledge of its patrons protected it from theft. Just one, of a sapphire and diamond pendant, by a thief named Salvatori Ottorino, is noted in its ledgers. Other than this single incident, the harsh realities of life in early twentieth-century Britain seem not to have impinged on Fabergé. The business was shielded by its elevated status from the poverty, militant socialism and the often violent campaign for female emancipation, which were features of life elsewhere in Edwardian London.

By 1911 the London branch had outgrown Premier House and Carl Fabergé sought a more prestigious setting befitting his status as jeweller to the crowned heads of Europe. In March that year he took over the premises of the chocolatiers Charbonnel et Walker at 173 New Bond Street (pl. 87). The glazed sweets and fruits previously sold there were replaced by enamelled and jewelled confections. The new shop was only one door away from its chief rival Cartier, at 175–7 New Bond Street. Rather fortuitously, the opening of the shop in the exceptionally hot summer of 1911 coincided with a wave of Russophilia in Britain. Serge Diaghilev's Ballets Russes had premiered at Covent Garden shortly beforehand on 21 June and on 26 June they danced before the newly crowned King George V and Queen Mary. The performances dazzled London audiences and had a profound effect on spectators. The Edwardian diarist Hwfa Williams, a customer of Fabergé, noted 'the most conservative tastes succumbed to the beauty of the new Slavic art'.[10] Vaslav Nijinsky's dance movements and Léon Bakst's revolutionary stage designs presented an image of a Russia charged with sensuality. *The Sunday Times London* euphorically described the performances as 'an expression of fierce primitive motion' that leaves 'one rather breathless'.[11] The influence of the Ballets Russes

permeated artistic sectors ranging from interior design to dress. Lady de Grey, a prominent customer of Fabergé, hung pictures by Bakst in her sitting room and Lady Cunard, another customer, bought green lamé and lacquer screens to decorate her Cavendish Square home in the style of the Ballets.

Most of the works purchased from Fabergé in London were bought as gifts and the firm's wares were the default choice for presents among members of the Edwardian elite. Weddings, birthdays, anniversaries and weekend country-house parties were regularly accompanied by exchanges of gifts from Fabergé . One of Fabergé's most prolific gift-giving customers was Stanislas Poklewski-Koziell, a charismatic Russian diplomat stationed in London. Whenever he attended a house party, he arrived, according to Bainbridge, 'loaded with things from Fabergé; two large suitcases filled with them'.[12] Lady Alington, a hostess at the centre of London society, decreed that all the ladies at her Christmas party must exchange Fabergé presents. As there were between 20 and 30 guests, the number of Fabergé gifts required was substantial. Those who could not afford the cost were forced to refuse her invitation, while others economically passed on gifts they had previously received, sometimes absent-mindedly back to the original donor.[13] The use of Fabergé works as gifts is reflected in the patterns of business at the branch. Its trade largely coincided with the social seasons when its customers mingled. Practically all sales were made between mid-May and the end of July, and between mid-October and the end of December. Christmas was an especially busy time, which saw sales peak.

Fabergé creations were ideally suited to be gifts as they were not intrinsically valuable and therefore not likely to compromise the recipient. This was especially important in the etiquette of Edwardian gift-giving. A gift had to please but not be viewed as an attempt to buy favour. It was acceptable to give money to those below you in the social order, but not to your peers. Fabergé works were especially

88
CHRYSANTHEMUM, 1903–8
Chief workmaster Henrik Wigström (1862–1923), St Petersburg
Nephrite, rock crystal, enamel, gold; 24.6 x 11.3 x 7 cm
Purchased by Stanislas Poklewski-Koziell, 27 November 1908 and given to Queen Alexandra
The Royal Collection / H.M. Queen Elizabeth II (RCIN 40506)

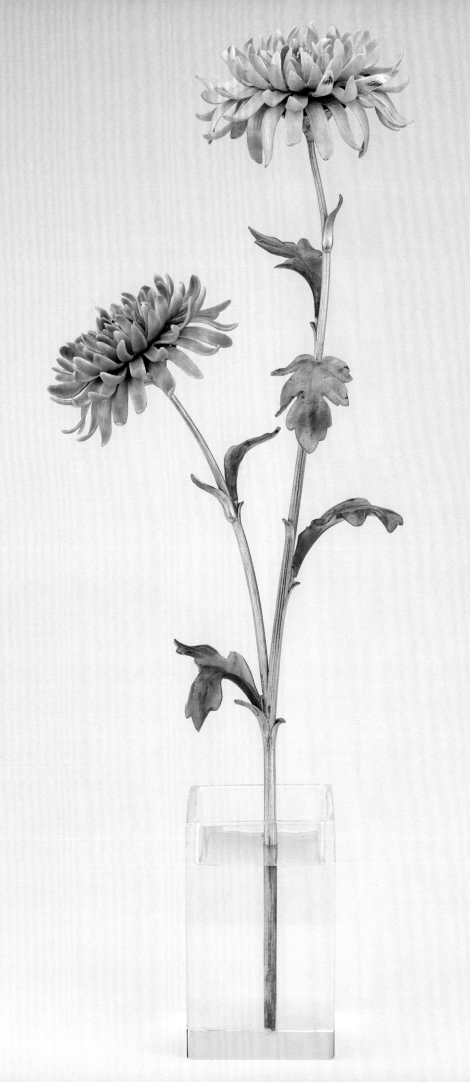

89
CIGARETTE CASE, c.1909

Workmaster August Hollming
(1854–1913), St Petersburg
Coloured golds, sapphire;
cigarette case 1.2 x 8.3 x 6.2 cm;
wooden box 3.1 x 11.9 x 9.5 cm
Purchased from Fabergé in London on
28 April 1909 by Joseph Magee Esq.
Private Collection

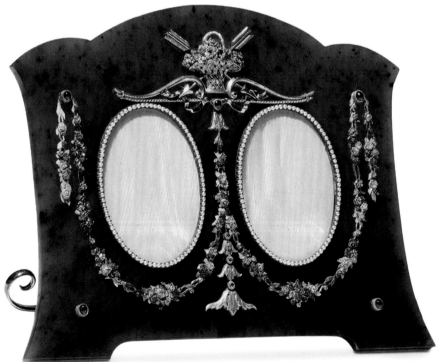

90
PHOTOGRAPH FRAME, 1903–8

Workmaster Karl Hjalmar Armfelt
(1873–1959), St Petersburg
Nephrite, gold, rubies, pearls; w. 14 cm
Purchased in London by Robert
Younger on 14 October 1909
The Woolf Family Collection

useful in this context because their desirability was perceived to lie in their craftsmanship and artistry rather than the value of the precious materials they contained. Carl Fabergé nurtured this perception of his creations as works of art, stating 'Expensive things interest me little if the value is merely in so many diamonds or pearls'.[14] Echoing this design philosophy, Mark Romer, Fabergé's British lawyer, compared valuing his client's works on the basis of their constituent materials to appreciating the contents of the National Gallery as merely a 'collection of canvas'.[15]

The firm's artistry was particularly prized in Britain and the pieces sent to London were of the highest calibre. Franz Birbaum, Fabergé's workshop manager, noted that special attention was 'paid to the technical finish' of items destined for the branch. The opulence of the stock Fabergé offered in London was in keeping with the lavish tastes of his British clientele. It was a time of conspicuous consumption and the firm's creations fitted easily into their luxurious lives. Jewelled functional objects, such as the bell pushes that were used daily to summon servants, and the more elaborate *objets de fantaisie* were grouped together on tables for their owners and guests to admire. The interiors of Edwardian homes particularly lent themselves to displaying gold and enamel work. Polesden Lacey, the country home of the Hon. Mrs Greville, the McEwan brewery heiress and one of the branch's most loyal customers, was transformed by the architects of The Ritz, Mewès & Davis, into a spectacle of luxury. Its silk-lined walls and gilded ornamentation were the perfect backdrop for Fabergé's creations.

The London branch offered the full range of Fabergé works, from conventional jewels to more unusual items like whip handles and enamelled dog bells. *Objets de fantaisie*, such as flower studies represented in enamels and Siberian hardstones, were highly prized. In November 1908 Poklewski-Koziell paid £117 for a pink and yellow enamel chrysanthemum (pl. 88), standing in a rock crystal pot. It was the most expensive flower study sold by Fabergé in London and was bought as a gift for Queen Alexandra. Given the ubiquity of smoking in Edwardian Britain, smoking accessories and, in particular, cigarette cases were popular items at Fabergé. Cases were available in a wide range of materials and finishes, including indigenous Russian and tropical hardwoods. Prices for wooden cases started at £1, fluted silver cases mounted with single stone sapphire thumbpieces cost £5 upwards, and those in gold from £23. The costliest of all cigarette cases sold at Fabergé's London branch was made of gold in a tubular form, inlaid with white enamel and mounted with foiled chalcedonies and diamonds; it was bought by Mrs William Bateman Leeds for £220 in September 1913.

Fabergé's jewelled table clocks and photograph frames were particularly suitable additions to lavish Edwardian interiors and were frequently bought by Fabergé's London customers. Clocks ranged in price from £19 for simple enamelled silver examples to £147 for more complex timepieces fashioned from hardstones and mounted in gold. Simple, though perfectly made, wooden photograph frames could be bought for as little as £2. Naturally, prices increased when they were made of silver, hardstones or gold; in July 1913 Leopold de Rothschild paid £135 for an enamelled dark blue frame, mounted with platinum and gold garlands. The mark-up on pieces sold in London was typically 80 to 100 per cent. Greater profits were made on the more elaborate and artistic works; a botanical study of a raspberry bush cost Fabergé £11.1s to make and was sold to Queen Alexandra on 27 May 1909 for £26.5s, representing a profit of just over 126 per cent.

The costliest items for the House of Fabergé to produce and the most expensive sold in London were its jewels. Indeed the firm was famous for its extraordinarily delicate and refined jewellery. The most elaborate jewels sold by Fabergé in London were tiaras, an essential prerequisite for

every Edwardian lady of note. In December 1909 Mrs Wrohan, the mistress of Lord Northcliffe, the proprietor of the *Daily Mail* newspaper, bought a tiara of brilliant and rose-cut diamonds mounted in platinum and silver for £1,400, the highest price paid for any item at the London branch. Put in context, this sum was approximately 100 times the annual salary of a scullery maid at that time.

Bainbridge carefully studied the lifestyles of Fabergé's clientele in London and the workshops in Russia tailored pieces to their interests. The most notable example of this was the firm's Sandringham Commission, comprising hardstone sculptures of the menagerie of animals kept by King Edward VII and Queen Alexandra on their favourite Norfolk estate. Fabergé also produced painted enamel scenes depicting the British homes and environs of its customers, an evolution of similar scenes produced in Russia for Fabergé's home market. With the craftsmen at his command, Bainbridge envisaged 'all England in front of me in warm sepia enamel: the Palaces, the Cathedrals, waterfalls, the Houses of Parliament and so on, ad infinitum'.[16] Filled with enthusiasm he sent topographical views of Britain to Russia, where Fabergé's enamellers meticulously painted them in muted tones of pink enamel and fired them directly onto gold boxes or sheets of gold that were mounted into hardstone frames and boxes. A variety of scenes from Sandringham were also painted: two of the main house, one of the avenue of elm trees leading to the estate's mews known as 'Sandringham Alley', one of the Model Dairy and another of the Church of St Mary Magdalene. All were bought by members of the royal family or their households. A box showing Balmoral and Windsor Castles and a frame mounted with a view of Hampton Court from the Great Fountain garden were also made. Scenes of the Houses of Parliament, Shakespeare's Church (the Church of Holy Trinity) in Stratford-Upon-Avon, and Durham Cathedral followed. With entrepreneurial flair Bainbridge realized that

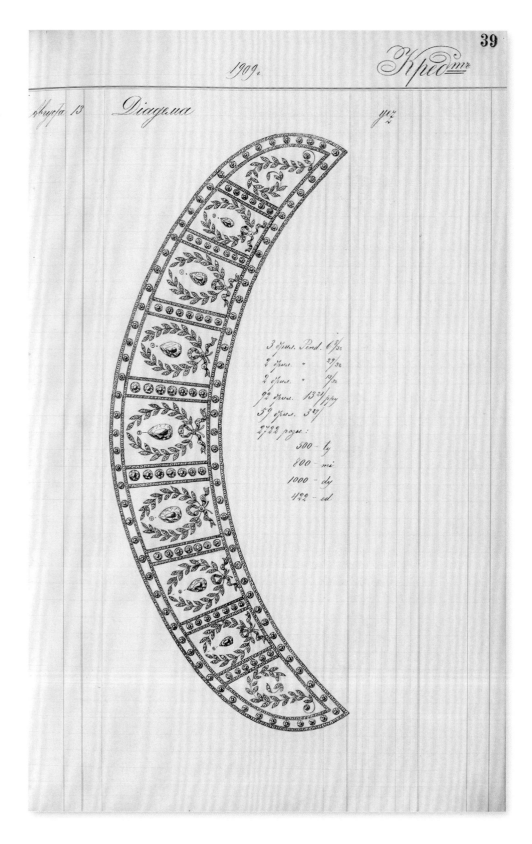

91
Watercolour design for a tiara of
brilliant and rose-cut diamonds
mounted in platinum and silver, by
chief jeweller Albert Holmström
(1876–1925), dated 13 August 1909.

A tiara of the same description was
purchased by Mrs Wrohan, the mistress
of Lord Northcliffe, from Fabergé in
London on 14 December 1909 for
£1,400, the most expensive item sold
by the firm in Britain.
Wartski, London

92
BOX, WITH VIEW OF THE PALACE
OF WESTMINSTER, 1908

Chief workmaster Henrik Wigström
(1862–1923), St Petersburg
Nephrite, gold, sepia enamel;
3.8 x 13.4 x 9 cm
Purchased by Grand Duke Michael
Alexandrovich, younger brother of
Emperor Nicholas II, on 5 November
1908, by whom gifted to King Edward
VII and Queen Alexandra
The Royal Collection / H.M. Queen
Elizabeth II (RCIN 40498)

93
FRAME, WITH VIEW OF
SANDRINGHAM HOUSE, 1908

Chief workmaster Henrik Wigström
(1862–1923), St Petersburg
Nephrite, gold, half-seed pearls, sepia
enamel, ivory; 9.0 x 15.2 x 7.1 cm
Purchased by King Edward VII in
November/December 1908
The Royal Collection / H.M. Queen
Elizabeth II (RCIN 40492)

paintings of his customers' homes would be hard to resist for either themselves or their friends to buy as gifts. On his instruction, Fabergé's enamellers produced additional scenes of Chatsworth House, the Derbyshire home of the Dukes of Devonshire, as well as Eaton Hall, the Cheshire estate of the Dukes of Westminster, and one of Gopsall Hall, the now-demolished Leicestershire seat of the Earl of Howe, Queen Alexandra's devoted Lord Chamberlain and a frequent customer of the firm.

Fabergé further immortalized Edwardian Britain by producing miniature hardstone portraits of British characters. They typically stand 15 to 20 centimetres high and are complex mosaics assembled from coloured Siberian hardstones. As was the case for the earlier painted enamel scenes,

the British hardstone figures were adaptations of works previously produced by Fabergé for its Russian customers. These portraits were a continuation of a Russian tradition of representing national types in hardstone. Fewer than 50 examples are recorded, and they are among the firm's most challenging and highly prized works. Fabergé's British figures include a Chelsea pensioner, the veteran soldier's distinctive scarlet coat depicted in purpurine, a man-made red lead oxide compound (pl. 95). His cap, trousers and boots are cut from black jasper and he leans on a gold cane. It was bought by King Edward on 22 November 1909 and given to Queen Alexandra for her birthday on 1 December. Two studies of John Bull, the personification of Britain, were produced by

94
BOX, WITH SCENES OF
CHATSWORTH HOUSE,
DERBYSHIRE, 1908

Chief workmaster Henrik Wigström
(1862–1923), St Petersburg
Gold, painted enamel; 6.5 x 2.8 x 2.1 cm
Purchased by Queen Alexandra
in December 1908 and given as a
Christmas gift to her friend,
Louise Frederica Augusta Cavendish,
the Dowager Duchess of Devonshire
The Devonshire Collections,
Chatsworth

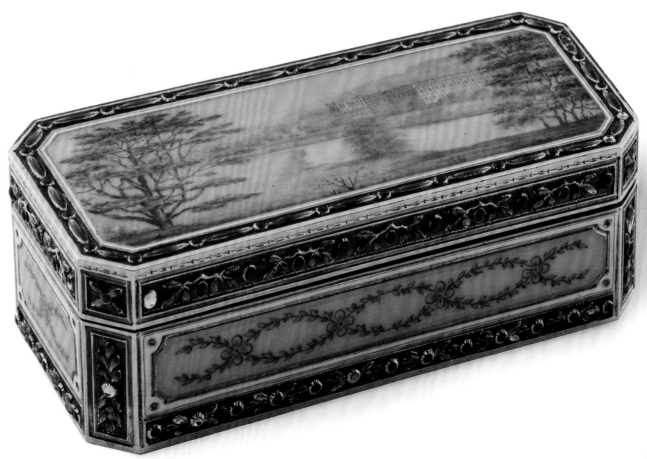

95
CHELSEA PENSIONER, *c.*1909

Chief workmaster Henrik Wigström
(1862–1923), St Petersburg
Purpurine, aventurine quartz, jasper,
gunmetal, gold, enamel, sapphires;
h. 11.2 cm
Purchased by King Edward VII on 22
November 1909
The Royal Collection / H.M. Queen
Elizabeth II (RCIN 40485)

96
JOHN BULL, THE
PERSONIFICATION OF ENGLAND,
1908

Chief workmaster Henrik Wigström
(1862–1923), St Petersburg
Purpurine, lapis lazuli, coloured jaspers,
quartz, chalcedony, gold, sapphires;
h.12 cm
Purchased by Emperor Nicholas II from
Fabergé in St Petersburg on 12 April 1908
Private Collection

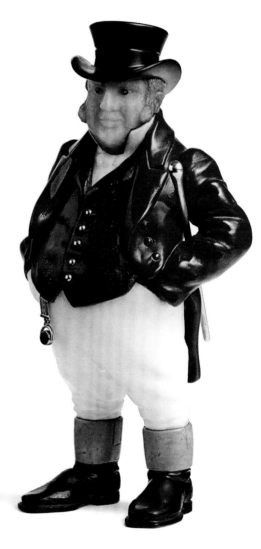

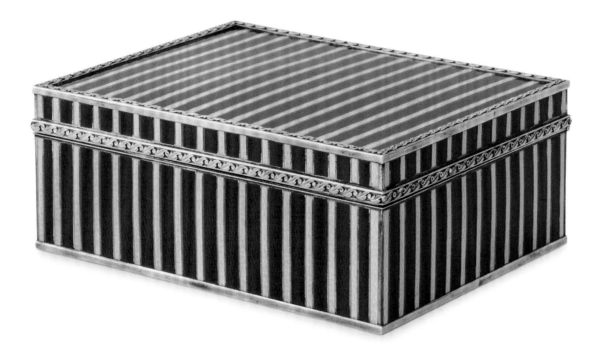

Fabergé's lapidaries; one of these – the figure wearing a purpurine waistcoat – was bought by Emperor Nicholas II before it ever came to England (pl. 96). Fabergé also took inspiration from British literature and created figures of the Mad Hatter and Tweedledum and Tweedledee from Lewis Carroll's *Through the Looking-Glass and What Alice Found There*. These unusual figures are the only ones, in Russia or Britain, inspired by literary creations. To cater for American clients in London, Fabergé modelled a figure of Uncle Sam, the national personification of the United States government, with a white onyx hat, a coat of obsidian and an enamelled waistcoat. It was sold for £60 to the glamorous American socialite Virginia Fair Vanderbilt on 10 September 1909. Its whereabouts is currently unknown.

A manifestation of Carl Fabergé's work unique to Britain and the London branch was inspired by the passion for horse racing shared by many of his British customers. To identify themselves in races jockeys were required to wear coloured jackets and hats, known as silks. Each racehorse owner had a unique pattern, which became a facet of their identity. Under Bainbridge's direction Fabergé began supplying enamelled works in the colours of his patrons' racing silks. The first to be represented were those of the Rothschild family in blue and yellow. Bainbridge sent a telegram to Fabergé requesting, 'Everything that has been made before now make in the Rothschild colours'. Fabergé responded with a variety of pieces including, to Bainbridge's astonishment, a motor mascot in the form of a bird with 'large diamond eyes' and wings that flapped as the car moved. Bainbridge intended the pieces to be bought by acquaintances of the Rothschilds as potential gifts to the family. The opposite happened and the Rothschilds themselves acquired the majority of these works – as presents

97
TABLE CIGARETTE BOX, IN THE RACING COLOURS OF THE ROTHSCHILD FAMILY, 1908–13

Chief workmaster Henrik Wigström (1862–1923), St Petersburg
Gold, silver gilt, enamel;
5.2 x 13.5 x 10.5 cm.
Baron Albert de Goldschmidt-Rothschild purchased a matching box on 13 June 1913
'The Link of Times' Foundation, Fabergé Museum, St Petersburg

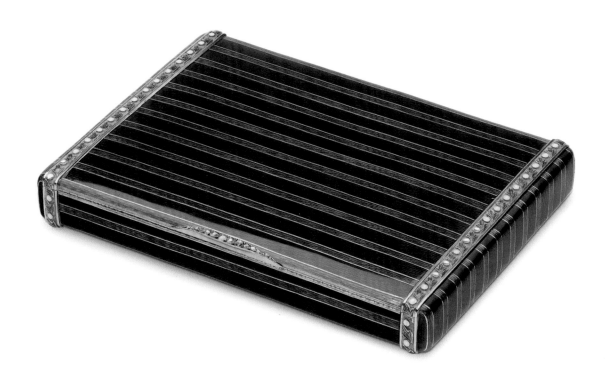

98
CIGARETTE CASE, IN THE RACING
COLOURS OF KING EDWARD VII,
1908–9

Chief workmaster Henrik Wigström
(1862–1923), St Petersburg
Gold, silver-gilt, enamel, diamonds;
w. 10.5 cm
Purchased by Mrs Neumann, wife of
the Randlord Sigmund Neumann,
25 October 1909, as a gift for King
Edward VII on his 68th birthday the
following month
Private Collection

for others. Leopold de Rothschild kept the pieces close to hand so that, 'Whenever he wanted to say "Good morning!" "I like you!" or "Don't bother me anymore!", he could simply slip a dark blue and yellow Fabergé object into his friend's pocket'.[17] Pieces were also made in the pink and yellow racing colours of ex-prime minister the Earl of Roseberry, the scarlet, blue and white colours of the Earl of Carnarvon and the purple and scarlet colours of King Edward VII. The King was especially fond of horse racing and works in his colours were ideal gifts for him. On 29 October 1909 Queen Alexandra bought the two most expensive items enamelled in her husband's colours: a gold-mounted clock and a gold-mounted photograph frame for £70 each. The frame remains in the Royal Collection and was most likely a gift to the King on his birthday 11 days later.

The London branch was the gateway to the world for the House of Fabergé and oversaw the firm's

activities not only in Britain but also in Western Europe and beyond. After Britain, France was the next biggest market for Fabergé's work in Europe and representatives from the London branch made sales trips to Paris from 1908 until the outbreak of the First World War. In Paris the primary customers were the Napoleonic Murat and Rothschild families, both of whom made substantial purchases. The glamorous Princess Cécile Murat (pl. 99) was perhaps Fabergé's most important customer in Paris. She was the daughter of Michel Ney, 3rd Duc d' Elchingen, grandson of the Napoleonic hero Marshal Ney, and Marguerite Furtado-Heine, a banking heiress. In 1884 Cécile married the 5th Prince Joachim Murat, a descendant of Prince Murat, Napoleonic Grand Marshall and King of Naples. The marriage united the two Napoleonic families and placed the Princess at the pinnacle of the Parisian elite. She enjoyed great wealth, having

inherited a fortune from her mother's family, and lived in a mansion at 28 rue de Monceau described by Marcel Proust as the most magnificent in Paris. By 1900 she had grown apart from her husband. She escaped her unfulfilling marriage in the company of the handsome adventurer Luzarche d'Azay. Although their relationship was conducted discreetly, it was an open secret in social circles and they remained lovers until the Princess's death in 1960. Between 1901 and 1916, the Princess commissioned a series of Fabergé cigarette cases for him. Agathon Fabergé remembered her as one of Fabergé's most demanding patrons, insisting upon 'the finest possible workmanship, the best which human hands could possibly create'.[18] The cases were mementos of times she spent with Luzarche d'Azay and were given to him each New Year in celebration of another year together. They incorporated decorative rebuses and secret messages, the meanings of which were known only to the lovers themselves.

The London branch catered for Fabergé's customers elsewhere on mainland Europe. In February 1910 representatives from the London branch made a sales trip to Rome: its customers in Italy were mostly members of its royal family and aristocracy. Queen Elena of Italy, wife of King Victor Emmanuel III, acquired 20 pieces. She had a fondness for the colour mauve and six of her choices were enamelled in this colour. Then in spring 1913 the London branch undertook a trip to the fashionable French Riviera. Cannes was a particularly popular destination for the Russian imperial family. Grand Duke Michael Mikhailovich kept a home there, named 'Villa Kazbeck'. He visited it frequently and invited his friends and relations to share in the pleasures of the area. When the Princess of Pless stayed at the villa she was struck to find herself 'amongst so many Russian royalties'.[19] The concentrated clientele of Cannes made the journey to the Riviera successful for Fabergé and encouraged the branch to make a return trip in 1914.

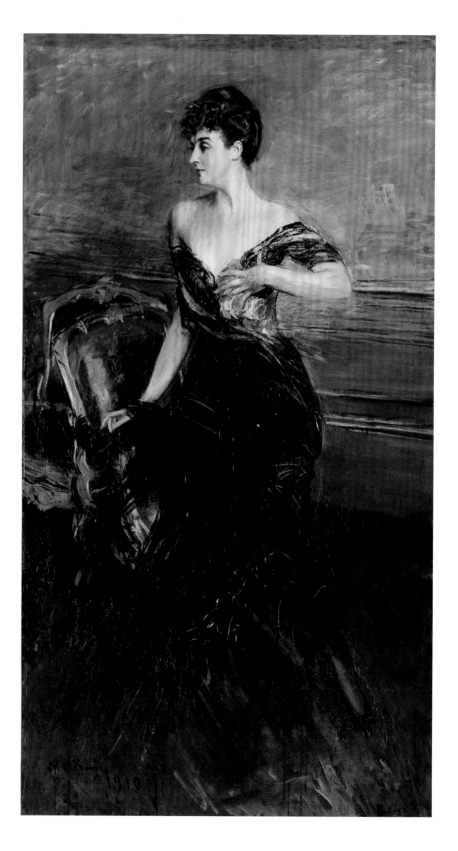

Opposite

99
PORTRAIT OF PRINCESS CÉCILE
MURAT (1867–1960), 1910

Giovanni Boldini (1842–1931)
Oil on canvas; 239 x 130 cm
Private Collection

100
CIGARETTE CASE, WITH MAP
OF THE NILE VALLEY, 1903–4

Chief workmaster Henrik Wigström
(1862–1923), St Petersburg
Gold, diamonds, rubies, emeralds,
sapphires, cotton; 2.0 x 11.4 x 7.5 cm
Purchased by Princess Cécile Murat,
given to Luzarche d'Azay, 1904
Musée des Arts Décoratifs, Paris (Inv.
38340), Estate Luzarche d'Azay, 1960

The London branch's furthest flung ventures
were to Siam, modern-day Thailand. The Siamese
royal family were diplomatically linked to that
of Russia and in 1908 Nicholas Fabergé began
travelling from London to Bangkok to show his
family's works to King Rama V. Following the
King's death in 1910, Nicholas continued to serve
his son, the English-educated King Rama VI.
Fabergé tailored its works towards Siamese tastes,
just as it had done for its customers in London.
Enamelled scenes were made of Bangkok, by the
same artist who painted views of Britain. Fabergé
also undertook commissions for the Siamese royal
family, just as it had done for the British royal family.
Some of the pieces produced are a unique fusion
of Russian decorative art and South East Asian
forms. Following the death of Rama V in 1910,
his heir Rama VI sent an order to Fabergé for a
nephrite Buddha to adorn a temple commemorating
his father. A series of similar, smaller, nephrite
representations of Buddha with enamelled gold
mounts were also made for the Siamese market.
Another of the sacred objects supplied to the
Siamese court by Fabergé was a spectacular lustral
water bowl, carved from nephrite and supported on
sculpted yellow gold representations of the Hindu
gods Brahma, Vishnu and Shiva.

Indeed Fabergé's world was not so far removed
from our own, for the Edwardian era was an
international one, in which patrons and craftsmen
criss-crossed the globe. Fashions spanned borders
and were pursued by an increasingly mobile elite.
Fabergé's presence in London was a product of this
modern age. His reputation spread from Russia to
London and from London to far flung destinations.

BOND STREET AND INTERNATIONAL LUXURY

ANNA FERRARI

Regent Street is for the wealthy suburbians [sic] *and Bayswater, Oxford Street is for the world, but Bond Street is for princes and Park Lane.*

Olivia's Shopping, 1906

In 1906 a London shopping guide aimed at middle-class women introduced Bond Street as the epitome of exclusive shopping, humorously cautioning readers against exorbitant prices and warning that 'the air one breathes is made of gold'.[1] Mayfair was the most prestigious area in London, a focus for luxury. On its fringes a palatial hotel, The Ritz, opened in Piccadilly in 1906, the same year Fabergé settled in Dover Street, which ran parallel to Bond Street. Historically home to the great aristocratic houses, such as Devonshire House and the Duke of Westminster's Grosvenor House, Mayfair was also favoured by the new high society of industrialists, bankers and financiers who sought to emulate the aristocracy and also became Fabergé's clients. In the 1880s Piccadilly Terrace was nicknamed 'Rothschild Row' as members of the banking dynasty settled there, while, at the turn of the century, Sir Ernest Cassel, the Jewish financier and adviser to the Prince of Wales (who became King Edward VII), acquired Brook House in Park Lane, joining diamond and railway magnates, and other plutocrats. Mayfair was also conveniently close to royal palaces: Marlborough House, the Prince of Wales's London

home, and Buckingham Palace. As the shopping guide succinctly put it, Bond Street was 'for princes and Park Lane'.

London was then the capital of an empire at its peak. Staggering wealth poured into the City, which became the world's financial centre between the 1890s and 1914, with almost half of the world's capital flowing through it.[2] It attracted an increasingly cosmopolitan elite, whose vast fortunes fuelled 'conspicuous consumption' with the display of extravagant acquisitions serving to bolster social status.[3] King Edward VII's accession to the throne in 1901 ushered in a new era of pleasurable frivolity among court circles, following decades of solemnity as Queen Victoria withdrew into seclusion following Prince Albert's death in 1861. Bond Street offered this elite a plethora of exclusive retailers, many of whom held royal warrants. It was host to antique dealers and art gallerists (Duveen and Colnaghi); society photographers (Lafayette and Bassano); florists; cigarette merchants; every fashion supplier from court dressmakers to furriers, and from milliners to bootmakers; hairdressers, and a 'coiffeur and posticheur'; as well as 'complexion specialists' who occupied the upper floors, one of whom even advertised 'Hair & Scalp treat[ments] by electricity'![4]

However, in the early 1900s Bond Street became the heart of an increasingly international luxury market. French, Japanese and Russian retailers, particularly jewellers and goldsmiths, converged on Bond Street: Louis Vuitton, the French trunk maker, and Yamanaka, the Asian art dealership, opened in 1900, and French jewellers followed including Chaumet, which opened in 1905, Lacloche Frères by 1908, Cartier in 1909 and Boucheron in 1913. In relocating from Dover Street to Bond Street in 1911, Fabergé took part in this broader internationalization of the luxury market. Savvy luxury retailers, many of whom had shown at world fairs in Paris and in America, pursued cosmopolitan elites and astutely expanded their clientele. French retailers especially seized the opportunity, responding to King Edward VII's love for all things

101
An advertisement for Cartier, showing their premises on New Bond Street in 1911.

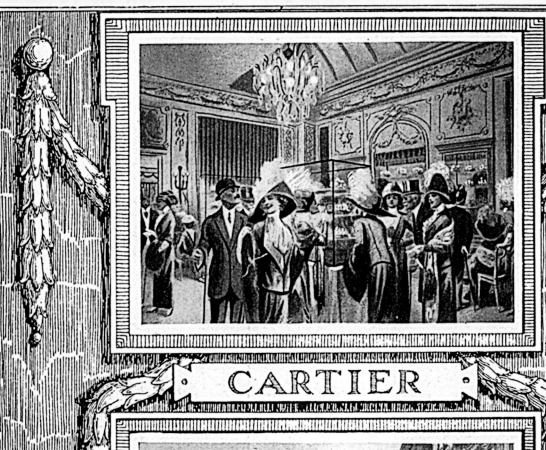

CARTIER

PARIS · LONDON · NEW YORK
175 NEW BOND STREET 176

French and benefiting from the improved Franco-British relations following the signing of the Entente Cordiale in 1904. Many of Fabergé's most valued clients patronized these shops in Bond Street, providing a picture of Edwardian luxury in London before the First World War.

Georges Vuitton, the son of Louis Vuitton who founded the eponymous company in Paris in 1854, counts among the first enterprising international business owners to open their premises in Bond Street in 1900. Georges understood London's strategic importance for his business's international expansion. He opened the first branch outside France in 1885 at 289 Oxford Street but swiftly moved to improve sales, first to The Strand in 1889 before finally relocating to Bond Street.[5] A sign of Vuitton's ambitions, the shop at 149 New Bond Street occupied the entire building. Lettering on the facade promoted 'Trunks & Bags' and 'Travelling Requisites' while the shop's windows were stacked from floor to ceiling with different types of luggage. The cover of a 1901 Vuitton catalogue presented an elegant woman dressed for travel, surrounded by examples of one of Vuitton's earliest innovations: the stackable flat-topped trunk, which replaced old-fashioned trunks with domed tops that were designed to repel rainwater. The London branch launched Vuitton's international expansion and by the beginning of the twentieth century it was selling merchandise through agents in cities across the United States, as well as in Buenos Aires. Its customers spanned an international elite from Alfonso XIII, King of Spain, to the Russian aristocracy.

Cartier opened a branch in London in 1902, the year of King Edward VII's coronation. Cartier's first London premises were on New Burlington Street but in 1909 it relocated to the more prestigious address of 175 New Bond Street, with its opulent neo-classical facade of gilt marble.[6] Founded in Paris in 1847 by Louis-François Cartier, the jeweller opened luxurious premises in Paris on the rue de la Paix in 1899, from where Louis-François's three

102
Louis Vuitton English catalogue cover, 1901.
Louis Vuitton Collection

Opposite above
103
Tiara, made by Cartier, Paris, in 1903 for Consuelo, Duchess of Manchester.
V&A (M.6:1-2007)

Opposite below
104
Brooches (set as a necklace), made by Cartier, Paris, in 1903 and sold to Sir Ernest Cassel.
Cartier Collection

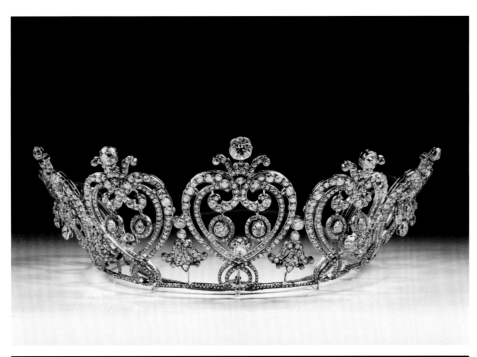

grandsons launched their international empire: Louis managed Paris, Jacques oversaw the London branch and Pierre opened the New York branch in 1909. In its first two years in London, Cartier made a flurry of sales to members of Edward VII's circle including Lillie Langtry, the Duchess of Devonshire, Lady de Grey and Mrs Keppel. Consuelo, Dowager Duchess of Manchester, commissioned a diamond tiara in Cartier's fashionable 'garland style' inspired by the French eighteenth century, which held appealing associations for a plutocracy seeking social validation.[7] Consuelo was an American-Cuban heiress who married George Montagu, the future 8th Duke of Manchester, in 1876, and who charmed British society with her banjo playing and her Spanish songs. She joined the many American heiresses who, between the 1870s and 1914, married into British aristocracy and bolstered family fortunes, ultimately transforming British high society.

This new plutocracy patronized both Cartier and Fabergé. Mrs William Bateman Leeds, the immensely wealthy American widow of a tin industrialist who lived in Mayfair before the First World War, became one of Fabergé's best customers in London for ornamental objects, whilst preferring Cartier for jewellery.[8] Sir Ernest Cassel, who became one of King Edward VII's closest friends, was a customer at both Fabergé and Cartier from where, in 1903, he purchased a pair of diamond-set articulated brooches as a gift to his sister, Wilhemina. Inspired by Japanese designs featuring tumbling wisteria, the brooches were inventively conceived to be worn either as a stomacher, a necklace, a corsage ornament or a tiara. Set in platinum they reflected the new fashion for delicate settings, which almost disappeared amid dazzling diamonds. Cartier also catered to the international fashion for Russian works of art and sought to satisfy the demands for Fabergé-like pieces by creating enamelled objects, cigarette cases and hardstone animals of its own.[9] Cartier designers were adept at drawing inspiration from different

105
Tiara in the 'kokoshnik' style, made by Chaumet for the Duchess of Westminster, c.1910–11.

periods and traditions but it remains astonishing that a contemporary St Petersburg goldsmith influenced the Parisian jeweller. When Fabergé's London branch moved to 173 New Bond Street in 1911, it became Cartier's neighbour, adding to the rivalry with the French firm.

Chaumet sought the same international clientele of Europeans, Americans and Russians as Cartier and opened at 154 New Bond Street in 1905.[10] Founded in 1780 by Marie-Etienne Nitot, the French jewellery firm had a brief presence in Mayfair in the late 1840s when the goldsmith Jean-Valentin Morel set up a branch which benefited from Queen Victoria's royal patronage.[11] At the turn of the century, it firmly re-established itself in London. The new branch on Bond Street served her son and successor King Edward VII, as well as members of his circle, many of whom had previously been customers of the Paris branch. The coronation of King George V and Queen Mary

in 1911 spurred commissions for new tiaras that etiquette and fashion required to be worn at formal occasions. Hugh Grosvenor, Duke of Westminster, commissioned from Chaumet a 'kokoshnik', a Russian-style tiara, for his wife Constance, Duchess of Westminster, most likely to wear at the coronation celebrations. Their choice of the 'kokoshnik' style, like their purchases from Fabergé in London, reveals their taste for the Russian fashion.[12] Chaumet took inspiration from the traditional Russian solid, halo-shaped headpiece whilst creating a delicate design with elegant diamond forget-me-nots creeping down translucent blue enamel, interrupted by curved rows of diamonds. Other French jewellers, including Cartier, also reinvented the 'kokoshnik' form, which became a fashionable style at the beginning of the twentieth century.[13]

Apart from French- and Russian-inspired jewellery, Bond Street also reflected the vogue for Asian art and decorative arts. Yamanaka, founded in

106
Yamanaka showroom, 127 New Bond
Street, London, 1910.
Yamanaka & Co., Ltd

Osaka and specializing in traditional Japanese arts, had successfully established branches in New York (in 1894) and Boston (in 1899) before opening at 127 New Bond Street.[14] Its inventory included objects and furniture made especially for export (such as pottery, furniture and jade jewellery) as well as antiques. Perhaps as a concession to its British clientele, in London Yamanaka also sold plants, possibly the potted bonsai trees displayed on decorative stands in the shop's ground floor showroom. Yamanaka's success reflected the trend for *Japonisme*, the craze for Japanese art and design in France and the rest of Europe that followed Japan's opening up to international trade in the 1860s after centuries of isolation. Yamanaka became one of the most influential dealers in Asian art in the 1910s, selling to important collectors in Britain and America, and fostering relationships with museums such as the V&A, which purchased Japanese screens, sword guards and Chinese bronze objects between 1910 and 1912.[15] During those years the V&A also added Japanese netsuke to its collection, which were either given or bequeathed. These miniature sculptures were originally attached to inro, small decorative containers worn by Japanese men at the waist, suspended from the kimono's obi. Netsuke became fashionable among collectors, including Fabergé's clients in London.[16] In St Petersburg Carl Fabergé himself owned a collection of over 500 netsuke, which are recognized as one of the sources of inspiration for his hardstone animal figures. When Cartier sought to emulate Fabergé's works, the jeweller turned to Yamanaka, who became one of the firm's providers, placing the Asian art dealer at the centre of international luxury.[17]

In her novel *The Edwardians* (1930), Vita Sackville-West vividly conjured this world. A pivotal encounter between the young aristocratic Sebastian and his lover Sylvia, Lady Roehampton, takes place in the latter's London townhouse where Fabergé and Cartier objects mingle with Chinese wares, all of which could have been bought in Bond Street:

[Sebastian's] mind, concentrated on a small, irrelevant object, so that it seemed that object was the only thing of importance to him in the world: a crystal rabbit of Chinese carving, standing on the table immediately beneath the lamp. [...] He had seen the rabbit a thousand times before; he had, in fact, given it to Sylvia himself; it was as familiar to him as the many other objects which stood about upon the tables – the Celadon bowls, the jade ash-trays, the Fabergé cigarette-boxes, or the little jewelled clocks from Cartier'[18]

Even before the First World War, Bond Street and Mayfair were not impervious to events that heralded a new era. In December 1910 modern art erupted in the heart of the establishment when the painter and critic Roger Fry opened an exhibition entitled *Manet and the Post-Impressionists* at the Grafton Galleries close to Bond Street. It presented ground-breaking works by artists who were then little-known in Britain, including Paul Cézanne, Paul Gauguin, Vincent van Gogh, Henri Matisse and Pablo Picasso. Widely criticized, it was a watershed moment that introduced French modern art to Britain. Bond Street also witnessed militant suffragettes and their violent political campaign when, in March 1912, members of the Women's Social and Political Union fighting for votes for women smashed shop windows in Bond Street and across London's West End. The First World War interrupted the suffragettes' campaign and radically transformed society, including the elite's way of life. In the post-war years, great London townhouses were demolished, notably Devonshire House in 1924 and Grosvenor House in 1927, symbolizing profound social change. Following the outbreak of the First World War, the Fabergé branch in New Bond Street closed its doors in 1917. Its neighbours, however, adapted. Yamanaka continued until 1940, and Cartier, Chaumet and Louis Vuitton remain in Bond Street today, which has maintained its reputation as one of the most prestigious retail addresses since the Edwardian era.

107
NETSUKE IN THE FORM OF A
HARE, MADE BY KŌICHI, 1800–50

Wood with inlaid eyes; h. 3 cm
V&A (Salting Bequest, A.954-1910)

108
DOUBLE BELL-PUSH IN THE
FORM OF A CRAB IN THE
JAPANESE TASTE, 1911–12

Chief workmaster Henrik Wigström
(1862–1923), St Petersburg
Silver, blue chalcedony, moonstones;
w. 12.3 cm
Private Collection

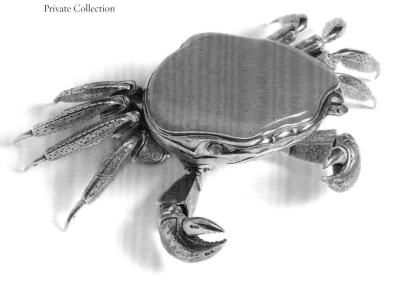
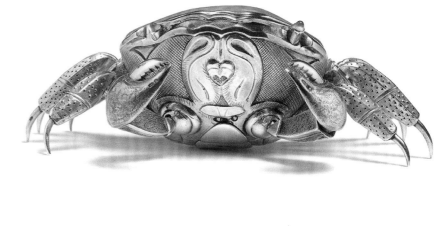

ROTHSCHILD VASE

THE CORONATION OF KING GEORGE V AND QUEEN Mary on 22 June 1911 was an important occasion for Fabergé's London branch and an opportunity to serve its customers. King George was a longstanding and discerning patron of Fabergé. A gift from the firm would be a natural choice for his friends to mark the event. This large enamelled and jewelled gold mounted rock crystal cup was given to the new King and Queen for the coronation by their friend, the financier Leopold de Rothschild. It is inspired by the lapidary works of the Renaissance and is decorated with jewelled polychrome enamels. The cup was made by Fabergé's second chief workmaster Michael Perchin, who specialized in neo-Renaissance objects for the firm.

Leopold's gift to the new King and Queen was carefully planned well in advance. He bought the cup on 12 April 1911 over two months before the ceremony. Two of the reserves on the rock crystal were engraved with the date of the coronation in Roman numerals and the royal arms to mark the occasion. Leopold was a generous gift-giver – Bainbridge, who dealt with many generous patrons, described him 'as a perpetual Father Christmas'. The cup was a particularly significant gift; at a cost of £430 it was the most expensive work of art purchased from Fabergé in London. It was also an apt choice for Leopold, as the Rothschild family were renowned for collecting Renaissance works of art.

Yet the cup was only one part of Leopold's elaborate plan for his coronation gift. As well as being known as art connoisseurs, the Rothschild family were also celebrated for their cultivation of orchids. They devoted considerable time and resources to growing these plants, which were so rare at the time. Large, heated glasshouses were built to house them, and teams of gardeners carefully tended them at Gunnersbury, Leopold's estate to the west of London. Exotic examples were collected via the Rothschilds' worldwide network of banking agents and sent there. The family's fondness for the plants has been said to derive from the similarities they saw between themselves and orchids. Both were eccentric and curious imports, highly prized, the subject of envy and requiring special handling.

Early on the day of the coronation, Leopold's gardener brought orchids from the glasshouses to Fabergé's premises. There they were arranged in the cup, which was then taken to Buckingham Palace. It was placed on the royal breakfast table for the King and Queen to discover soon after they woke. And so Leopold had bought this Fabergé piece, the most expensive object sold at Fabergé in London, as a vase to hold a gift of orchids.

109
PORTRAIT OF LEOPOLD DE ROTHSCHILD (1845–1917), EARLY 20TH CENTURY

Herbert A. Horwitz
(active 1892–1906)
Oil on canvas; 60 x 48 cm
The Rothschild Archive (NMR134)

110
ROTHSCHILD VASE, BEFORE 1896

Chief workmaster Michael Perchin
(1860–1903), St Petersburg
Rock crystal, gold, enamel, sapphires, rubies, emeralds; 16.5 x 13.5 cm
Purchased by Leopold de Rothschild, 12 April 1911, given to King George V and Queen Mary on 22 June 1911, the day of their coronation
The Royal Collection / H.M. Queen Elizabeth II (RCIN 8949)

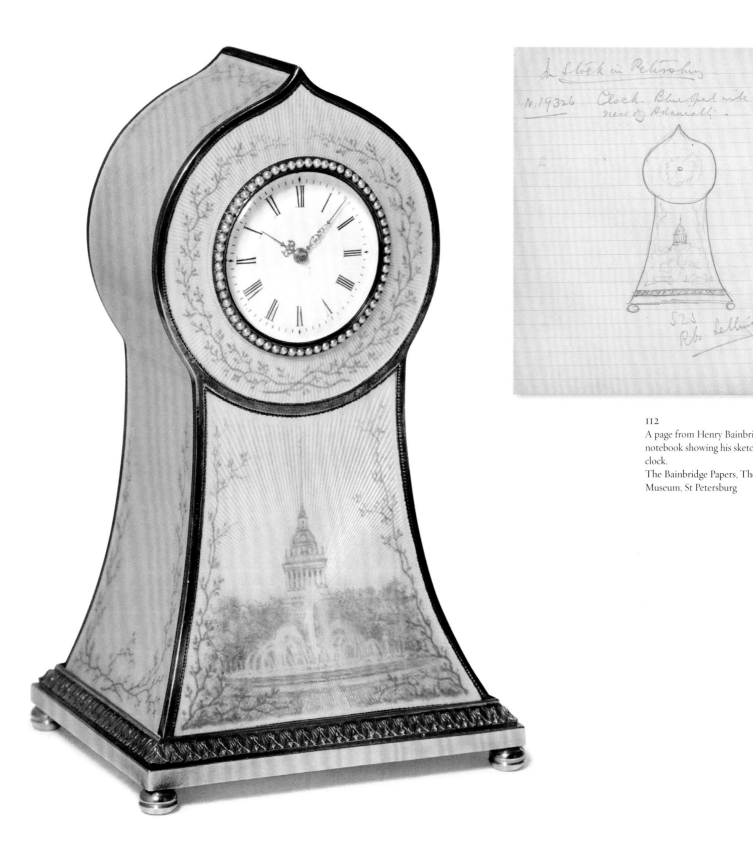

112
A page from Henry Bainbridge's notebook showing his sketch of this clock.
The Bainbridge Papers, The Fabergé Museum, St Petersburg

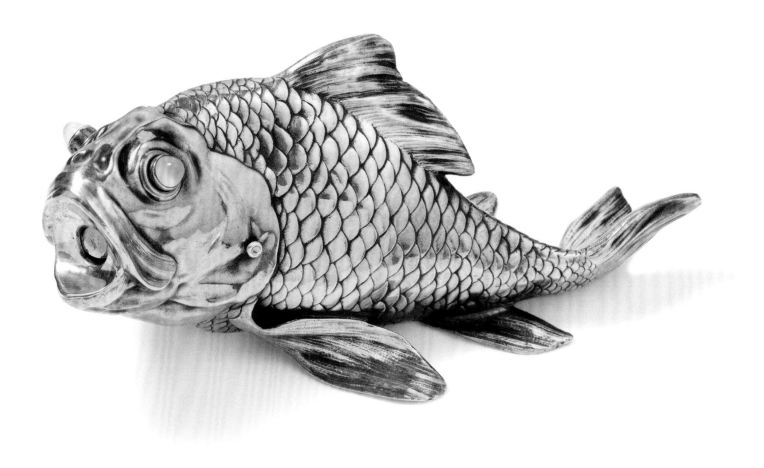

113
CIGAR-CUTTER, MODELLED AS A CARP IN THE JAPANESE TASTE, 1903–8

Chief workmaster Henrik Wigström (1862–1923), St Petersburg
Silver, gold, stained chalcedonies; l. 13.3 cm
Purchased by 4th Earl Howe, 24 November 1908
The Woolf Family Collection

Opposite
111
CLOCK, *c.*1910

Chief workmaster Henrik Wigström (1862–1923), St Petersburg
Enamel, gold, pearls; h. 10.8 cm
Courtesy of A La Vieille Russie, New York

An opalescent enamelled gold clock painted in sepia enamel with a view of the Russian Admiralty. When Bainbridge visited St Petersburg, he sketched pieces being produced in the workshops and vied to bring the best of them to London for sale.

Fabergé's inspiration came from many sources. He particularly admired Japanese works of art and owned a significant collection of Japanese artifacts, which were displayed within his private apartment at the firm's premises on Bolshaya Morskaya Street in St Petersburg. This imaginative silver cigar-cutter is modelled on a Japanese Meiji period bronze. When its protruding pink chalcedony eyes are pressed, the blade opens across its mouth and the fish appears to breathe.

Opposite
114
VANITY CASE, 1908–12

Chief workmaster Henrik Wigström (1862–1923), St Petersburg
Gold, enamel, emerald, glass, foil; 7.5 x 5 cm
Purchased by Mrs William Bateman Leeds, 14 December 1916
The Beilin-Makagon Art Foundation

A jewelled and enamelled gold vanity case, enamelled translucent
pink over an engraved ground with opaque white borders, the
gold edging decorated with white and green enamel floral trails.
The case contains a mirror and hinged compartments for powder
and lipstick, and is opened by pressing a cabochon emerald.
Nancy Leeds's husband, William, had prospered in the American
tin-plate trade and left his widow and young son a fortune when
he died in 1908. Nancy moved to London shortly afterwards and
became one of Fabergé's best customers.

115
CIGARETTE CASE, 1908–11

Chief workmaster Henrik Wigström (1862–1923), St Petersburg
Gold, platinum, diamonds, agate, enamel; 8.99 x 4.34 x 3.06 cm
Purchased by Mrs William Bateman Leeds, 23 September 1913
The Beilin-Makagon Art Foundation

A jewelled and enamelled gold cigarette case of tubular form,
set with singular rose diamonds and rose diamond florets in
platinum, the ends mounted with pale agate panels over pink foil.
It has two central reserves: one mounted with a diamond set bow
and quiver and the other with the crowned letter 'A'. This was
the most expensive case ever sold at Fabergé in London at a price
of £220.

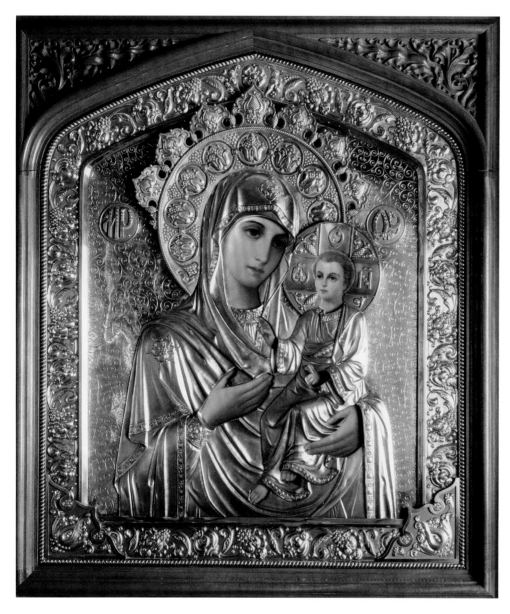

116
ICON OF THE MADONNA AND CHILD, 1896–1908

Moscow
Wood, paint, silver, enamel; 98.0 x 85.0 cm
Purchased by the Duchess of Norfolk, 15 February 1908
His Grace the Duke of Norfolk

This icon, with a silver and matt green enamel cover (not
shown), was commissioned by the Duchess of Norfolk at a cost
of £225. The icon was stopped by the Goldsmiths' Company en
route to Fabergé's London branch from the company's workshops
in Moscow to test the quality of the silver it contained. It now
hangs in the Library of Arundel Castle, West Sussex.

117
PANAGIA, A JEWELLED ICON WORN IN THE
RUSSIAN ORTHODOX TRADITION, 1908–16

Chief workmaster Henrik Wigström (1862–1923), St Petersburg
Gold, enamel, sapphires, rubies, pearls, diamonds; 15.24 x 8.57 cm
Purchased by Mrs Mango, a Turkish shipping heiress, 30 October 1916
Courtesy of A La Vieille Russie, New York

Made of yellow gold, lavishly set with cabochon rubies, blue
sapphires, pearls and rose diamonds, this panagia is centred by a
sophisticatedly enamelled medallion of Christ Pantocrator and
surmounted by an imperial Russian crown. This fine cloisonné
example is based on an 11th-century medallion, which
Fabergé would certainly have known.

118
BOX, 1903–8

Chief workmaster Henrik Wigström (1862–1923), St Petersburg
Gold, moss-agate, foil, enamel, rubies, diamonds; 2.7 x 5 x 3.9 cm
Purchased by Princess Hatzfeldt, 16 November 1910
Private Collection

This jewelled, enamelled and moss-agate mounted gold
bonbonnière of pentagonal form, its side panels decorated with
arabesques and ribbon-tied laurel swags hung from cabochon
rubies, has a hinged lid inset with moss agate over a pink foiled
ground. It was purchased by Princess Hatzfeldt who, born
Clara Prentice and adopted by Californian railroad tycoon
Collis P. Huntingdon, inherited a considerable fortune. In 1889
she married Prince Francis von Hatzfeldt-Wildenburg and
established herself in English society, acquiring over 50 pieces of
Fabergé between 1907 and 1916.

Opposite
120
CHARTWELL DISHES, 1911

Silversmith Andrew Tysall (active 1887–1918), engraver Frank Lutiger (active 1896–1931), London
Silver-gilt; w. 12.5 cm
Sold by Fabergé in London to Sir Ernest Cassel, who presented them to Winston Churchill, 1st Lord of the Admiralty (1911–15 and 1939–40)
National Trust Collections, Chartwell (The Churchill Collection) (NT1100765.1–12)

A set of 12 silver table bowls depicting the growth of the British Navy from the 11th century was presented to Winston Churchill by Sir Ernest Cassel, a renowned merchant banker and the young Winston's mentor, financial advisor and in due course lifelong friend. The last bowl shows an Invincible class battlecruiser and a Bellerophon class battleship, launched in 1907. The latter was one of the dreadnought ship types. These powerful vessels captured the British public's imagination. With the German naval threat growing, and stoked by a belligerent press, popular opinion patriotically supported their production. The bowls were later kept at Chartwell, Churchill's country residence in Kent. Churchill used dinners at Chartwell to promote his and Britain's interests, and occasionally employed the table dressings to re-enact naval battles.

119
PORTRAIT OF SIR ERNEST CASSEL
(1852–1921), 1900

Philip de László (1869–1937)
Oil on canvas; 84.0 x 71.0 cm
Sir Timothy Cassel

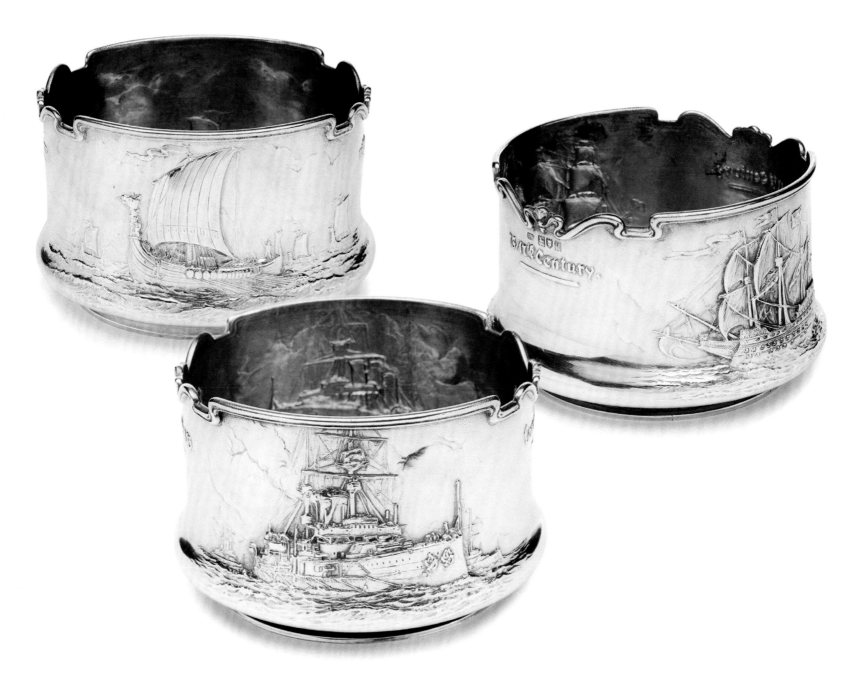

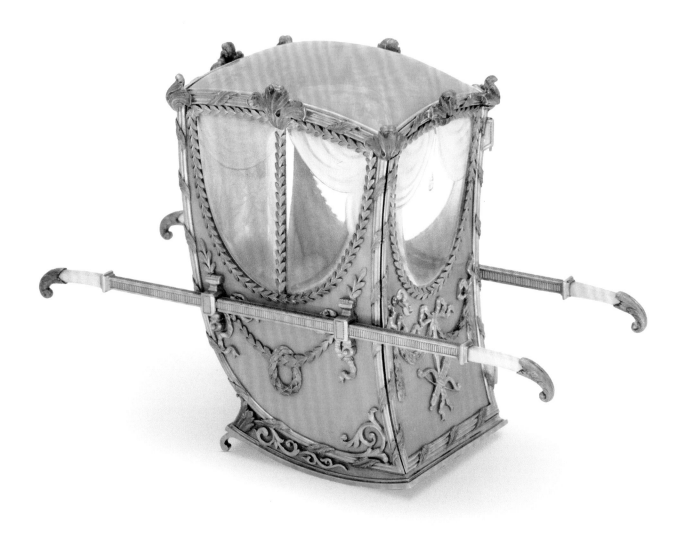

121
SEDAN CHAIR, *c.*1908

Chief workmaster Henrik Wigström (1862–1923), St Petersburg
Gold, enamel, rock crystal, mother-of-pearl; 7.62 x 4.13 cm
Purchased by Leopold de Rothschild, 8 July 1910
Courtesy of A La Vieille Russie, New York

A miniature gold and pink enamelled sedan chair, its rock crystal
windows carved with parted drapes, the interior in mother-of-
pearl. The sedan chair was purchased by Leopold de Rothschild
as a birthday gift for his brother Alfred, who kept it in a showcase
in the sitting room of his London home at 1 Seamore Place, Park
Lane, Mayfair.

122
PORTRAIT OF MRS VIRGINIA FAIR
VANDERBILT (1875–1935), 1905

Giovanni Boldini (1842–1931)
Oil on canvas; 203.8 x 114.9 cm
Gift of Mrs Vanderbilt Adams, Fine Arts
Museums of San Francisco (67.31.1)

123
POLAR BEAR, *c.*1909

St Petersburg
White onyx, rubies; w. 12.7 cm
Purchased by Virginia Fair Vanderbilt, 10 September 1909
Symbolic & Chase

A study of a prowling polar bear, carved from a single block of white onyx and mounted with ruby eyes. The polar bear was purchased by the American socialite Virginia Fair Vanderbilt, wife of William Kissam Vanderbilt II. It was a gift to her friend Berthe, Marquise de Ganay, in memory of happy times spent together at Beaufort Castle, Invernesshire, Scotland, in 1909.

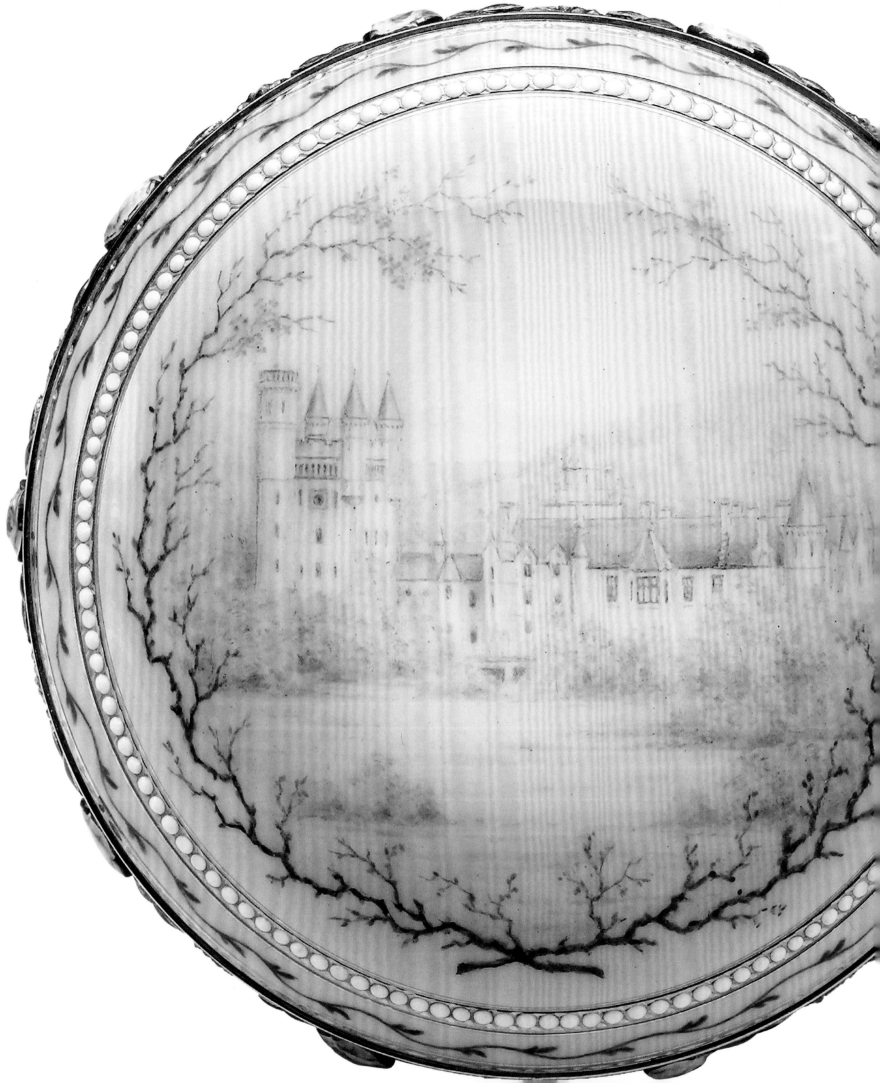

3

THE BRITISH ROYAL FAMILY AND FABERGÉ

Caroline de Guitaut

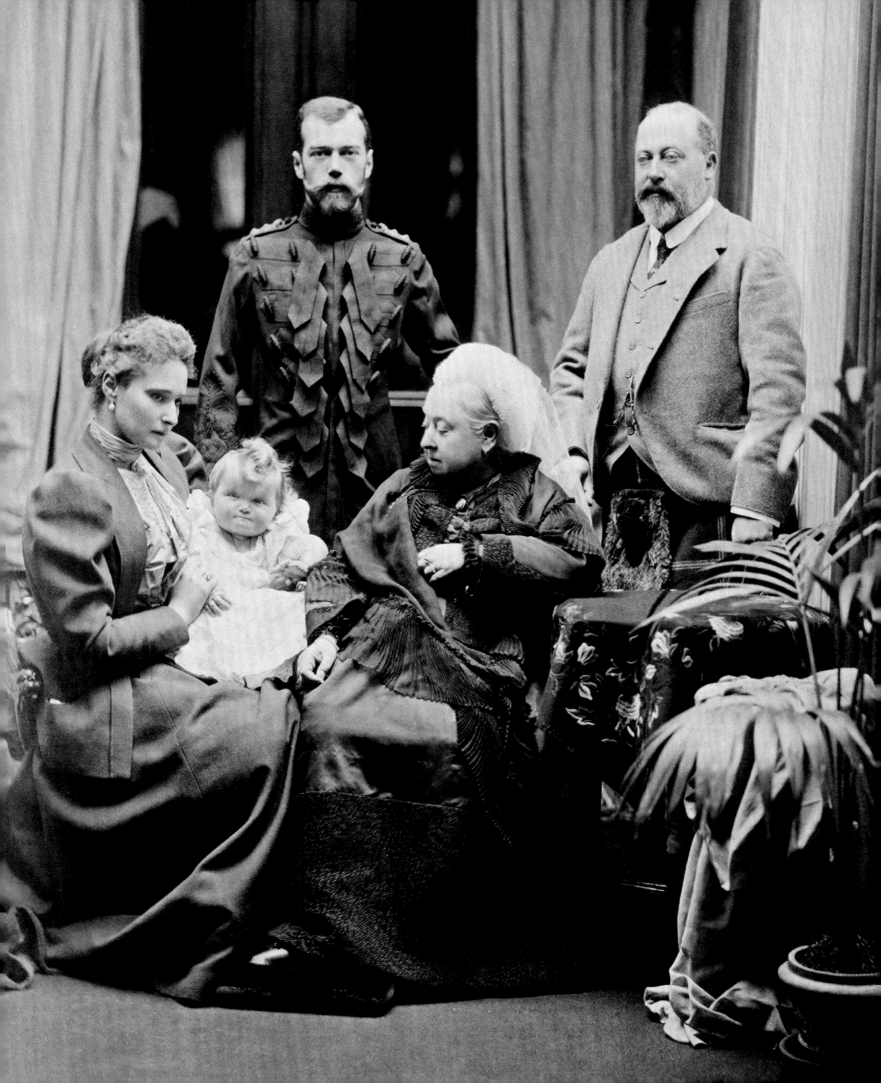

Chapter opener
124
BOX, WITH SCENE OF BALMORAL
CASTLE ON ONE SIDE AND
WINDSOR CASTLE ON THE
OTHER, 1903–7
(detail; see p.170)

THE CLOSE ASSOCIATION OF THE BRITISH ROYAL family with Fabergé's works stretches over almost 140 years from the 1880s to the present day. Formed by successive monarchs and their consorts from Queen Victoria to H.M. Queen Elizabeth II, the resulting collection represents the extraordinary scope of the firm's output from Imperial Easter Eggs, miniature hardstone animals and impressive gem-set presentation snuff boxes to exquisitely jewelled and enamelled flowers. Acquisitions, whether by gift or purchase, have resulted in the formation of a collection that is not only of substantial scale but also one of unique provenance. It represents the only intact collection of Fabergé dating from before the Russian Revolution, one formed largely through royal dynastic patronage and exchange. It is, in essence, like so much of the Royal Collection, a collection of collections, each generation having added pieces that demonstrate a particular taste and interest.

In examining this collection of collections in detail, it is evident that many of the pieces pre-date the establishment of the London outpost of Fabergé, which was first set up at Berners Hotel in 1903.[1] Prior to this date, works by the firm entered British royal ownership due to the close family relationship between the Russian imperial family and Queen Victoria (1819–1901) and her successors. The Queen's second son, Alfred, Duke of Edinburgh (1844–1900), married the only surviving daughter of Emperor Alexander II, Grand Duchess Marie Alexandrovna (1853–1920), in 1874, thereby directly uniting the British and Romanov dynasties for the first and only time. During the course of their marriage, important items of silver – possibly including pieces made by Fabergé – were acquired for their own use and also given as gifts to members of the royal family in England. However, it was three further dynastic marriages that would prove pivotal in the complex interrelationship of European royal houses in the nineteenth century and would also serve to

125
Queen Victoria, the Prince of Wales, Emperor Nicholas II, Empress Alexandra Feodorovna and their daughter Grand Duchess Olga, during their stay at Balmoral, Scotland, 1896. Photograph by Robert Milne The Royal Collection / H.M. Queen Elizabeth II (RCIN 2105927)

elevate Carl Fabergé's work and promote it to an international audience.

On 10 March 1863 Albert Edward, Prince of Wales (later King Edward VII; 1841–1910), married Princess Alexandra of Denmark (1844–1925) while her younger sister, Princess Dagmar (1847–1928), married the future Emperor Alexander III of Russia (1845–1894) three years later in 1866. These two unions created a close family bond between the three royal families of Great Britain, Russia and Denmark and ultimately created a network of prestigious clients for the firm of Fabergé. Empress Maria Feodorovna (the name Princess Dagmar took on entering the Orthodox faith) was the first member of the Romanov dynasty to purchase jewels by the firm. These were from a remarkable collection created as copies of the Scythian Treasure, housed in the Hermitage Museum, which had been presented at the Pan-Russian exhibition in 1882.[2] The Empress and her husband, Alexander III, became the first important imperial clients of the firm, placing commissions and purchasing pieces for themselves. In addition they also acquired a myriad of items bought as gifts, which were sent to their extended family for birthdays and Christmases, and were liberally distributed amongst their English and Danish relations with whom they would spend the annual summer holidays in Denmark. Such gifts were also given on their regular visits to England.

The third marriage, which would unite the families still more closely, was that between Queen Victoria's favourite granddaughter, Princess Alix of Hesse and by Rhine (1872–1918) and the last Emperor of All Russia, Nicholas II (1868–1918). The wedding took place in the cathedral chapel of the Winter Palace in November 1894, less than a month after he had acceded to the throne following the premature death of his father. This union would also result in the acquisition of important gifts by Fabergé, including an enamelled silver-gilt notebook case (pl. 126) that the couple sent to Queen Victoria for Christmas in 1896, which contains the signatures

of the crowned heads of Europe who attended her official Diamond Jubilee celebrations the following year on 22 June 1897. A diamond and sapphire brooch presented to Queen Victoria for the same occasion was specially commissioned by the Emperor and Empress, its design incorporating the figure '60' in Slavonic characters.[3]

From the 1880s onwards the Prince and Princess of Wales, later King Edward VII and Queen Alexandra, began to form what would become an unrivalled collection of works by Fabergé. These pieces were initially gifts from Maria Feodorovna to her sister and included many decorative and practical items, sent from St Petersburg or given in person, including boxes, frames for photographs or miniatures, and carved hardstone animal sculptures. One such gift was a nephrite gem-set box mounted with a diamond fleur-de-lys, which was sent to Alexandra for Christmas in 1897; another was one of the most sumptuous frames in the Royal Collection, containing a portrait miniature of Empress Maria Feodorovna by the Danish miniaturist Johannes Zehngraf (1857–1908), based on a photograph by the Russian Alexander Pasetti (c.1850–1903) (pl. 128), and set in a four-colour gold mount on a ground of rich mauve guilloché enamel. Queen Alexandra developed a renowned passion for Fabergé's flower studies acquiring 22 of the 26 in the Royal Collection and although the exact dates of acquisition are not precisely known in every instance, several were in her possession before the opening of the London branch of the firm.

The rapidly developing interest of both Edward VII and Queen Alexandra in Fabergé's pieces almost certainly contributed to Carl Fabergé's decision to open a retail branch of his business in London. The effusive memoirs of Henry Charles Bainbridge, the manager of the branch from 1907, which were published in his 1933 autobiography *Twice Seven*, help to convey this interest and offer an insight into how the royal family used the shop. Visits were regular and rarely made alone: 'When

I opened that shut door in Dover Street I was confronted not by one Queen, but by two Queens and two Kings and Princess Victoria ... I remember Princess Victoria saying: "Can we open the drawers?" You can imagine what an Aladdin's Cave it was: each drawer... filled with the most beautiful things in the world.'[4] The Queen was certainly a loyal customer but although she purchased pieces for herself, the majority of items were intended to be given away to friends and relations. Her accounts reveal that between 1902 and 1914 purchases listed as presents were four times those charged to her private expenses.[5]

Not only did the British royal family encourage their European relations to become clients but also their well-known admiration for Fabergé encouraged their circle in Edwardian society to purchase pieces from the firm too, often in anticipation of royal birthdays or other notable occasions. Bainbridge prided himself on understanding the preferences of Queen Alexandra when it came to Fabergé's ever-expanding range of seemingly irresistible products and this is borne out by surviving documentation including the Queen's accounts, the notes in Bainbridge's daybooks and the extant pieces in the Royal Collection. In addition, the surviving sales ledgers of the London branch have subsequently enabled the provenance of many pieces to be confirmed by matching those bearing scratched inventory numbers with the name of the customer, date of purchase and price paid. Queen Alexandra's collection was certainly bolstered by many pieces presented to her as gifts, as Bainbridge observed,[6] and in this context it was made clear that the more modestly priced items – costing on average £30 – were felt to be appropriate whereas anything more expensive might cause embarrassment or even offence. As a result, while her collection featured small picture frames and boxes it was dominated by animal sculptures produced in a wide variety of Russian hardstones, which she evidently found both charming and amusing. When she lived at

126
Notebook, before 1896
Workmaster Johan Viktor Aarne
(1863–1934), St Petersburg
Silver-gilt, enamel, moonstones;
1.8 x 16.2 x 12.6 cm
Purchased by Emperor Nicholas II and
Empress Alexandra Feodorovna as a gift
for Queen Victoria, Christmas 1896
The Royal Collection / H.M. Queen
Elizabeth II (RCIN 4819)

Marlborough House as Princess of Wales, these
were grouped on tables placed around her sitting
room, often mingled with other pieces by the
firm. At Sandringham, the animals, again mixed
with other pieces, had pride of place prominently
situated in the drawing room in two large glass-
fronted cabinets, which were amongst the earliest
in the country to be lit electrically and provided an
impressive talking point for guests such as Consuelo
Vanderbilt (1877–1964), who especially noted the
Queen's 'unique collection of bejewelled flowers and
animals'.[7] Queen Alexandra's collection of animals
is remarkable for its diversity, with almost every
kind of domestic or wild animal represented. Frogs
or toads and elephants, however, were particularly
popular. A reference to her Danish heritage and
to the highest order of chivalry in Denmark, the
Order of the Elephant featured not just as an animal
sculpture but as a decorative element on letter-
openers and bell-pushes, often also encompassing
the national colours of red and white.

In spite of the strict price range stipulated for
royal gifts, the Queen received two exceptional
Fabergé flowers for her collection as presents from
Stanislas Poklewski-Koziell, a diplomat at the
Russian Embassy in London. In 1907 he presented
her with a flower study (purchased for £52 5s), the
flowers delicately enamelled in shades of pale pink
and fixed to a green gold stem placed in a carved
rock crystal vase (pl. 129). A year later he added the
comparatively large-scale Chrysanthemum, which
cost the very substantial sum of £117, given either
as a Christmas present that year or as a birthday
present, the Queen's birthday being 1 December. In
1894, as Princess of Wales, she had celebrated her
birthday in Russia accompanied by the Prince of
Wales and their eldest son, George, Duke of York
(later King George V, 1865–1936), as the family
were in St Petersburg to attend the funeral of her
brother-in-law, Emperor Alexander III. The
Prince of Wales and son George visited Fabergé's
headquarters to make their purchases, as had other

Opposite
127
PORTRAIT OF
QUEEN ALEXANDRA
(1844–1925), 1908

François Flameng (1856–1923)
Oil on canvas; 254.0 x 132.1 cm
The Royal Collection / H.M. Queen
Elizabeth II (RCIN 405360)

128
FRAME, WITH PORTRAIT
MINIATURE OF EMPRESS
MARIA FEODOROVNA,
BEFORE 1896

Workmaster Michael Perchin
(1860–1903), St Petersburg;
miniaturist Johannes Zehngraf
(1857–1908)
Gold, enamel, portrait miniature;
9 x 7.8 x 7.3 cm
The Royal Collection / H.M. Queen
Elizabeth II (RCIN 40107)

members of her Russian family. On her birthday, celebrated at the Anitchkov Palace, the Duke of York noted in his diary: 'Motherdear's birthday (50)... saw all the presents, she has got half Fabergé's shop'.[8]

King Edward VII appeared to enjoy Fabergé's work as much as his wife, in particular those objects that were both practical and amusing. A prolific smoker, in 1906 the Queen gave him a table cigar lighter in the form of a frog, which was almost certainly made to appeal directly to his sense of humour, and earlier, in 1895, he had received a cigarette holder from his nephew and niece, the Emperor and Empress of Russia.[9] Smoking accessories were one of the firm's most successful products, snuff boxes giving way to cigarette cases as fashions changed. These ranged from simple birchwood with minimal gold embellishments, to chased multi-coloured gold versions, and finally to sumptuous enamelled examples mounted with precious stones. Edward VII bought such items for himself and also as gifts for family and friends, including a gold-mounted nephrite cigarette case, which he gave to Lord Burton of the Bass brewing dynasty in 1902 and which was sold after his death, later being reacquired for the Royal Collection by H.M. Queen Elizabeth II in 1958. One of the most elegant examples that likewise passed in and out of royal ownership was a gift in 1908 to Edward VII from his mistress, Mrs George Keppel. She purchased the cigarette case from the London branch and gave it to the King as a token of her affection, symbolized by the diamond-set snake representing everlasting love, which is its principal decorative feature (see pp. 162–3).

King Edward VII regularly received gifts from the Russian imperial family for his birthday, for Christmas and for other notable occasions, including the elegant three-colour gold cigarette case (pl. 130) sent by Maria Feodorovna to mark the 40th wedding anniversary of the King and Queen in 1903, and other pieces particularly from

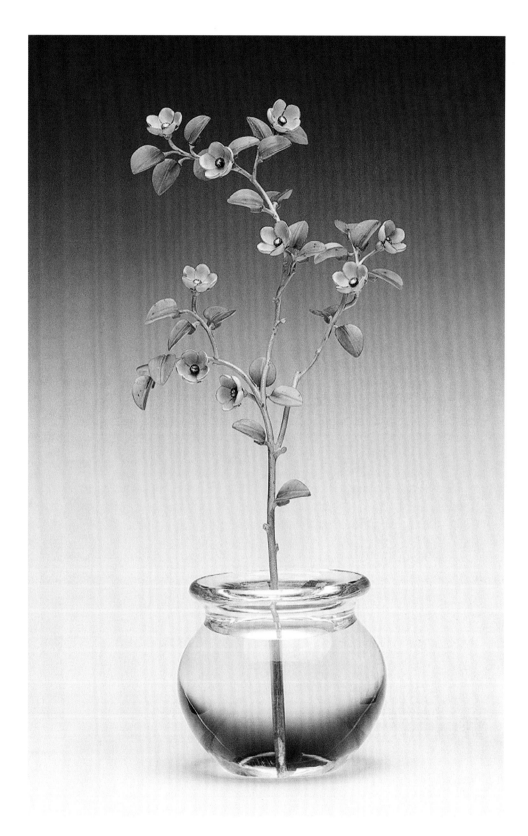

'Nicky' and 'Alix', the affectionate family names for his nephew and niece, the Emperor and Empress of Russia. In addition he would also receive from Nicholas II official gifts, exchanged between the two men as sovereigns; one an autocrat, the other a constitutional monarch. The most notable example marked the King's state visit to Russia in 1908. The meeting took place at Reval (now Tallinn, Estonia) from 5 to 14 June and is recorded in an album compiled by Queen Alexandra containing photographs, menus, newspaper cuttings, postcards, music programmes and autographs (RCIN 2916968). The state visit was in fact also a family reunion. The King accompanied by Queen Alexandra and their daughter, Princess Victoria, resided on the royal yacht *Victoria and Albert*, while the Emperor and Empress accompanied by their children stayed on their imperial yachts, the *Standard* and the *Polar Star*. The meetings, conducted entirely at sea, involved diplomatic discussions, lunches, dinners and family gatherings. In the customary exchange of official gifts, Nicholas II made Edward VII an admiral of the Russian fleet, which the King reciprocated by making his nephew admiral of the British navy. In addition the Emperor sent his uncle a large-scale presentation bowl, carved from a single piece of nephrite and mounted in gold with oyster guilloché enamel and cabochon moonstones. According to the accounts of the Imperial Cabinet, the bowl was paid for on 23 May 1908 but was not delivered until November 1908, five months after the meeting had taken place.[10]

On their return to the United Kingdom, Fabergé pieces recording historic British monuments were in due course produced for the royal family, just as they had been for the Russian aristocracy. They depicted in meticulous detail views of Stratford, Durham and the Houses of Parliament (pl. 92) in finely painted enamel. More specific views of the royal residences were also recorded, including the castles at Windsor and Balmoral (pl. 147) and Sandringham House, the beloved Norfolk residence of Edward VII and

Queen Alexandra that was replicated in multiple formats showing different architectural elements. For instance, the King bought a nephrite frame with a sepia enamelled view of Sandringham House in 1908, his daughter purchased a framed view of Queen Alexandra's Dairy and the Queen a nephrite box with a view of Sandringham Alley (pl. 148), an avenue of elm trees that led from the house to the mews.

Edward VII was keen to shape the contents of the Fabergé collection in other ways, largely by purchasing pieces as gifts for his consort. Knowing of Queen Alexandra's fondness for the charming and highly successful animal sculptures, and inspired by his own love of horses and dogs, he placed a commission with the firm that would make a remarkable impact on both the collection and Fabergé's work for his British clients. In 1907, spurred on by Bainbridge's encouragement and Mrs Keppel's enthusiasm, the King decided to mark the Queen's birthday with portrait models of some of their favourite horses and dogs, kept on the estate at Sandringham. In order to meet the requirements of the commission, a number of Fabergé's sculptors were sent from St Petersburg to record the animals from life, staying on the estate in order to carry out their work. Many of the sculptures are portraits of known animals, including 'Persimmon' (the King's most successful racehorse; pl. 143), 'Caesar' (his favourite terrier; pl. 135), 'Vassilka' (the champion Borzoi owned by Queen Alexandra; pl. 150) and 'Iron Duke' (the King's shooting pony). On seeing the quality of the models assembled in Queen Alexandra's Dairy for his review, King Edward widened the remit of the commission to include studies of animals from the estate farms, such as the Norfolk Black turkey (pl. 133), Bantam cockerel (pl. 132), Dexter bull (pl. 153) and prize breeds of pig (pl. 154). The King's dominance on the turf also led Fabergé, at Bainbridge's suggestion, to produce ranges of desirable yet functional objects to be made in the royal racing colours. A gold-

129
FLOWER, NAMED BY FABERGÉ AS
A 'BRANCH OF ROSES', 1903–8

Chief workmaster Henrik Wigström
(1862–1923), St Petersburg
Nephrite, rock crystal, enamel, gold,
diamonds; 16.8 x 9 x 5.5 cm
Purchased by Stanislas Poklewski-
Koziell 15 October 1907 and given to
Queen Alexandra
The Royal Collection / H.M. Queen
Elizabeth II (RCIN 40504)

Opposite

130
CIGARETTE CASE, WITH INITIALS
OF KING EDWARD VII AND
QUEEN ALEXANDRA, 1896–1903

Moscow
Gold, ruby, diamonds; 1.4 x 9.4 x 6.8 cm
Given by Dowager Empress Maria
Feodorovna to King Edward VII
and Queen Alexandra on their 40th
wedding anniversary, March 1903
The Royal Collection / H.M. Queen
Elizabeth II (RCIN 4344).

131
Prince Edward of Wales (later King
Edward VIII), Emperor Nicholas II,
Tsarevich Alexei and the Prince George
of Wales (later King George V),
Cowes, 4 August 1909
Arthur William Debenham
(1875–1944)
The Royal Collection / H.M. Queen
Elizabeth II (RCIN 2509253)

mounted frame enamelled in the distinctive colours of purple and scarlet was purchased by Queen Alexandra in October 1909 for Edward VII's 68th birthday a few weeks later on 9 November. Since its acquisition it has contained a photograph of 'Persimmon', taken c.1900 at the Sandringham Stud by Queen Alexandra, an accomplished amateur photographer. In addition to the frame, she also purchased a gold-mounted clock, again enamelled in the King's racing colours but this is no longer in the Royal Collection. Other pieces similarly enamelled included a pair of cufflinks, a cigar holder and a cigarette case, the last two examples having re-entered the collection in recent years. Fabergé replicated this successful formula for the King's

great friend and rival in the racing world, Leopold de Rothschild, for whom the firm created boxes, frames and other items in his colours (pl. 97). Rothschild, together with Sir Ernest Cassel, Lord Revelstoke, the Duke of Norfolk and the Marquis de Soveral, comprised some of the firm's most important clients, all of whom were close friends of the King.

Edward VII, like Queen Alexandra and their children, would visit the London shop to view new Fabergé pieces. The last purchase he made before his death was in November 1909, when he bought one of only two figures representing non-Russian characters: a composite hardstone sculpture of a Chelsea pensioner. The figure is not identified

132
COCKEREL, 1908
Chief workmaster Henrik Wigström (1862–1923), St Petersburg
Obsidian, purpurine, jasper, diamonds, gold; 9.9 x 7.8 x 4.7 cm
Purchased by Queen Alexandra, 29 October 1909
The Royal Collection / H.M. Queen Elizabeth II (RCIN 40454)

133
NORFOLK BLACK TURKEY, 1908–9
Chief workmaster Henrik Wigström (1862–1923), St Petersburg
Obsidian, lapis lazuli, purpurine, gold, diamonds; 9.7 x 8.5 x 7.3 cm
Purchased by the Prince of Wales (later King George V), 15 October 1909
The Royal Collection / H.M. Queen Elizabeth II (RCIN 40446)

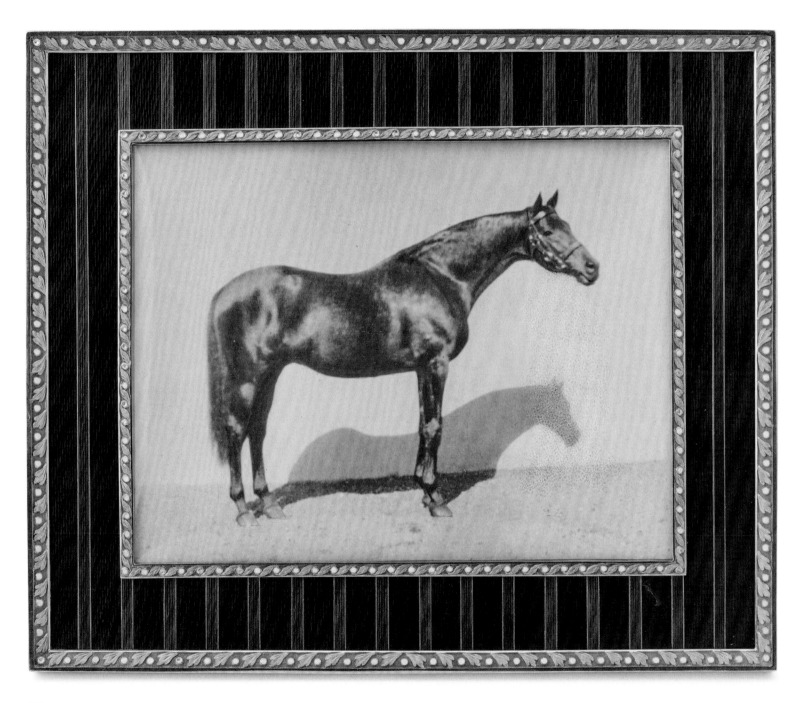

134
FRAME, IN THE RACING COLOURS OF
EDWARD VII, WITH PHOTOGRAPH OF
'PERSIMMON', c.1909

Chief workmaster Henrik Wigström
(1862–1923), St Petersburg
Gold, enamel, silver-gilt, moonstones;
15.8 x 10.1 cm
Purchased by Queen Alexandra from
Fabergé's London branch, 29 October 1909
The Royal Collection / H.M. Queen
Elizabeth II (RCIN 15168)

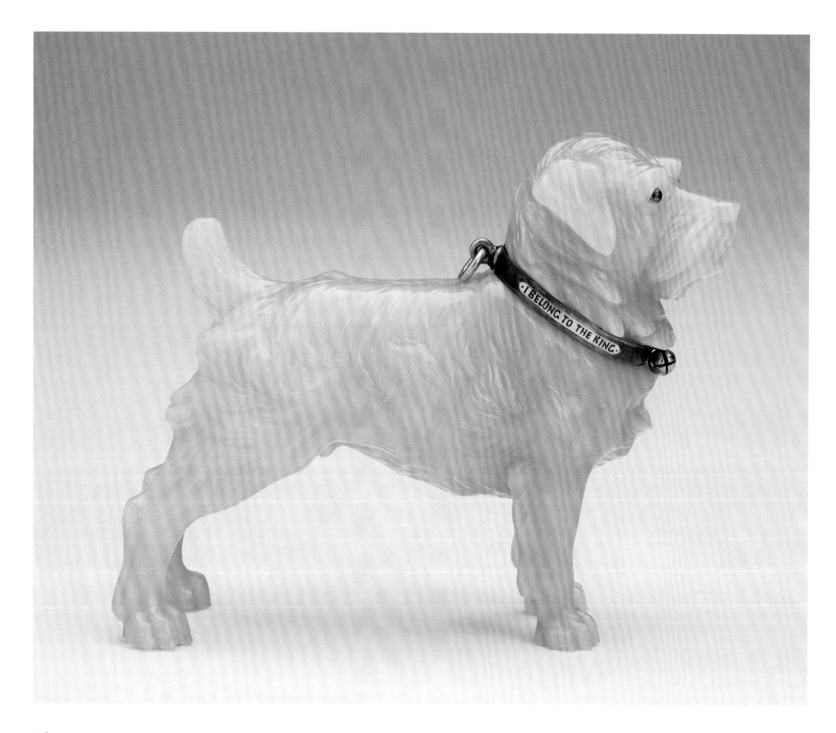

135
'CAESAR', 1910

St Petersburg
Chalcedony, gold, enamel, rubies;
5.1 x 6.5 x 2.2 cm
Purchased by the brewery heiress
the Hon. Mrs Greville, 29 November 1910
Royal Collection Trust / H.M. Queen
Elizabeth II (RCIN 40339)

The most poignant acquisition made during
the Sandringham Commission was a model of
King Edward VII's Norfolk terrier 'Caesar'.
The King and 'Caesar' were inseparable.
Following Edward VII's death in May 1910,
'Caesar' roamed the corridors of Buckingham
Palace looking for his master. The postcard,
right, was issued with the caption: 'The late
King Edward VII, with his favourite dog
Caesar.' A sentimental book published in June
1910, entitled *Where's Master?* and supposedly
written by 'Caesar', sold over 100,000 copies.
His close bond with the King is acknowledged
on Edward VII's tomb in St George's Chapel,
Windsor, where he is represented eternally
curled up at the King's feet. The model was
purhased by the Hon. Mrs Greville for £35,
as a birthday gift for the King's widow, Queen
Alexandra.

with a known person but it perfectly replicates the instantly recognisable scarlet tunic and black cap worn by residents of the Royal Hospital, in London's Chelsea, which was established by King Charles II in 1682 to house meritorious veteran soldiers. The King would die the following year but his widowed Queen outlived him by a further 15 years, continuing to reside in the United Kingdom, at Sandringham and at Marlborough House in London, and in Denmark, where she shared a residence with her sister, the Dowager Empress Maria Feodorovna, outside Copenhagen.

The lasting influence of collecting and enjoying Fabergé on the part of Edward VII and Queen Alexandra was keenly embraced by the next generation, particularly by their son, Prince George, Duke of York, and by their second daughter Princess Victoria. Princess Victoria (1868–1935) developed a keen interest in the work of Fabergé and was a customer of the London branch, purchasing jewellery, animals, flowers, cigarette cases and frames. She inherited important pieces from her mother but as she did not marry her collection was ultimately bequeathed to her brother. As Duke of York, Prince of Wales and later King, George V would become an important patron of the firm, often making purchases from the London branch that ranged from cigarette cases to animal sculptures, including portraits of his own dogs as part of the Sandringham Commission.

Pieces were sent on approval for George V to see at Marlborough House but, like his parents, the King enjoyed visiting the shop and was often accompanied by his consort, Queen Mary. She was to become highly knowledgeable about Fabergé's work, as Bainbridge noted, describing her in 1949 as 'the greatest surviving connoisseur of Fabergé's craftsmanship'.[11]

The reign of George V and Queen Mary began with the presentation of a magnificent Fabergé gift: on the day of their coronation, 22 June 1911, a rock crystal vase, mounted in gold and gem-set

in a neo-Renaissance style, was given to them by Leopold de Rothschild to mark the occasion. The vase was selected from stock held at the London branch but had to be prepared in some haste. As a result, the engraving of the royal arms and presentation inscription was carried out by a specialist engraver in London, rather than being despatched to Russia and back again. The close relationship with the Russian imperial family meant that there was a continuous stream of gifts, as in the previous generation, particularly between the King and his first cousin, Nicholas II (the pair bore a remarkable family resemblance), and their consorts. These gifts were not intended merely for visual enjoyment, but were regularly used including photograph frames, cigarette cases and a desk seal that accompanied the King wherever he resided, to be positioned on his desk.[12] Commissions were also placed, notably for a cameo portrait of their son, the future Edward VIII (pl. 136), at the time of his investiture as Prince of Wales in 1911. Carved from smoky quartz and mounted on a chased gold stand, it was paid for by the King and presented to Queen Mary for her birthday in May 1912. The Queen received gifts from other members of her family, and also from friends, in addition to making her own purchases, and these acquisitions spanned both pre- and post-revolutionary Russia. Their most notable acquisitions as a couple were the three Imperial Easter Eggs purchased through London dealers in the 1930s, which were a poignant reminder of the lost imperial family in Russia as well as significantly augmenting the calibre of the Royal Collection. Both the King and the Queen became loyal customers of London dealers Wartski, through whom they acquired many pieces including – unwittingly – an elephant automaton (pl. 194), which was originally the surprise from yet another Imperial Easter Egg, the 1892 Diamond Trellis Egg from which it had been separated in the 1920s.[13]

Queen Mary placed great emphasis on documenting the collection. She annotated by hand

Opposite left
136
PORTRAIT CAMEO OF
EDWARD, PRINCE OF WALES
(LATER KING EDWARD VIII)
ON AN EASEL, 1911–12

Chief workmaster Henrik Wigström
(1862–1923), St Petersburg
Smoky quartz, diamonds, gold, silver;
10.2 x 4.5 x 6 cm
Purchased by King George V,
27 April 1912, as a gift for
Queen Mary's birthday
The Royal Collection / H.M. Queen
Elizabeth II (RCIN 23314)

Opposite right
137
Design for the portrait cameo, dated
6 April 1912, from the design album of
Henrik Wigström.

a series of volumes, noting provenance and other observations as her knowledge of the collection grew. In addition to her interest in London auction house sales, she began to lend pieces to early exhibitions of Russian art in the capital including *The Exhibition of Russian Art*, held in the summer of 1935 in Belgrave Square in aid of the Russian Red Cross. After Queen Mary's death in 1953, an exhibition devoted to her art treasures from Marlborough House was staged at the Victoria and Albert Museum, including several important pieces of Fabergé, most notably the Mosaic Imperial Easter Egg (pl. 205).

The succeeding generations of the royal family continued to make additions to the collection. Mirroring the accession and coronation of

George V and Queen Mary, gifts were received by King George VI (1895–1952) and Queen Elizabeth (1900–2002) at the time of their coronation in 1937, including a large maple wood frame purchased through Wartski and presented by the Maharajah of Nawangar. The King added several elegant cigarette cases, which were regularly used, as well as clocks and an *objet de fantaisie* – a miniature bonbonnière in the form of a Louis XV-style desk (pl. 138). Queen Elizabeth's tastes ranged widely from enamelled pieces in the Russian tradition made in the workshop of Feodor Rückert to a magnificent example of an imperial presentation snuff box, the lid mounted with a portrait miniature of Emperor Nicholas II. In the 1940s the Queen added two remarkable flower studies, one of Buttercups and Cornflowers embellished with a jewelled bee and the other of Cornflowers and Oats. The latter piece features a gold stem of oats, its gold husks mounted *en tremblant* so that the slightest vibration makes them sway as if brushed by a gentle breeze. Surprisingly, this highly fragile object was placed in Queen Elizabeth's shelter room at Buckingham Palace during the Blitz in the Second World War. In a letter to her mother-in-law Queen Mary, with whom it was jointly purchased, Queen Elizabeth described it as 'a charming thing and so beautifully unwarlike'.[14]

Throughout her long life, Queen Elizabeth lent items from her Fabergé collection generously and often, something which her daughter, H.M. Queen Elizabeth II, has continued to do throughout the 69 years of her own reign, which began in 1952. As Princess Elizabeth, one of the first pieces to enter her possession was a fan, which had belonged to her great-grandmother Queen Alexandra. Other pieces were received jointly by Princess Elizabeth and the Duke of Edinburgh as wedding gifts in 1947 and from the 1950s onwards the Queen has made occasional purchases from the firm of Wartski and Fabergé gifts have been presented to her. However, the hallmark of the Queen's engagement with the collection has been a desire to share it with the widest possible audience, both in the United Kingdom and internationally via major exhibitions. Two important exhibitions held at the Victoria and Albert Museum received very generous loans from the collection. The first, *Great Britain USSR*, was staged at the height of the Cold War in 1967; ten years later, in 1977, the second exhibition marked the Queen's Silver Jubilee. This time entirely devoted to Fabergé, it was the first survey of the goldsmith and jeweller ever mounted and the Queen lent 286 pieces from the Royal Collection. Even larger exhibitions followed, drawn solely from the Royal Collection and mounted at the Queen's Galleries in 1985, 1995 and in 2003, in both Edinburgh and London, with a further exhibition at Buckingham Palace in 2011. Almost 150 years after the first pieces entered royal ownership, the collection is enjoyed, occasionally added to and publicly available at the click of a button via the Royal Collection's online catalogue. Moreover, the next generation of the royal family, notably H.R.H. The Prince of Wales, continues to maintain the interest in, and admiration for, Fabergé's work that so fascinated his forebears.

138
MINIATURE DESK, IN THE LOUIS XV STYLE, 1903–8
Chief workmaster Henrik Wigström (1862–1923), St Petersburg
Gold, enamel, mother-of-pearl interior; 11 x 8.7 x 6.5 cm
Purchased by Leopold de Rothschild, 12 July 1909, and given to his brother Alfred
The Royal Collection / H.M. Queen Elizabeth II (RCIN 100013)

KEPPEL CASE

ALICE KEPPEL, THE VIVACIOUS EDWARDIAN SOCIETY hostess and mistress of King Edward VII, was a regular visitor to Fabergé in London. Born in 1868, the eighth daughter of Sir William Edmonstone, she grew up at the family seat, Duntreath Castle in Stirlingshire. In 1891 she married the Hon. George Keppel, the third son of the 7th Earl of Albermarle. Eight years into her marriage, she met Albert Edward, Prince of Wales, later King Edward VII. Her charming personality and captivating beauty bewitched the Prince and they were soon lovers. Mrs Keppel became his favourite companion and remained *maîtresse en titre* for the rest of his life. Her kindliness, discretion and ability to manage the King's tempers were welcomed by courtiers and politicians alike. Osbert Sitwell recollected, in his 1947 autobiography *Great Morning*, that she had a 'power of enchantment' and 'Her conversation was lit by humour, insight and the utmost good nature.'

Mrs Keppel's love for the King is expressed in her gift to him of this lavish and heavy gold cigarette case. It is made from red gold fired with layers of translucent royal blue enamel over an engraved moiré ground, giving it the appearance of shimmering silk. The case has concealed hinges and opens by pressing the marquise-shaped diamond push piece to the front. It is strikingly entwined by a diamond snake holding its tail in its mouth. The snake is set with rose-cut diamonds of different sizes, which produce variations in scintillation along its undulating body. Fine wisps of metal hold the

stones in place and their setting is a tour de force of the gem-setter's art. The snake motif, known as an Ouroboros, originates from antiquity and is emblematic of eternity. In the lore of gemstones the durability of diamonds communicates constancy. This diamond snake therefore doubly symbolizes never-ending devotion, turning the case into an explicit declaration of love from Mrs Keppel to the King.

Following the death of King Edward VII in May 1910, a distraught Mrs Keppel discreetly left the country for two years and Queen Alexandra returned the case to her. The Queen's action could be interpreted as a snub; but it was not intended that way. The Queen returned several Fabergé gifts given to the King by his close friends. She had tolerated Mrs Keppel's dalliance with her husband and her intention was for the case to be an enduring keepsake of their relationship. In May 1936, three months after the death of King George V, Mrs Keppel returned the case to royal hands by sending it to Queen Mary to be added to the Royal Collection of Fabergé. Queen Mary in her letter of thanks to Mrs Keppel commented on the poignancy of the case containing a stub of one of King Edward's cigars, which it still does to this day.

140
Letter to Mrs Keppel from Queen Mary, dated 9 May 1936.

Opposite
141
CIGARETTE CASE, *c.*1905

Moscow
Gold, enamel, diamonds;
1.7 x 9.6 x 7 cm
Presented by Alice Keppel to King Edward VII, 1908
The Royal Collection / H.M. Queen Elizabeth II (RCIN 40113)

139
PORTRAIT OF ALICE KEPPEL (1868–1947), *c.*1900–10 (detail)

Frederick John Jenkins (1872–1929)
Heliogravure; 27.9 x 20.3 cm
National Portrait Gallery, London (D8115)

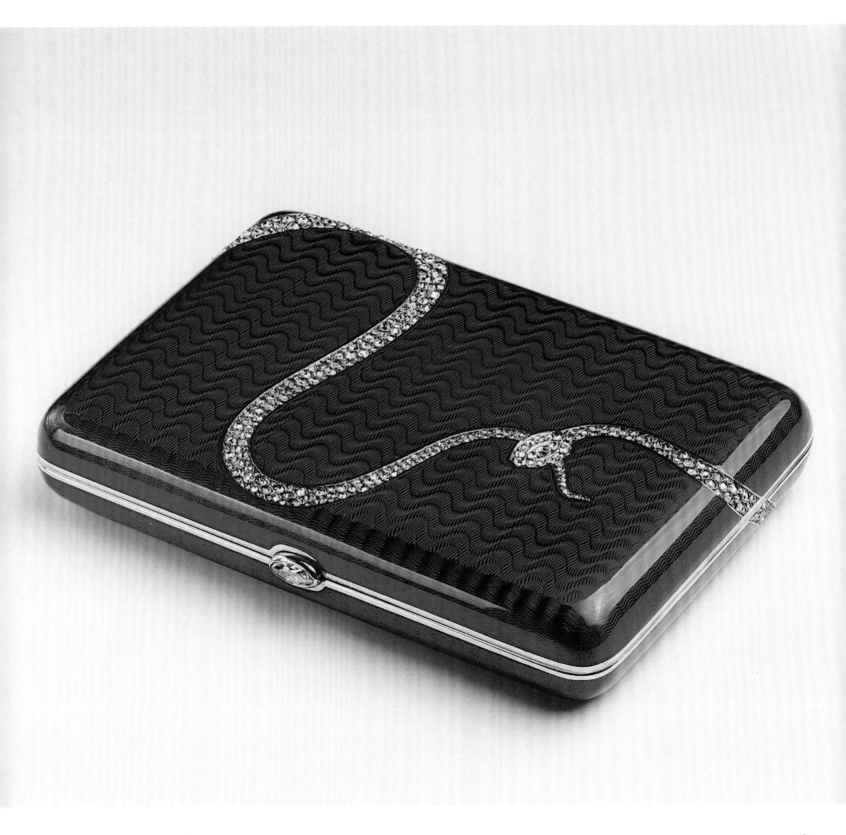

THE SPORT
OF KINGS

THE BREEDING AND RACING OF HORSES WAS AN obsession for many of Fabergé's British customers. In the late nineteenth century, horseracing evolved from a disreputable activity, tarnished by criminality, into a favoured pastime for the British upper classes. The reinvention of the sport was in large part due to Edward VII's life-long involvement with it. As both Prince of Wales and later King, he was a keen devotee of the turf. It was one of the few arenas in which he could compete on equal terms with members of his social circle. His successes led Lord Northcliffe to irreverently observe that he was 'the greatest Monarch we've ever had – on the racecourse'.[1]

In 1896 'Persimmon', the Prince's prized racehorse, won the most prestigious of all races – the Epsom Derby. 'Persimmon' was pitched against 'St Frusquin', which belonged to Leopold de Rothschild with whom the Prince had a close friendship. In spite of, and perhaps partly because of, their friendship Rothschild and the Prince were fierce horseracing rivals. 'St Frusquin' was one of the fastest racehorses of his generation and the favourite to win. The race began as expected and Rothschild's horse quickly took, and held, the lead. 'Persimmon' trailed behind until the last furlong when, willed forward by the crowd, he rallied dramatically and finished the home straight a neck in front. The stands erupted at the royal victory; the noise was

deafening: 'I never saw such a sight & I never heard such cheering', was how the Duke of York (later King George V) described the commotion.

'Persimmon' eventually retired to a special stable building on the stud farm at Sandringham. Edward VII's Sunday afternoon tours of the estate would conclude at the stud, where 'Persimmon's' pedigree and victories were recounted to his guests. The King's fondness for 'Persimmon' led to Fabergé modelling him as part of the Sandringham Commission of 1907. A wax maquette, sculpted by the Russian artist Boris Frödman-Cluzel, was sent to St Petersburg, where it was cast in silver and mounted on a nephrite base to represent grass. The finished study was sold to the King in London on 29 October 1908 for £135. His Majesty was so taken with it that two months later, on 21 December 1908, he acquired six further bronze copies.

Leopold de Rothschild was also a customer of Fabergé and the firm's celebration of the 1896 Derby extended to producing a portrait of the runner-up. Unlike the King, who was keen to celebrate his success, Rothschild initially showed little enthusiasm for having his horse modelled. When Henry Bainbridge suggested he be 'immortalised', Rothschild replied drily, 'Such a luxury is all very well for the King of England, I can't afford it'.[2] Undeterred, in 1912 Bainbridge suggested the idea again, this time to Marie, Rothschild's wife, who agreed to it. 'St Frusquin' proved a difficult subject; he was temperamental and the slightest clanking of a stable mate's chain would set him off. He was only steadied by bringing his favourite companion, the stable kitten, to the modelling sessions. The resulting silver model was bought by Mrs Leopold de Rothschild on 14 December 1912 and given by her to her husband. His reluctance to have the study made was clearly forgotten when, the following December, he too acquired bronze copies of it.

142
PERSIMMON WINNING THE DERBY AT
EPSOM, 1896

Major Godfrey Douglas Giles
(1857–1923)
Oil on canvas; 106.8 x 152.6 cm
The Royal Collection / H.M. Queen
Elizabeth II (RCIN 404338)

143
STATUETTE OF KING EDWARD VII'S
RACEHORSE 'PERSIMMON', 1908

Chief workmaster Henrik Wigström
(1862–1923), St Petersburg
Silver, nephrite; 4.3 x 31.2 x 9.6 cm
Purchased by King Edward VII,
29 October 1908
The Royal Collection / H.M. Queen
Elizabeth II (RCIN 32392)

Opposite
144
STATUETTE OF LEOPOLD DE
ROTHSCHILD'S RACEHORSE 'ST
FRUSQUIN', 1912 (detail)

Attributed to chief workmaster Henrik
Wigström (1862–1923), St Petersburg
Silver. h. 25.4 cm
Purchased by Mrs Leopold de Rothschild,
14 December 1912
Private Collection

SELECTED WORKS

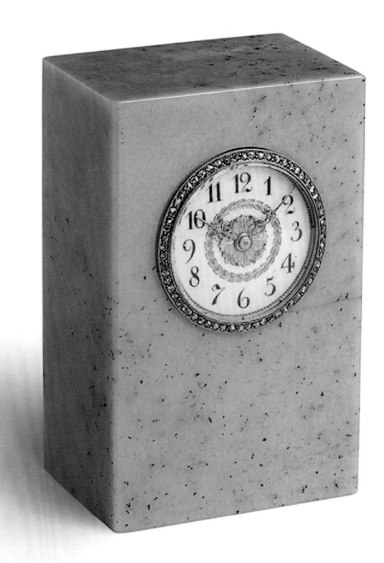

145
CLOCK, 1914

Chief workmaster Henrik Wigström (1862–1923), St Petersburg
Chrysoprasem, platinum, silver-gilt, diamonds; 6.8 x 4.3 x 3.1 cm
Purchased by Grand Duke Michael Mikhailovich, 5 June 1914,
as a gift for Queen Mary; then given by Queen Mary to her
granddaughter Princess Margaret, Countess of Snowdon
Wartski, London

In 1891 Grand Duke Michael Mikhailovich, the grandson of
Emperor Nicholas I, married Sophie von Merenberg, Countess
de Torby, granddaughter of the Russian poet Pushkin. Regarded
as a morganatic marriage, this caused a scandal and the Grand
Duke was banished from Russia. The couple settled in England,
where they enjoyed a prestigious standing in high society.
They became prominent customers of the London branch of
Fabergé. The names of the Grand Duke and his wife appear in
Bainbridge's ledgers with notable frequency and they amassed a
sizeable collection. They were so closely associated with the firm,
that Sonia Keppel thought as a child that the Grand Duke made
Fabergé's pieces.

146
Page from the Wigström design album,
dated 1913–14. The clock is shown next to
its design.

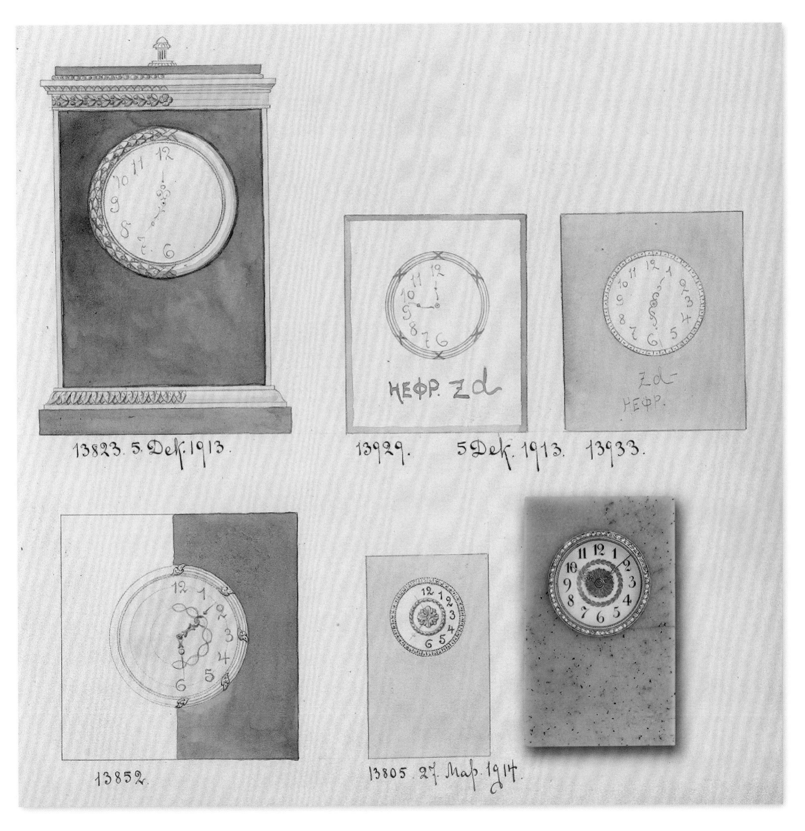

13823. 5. Dek. 1913.

13929. 5 Dek. 1913. 13933.

НЕФР. Zd

Zd
НЕФР.

13852.

13805. 27. Mar. 1914.

147
BOX, WITH SCENE OF BALMORAL CASTLE ON ONE SIDE
AND WINDSOR CASTLE ON THE OTHER, 1903–7

Chief workmaster Henrik Wigström (1862–1923), St Petersburg
Gold, sepia enamel, diamonds; 2.5 x 5.7 cm
Purchased by Sir Ernest Cassel, 4 November 1907
The Royal Collection / H.M. Queen Elizabeth II (RCIN 40490)

This circular box, which takes its inspiration from French 18th-century snuffboxes, was the first of the pieces enamelled with British scenes to be sold by Fabergé in London. Fabergé produced a range of such boxes, as well as frames, with enamelled scenes of well-known sites, first of Russia and later of Britain. The latter formed part of Fabergé's range tailored to excite and delight his British patrons. Bainbridge ensured that Fabergé's enamellers in St Petersburg were supplied with topographical photographs and a number of the views seen in Fabergé works are identical to those found on postcards produced by firms such as Valentine & Sons and Francis Frith & Company.

148
BOX, WITH SCENE OF 'SANDRINGHAM ALLEY', 1908

Chief workmaster Henrik Wigström (1862–1923), St Petersburg
Nephrite, gold, pearls, painted enamel; 2.4 x 6.7 cm
Purchased by Queen Alexandra, 3 November 1908
The Royal Collection / H.M. Queen Elizabeth II (RCIN 40496)

The scene depicting the avenue of elm trees at Sandringham, known as 'Sandringham Alley', which decorates this circular nephrite box, is painted over an engine-turned ground causing waves of light to play across the surface of the enamel when moved. The enamel was painted on a separate gold plaque and fired before being mounted onto the nephrite box.

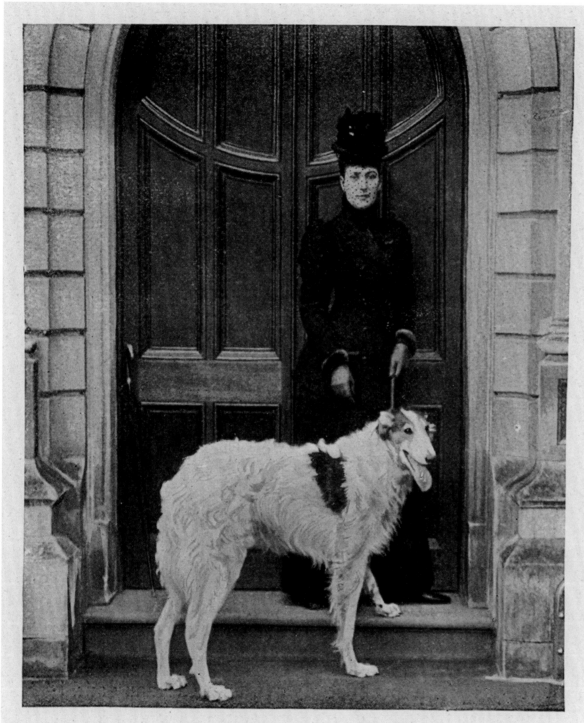

QUEEN ALEXANDRA AT SANDRINGHAM

(From a photo by T. Fall)

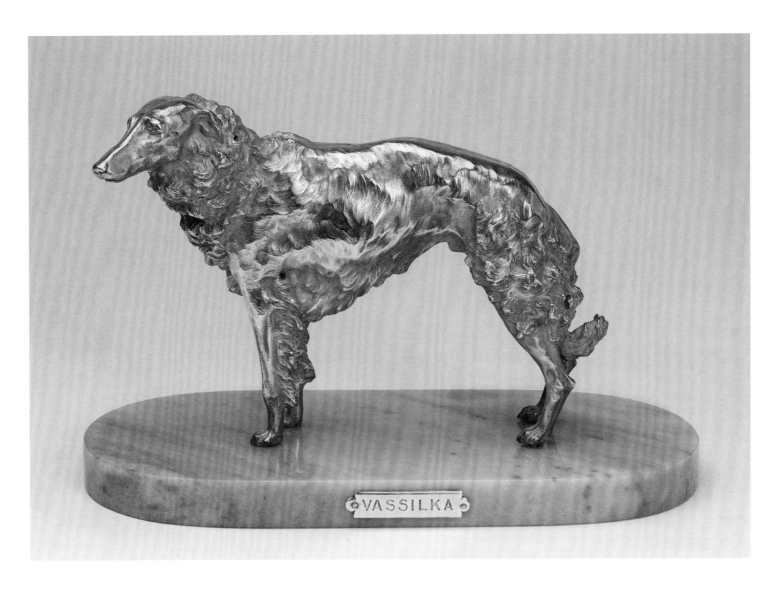

149
Queen Alexandra at Sandringham
with her Borzoi, 1896

150
'VASSILKA', 1908

St Petersburg
Silver, aventurine quartz; 13.4 x 21.1 x 9 cm
Purchased by Earl Howe, Queen Alexandra's Lord Chamberlain, 5 November 1909
The Royal Collection / H.M. Queen Elizabeth II (RCIN 40800)

'Vassilka' was a champion Borzoi owned by Queen Alexandra. This study of 'Vasilka' forms part of the Sandringham Commission. Rather than being carved in stone, as was the case for all but two of the animals modelled for the Commission, 'Vassilka' was cast in silver. If carved in stone, its slender legs would have been unable to support the weight of its body. Queen Alexandra became well known for her Borzois which she bred and showed.

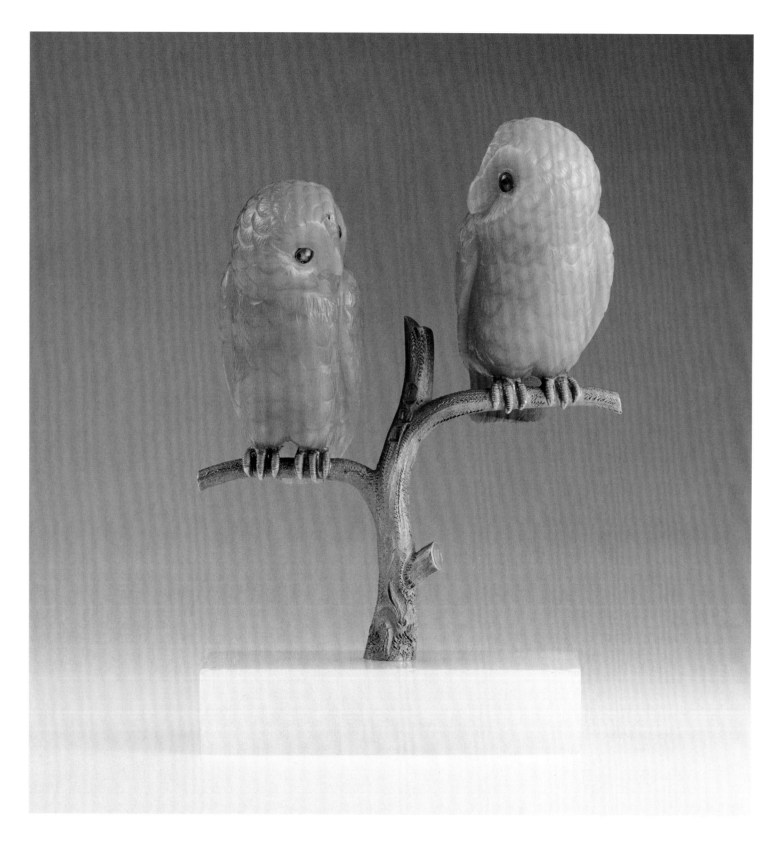

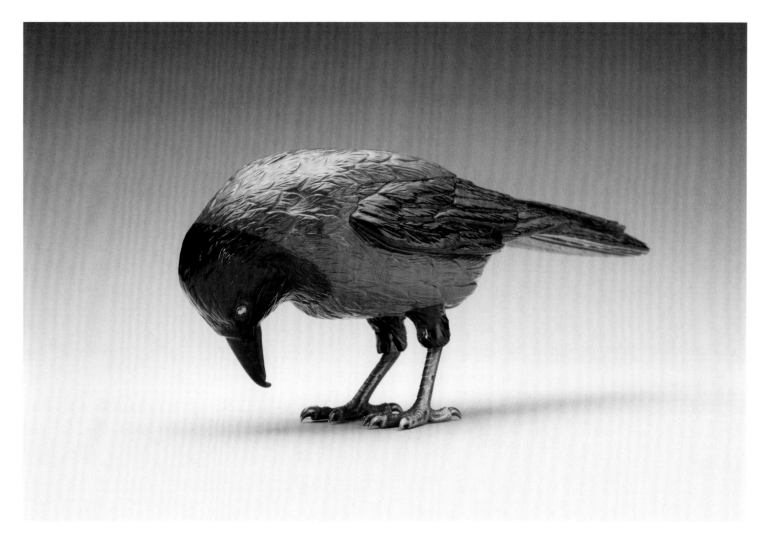

151
TWO OWLS PERCHED ON A BRANCH, 1903–8

Chief workmaster Henrik Wigström (1862–1923), St Petersburg
Agate, gold, white onyx, rubies; 5.7 x 4 x 2.2 cm
Purchased by Queen Alexandra, 3 November 1908
Wartski, London

Queen Alexandra acquired this whimsical portrayal of a pair of owls at the height of her patronage of Fabergé's London branch. Compared to the contemporary fashion for extravagance, the Queen's taste in Fabergé was restrained. She preferred the lapidary works – the animal and flower studies – to the more elaborate and jewelled confections.

152
CROW, c.1910

Chief workmaster Henrik Wigström (1862–1923), St Petersburg
Kalgan jasper, obsidian, aquamarine, silver-gilt; 7.8 x 15.7 x 5.7 cm
Purchased by Queen Alexandra, 25 November 1914
The Royal Collection / H.M. Queen Elizabeth II (RCIN 13756)

Easily double, if not triple, the size of Fabergé's smaller lapidary animals, this hardstone carving of a crow is one of Fabergé's largest animal studies. Surprisingly, it is one of only two pieces bought by Queen Mary directly from Fabergé in London. Following the First World War and the demise of the House of Fabergé in London, however, Queen Mary became a devoted collector and was instrumental in building the Royal Collection of Fabergé.

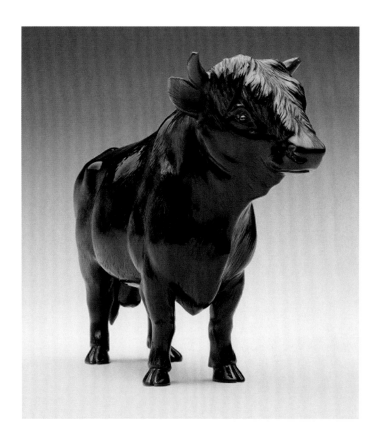

153
DEXTER BULL, 1908

St Petersburg
Obsidian, rubies; 8 x 11 x 4 cm
Purchased by Queen Alexandra, 3 November 1908
The Royal Collection / H.M. Queen Elizabeth II (RCIN 40428)

The Prince of Wales, later Edward VII, established a herd of
Dexter cattle at Sandringham in 1887 under the direction of
Irish cattle breeder James Robertson. A rare breed originating in
Kerry, southwest Ireland, Dexters are small cattle and ideal for
grazing parkland; they produce a rich milk and were included in
the dairy herd that supplied the royal household. This model of
a bull is made from a dark specimen of obsidian, a volcanic glass,
sourced from the northern Caucasus, which when polished has a
velvety sheen that was perfectly suited to capturing the glistening
and generally black-coloured coat of the breed. According to the
London sales ledgers, this Dexter bull was the only portrait of
cattle to be sold by Fabergé in London.

154
RECUMBENT SOW, c.1912

St Petersburg
Aventurine quartz, diamonds; 7.2 x 14.7 x 7.5 cm
Purchased by Princess Victoria, sister of King George V, 2 November 1912
The Royal Collection / H.M. Queen Elizabeth II (RCIN 40041)

This perfectly observed model of a sow has been credited by
Bainbridge as part of the Sandringham Commission, but this
seems unlikely. Although the exact number of works linked to
the Commission remains unknown, it was probably carried
out between 1907 and 1909. In the sales ledgers covering this
period a group of animals and scenes are recorded within a run
of inventory numbers starting at 17249 and ending at 19450.
Not only was the sow bought several years later, it also bares the
inventory number 22450, removing it further from the group.

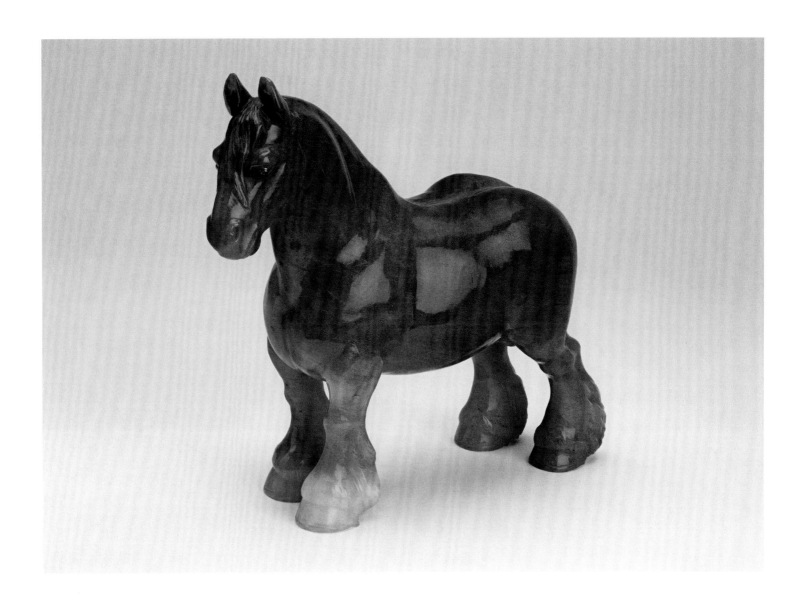

155
'HOE FOREST KING', 1908

St Petersburg
Quartz, sapphires; 14.5 x 17 x 5.7 cm
Purchased by Queen Alexandra, 27 May 1909
The Royal Collection / H.M. Queen Elizabeth II (RCIN 40412)

A carving of King Edward VII's prize-winning Shire horse,
'Hoe Forest King'. Shire horses were bred at Sandringham and
'Hoe Forest King' was modelled as part of the Sandringham
Commission. The public sales of Shire horses from the stables
were a popular event in the heavy-horse breeder's calendar.

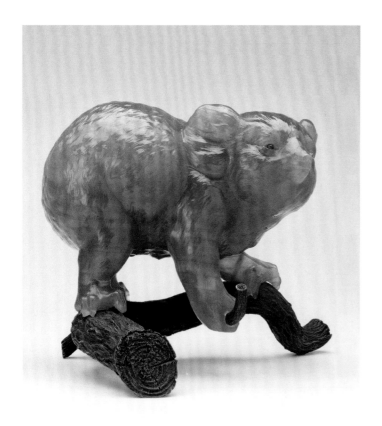

156
KOALA ON BRANCH, 1903–13

Chief workmaster Henrik Wigström (1862–1923), St Petersburg
Agate, silver, demantoid garnets; 6.6 x 8.2 x 7.3 cm
Purchased by King George V, 13 November 1913
The Royal Collection / H.M. Queen Elizabeth II (RCIN 40407)

157
WATER BUFFALO, c.1913

St Petersburg
Grey chalcedony, ivory, ruby; 5.9 x 8.4 x 3.3 cm
Purchased by King George V, 13 November 1913
The Royal Collection / H.M. Queen Elizabeth II (RCIN 40388)

As Duke of York, Prince of Wales and later King, George V continued the royal patronage of Fabergé's London branch. Like his mother Queen Alexandra, he was especially fond of the carved animal studies. The koala is one of a number of animals that reflected his travels. As Duke of York, he had visited Australia and New Zealand in 1901. Upon his return to Britain, he was made Prince of Wales. In 1913, as King George V, he purchased from Fabergé a small group of exotic animal studies, all associated with the Commonwealth. Native to Australia, the koala forms part of this group.

King George V visited India in 1911, the only British monarch to do so as Emperor of India. The buffalo is described as an 'Indian cow' in Fabergé's sales ledgers and was purchased by the King at the same time as the koala. The buffalo is described by the Royal Collection as one of Fabergé's most successful animal studies, primarily due to the exceptional translucency of the stone that was selected.

158
KANGAROO AND JOEY, *c.*1913

St Petersburg
Nephrite, diamonds; 8.8 x 3.1 x 9.7 cm
Purchased by King George V, 13 November 1913
The Royal Collection / H.M. Queen Elizabeth II (RCIN 40269)

Although Fabergé often sourced hardstones that would reflect
the characteristics of the animal portrayed, here the kangaroo
and its joey have been carved from a single piece of spinach-green
nephrite. The anatomy, however, remains faithful. This model
was the third of four Commonwealth animal studies bought by
King George V on his visit to Fabergé's London shop in 1913.
The final piece purchased in this group was that of a camel.

159
CHERRY, c.1907

St Petersburg
Rock crystal, nephrite, purpurine, gold, enamel, diamonds; 13.5 x 9.2 x 4.8 cm
Purchased by Lady de Grey from Fabergé's London branch on 21 December 1907
The Royal Collection / H.M. Queen Elizabeth II (RCIN 40218)

While the realism of this delicate and fragile flower study is remarkable, Fabergé may have considered decorative quality more important than botanical accuracy as the piece features both cherry blossom and fruit. Queen Alexandra's collection of Fabergé flower studies comprise 22 of the 26 examples in the Royal Collection. This cherry study was most likely a gift from her friend Lady de Grey. Bainbridge described Lady de Grey as 'one of the foremost figures in Edwardian Society'.

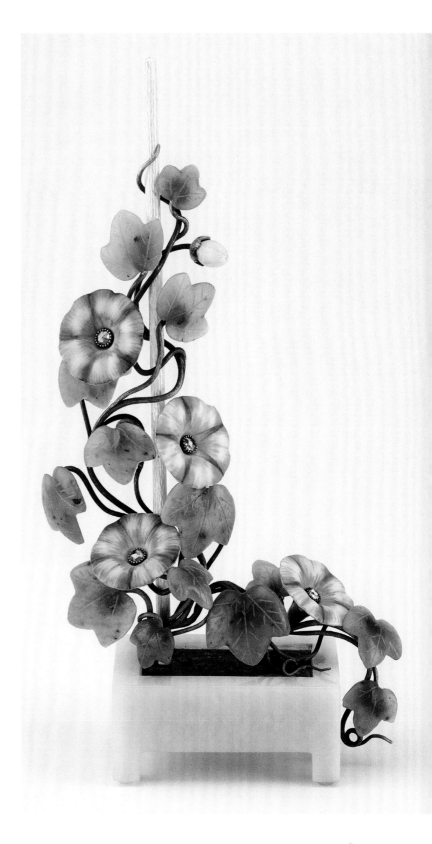

160

CONVOLVULUS, c.1908

Attributed to Jahr workshop, Moscow
Bowenite, gold, nephrite, enamel, diamonds; 11.1 x 6.5 x 2.5 cm
Purchased by Lady Sackville-West, 30 March 1908
The Royal Collection / H.M. Queen Elizabeth II (RCIN 8943)

The convolvulus was one of three Fabergé flowers purchased by
Lady Sackville, a renowned beauty. She was a Fabergé customer
before the advent of the London branch. In May 1896 she had
travelled to St Petersburg to attend the coronation of Nicholas
II and had visited the firm's shop. It clearly made an impression
and afterwards she recorded in her diary, 'you meet just everyone
at Fabergé'. The flower studies passed to her daughter Vita, the
writer and gardener who, with her husband Harold Nicolson,
created a remarkable garden at Sissinghurst Castle in Kent. Here,
as part of her daily routine, Vita picked the finest flowers from
the garden, arranged them in posy holders and placed them
between Fabergé's eternally blooming flowers.

161
PINE TREE, MODELLED IN THE MANNER OF
A HAN-KENGAI BONSAI, 1903–8

Attributed to chief workmaster Henrik Wigström (1862–1923), St Petersburg
Gold, bowenite, aventurine quartz, diamonds; 12.3 x 6.2 x 5.8 cm
Purchased by Prince George of Wales, later King George V, on 14 December 1908
The Royal Collection / H.M. Queen Elizabeth II (RCIN 40186)

This is one of Fabergé's most inspired pieces. It is derived from
the firm's study of Japanese works of art. The finely textured gold
tree descends from a bowenite pot on an aventurine quartz stand
in the manner of a han-kengai bonsai.

4

WAR,
REVOLUTION
AND EXILE

Hanne Faurby

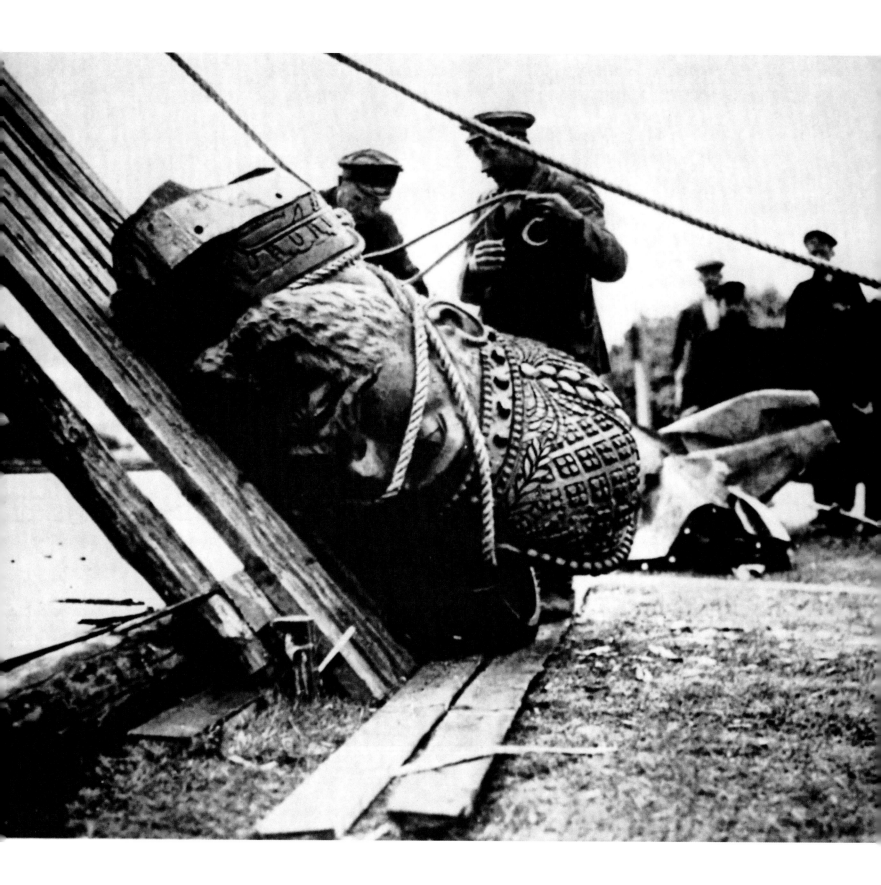

Chapter opener
162
COPPER BOWL, STAMPED
'война'(WAR), AFTER 1914
(detail; see also p.188)

FROM THE HEIGHT OF FAME AND FORTUNE, a succession of disasters brought the House of Fabergé to a close. It began with the First World War in 1914. The events that followed – the abdication of Emperor Nicholas II, the establishment of the Provisional Government and the Bolsheviks' successful takeover of the country – mark out the string of national and global events that would see the end of Fabergé, both the business and the man himself. The desire for a new world order had not, however, materialized overnight. While Carl Fabergé built his empire for an enchanted world, discontent with the Romanov regime had been brewing. Following the second French Revolution, the wish for reform was felt and fought for across Europe with Marxist ideology prevailing in Russia. An early victim of this revolutionary fervour was Emperor Alexander II (b.1818), grandfather of Emperor Nicholas II, who having survived previous attempts on his life was assassinated in 1881.

During the coronation festivities of Emperor Nicholas II in 1896, over 1,300 people were trampled to death and an equal number injured in what is remembered as the Khodynka Tragedy. Ill-advised by his uncle, the Emperor attended a ball that evening hosted by the French ambassador. This act was perceived as a lack of sympathy. Causing further public indignation, the tragedy hung over the Emperor's reign. The unsuccessful 1905 Revolution, which had been triggered by Russian defeat in the Russo-Japanese War, was followed by the country's deeply unpopular involvement in the First World War. Russia's casualties were a staggering 9,150,000 (Germany came second with 7,142,558) despite exiting in March 1918 – nine months before the war officially ended on 11 November 1918. These events paved the way for the final stand-off between the White and the Red Armies within Russia and gave birth to a new nation in which the likes of Fabergé were rendered superfluous.

As the First World War commenced, Carl Fabergé's *oeuvre* expanded. His impeccable ability to tailor his products to suit the desires and needs of his customers ensured continued business. Costly metals and precious stones were still in great demand in some circles, but the outbreak of the war fundamentally changed the imperial family's mood and official needs.[1] Fabergé echoed the austerity of the times in the pieces produced in his workshops. Without compromising the quality of these creations simpler forms were explored in less costly metals, such as brass, copper, steel and aluminium. Utilitarian items such as dishes, beakers and cooking pots were among the objects made. The designs were plain, the only decorative feature being the imperial double-headed eagle. Unlike pre-war production, these 'war-pieces' were reproduced in considerable numbers.

Other pieces produced during the First World War included items with the Red Cross motif: pendants, brooches (pl. 165) and even the two Imperial Easter Eggs of 1915 (pls 13 and 206). The eggs demonstrate the Emperor's recognition of and praise for the contributions of his wife and mother to the war effort. For, while the Emperor and his heir, the Tsarevich, went to the Front, the ladies of the imperial family focused their efforts on organizing medical supplies and caring for wounded soldiers. The Dowager Empress Maria Feodovrona was head of the Russian Red Cross and the Empress Alexandra, together with her two eldest daughters the Grand Duchesses Olga (1895-1918) and Tatiana (1897–1918), trained and worked as nurses (pl. 166).

Fabergé's support of the war effort included more than the mere production of official gifts, awards and badges, with some workshops crafting components for shells and rapid firing field artillery. A certificate from the Central War Supply Committee dated 14 October 1915 testifies to an order for '1,500,000 sets of articles' for the 1914 model hand grenade. The Holmström workshop is even said to have produced Pravatz and Rekord syringes.[2]

163
Pulling down the monument to Emperor Alexander III in the square in front of the Cathedral of Christ the Saviour in Moscow, 1918.

164
BOWLS, STAMPED 'война'(WAR),
AFTER 1914

Moscow
Copper, silver, brass; 3.0 x 10.9 x 10.9 cm
Courtesy of A La Vieille Russie, New
York

Opposite
165
A page from the Holmström workshop's
albums, dated 23 December 1914,
showing designs for jewelled and
enamelled brooches made to highlight
the efforts of the Russian Red Cross
during the First World War.
Wartski, London

Following the abdication of Emperor Nicholas II on 2 March 1917 a Provisional Government was immediately set up and Fabergé continued his services with the new establishment, as a petition addressed to the Minister of Justice Alexander Fyodorovich Kerensky dated 23 March 1917 attests. From this document we learn that Fabergé's Moscow premises had become a 'mechanical plant' and was in the process of fulfilling an order of 2,000,000 brass artillery plugs of the 1915 type for the Main Artillery Administration. Fabergé estimated this order would take about 10 months of round-the-clock work to complete.[3] The craftsmen in St Petersburg, or rather Petrograd as it was renamed in 1914, were working on an order for badges and other presentation articles for the Provisional Government's War and Sea Ministry. The pressing issue brought up by Fabergé in his petition regarded the lack of payment for orders. With little money coming in Fabergé was struggling to make ends meet. In Moscow his staff had not received their wages since January. The 'destructive atmosphere is spreading so quickly that if I don't pay the money due now the factory can no longer exist and the military commissions would not be fulfilled', he wrote.[4]

The pressures of keeping the business going during the war and revolutionary years had in fact induced Fabergé to write to the ruling powers on several occasions. A few years earlier, on 15 September 1915, he submitted a letter to the Office of the Palace Major humbly requesting assistance in his application for some of his masters and artists to be exempted from military duty. The application passed through various imperial offices and the paper trail brought to light the impact on Fabergé's staffing. The skilled workforce had almost halved by this point. Furthermore, the most specialized craftsmen were difficult to replace having benefited from over five years' training (see pp. 40, 50).[5] Yet the application was denied on the grounds that even within the Ministry of the Imperial Court itself staff could not be exempted from military duty.[6]

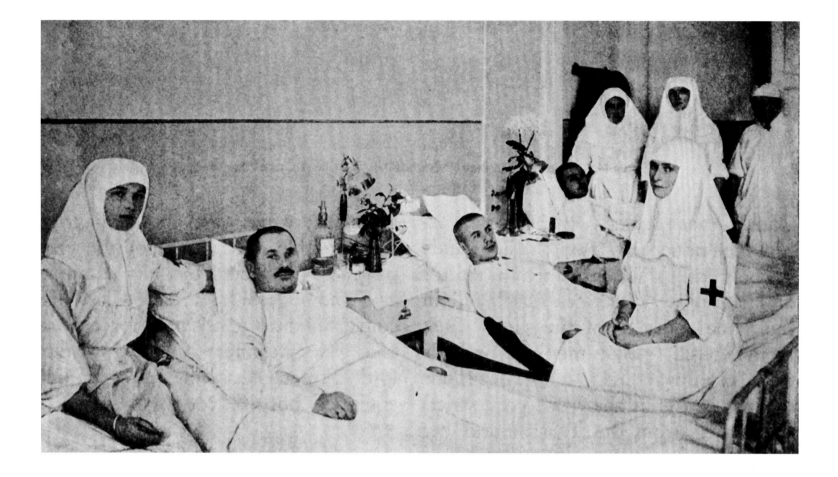

A year later Fabergé tried again; this time the urgency and desperation of the situation permeated the pages. The stone sculpture factory in Moscow had by then lost 26 specialists with only four masters remaining; the gold and silver factory in Petrograd had been reduced to 25 craftsmen from the pre-war 100. Orders would be impossible to meet if more staff were drafted. Meanwhile, as Fabergé stressed in capital letters, the number of orders coming in 'HAS INCREASED'.[7] He also drew attention to the firm's financial obligations, paying the leaseholds of the Odessa and London offices as well as his duty of care for the families of his enlisted employees. Bainbridge wrote of this point in Fabergé's life that 'The broken heart had yet to come to him who had done so much to keep his fellow men on an even keel.'[8]

During the October Revolution of 1917 the Bolsheviks succeeded in overthrowing the Provisional Government, which was still intent on fighting the deeply unpopular war against Germany. The Brest-Litovsk Treaty was signed between the Bolshevik Federal Government and Germany in March 1918, thus ending Russia's military involvement in the First World War. Shortly afterwards civil war erupted within Russia, which was to last for several years. To fund their campaign, the Bolsheviks turned to confiscating jewellery and other treasures, which they sold on the international market. This strategy, popularly referred to as 'Treasures for Tractors', would in the coming years also seal the fate of many items made by Fabergé. In the midst of this chaos, however, daily life continued. Wishing to secure the firm for the future,

166
Empress Alexandra Feodorovna and Grand Duchesses Olga and Tatiana Nikolaevna wearing Red Cross uniforms, serving at a hospital in Tsarskoye Selo, February 1916.

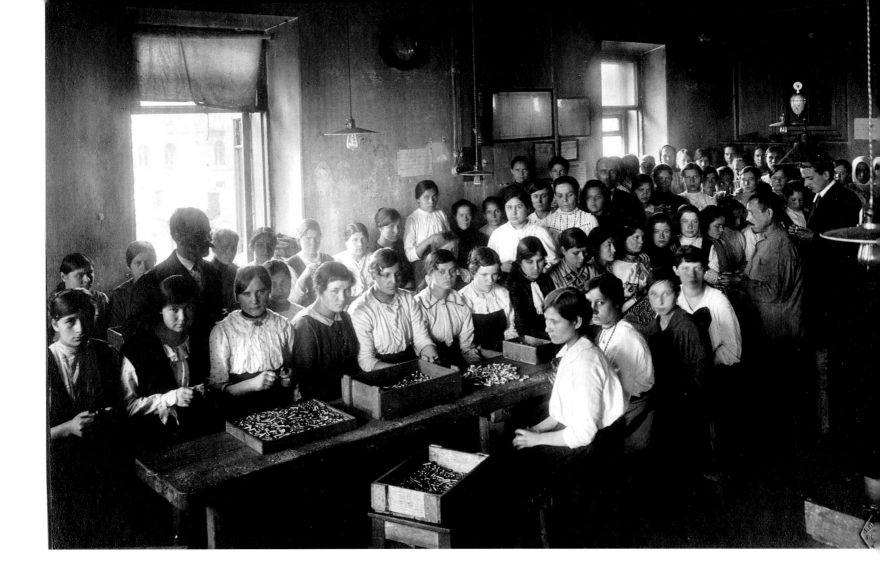

167
Albert Holmström's workshop in
St Petersburg during the First World
War. The women are assembling
ammunition parts for the Imperial
Artillery.
Fersman Mineralogical Museum,
Moscow

Fabergé registered his business as a joint-stock
company on 17 May 1916, with the shares divided
between himself, three of his four sons and a handful
of employees. According to Eugène, Fabergé's eldest
son, the company continued to support the powers
in government, including a year under Bolshevik
rule.[9]

As a result of the First World War it was no
longer possible for Fabergé to continue to supply the
London branch. Yet the branch managed to carry
on trading until January 1917. It sold off its final
stock, amounting to about 200 pieces, to the French
jewellery firm Lacloche Frères, whose London
premises were at 2 New Bond Street. The wooden
gift boxes for these pieces were relined with silk
bearing the name of 'Lacloche Frères' (pl. 168). A
letter written by Fabergé's British lawyers still exists

in the Rothschild Archives. Dated 7 February 1917
it states: 'Mr Fabergé is for the present, at all events,
closing down his business in London.'

Fabergé's premises in Petrograd remained at
24 Bolshaya Morskaya. A representative of the
Legation of the Swiss Confederation was lodging
there and, as the unrest and violence on the streets
of Petrograd raged, Fabergé and his family hoped
that some protection would be had from the official's
presence. With the nationalization of the firm by the
Bolshevik Federal Government, 'who have robbed,
what the[y] could find in the premises',[10] the Fabergé
family decided to entrust a bag of valuables to the
safekeeping of the Legation.[11] This was, however, all
lost following a suspicious theft on 4 November 1918.
It was a bleak and fateful year. A typhoid epidemic
and famine were raging in Russia; news of the

Emperor and his family's assassination had become public knowledge and two of Carl Fabergé's sons, Alexander and Agathon, were imprisoned.

Following years of unrest the craftsmen and other staff at the House of Fabergé were now spread across Europe. The creative environment that Carl Fabergé had moulded and which had been an instrumental factor in the firm's success was lost for ever. It would be impossible to recreate what had been. Yet, together with Andrea Marchetti (former Moscow branch manager) and Giulio Guerrieri (formerly of the Moscow based jewellery firm Th. Lorié, which had carried out commissions for Fabergé),[12] Eugène and his brother Alexander established Fabergé et Cie in Paris in 1924. It was a small business that relied on the 'old' clientele and focused mainly on repairs and sales of Fabergé pieces made before 1918. Eugène explained in his broken English: 'We are living in Paris since January 1921 as emigrants, have a modest bureau & are buying & selling precious stones & taking on commission jewellery-works of our old customers for selling. Of course the last time business are exactly like null, absolutely nothing to be done, but the first years were not so bad & we could exist decently.'[13]

The relationship with the British royal family remained intact. In a series of letters addressed to Bainbridge between August 1935 and January 1936, Eugène refers to a tricky enamel repair on an egg belonging to Queen Mary. In studying the egg and the possible method of its repair Eugène mentioned 'six [enamelled] parts of the bottom part of the egg'.[14] This seems to correspond with the design of the Twelve Panel Egg (1899), the second in a series of seven non-imperial eggs made for Barbara Kelch (whose family had made its fortune in Siberian gold mines) and given to her at Easter by her husband Alexander Kelch. The Twelve Panel Egg was purchased by King George V on 2 December 1933 for £275 and given as a Christmas present to Queen Mary. Eugène was keenly aware of Queen Mary's delight in Fabergé's creations. In February 1936 he wrote to Bainbridge asking if he

thought Her Majesty would be interested in a gold cigarette case with white enamelled stripes and a rock crystal box mounted in gold and decorated with pink enamel. It is also worth noting the relationship between Bainbridge and Fabergé's sons; not only the decades of correspondence between Bainbridge and Eugène, which easily jumps between the topics of family, acquaintances, business and research, but also Bainbridge's hospitality towards Agathon, another of Fabergé's sons, during his visit to London in 1937. Although Bainbridge had left Fabergé on bad terms with the father in 1915, the sons were clearly happy to continue the friendship and Bainbridge in some degree continued to act as a Fabergé agent in London.[15]

Of Fabergé's four sons, Agathon, with his independent spirit, similarly fell out with his father. He left the family business in 1916 to open an antiques shop. He was imprisoned twice by the Bolsheviks, first for 18 and then for 9 months' duration. Sometime after his release, probably around 1920/21, the Gokhran (an office within the State Treasury responsible for precious metals, jewels and works of art) became interested in his professional knowledge. Agathon was particularly skilled at assessing precious stones and had acted as his father's representative for the periodic examination and maintenance of the Romanov Imperial Regalia and Crown Jewels.[16] The Gokhran recognized Agathon as a suitable appraiser. In 1922 alone, 92,978 treasures were assessed and sorted under the direction of the Gokhran with only 6,069 reserved as cultural heritage to be preserved in museums.[17] The rest would have been sold either as a whole or broken up, depending on which was deemed to gain the highest price. Without the benefit of hindsight, reputation and provenance were irrelevant. Jewellery by Fabergé was regarded as contemporary and its intrinsic value the primary consideration; it was therefore more likely to be broken up than preserved. To a great extent this explains the relative rarity of Fabergé jewellery to this day. It must have been strange for Agathon Fabergé

168
BUCKLE, 1896–1908
Gold, silver-gilt, enamel, diamonds; 7.5 cm across
Purchased as part of the sale of remaining stock from Fabergé's London branch by the jewellers Lacloche Frères, 1917
Private Collection

to be part of this destructive work. For once the diamonds had been extracted from their settings and washed, they were placed in piles on a table for him to sort and package;[18] among these diamonds would undoubtedly have been those once worked by the House of Fabergé. Agathon remained in Russia for nearly a decade after the rest of his family had left, but then fled to Finland in 1928.

Sources disagree on the date of Carl Fabergé's exile from Russia; it could have been September 1918 or even as late as December 1919.[19] With the help of a good friend he arrived in Riga, a large harbour port on the Baltic Sea, from whence he travelled to Berlin, continuously running from revolutionary outbreaks. How he arrived in Riga, without his wife and sons, is little understood. Presumably Fabergé's flight was spurred by a combination of personal tragedy, national uncertainty and a window of opportunity. From

Berlin, he travelled to Wiesbaden, a popular spa location, via Frankfurt am Main and Homburg von der Höhe. While in Wiesbaden, in May 1920, he celebrated his 74th birthday with friends from Petrograd. In a letter to Bainbridge, dated 30 March 1931, Eugène explained the process of his father's exile and recalled his own, accompanied by his mother, Madame Fabergé. They had remained in Petrograd until 6 December 1918 when they left in secret for Finland, which they 'reached like smugglers after a hard voyage'. The route took them first by rail, followed by 20 kilometres on sledges through snow-covered woods and finally on foot under cover of darkness, carrying the few possessions they had managed to bring with them. We do not know the name of the Finnish village they reached, but it was located near Lake Ladoga, close to Kexholm (now Priozersk) in northwest Russia.

From there they travelled by rail to Terijoki via

169
In 1917 the Yusupov family left their mansion in St Petersburg, their treasured possessions carefully hidden in various secret places to await their return. The Yusupov treasures were discovered in 1925. Here they are being assessed and some broken up. Fabergé workmaster Feodor Afanasiev stands in the centre.
Emergency Commission photograph, dated 12 June 1925

170
Carl Fabergé with his grandson
Peter (Agathon's second son), on the
terrace of Hotel Bellevue, Switzerland,
summer 1920.

Viborg, a short distance from the Russian frontier.
Here they had to remain in quarantine before
they were allowed to continue their journey to
Helsingfors. Eugène stayed there until July 1919 and
then continued on to Stockholm. Madame Fabergé
went first to England and later to Switzerland to
join her daughter-in-law and grandson Alik.

In 1920, after a long separation, Eugène and his
mother joined Carl Fabergé in Wiesbaden where
he had fallen ill. Then, at the beginning of June,
Eugène and Madame Fabergé brought Carl to a villa
in Lausanne overlooking Lake Geneva. The fresh air
and views restored him for a while to the point where
he was able to manage a few excursions assisted by
his grandson Peter. Nevertheless, as Eugène wrote to
Bainbridge on 27 April 1934:

> he was suffering from inactivity, having always been
> most laborious, active & diligent, such a life without
> ... work was insupportable for him. – He repeated
> often: 'Such a life is not a life any more, when I
> can not work & be useful; it is not worth while to
> live.' His heart was broken. After having worked 50
> years, after having created a first class jewellery firm,

known all over the world, after having lived a good,
prosperous, beautiful & laborious live [*sic*], he was
forced to observe, how all the work of his life broke
down so stupidly & senseless.

A fall at the end of July 1920 left Carl Fabergé
bedridden until his death on 24 September that
year. He had been diagnosed with liver cancer
but was to all accounts unaffected by it and kept
his mind occupied with books and newspapers.
According to Eugène, Madame Fabergé was with
him when he passed away early that morning,
noting that his father had smoked half a cigarette
half an hour before he died. He was cremated at
Lausanne Crematorium to the notes of a favourite
Beethoven mass. Eugène later united his parents
by taking his father's ashes from Lausanne to
Cannes, where Madame Fabergé died in 1925. At
Cannes Protestant Cemetery, Eugène ensured
that his father's wishes for a black gravestone were
met. Embellished with gold lettering it marks
the final resting place of Augusta FABERGÉ née
JACOBS and Charles FABERGÉ – Joaillier de la
Cour de Russie.

WILD
ROSE

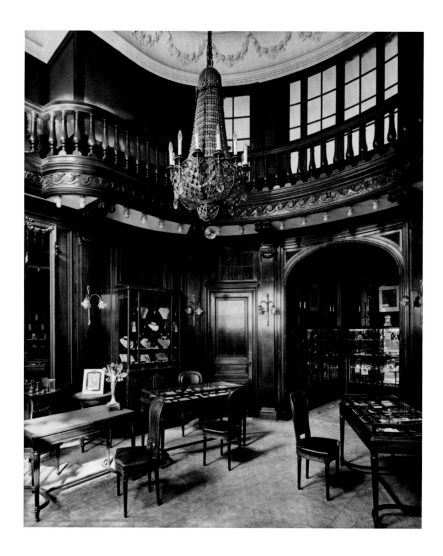

FABERGÉ'S CREATIVITY WAS GIVEN FULL REIN IN HIS *objets de fantaisie*, rare works that served no purpose other than to delight. They were favoured by his most esteemed patrons and flower studies are amongst his most prized fantasy objects. Only a small number were made and only approximately 80 still exist, the largest holding being in the collection of H.M. Queen Elizabeth II.

In his flower studies Fabergé creates the illusion that an actual flower has been plucked from a garden and placed in a waiting posy vase. They were extremely challenging works and in many respects are a form of alchemy in reverse, whereby unyielding hardstones and rigid metals are turned into fleeting moments of nature.

The flower studies were much admired in London and this bloom, which traditionally has been identified as a wild rose, was in Fabergé's shop when it was forced to close in early 1917. Its five windswept leaves are delicately sculpted from Siberian jade, sourced from the wilderness bordering the River Onot, close to Russia's Mongolian border. The posy vase is carved from a single piece of rock crystal, subtly shaped and giving the impression of being half-filled with water. Fabergé has ingeniously exploited the similarity in the refractive indices (or light-bending properties) of water and rock crystal, the flower's curving stem appearing to break at the point where it is placed in the vase, just as it would when entering water. The stem is made from gold, which has been finely engraved to give it a

natural appearance. Its slender gauge required it to be bolstered with a steel core, to give it sufficient strength to hold up the flower. The undulating gold petals are enamelled pale pink and painted with thin pale blue veining, probably applied with the single bristle of a brush. The tip of the lower left petal is painted with a duller pink enamel at its outer edge. This demonstrates Fabergé's mastery in modelling flowers, for he is showing the first signs of decay after the flower has been cut. From the petals the eye is then drawn inwards to a brilliant-cut diamond nestling at the centre of the flower, from which emanate delicate gold stamens capped with rose diamonds.

171
The interior of the Lacloche Frères shop at 2 New Bond Street, London, 1910.

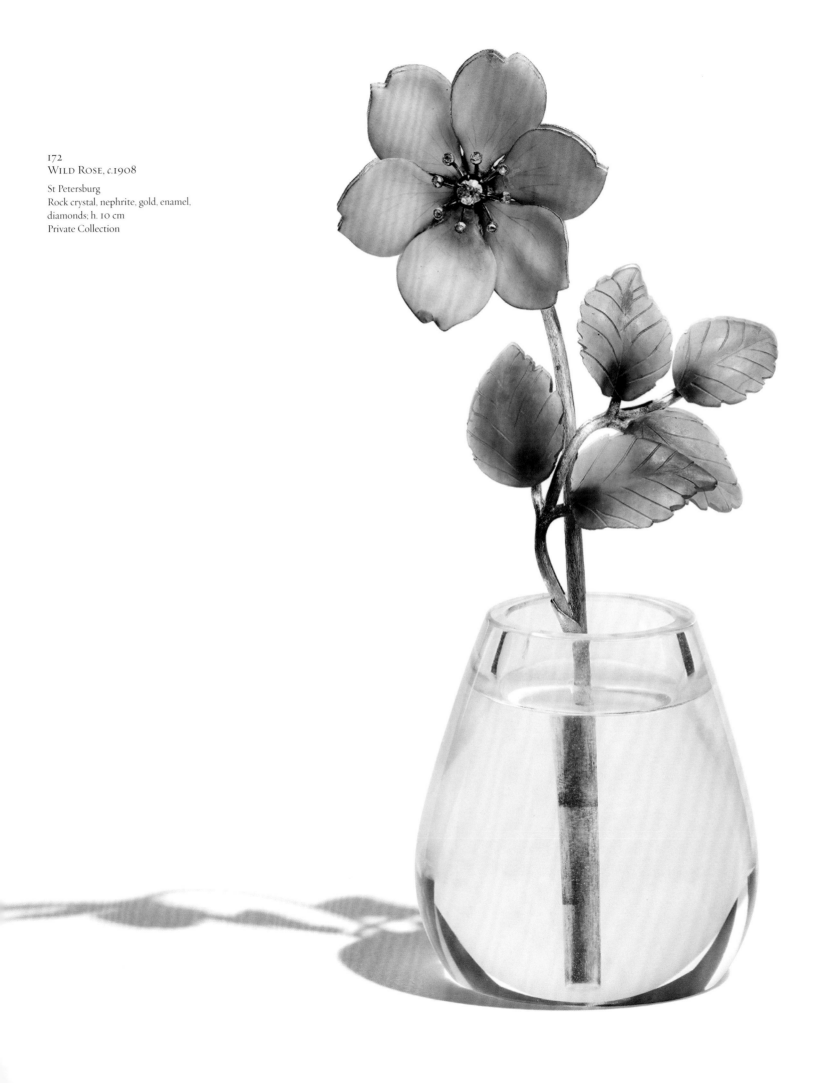

172
WILD ROSE, *c*.1908

St Petersburg
Rock crystal, nephrite, gold, enamel,
diamonds; h. 10 cm
Private Collection

SELECTED WORKS

173
Cooking pot, after 1914

Moscow
Copper and brass; 12.7 x 13.4 cm
The India Early Minshall Collection, The Cleveland Museum of Art, Ohio (1966.511)

This brass-mounted copper cooking pot is an example of the utilitarian items supplied by Fabergé after Russia entered the First World War. With the conflict raging on Russia's western borders, the business turned from producing precious works of art to supporting the war effort. This cooking pot is stamped 'K. Fabergé' in Cyrillic, together with the date '1914' and the Russian word 'война' (war).

174
Russian Reserve Soldier, 1915

Craftsman P.M. Kremlyov; artist G.K. Savitskii, St Petersburg
Multi-coloured jaspers, changlong, ophicalcite, pegmatite, silver, gold; h. 17 cm
The Fersman Mineralogical Museum, Moscow (PDK-2571)

In this lapidary study, Fabergé captures a moment in the life of an ordinary Russian soldier during the First World War, who is taking solace in the pleasure afforded by a cigarette (the cigarette is now missing).

175
HATPIN, c.1913

Workmaster Alfred Thielemann (1870–1909),
St Petersburg
Gold, silver, enamel, diamonds, holly wood, steel, velvet; 3.4 x 24.3 x 2.2 cm
Wartski, London

This jewelled and enamelled gold hatpin is topped with a sphere
of matt opaque blue enamel punctuated with a repeating pattern
of three leaf clovers mounted with rose-cut diamonds. The
hatpin was another of the items purchased by Lacloche Frères
after the Fabergé branch in London closed. As with the buckle
(see p.193), Lacloche kept the pin its original Fabergé case and
relined the lid satin with its own company name.

176
ASHTRAY, 1914

St Petersburg
Purpurine, gold, enamel; 1.2 x 4.5 cm
Acquired from Fabergé's London shop by H. Samuelson on 16 December 1915
Wartski, London

This enamelled ashtray, the gold rim enamelled opaque white
and bound with gold ties, remains in its original silk and velvet-
lined holly wood case. An ashtray matching this description was
purchased from Fabergé's London shop by H. Samuelson on 16
December 1915. The lid satin of the box is stamped 'Petrograd'
rather than 'St Petersburg', so dating the tray to after August
1914, when the name of the city was changed from the Germanic
St Petersburg to Petrograd.

177
PRESENTATION CIGARETTE CASES, AFTER 1914

Moscow
Copper, brass, silver; l. 9.5 cm
'The Link of Times' Foundation, Fabergé Museum, St Petersburg

These cigarette cases, in copper, brass and silver, are each
stamped with an imperial double-headed eagle, the dates 1914
and 1915, the Russian word 'война' (war), above 'K. Fabergé'
in Cyrillic. A small number of these presentation cases bear the
crowned cypher of Empress Alexandra Feodorovna, the date
1916 and inscription 'Tsarskoe Selo' on the reverse.

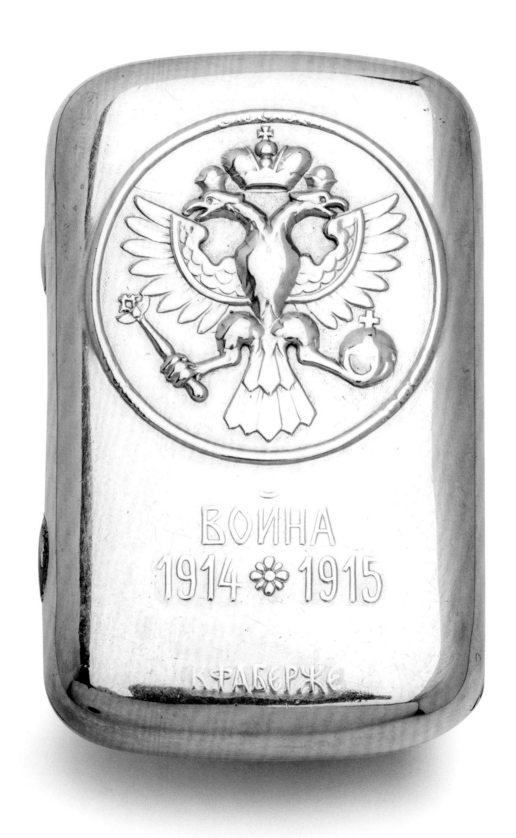

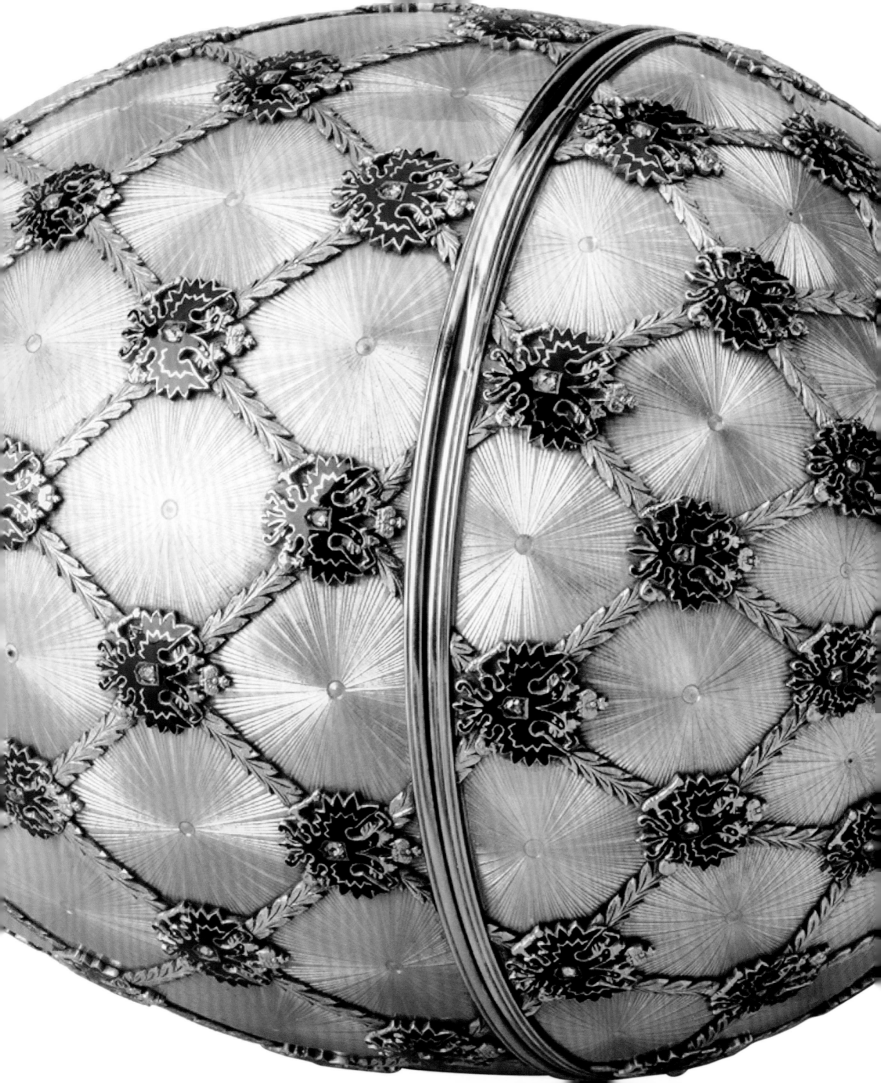

5

THE LEGACY
OF THE IMPERIAL
EASTER EGGS

Géza von Habsburg

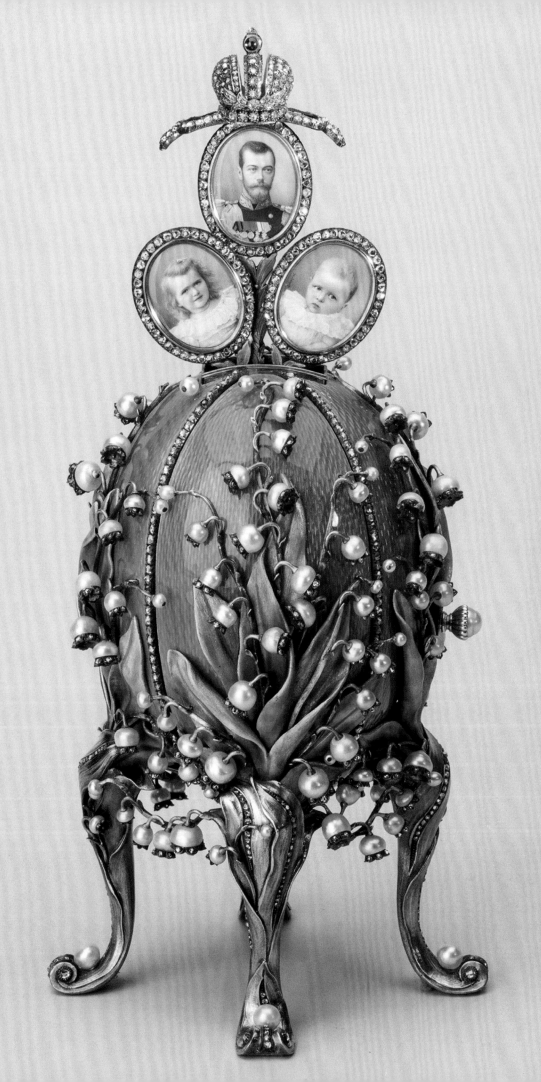

Chapter opener
178
IMPERIAL CORONATION EGG,
1896–7
(detail, see also p. 210)

179
LILIES OF THE VALLEY EGG,
1897–8

Workmaster Michael Perchin
(1860–1903), miniaturist Johannes
Zehngraf (1857–1908)
St Petersburg
Gold, translucent rose pink and green
enamel, diamonds, rubies, pearls, rock
crystal, portrait miniatures; h. 15.1 cm
(egg when closed)
Presented by Emperor Nicholas II as a
gift to his wife, the Empress Alexandra
Feodorovna, Easter 1898
'The Link of Times' Foundation,
Fabergé Museum, St Petersburg

THE NAME OF CARL FABERGÉ HAS FOREVER BEEN
identified with the series of Imperial Easter Eggs,
which the great Russian craftsman produced for the
imperial family in Russia. Commissioned by the last
two Emperors, beginning in 1885, Fabergé's imperial
eggs have, over recent years, acquired a unique cult
status in the art world and popular culture. They
have achieved millions of dollars at sales both by
private treaty and at auction; inspired scores of
exhibitions attracting many hundreds of thousands
of visitors; engendered countless publications;[1]
and featured in numerous films, TV series,
documentaries and cartoons. Consequently, due to
their celebrity, they have also prompted many tens
of thousands of imitations and a few very audacious
forgeries. In all these respects, Fabergé's imperial
eggs have had an immense following.

And yet, at their inception, such eggs were not
a novelty. The gifting of eggs at Easter-time was
a Russian Orthodox tradition harking back many
centuries. In Western Europe gem-set eggs with
royal provenances can be attested to the eighteenth
century. A gilded and enamelled egg containing the
model of a hen, which in turn held a replica of the
Imperial Crown and a precious ruby ring within,
was kept in the Green Vault treasury in Dresden
and was certainly known to Fabergé (pl. 180).[2] This
work, or others very similar to it that survived in the
treasuries of Rosenborg Castle in Denmark and the
Kunsthistorisches Museum in Vienna,[3] would have
served as a prototype for Fabergé's First Hen Egg of
1885 (pl. 181).

While earlier scholarship was unclear about
the number of imperial eggs produced by Fabergé,
it is accepted today that 50 eggs were completed
between 1885 and 1916. Ten were commissioned
as Easter presents by Emperor Alexander III for
his wife, Maria Feodorovna, until the Emperor's
untimely death in 1894. His son Emperor Nicholas
II dutifully continued the tradition, gifting one
egg every Easter to both his wife, Alexandra
Feodorovna, and to his mother. No eggs were

commissioned for 1904 and 1905, the years of
the disastrous Russo-Japanese War. The two
eggs planned for 1917 were in progress, but never
delivered as Emperor Nicholas abdicated shortly
before Easter and his mother had moved to Kiev. Of
the 50 completed eggs, only 42 were thought to have
survived the 1917 October Revolution. However,
of the eight missing eggs, one, the Third Imperial
Egg of 1887, appeared unrecognized at an auction
in New York in 1964 and was sold for $2,450. It
re-appeared, after being listed for its scrap value of
under $14,000, at a Midwest flea market in 2011
and was identified as being imperial. This leaves
only seven of the completed eggs missing.

The commission of Fabergé's First Hen Egg is
well documented.[4] On 1 February 1885, less than
two months before Easter, Alexander III wrote
to his brother Grand Duke Vladimir asking for
the surprise of the egg – which originally must
have been planned by Fabergé to be a ring within a
crown as with earlier prototypes – to be replaced
by a specimen ruby which the recipient, Empress
Maria, could wear on a chain. The second, Hen Egg
with Sapphire Pendant (1886), now lost, required
feedback from the Emperor regarding the materials
to be used: whether silver or gold, whether set with
rose-cut diamonds or not. It is described in Fabergé's
invoice as 'Hen of gold and brilliant diamonds,
picking a sapphire egg out of a wicker basket'.
Thereafter, Fabergé was given a free hand as to the
design of the egg and the choice of its theme. 'Your
Majesty will be satisfied' was reportedly Fabergé's
answer to any questions from the Emperor. If a
number of Fabergé's Imperial Easter Eggs draw their
inspiration from earlier sources, by 1890, the date of
the Danish Palaces Egg,[5] Fabergé had freed himself
from traditional Easter themes, turning to subjects
of family interest, with an abundance of miniature
portraits,[6] favourite abodes[7] and preferred means
of transport.[8]

Despite the restrictions of the egg shape, Fabergé
achieved miracles of invention 50 times over:

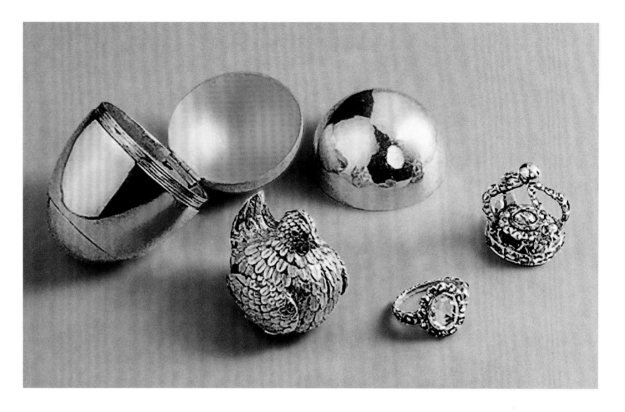

180
GOLDEN EGG WITH HEN, *c.*1720
Probably Dresden
Gold, enamel, rubies, diamonds;
length 5 cm
Formerly in the collection of Elector
Augustus the Strong of Saxony
(1670–1733), The Green Vault,
Dresden (Inv. VI, Nr. XIII)
Private Collection

fashioned into the form of an Easter egg were a basket of wild flowers;[9] the towers and a dome of the Moscow Kremlin;[10] a cradle;[11] and an automated peacock nestling in a bower, which when wound up displays its tail feathers; while a yacht or an equestrian figure is displayed within an ovoid rock-crystal shell.[12] Perhaps the most ingenious inventions are those of a Temple of Love, placed beneath an egg-shaped dome[13] and a bay tree automaton, disguised as an Easter egg.[14] Interestingly, none of the eggs, except for the Red Cross Egg with Icons,[15] appears to have any religious Easter connotations. Heated debates may have preceded the choice of shape and content of the Easter eggs, some of which took up to two years to make. These were well-kept secrets within the firm. One often-quoted joke concerned an inquisitive Grand Duchess, who insisted on learning the shape of that year's egg, to which Fabergé is said to have replied: 'This year, your Highness, we will be featuring square

eggs' – not that far-fetched when considering the square tub in which stands the Bay Tree Egg (1911), containing a mechanized songbird.

This legendary series is without doubt the most extraordinary group of jewelled *objets d'art* ever to have been commissioned from an artist. The boundless genius behind their apparently unceasing invention and their exquisite craftsmanship reflects the extraordinary flowering of the arts in the decades immediately preceding the fall of the Romanov empire, mirroring the splendour, power and wealth of this dynasty and of its court. To prescient spectators, however, these masterpieces also herald, as in a Greek tragedy, the relentless approach of an oncoming tragic final act.

Initially, the subjects of the eggs are centred on Emperor Alexander III, Empress Maria and their children (1890, the Danish Palaces Egg; 1891, the Memory of Azov Egg; 1892, the Diamond Trellis Egg; and 1893, the Caucasus Egg). Beginning in

181
HEN EGG, CONTAINING
MINIATURE HEN, 1884–5
St Petersburg
Gold, enamel, ruby; 6.4 cm
Presented by Emperor Alexander III to
Empress Maria Feodorovna, Easter 1885
'The Link of Times' Foundation,
Fabergé Museum, St Petersburg

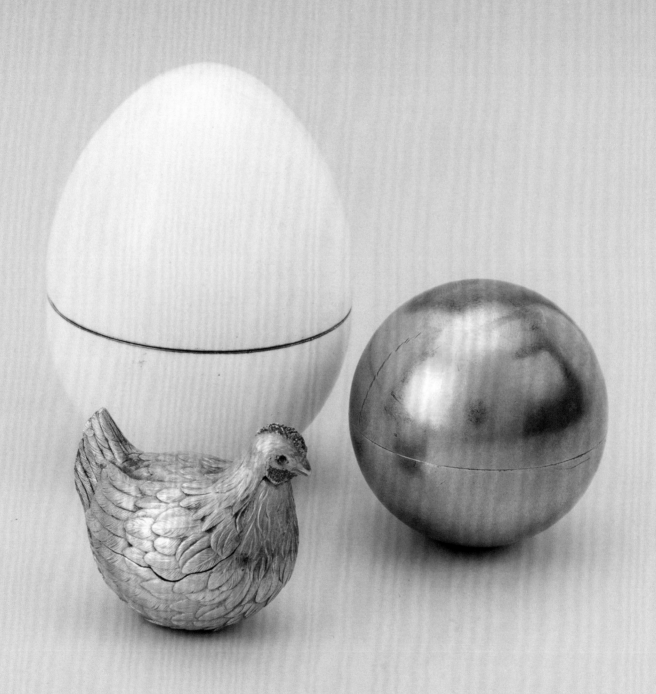

182

IMPERIAL CORONATION EGG,
CONTAINING A MINIATURE
REPLICA OF THE CORONATION
COACH, 1896–7

Workmasters Michael Perchin
(1860–1903) and Henrik Wigström
(1862–1923), St Petersburg
Egg: vari-coloured gold, enamel,
diamonds; miniature: gold, platinum,
enamel, diamonds, rubies, rock crystal;
h. (egg) 12.7 cm, l. (miniature) 9. 3 cm
Presented by Emperor Nicholas
II to his wife, Empress Alexandra
Feodorovna, for Easter 1897, as a
memento of her entry into Moscow
on 26 May 1896, the day of their
coronation in the Uspenski Cathedral
'The Link of Times' Foundation,
Fabergé Museum, St Petersburg

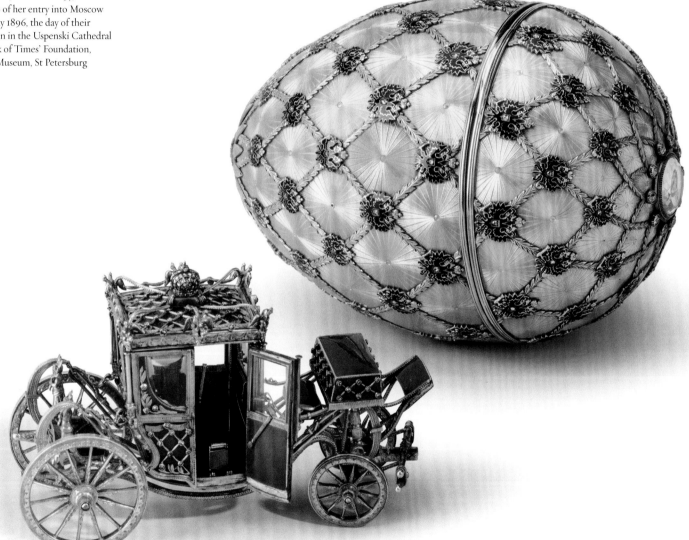

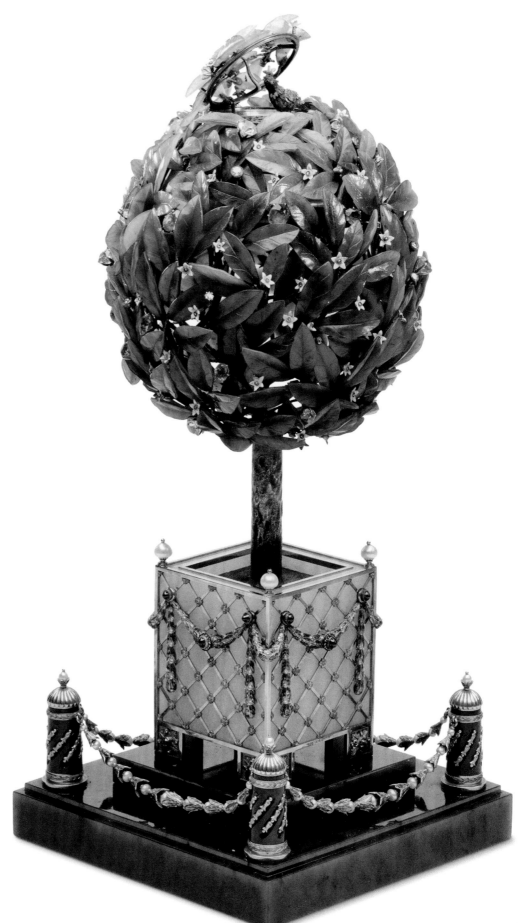

183
BAY TREE EGG, CONTAINING
FEATHERED SONGBIRD, 1911

Workmaster unknown
St Petersburg
Gold, green and white enamel, nephrite,
diamonds, rubies, amethysts, citrines,
pearls and white onyx; h. 25.7 cm (when
closed), 29.8 cm (when opened)
Presented by Emperor Nicholas II to his
mother, the Dowager Empress
Maria Feodorovna, for Easter 1911
'The Link of Times' Foundation,
Fabergé Museum, St Petersburg

1894 the love story of Emperor Nicholas II and Empress Alexandra unfolds, showing their homes (1896), the happy couple with their chubby first daughter (1897); Nicholas with their two daughters (1898); the cradle of their long-awaited son Tsarevich Alexei containing his portrait miniature (1907); Alexei's miniature (1907, lost); their beloved Alexander Palace and their five children (1908); their yacht, the *Standard* (1909); an allegory of all five children (1910); Nicholas and Alexandra with their four daughters (1911); the Tsarevich (1912); their five children (1914); Alexandra and her two eldest daughters as nurses (1915); and Nicholas and the Tsarevich distinguished for valour on the Order of St. George Egg (1916), one year before the Emperor's abdication.

After the fall of the Russian monarchy, all its expropriated *objets d'art* and remaining jewels were assembled and inventoried at the Anichkov Palace in St Petersburg.[16] A detailed list of these works was established in September 1917 before they were crated and sent to Moscow later that month to be stored at the Kremlin Armoury. By March 1922 the most valuable objects, including the Russian Crown jewels and the Fabergé Easter eggs, were transferred to the Gokhran with a view to preparing for their sale abroad. Photographs taken in 1923 show 13 imperial eggs alongside the Crown jewels. They were displayed together in order to assuage the growing concern of the populace, which had caught wind of the planned sale. The final decision to sell a number of the Easter eggs was, after some uncertainty, made by the Commissariat on 17 June 1927. This was rapidly followed by an announcement by Wartski, jewellers in Llandudno and London, that they had spent £100,000 on Russian treasures.[17] This 'haul' does not mention any Easter eggs, except for the Sedan Chair with Blackamoors, the 'surprise' of the 1914 Catherine the Great (Grisaille) Egg. From this time onwards Wartski went on to acquire and sell a total of 13 imperial eggs, the last being the Third Imperial Egg of 1887.

In 1934 a first significant auction was held at Christie's in London dedicated to 87 *objets d'art* by Fabergé including his First Hen Egg of 1885, which sold for £85. A Fabergé Renaissance rock-crystal reliquary, formerly owned by Empress Maria but no longer recognized as an imperial egg, was sold for £110. An extraordinary exhibition of Russian art, the first of its kind, was held in August 1935 at the house of Madame Koch de Gooreynd, at 1 Belgrave Square, in aid of the Russian Red Cross. The exhibition included more than 150 articles by Fabergé, including eight imperial eggs. The catalogue illustrated the 1897 Coronation Egg, the 1906 Swan Egg, the 1908 Peacock Egg and the 1911 Bay Tree Egg.

One of Wartski's wealthiest clients, the beer baron Arthur E. Bradshaw, at one time owned 500 decorative art objects, a large number of them by Fabergé, including the 1897 Coronation Egg and the 1898 Lilies of the Valley Egg[18] as well as the 1911 Bay Tree Egg. Another assiduous collector, Charles Parsons, of whom little more is known than his name, acquired three imperial eggs in 1935 including the 1898 Lilies of the Valley Egg and the 1895 Rosebud Egg.[19] A mysterious Colonel Kolb also acquired a number of Wartski's Fabergé eggs. Other British luminaries included Sir Bernard Eckstein, who at one time was a major Fabergé collector and owned the 1913 Winter Egg.[20]

Meanwhile, the Soviet-friendly entrepreneur Armand Hammer, active in Russia on behalf of American business interests soon after 1921, organized shipments of Russian artifacts to New York.[21] These included 10 Fabergé Imperial Easter Eggs given to Hammer by the Bolshevik Federal Government in 1930. During the Great Depression, even the most established of American fortunes had faltered. To offset the devastating effects of this economic downturn, Hammer struck on the idea of marketing these works of art through department stores. He cleverly orchestrated a six-month travelling exhibition entitled *Russian Imperial*

184
Display of 13 imperial eggs and Russian imperial regalia at the Gokhran, Moscow, 1923. The future of the state valuables was defined according to the decision of a commission formed in 1922 and comprised of leading experts from the Hermitage Museum, the Historical Museum and the Academy of Sciences among others.

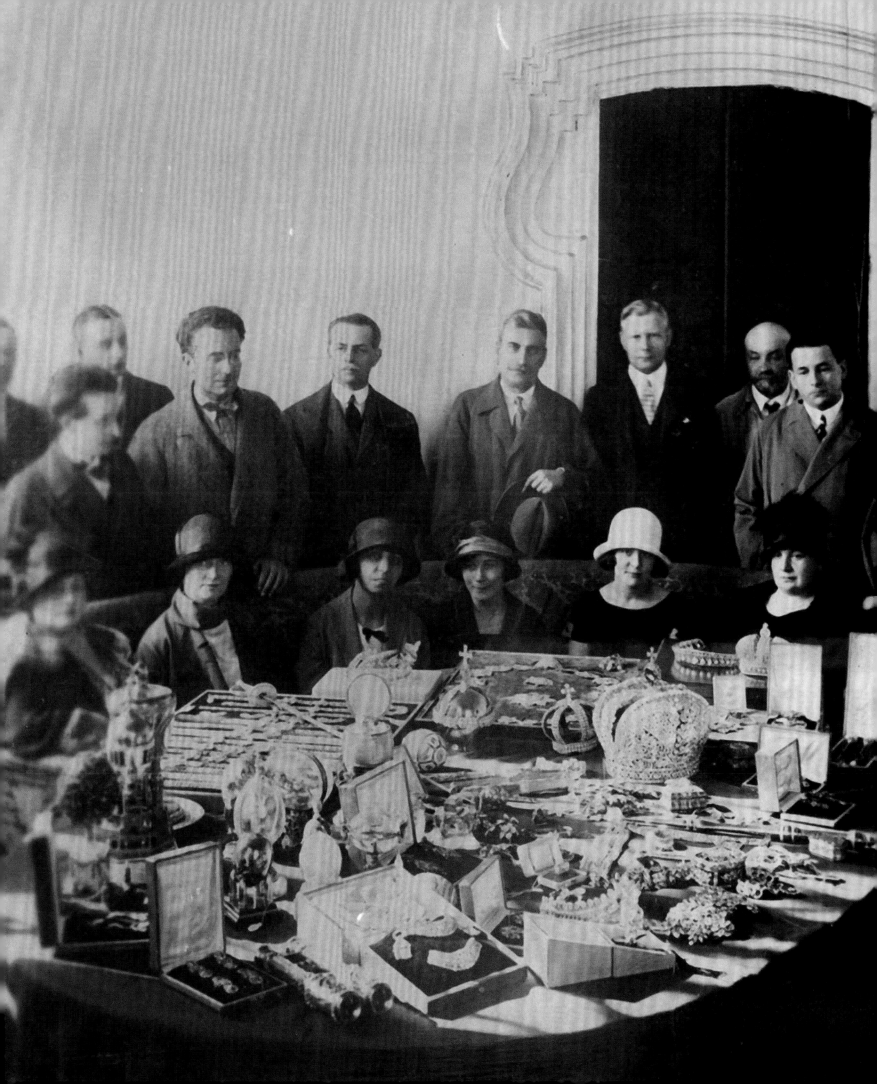

Treasure, which appeared in 12 stores nationwide ending at Lord and Taylor, New York, in 1933. As an agent of the young Bolshevik Republic, working hand-in-hand with Anastas Mikoyan, Commissar for Foreign and Domestic Trade, Hammer opened his own Hammer Galleries at Lord and Taylor. A further showing was held at Marshall Fields in Chicago during the World's Fair of 1933–4. *The New York Times* announced on 2 January 1933: 'Jewelry of Czar on view this week. Gift Easter Eggs Encrusted with Gems among pieces bought in Russia by Dr. Hammer'. They were estimated collectively at $1 million and included the 1896 Revolving Miniatures Egg and the 1912 Tsarevich Egg.[22] Even the humblest object sold by Armand Hammer was supplied with a small parchment certificate embossed with a double-headed eagle, attesting to its provenance from one or other member of the imperial family.

It is at these venues and further exhibitions held in 1937 and 1939 that the Fabergé objects attracted the interest of a quartet of dedicated ladies – Matilda Geddings Gray, Marjorie Merriweather Post, Lillian Thomas Pratt and India Early Minshall – whose collections would respectively embellish museums in New Orleans (presently on long-term loan at the Metropolitan Museum, New York); Hillwood, Washington D.C.; Virginia and Cleveland. Between them they owned 12 Imperial Easter Eggs.[23] The first Fabergé egg to be negotiated on American soil was the 1914 Catherine the Great Egg,[24] sold by Hammer to Eleanore Barzin in 1931 for $12,500. Eleanore presented it to her mother, Marjorie Merriweather Post of Postum Cereal Company fame, for her birthday. This was the first sale of an imperial egg in America to a client with celebrity status.

Another specialist in Russian art, a colleague and later competitor of Armand Hammer, Alexander Schaffer, together with his wife Ray,[25] opened a gallery named Russian Imperial Treasures, where they showed the 'Schaffer Collection of Authentic Russian Imperial Art Treasures' in 1933. This

would become A La Vieille Russie in 1941, which after the demise of the Hammer Russian Galleries, remains until this day the main source of Fabergé in the United States. A La Vieille Russie held a number of major Fabergé exhibitions in 1949, 1961, 1968, 1983 and 2000. One of their major clients was King Farouk of Egypt, whose collections after his abdication were sold in Cairo by Sotheby's in 1953.[26] His extensive holdings in precious objects with some 180 items by Fabergé included the 1906 Swan Egg and the 1898 Kelch Hen Egg.[27] Among the most voracious and discerning early American collectors of Fabergé's work were Jack and Belle Linsky of Swingline Staples fortune, who owned the Renaissance Egg,[28] shipping magnate Lansdell Christie of Long Island who owned three Fabergé eggs, as well as celebrities Bing Crosby and Frank Sinatra.

Malcolm Forbes (1919–1990), the American businessman, owner-publisher of *Forbes* magazine and promoter of capitalism, known for his opulent lifestyle and keen business savvy, became the leading Fabergé collector beginning in the 1960s.[29] His first Fabergé egg, commissioned from the firm by Consuelo Vanderbilt, Duchess of Marlborough, in 1902,[30] was acquired by Forbes in 1963 through his advisors A La Vieille Russie.[31] Forbes assembled the most prestigious Fabergé collection in the United States, including 12 Easter eggs and approximately 320 other art objects. Apart from providing the excitement of the chase, his collection served another purpose, acting as 'trophies of capitalist triumph' to be pursued with great zeal and generously loaned to exhibitions. He had some of his hot air balloons decorated as Fabergé eggs and baptized his DC-9 jet 'Capitalist Tool'. One wonders what the Russian response would have been on seeing the 'Capitalist Tool' land at Moscow's Sheremetyevo Airport, when transporting nine of Forbes's Imperial Easter Eggs to the 1994 Easter Egg exhibition at the Kremlin.

One satisfying moment in Forbes's career

185
American businessman and publisher
Malcolm Forbes with a selection of
Imperial Easter Eggs from his Fabergé
collection.

came in 1979, when he acquired two of the most
iconic Fabergé imperial eggs from Wartski by
private treaty – the 1897 Coronation Egg and
1898 Lilies of the Valley Egg – for the sum of
£532,000 ($2,160,000).[32] Another such moment
may have occurred in 1985, when he secured the
1900 Cockerel Egg at Sotheby's for £1,375,000
($1,760,000),[33] prompting the auctioneer to
announce, as if in a soccer match: 'Forbes 11 –
Kremlin 10', which was used as a headline in *The
New York Times*. This referenced the number of
Fabergé imperial eggs held by the Moscow Armoury
Museum, now outdone by Forbes, as the latest score
in the ongoing Fabergé egg race.

Following the death of Malcolm Forbes, his
sons decided to sell the remainder of the collection
comprising more than 200 objects by Fabergé
and including nine Imperial Easter Eggs at an
auction by Sotheby's in 2004. This was a welcome
opportunity for Russia to strike back. Rather
than await the auction, the patriotic billionaire
Russian entrepreneur, Viktor Vekselberg, was able
to acquire the entire collection for just over $100
million.[34] Vekselberg was quoted as saying that this
was 'perhaps the most significant example of our
cultural heritage outside Russia. This is a once in a
lifetime chance to give back to my country one of its
most revered treasures', thus, making them available

186
Interior of the Fabergé Museum,
created within the Shuvalov Palace,
St Petersburg.

to the Russian people. True to his word, they are presently shown, together with about 1,000 of his other Fabergé treasures, at the lavishly embellished Shuvalov Palace on the Fontanka Canal, which has become a leading attraction in St Petersburg.

Major beneficiaries of the rapidly increasing number of Fabergé auctions included a couple of truly passionate Houston collectors: the late Artie McFerrin, a hugely successful businessman in the chemical and petroleum industry, after whom the Texas University Department of Engineering is named, and his wife Dorothy, both major philanthropists.[35] They began their quest to amass a Fabergé collection in 2005 and have since acquired the largest collection in the United States comprising over 600 objects. Among them are featured the 1902 Kelch Rocaille Egg[36] and the 1892 imperial Diamond Trellis Egg,[37] whose 'surprise', a mechanized diamond-set ivory elephant, was recently discovered in the Royal Collection Trust. The McFerrin Collection is on long-term view at the Houston Museum of Natural Science.

The degree to which Fabergé eggs have appreciated at auction[38] is illustrated by the prices paid for the 1913 Winter Egg: in 1949 £1,870, in 1994 £3,560,539 and in 2002 £6,872,000; the 1900 Cockerel Egg sold in 1973 for £82,666 and in 1985 for £1,375,000. Eleven imperial eggs have been sold at auction, of which one (the Winter Egg) has sold three times, and the Cockerel Egg twice. Ten non-imperial eggs have been sold at auction, of which two (the 1900 Pine Cone Egg and the Nobel Egg) have been sold twice.[39] It is noteworthy, that the auction record is presently held by a 'non-imperial' egg, the 1902 Rothschild Clock Egg, sold in 2007 for £9,980,000. It was acquired amid much fanfare by the Russian businessman Alexander Ivanov, founder of the Fabergé Museum in Baden-Baden, where it was temporarily exhibited, only to reappear as President Vladimir Putin's gift to the Hermitage Museum in St. Petersburg on the occasion of its 250th anniversary in 2014.

Fabergé's Third Imperial Egg, created for Empress Maria Feodorovna in 1887 and acquired at a little over scrap value in the American Midwest for $13,302 several years ago, is rumoured to have been sold by Wartski for £20 million ($33 million). Kieran McCarthy of Wartski is quoted as saying of its discovery: 'we doubt everything, but this story is so wonderful you couldn't really make it up – it is beyond fiction and in the legends of antique dealing, there is nothing quite like this'. 'I was flabbergasted – it was like being Indiana Jones and finding the Lost Ark.'[40]

Carl Fabergé's prestigious reputation and the public's continued fascination with his works is acknowledged by the many international exhibitions devoted to the goldsmith. Sir Roy Strong (b.1935), director of the V&A between 1973 and 1987, believed that for an exhibition to be successful it required 'jewellery', 'sex' or 'Fabergé'. The legendary 1977 exhibition at the V&A, *Fabergé 1846–1920*, organized by A. Kenneth Snowman of Wartski, was appropriately successful, attracting 150,000 visitors.[41] The first major exhibition on the European Continent, *Fabergé Hofjuwelier der Zaren*, under the aegis of Johann Georg, Prince von Hohenzollern, director of the Munich Kunsthalle, in 1986/87, with the present author as curator, attracted 250,000 visitors.[42] Ten years later, in 1996, *Fabergé in America* saw the prestigious Metropolitan Museum of Art in New York obliged to close its doors to the public during some weekends, given the unexpected number of visitors (400,000 in New York alone and a total of one million including the four further venues nationwide).[43]

The chequered life of the post-Revolutionary Fabergé brand took another turn when, following Carl Fabergé's death in exile in Switzerland in 1920, two of his sons, Eugène and Alexander, founded Fabergé et Cie in Paris in 1924 with a view to continuing production and restoring damaged artifacts. Due to the advent of the Art Deco style around 1925, which stood in stark

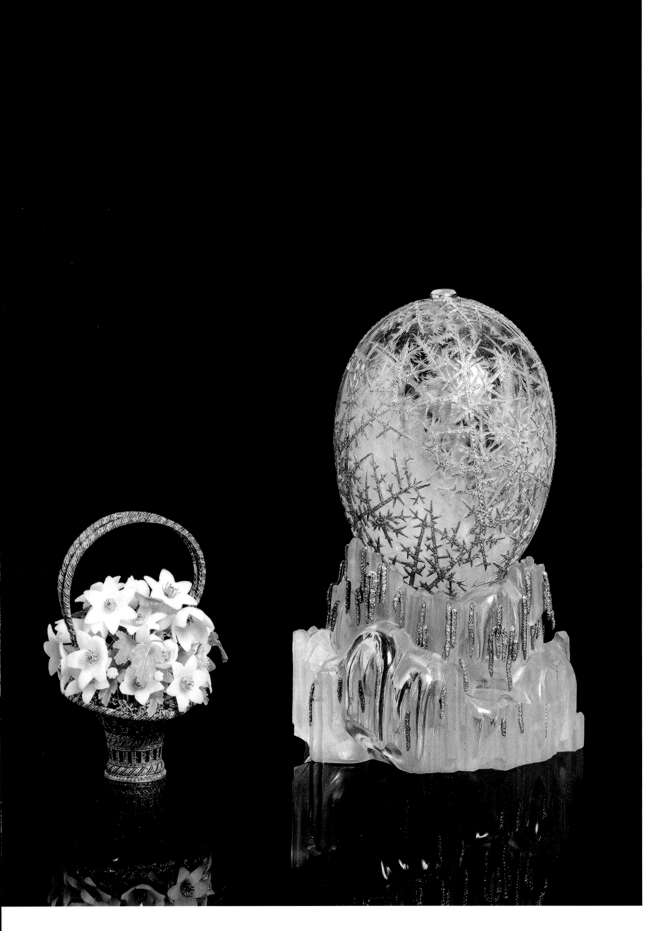

187
WINTER EGG, CONTAINING
BASKET OF WOOD ANEMONES,
1912–13

Designed by Alma Pihl (1888–1976)
and made in the workshop of her uncle,
Albert Holmström (1876–1925),
St Petersburg
Rock crystal, platinum, chrysolite,
diamonds, demantoid garnets; h. 14.2 cm
Presented by Emperor Nicholas
II to the Dowager Empress Maria
Feodorovna, Easter 1913
Private Collection

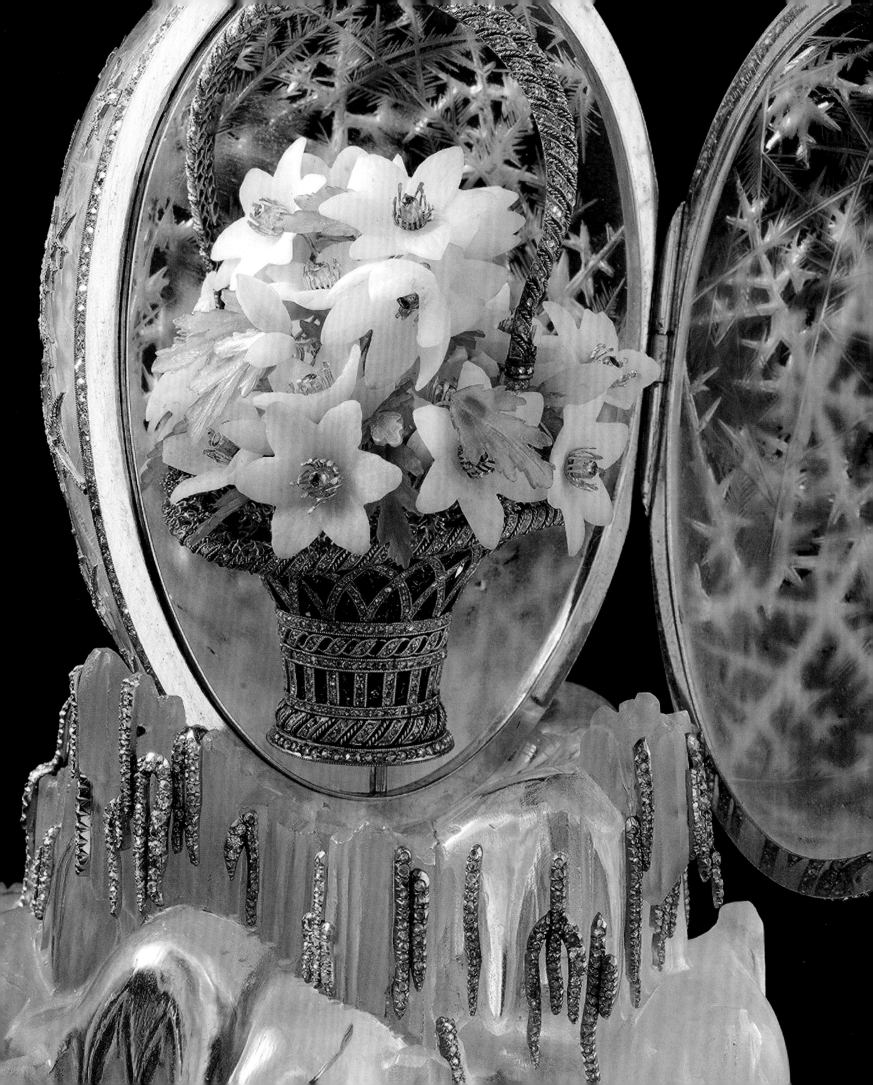

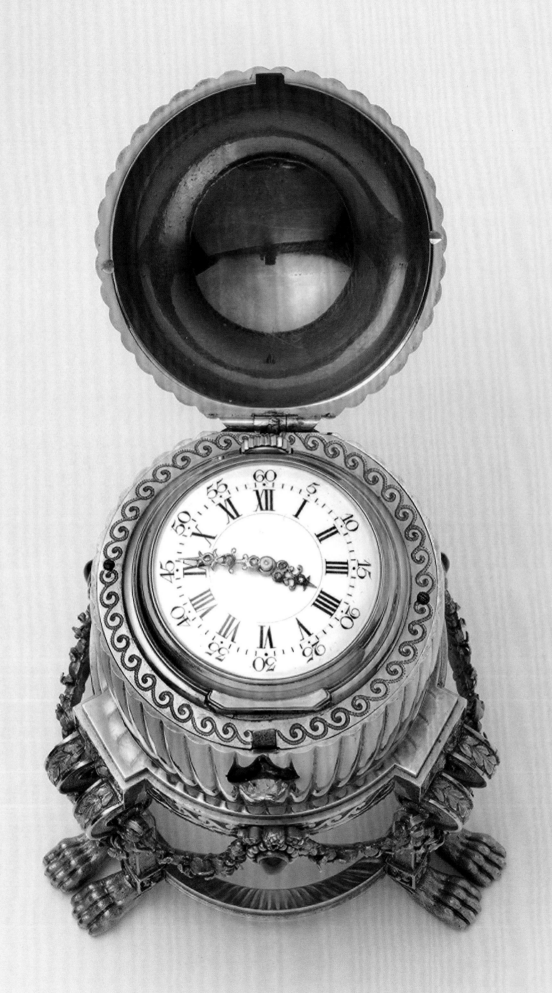

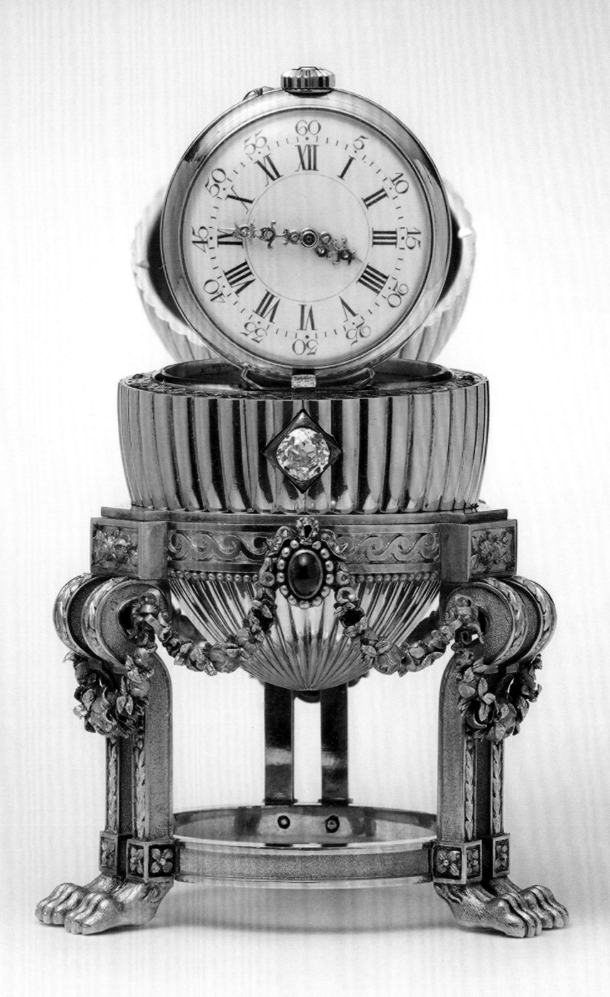

contrast to Fabergé's creations, their attempts were unsuccessful. Other family members active in the West after the Revolution were two sons of Agathon: Theodore Fabergé (1904–1971) working for the Geneva jeweller Lombard, and his brother Igor (1907–1982), also in Geneva, acting as jeweller and designer for Franklin Mint. Another grandson of Carl's, Theo (1922–2007), son of Nicholas, was known as a gifted award-winning wood-turner.[44]

Unbeknown to the Fabergé family, a Russo-American entrepreneur, Sam Rubin, started a perfume business in 1937 which, on the advice of his friend Armand Hammer, he fraudulently called 'Fabergé'. To avoid expensive legal proceedings the family, rather than sue, settled out of court for the paltry sum of $25,000, allowing the name's use only for perfume. Rubin sold Fabergé Inc. in 1964 to George Barrie's cosmetics company, Rayette, for $26 million. After actor Cary Grant's retirement from the film business in 1966, Barrie invited him to become a director and creative consultant to Fabergé Inc. in 1968. His salary was a modest $15,000 a year, but he had the use of a New York penthouse and the company's jets, which he gladly used, as did his friend and fellow actor Roger Moore, who also joined Fabergé as a board member and brand ambassador in 1970. Another celebrity involved with the Fabergé brand name was the model Margaux Hemingway, who in 1977 was paid $1 million to act as 'spokesmodel' for *Babe*, a Fabergé fragrance. This contract was reported to have been the largest single advertising contract ever involving a female personality. Also in 1977, Farrah Fawcett, of TV series *Charlie's Angels* fame, signed a seven-figure deal with Fabergé to create her own line of hair care products. The cosmetic company's most profitable and wildly successful product, however, was *Fabergé Brut*, launched in 1964 and to which Elvis Presley, Sylvester Stallone and soccer stars Franz Beckenbauer and Paul Gascoigne subscribed. In 1972 Barrie founded Brut Film Productions, an offshoot of Fabergé. One of the first films produced

in 1973, and perhaps the short-lived company's most successful, was *A Touch of Class* with Glenda Jackson and George Segal, which won the actress an Oscar. Fabergé, together with the cosmetics brand Elizabeth Arden, was acquired by Unilever in 1989 for $1.55 billion. Unilever operated the Fabergé brand as a licensing business, with the German jewellery company Victor Mayer successfully using the name 'Fabergé' for egg-shaped objects as well as for jewellery.[45]

In 2007 the Pallinghurst Resources private equity fund acquired the Fabergé brand from Unilever with the intention of restoring the name to its former glory. Theodore and Tatiana (1930–2020) Fabergé, respectively grandson and great-granddaughter of Carl Fabergé, together with Sarah, Theo's daughter (b.1958), became Founder Members of the Fabergé Heritage Council in an advisory capacity. The modern manifestation of Fabergé specializes in complicated watches and jewellery. As in Carl Fabergé's time, bespoke plays an important role in the firm's present-day creations, with buyers able to select gemstones from the mines of Gemfields, Fabergé's parent company. The company has also produced a small number of jewelled eggs in homage to Fabergé's original creations, including the Pearl Egg, made for a Middle Eastern connoisseur, and the Spirit of Ecstacy Egg, made for Rolls Royce. The degree to which Fabergé's iconic Easter eggs are now celebrated as status symbols can be judged by the number of films and documentaries in which they have appeared, in either central or peripheral roles.[46] The earliest may be Albert R. Broccoli's 1983 film *Octopussy*, thirteenth in the James Bond series, in which Roger Moore as MI6 agent 007 takes part in the auction of a poor rendition of the Coronation Egg. The film is based on a short story titled 'Property of a Lady', commissioned in 1963 by Sotheby's from Ian Fleming, which appeared a year later in a serialized version in *Playboy* magazine. *Love among Thieves* (1987), Audrey Hepburn's last film, is an improbable story about the theft of several

Previous spread
188
THIRD IMPERIAL EGG,
CONTAINING VACHERON
CONSTANTIN WATCH, 1886–7

Workmaster August Holmström
(1829–1903), St Petersburg
Gold, sapphires, diamonds; h. 8.2 cm
Presented by Emperor Alexander III to
Empress Maria Feodorovna, Easter 1887
Private Collection

Fabergé eggs. *Ocean's Twelve* (2004) became a hugely popular film, which grossed over $362 million compared to a budget of $110 million, and involved the theft of another version of Fabergé's Coronation Egg. The disappearance of Fabergé's Winter Egg, worth $20 million, is central to the plot of the 2008 film *Cold Play*, while a Fabergé egg thief appears in one of the episodes of the TV series *Murder She Wrote* – 'An Egg to Die For' (1994). Fabergé eggs even feature in cartoons including *The Simpsons* (1995) and *Scooby Doo* (2012). The ultimate accolade came in 2011 with the French film *Les Intouchables*, which broke box office records worldwide. Based on a true story, it relates the unexpected friendship that develops between a handicapped aristocrat and his carer, an ex-convict, despite the fact that the latter steals a prized Fabergé egg during his job interview. No other artifacts have received such cult status throughout both the art world and popular culture. They are symbols not only of the splendour, power and wealth of the Romanov dynasty but also priceless treasures to be tempted by – quite a legacy for the Russian goldsmith.

189
Poster for the James Bond film
Octopussy, 1983.

THE MISSING NÉCESSAIRE EGG

FABERGÉ'S FAMOUS IMPERIAL EASTER EGG COMMISSION consisted of 52 eggs. Only 50 were ever delivered to the Emperors; the First World War followed by growing revolutionary fervour in Russia prevented the last two from reaching their destination. Of the remaining Easter eggs, the whereabouts of 43 are documented. Out of the seven missing examples, two are known to have survived the chaos of early twentieth-century Russia. The search for these eggs, one of which was last seen in London in 1952, has been – and still is – the subject of intense investigation.

The egg that was last seen in London is the Nécessaire Egg, given by Emperor Alexander III to his wife Maria Feodorovna for Easter 1889. This distinctive small gold egg, decorated with wave-like motifs and mounted with jewels, contains 13 diamond-set toilet articles. In 1917, as German forces threatened St Petersburg, the Provisional Government confiscated the imperial family's treasures and moved them to the Moscow Kremlin for safekeeping. Among the items taken was a 'Gold Nécessaire egg, decorated with multi coloured precious stones'. Between 17 February and 24 March 1922 responsibility for the eggs was transferred from the Kremlin Armoury to the Council of People's Commissars, and included in the transfer was '1 gold Nécessaire egg, with diamonds, rubies, emeralds and 1 sapphire'. Like many of the other imperial treasures, the egg was later sold by the Bolsheviks to fund their industrialization programmes.

It subsequently appeared in London at the Fabergé specialists, Wartski. In November 1949 Wartski staged their first exhibition devoted to Fabergé's work at their Regent Street premises. Having lost its imperial history in the interim, the egg was lent anonymously to the exhibition, in which it was described as: 'A fine gold egg, richly set with diamonds, cabochon rubies, emeralds, a large coloured diamond at top and a cabochon sapphire at point. The interior is designed as an Etui with thirteen diamond set implements.'

Within the following three years Wartski acquired the egg and on 19 June 1952 sold it to a buyer, identified in the ledgers only as 'A Stranger', for £1,250. The purchaser, whose anonymity was discreetly but frustratingly safeguarded throughout their records, remains unidentified. This was the last occasion on which the priceless missing Imperial Nécessaire Egg was recorded. Who was the stranger, and where is the egg now?

190
An archival photograph, discovered by
British researcher Kellie Bond, showing
a group of Russian treasures. On the
left is the missing Imperial Nécessaire
Egg, and beside it is an imperial gold
chalice of 1791, commissioned by
Catherine the Great.

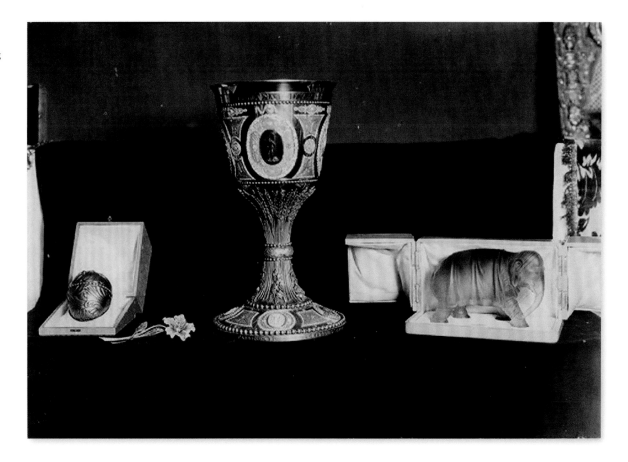

SELECTED WORKS

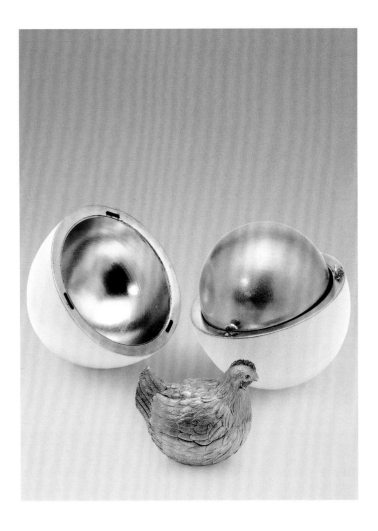

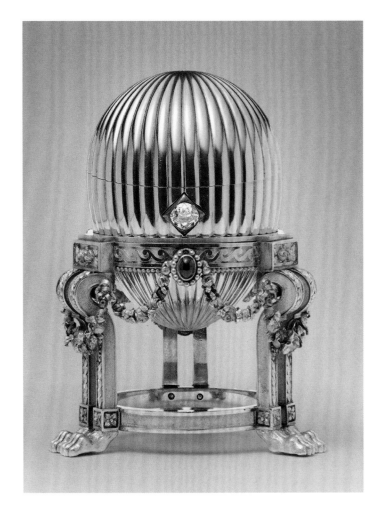

191
HEN EGG, 1884–5

St Petersburg
Gold, enamel, rubies; h. 6.4 cm
Presented by Emperor Alexander III to Empress Maria Feodorovna, Easter 1885
'The Link of Times' Foundation, Fabergé Museum, St Petersburg

The first of the series of Imperial Easter Eggs, the opaque white enamelled outer shell of the golden egg opens to reveal a gold yolk, within which sits a plump coloured gold hen with ruby eyes. Originally, the hen in turn contained a jewelled replica of the Imperial Crown with a ruby pendant egg, both of which are missing. The egg is modelled on earlier European works of art representing Easter eggs (see pl. 180).

192
THIRD IMPERIAL EGG, 1886–7

Chief workmaster August Holmström (1829–1903), St Petersburg
Gold, sapphires, diamonds; h. 8.2 cm
Presented by Emperor Alexander III to Empress Maria Feodorovna, Easter 1887
Private Collection

The jewelled and ridged yellow-gold egg, resting on a tripod pedestal encircled by coloured gold garlands suspended from cabochon blue sapphires, topped with rose diamond-set bows, stood on chased lion's paw feet. It contains a surprise of a lady's watch by Vacheron Constantin, with a white enamel dial and openwork diamond-set gold hands. The watch has been taken from its case in order to be mounted inside the egg and is hinged, allowing it to stand upright (see pl. 188).

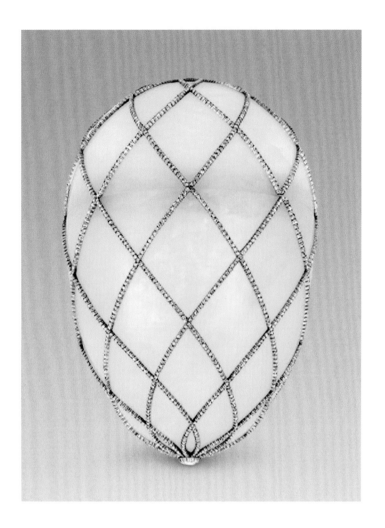

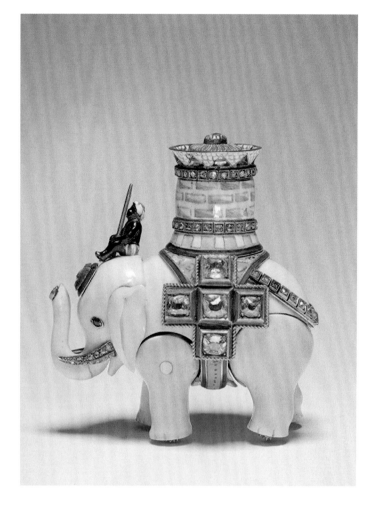

193
DIAMOND TRELLIS EGG, 1891–2

Workmaster August Holmström (1828–1903), St Petersburg
Bowenite, diamonds, gold, silver; 10.8 x 6.7 x 6.5 cm
Presented by Emperor Alexander III to Empress Maria Feodorovna, Easter 1892
Artie & Dorothy McFerrin Collection at the Houston Museum of Natural Sciences
(McF 287)

194
AUTOMATON ELEPHANT SURPRISE,
DIAMOND TRELLIS EGG, 1891–2

Chief workmaster Michael Perchin (1860–1903), St Petersburg
Ivory, gold, diamonds, enamel, brass, nickel; 6.0 x 5.5 x 3.4 cm
The Royal Collection / H.M. Queen Elizabeth II (RCIN 9268)

Carved from pale green bowenite, this egg is enclosed in a lattice of rose-cut diamonds with gold mounts. Originally, it had a base with three cherubs that held the egg. The cherubs were said to represent the three sons of the imperial couple: the Grand Dukes Nicholas, George and Michael. The surprise contained within the egg – an automaton in the form of an elephant – was missing until 2015, when it was located in the Royal Collection, London.

The miniature elephant automaton is almost identical to the badge of the Danish Order of the Elephant, the most senior order of chivalry in Denmark, except that it is made of ivory rather than white enamel and it incorporates a mechanism. The elephant is wound with a watch key through a hole hidden underneath the diamond cross on its side. It walks on ratcheted wheels and lifts its head up and down.

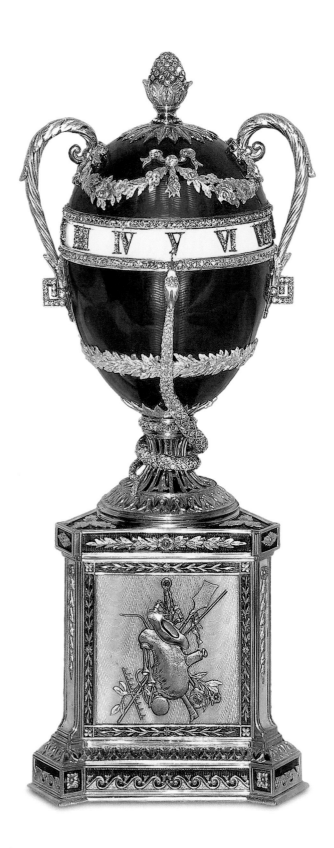

195
BLUE SERPENT CLOCK EGG, 1894–5

St Petersburg
Gold, enamel, diamonds; h. 18.5 cm
Presented by Emperor Nicholas II to Dowager Empress Maria Feodorovna,
Easter 1895
Archives du palais de Monaco

A jewelled and enamelled gold egg in the Louis XVI style
designed as a rotary clock, the diamond snake encircling it
telling the time with its extended tongue. The triangular base
is decorated with applied gold motifs representing the arts and
sciences. Emperor Alexander III died in October 1894 and this
Egg, which would have been his gift to the Empress, was instead
presented to her by Alexander's son and heir, Nicholas II.

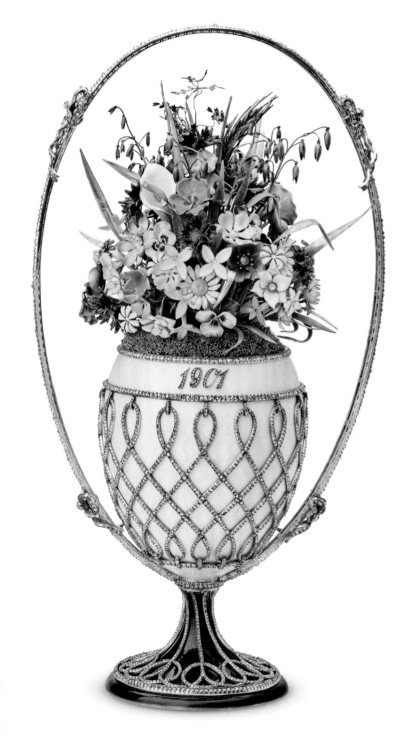

196
BASKET OF WILDFLOWERS EGG, 1900–1

St Petersburg
Gold, silver, enamel, diamonds; 23 x 10 cm
Presented by Emperor Nicholas II to Empress Alexandra Feodorovna, Easter 1901
The Royal Collection / H.M. Queen Elizabeth II (RCIN 40098)

The translucent white enamel egg, designed as a vase with
interlacing rose diamond-set ribbons, contains a colourful
abundance of enamelled wildflowers emerging from a bed of
gold moss, the overarching handle set with rose diamonds and tied
with rose diamond bows, the tapering base later enamelled blue.
Empress Alexandra, who owned several Fabergé flower works, kept
the egg in her study at the Winter Palace. It was shown at the 1902
charity exhibition held at the Von Dervis mansion in St Petersburg.

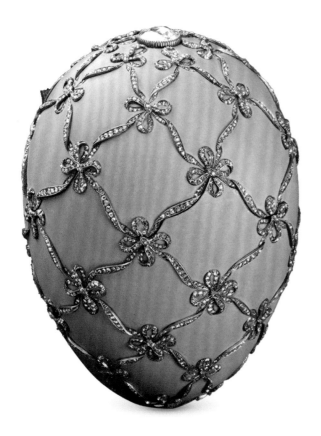

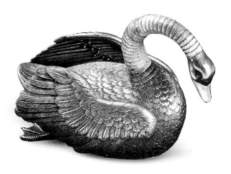

197
SWAN EGG, 1905–6

St Petersburg
Gold, enamel, platinum, aquamarine, diamonds;
egg: 10.1 x 7.3 cm; swan: 4.3 x 2.9 x 5.7 cm; basket: 5.5 x 5.2 cm
Presented by Emperor Nicholas II to Dowager Empress Maria Feodorovna,
Easter 1906
Private Collection

The egg's gold shell is enamelled opaque matt lilac and encircled
by diamond ribbons tied with bows. It is topped by a diamond
over the date 1906. The surprise is a silver-plated gold swan
automaton, modelled on a life-size 18th-century automaton in
the Bowes Museum, Barnard Castle, County Durham, made by
the British inventor James Cox. Fabergé may have seen the Cox
swan when it was displayed at the 1867 Paris Exposition. Here,
it sits in an aquamarine pool, applied with delicately chased
coloured gold lily pads. When wound up under one wing,
chased gold feet guide the bird along its course; it wags its tail in
characteristic manner.

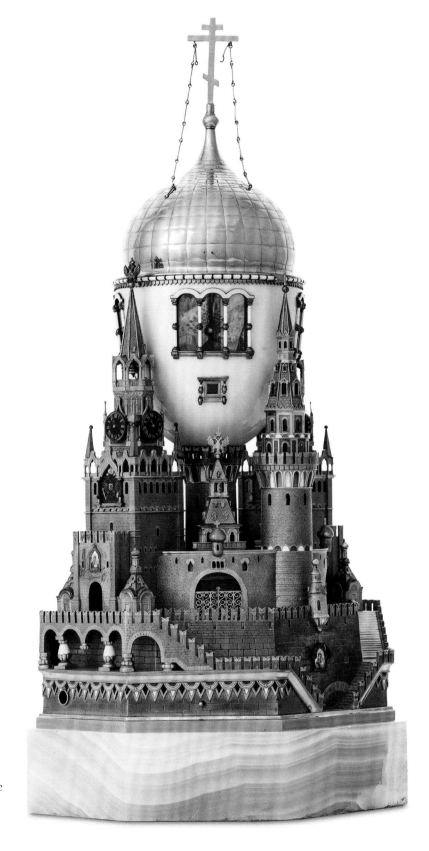

198
MOSCOW KREMLIN EGG, 1904–6

St Petersburg

Gold, silver, onyx, glass, enamel; 36.1 x 18.5 x 17.5 cm
Presented by Emperor Nicholas II to Empress Alexandra Feodorovna, Easter 1906
The Moscow Kremlin Museums (MP-647/1)

This egg is inspired by the Uspenski Cathedral of the Moscow
Kremlin, where the Russian Emperors were crowned. The glass
windows of the opaque white enamel egg allow a glimpse into
the interior of the Cathedral, with its miniature icons, carpets
and High Altar. It is topped by a gold cupola and supported on
a red gold representation of the towers, staircases and turrets
of the Kremlin. The duplicated models of the Spasskaya Tower,
bearing the coats of arms of the Russian empire and Moscow, are
each mounted with a clock face. Within is a music box, wound
by a gold key, which plays Nicholas II's favourite hymn, 'Izhe
Kheruvimy' (Song of Cherubim).

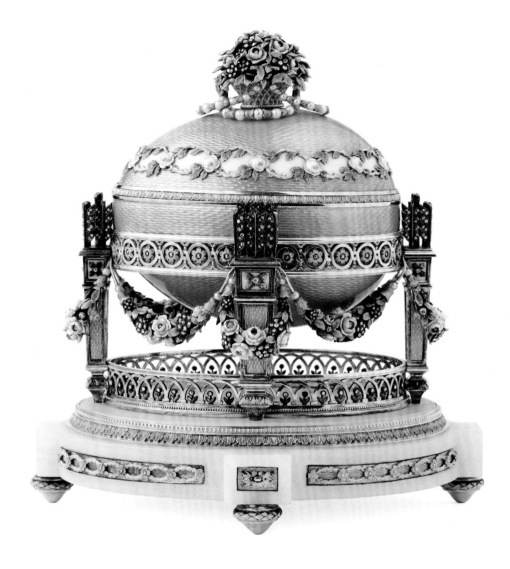

199
CRADLE WITH GARLANDS EGG, 1904–7

Chief workmaster Henrik Wigström (1862–1923), St Petersburg
Gold, enamel, onyx, pearls, diamonds; h. 14.6 cm
Given by Emperor Nicholas II to his mother
Dowager Empress Marie Feodorovna for Easter, 1907
Private Collection

From 1890 onwards the Imperial Easter Eggs frequently
reflected events in the imperial family's life and the state of
Russia. After the birth of four daughters the Romanov dynasty
yearned for a male heir to Emperor Nicholas II and Empress
Alexandra. In 1904 their prayers were answered by the birth of
Tsarevich Alexei, who they believed would continue ruling in the
Romanov name. The Cradle Egg marks their joy at his birth and
his family's love for him. The diamond quivers, filled with arrows,
are tokens of enduring love and the enamelled gold pink roses
adorning the egg represent happiness in the language of flowers.
Its delivery was delayed by the Russo-Japanese War of 1904–5,
during which no eggs were made.

200
PEACOCK EGG, 1907–8

Chief workmaster Henrik Wigström (1862–1923), St Petersburg
Rock crystal, gold, silver-gilt, enamel; 19 x 16 x 11 cm
Presented by Emperor Nicholas II to Dowager Empress
Maria Feodorovna, Easter 1908
Private Collection

The rock crystal shell of the egg reveals its surprise of an
enamelled gold peacock automaton, perched in the branches of
a coloured gold tree with jewelled and enamelled flowers. The
peacock, when taken out of the egg and wound up, proudly struts
about, fanning out its tail feathers. Like the automaton of the
Swan Egg, this surprise was also inspired by a work by the British
inventor James Cox, this time the Peacock Clock, housed in the
Winter Palace in St Petersburg.

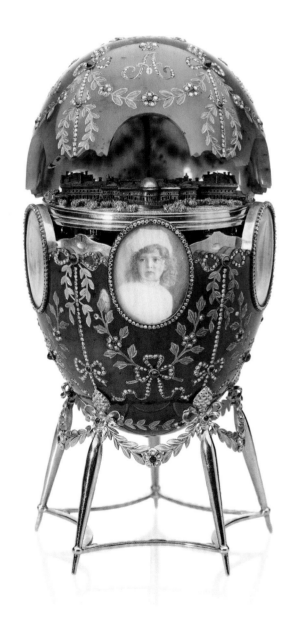

201
ALEXANDER PALACE EGG, 1908

Chief workmaster Henrik Wigström (1862–1923), St Petersburg
Nephrite, gold, silver, diamonds, rubies, enamel, crystal, ivory, watercolour on ivory;
h. 11 cm
Presented by Emperor Nicholas II to Empress Alexandra Feodorovna, Easter 1908
The Moscow Kremlin Museums (MP-648/1-2)

This egg celebrates the five children of Emperor Nicholas II and
Empress Alexandra Feodorovna: Olga, Tatiana, Maria, Anastasia
and Alexei. The nephrite body is inlaid with triumphal gold
laurels, flowers and bows set with rubies and diamonds and
oval diamond- framed portraits of the five children, the reverse
of each one engraved with their names and dates of birth. The
surprise is a miniature enamelled gold model of the the imperial
family's favourite residence, the Alexander Palace and gardens at
Tsarskoye Selo, mounted on a gold table.

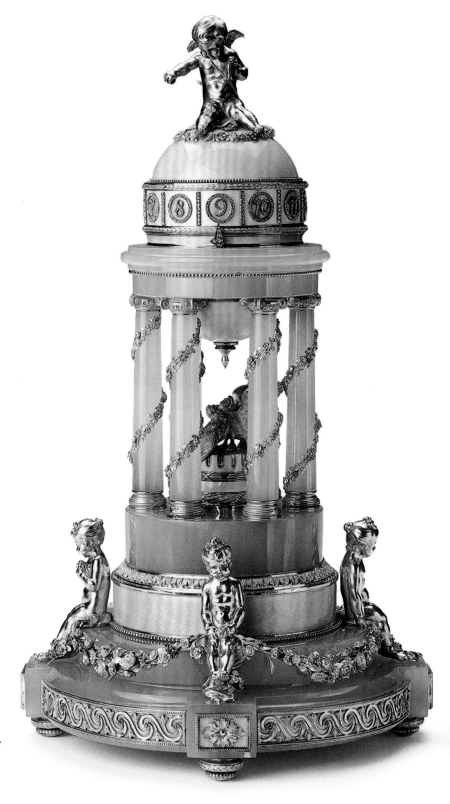

202
COLONNADE EGG, 1909–10

Chief workmaster Henrik Wigström (1862–1923), St Petersburg;
movement for the rotary clock supplied to Fabergé by Henry Moser & Cie
Bowenite, gold, silver-gilt, platinum, enamel, diamonds; 28.6 x 17 cm
Presented by Emperor Nicholas II to Empress Alexandra Feodorovna, Easter 1910
The Royal Collection / H.M. Queen Elizabeth II (RCIN 40084)

The Colonnade Egg, a gift from Emperor Nicholas II to the
Empress Alexandra Feodorovna, is an expression of his love
for his wife and children. The enamelled, jewelled and gold-
mounted bowenite egg is modelled as an Arcadian temple,
the four silver-gilt cherubs around the base representing his
daughters, the pair of doves inside his enduring relationship with
his wife, and the Cupid on top his son and heir Alexei. The figure
of Cupid, which once held an arrow with which to point to the
hour, sits above a rotary clock, communicating the message that
as time ticks by, love remains.

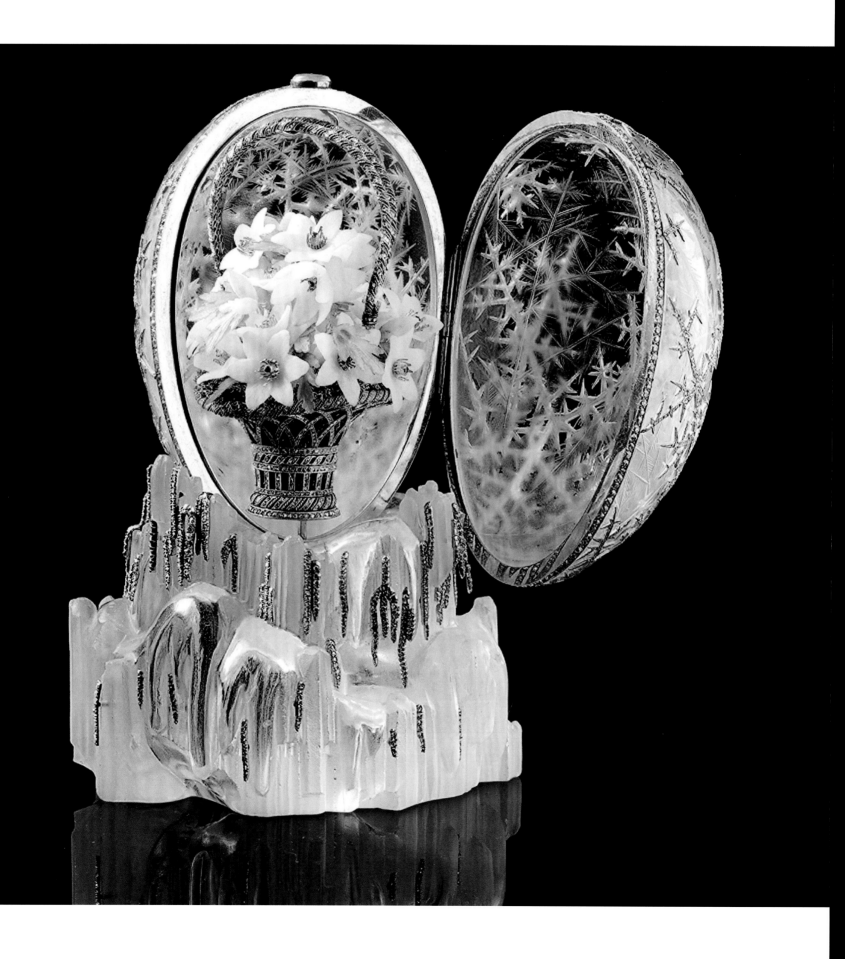

203
WINTER EGG, 1912–13

Designed by Alma Pihl (1888–1976) and made in the workshop of her uncle,
Albert Holmström (1876–1925), St Petersburg
Rock crystal, platinum, chrysolite, diamonds, demantoid garnets, moonstone;
h. 14.2 cm
Presented by Emperor Nicholas II to Dowager Empress Maria Feodorovna, Easter 1913
Private Collection

Russia's harsh yet beautiful winters inspired this poetic rock
crystal egg. Its shell is decorated with delicately engraved and
diamond-mounted platinum frost patterns. The stand is carved
from rock crystal to represent melting ice, with diamond rivulets
running from it. A cabochon moonstone sits above the egg with
the date 1913 inscribed beneath. Inside the egg is a diamond-
set platinum basket of wood anemones with chrysolite petals,
heralding the passing of winter and arrival of spring.

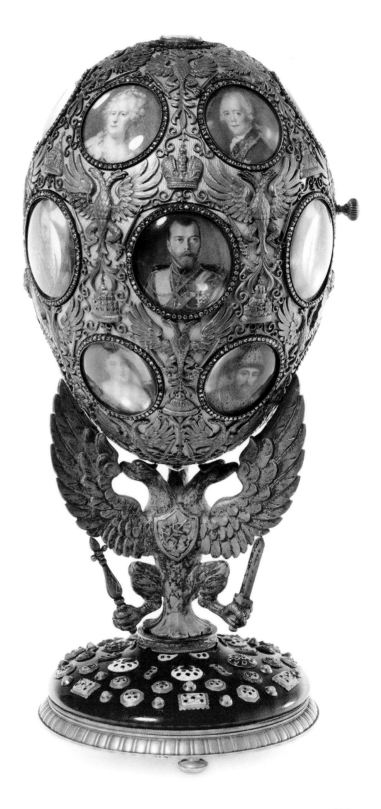

204
ROMANOV TERCENTENARY EGG, 1913

Chief workmaster Henrik Wigström (1862–1923), St Petersburg
Gold, silver, steel, diamonds, turquoise, purpurine, rock crystal, enamel, ivory,
watercolour on ivory; 19 x 7.8 cm
Presented by Emperor Nicholas II to Empress Alexandra Feodorovna, Easter 1913
The Moscow Kremlin Museums (MP-651)

In 1913 Russia celebrated the tercentenary of Romanov rule,
which began with Mikhail Fyodorovich Romanov in 1613. The
translucent white enamel egg is encased in gold double-headed
eagles and crowns and mounted with circular portraits, framed
in diamonds, of Russia's 18 Romanov rulers. It stands on a
three-sided imperial eagle, its talons holding the sceptre, orb and
Romanov sword, upon a gold-mounted domed purpurine base
with heraldic-like enamel motifs. Within the egg is a revolving
steel globe, showing in gold (for the land masses) and blue steel
(for the sea) the extent of Russia's territory in 1613 and 1913.

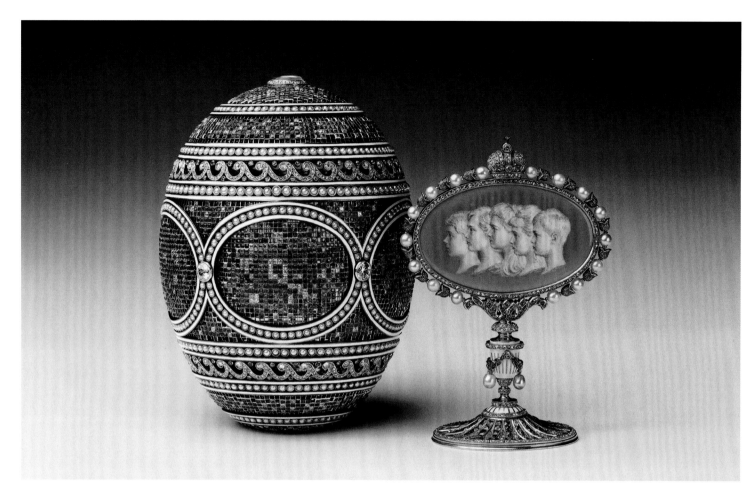

205
MOSAIC EGG, 1913–14

Designed by Alma Pihl (1888–1976) and made in the workshop of her uncle, Albert Holmström (1876–1925), St Petersburg
Gold, platinum, enamel, diamonds, rubies, emeralds, topaz, quartz, sapphires, garnets, moonstone, pearls, portrait miniature; 9.5 x 7 cm
Presented by Emperor Nicholas II to Empress Alexandra Feodorovna, Easter 1914
The Royal Collection / H.M. Queen Elizabeth II (RCIN 9022)

The Mosaic Egg is a masterpiece of goldsmithing. The tiny cells in its curving shell are cut from sheets of platinum to create a lattice in which are mounted a myriad of gemstones, imitating petit-point embroidery. The surprise is a jewelled and enamelled gold frame holding an enamel portrait of the Emperor and Empress's five children in profile, the reverse of which bears their names and the date 1914. The egg is signed 'G. Fabergé' rather than 'C. Fabergé', which is believed to be a tribute to Carl's father Gustav on the 100th anniversary of his birth in 1814.

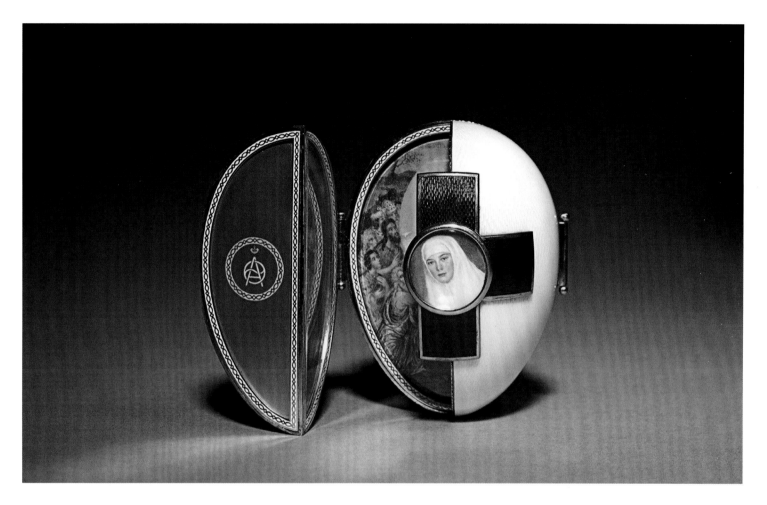

206
RED CROSS WITH TRIPTYCH EGG, 1914–15

Chief workmaster Henrik Wigström (1862–1923), St Petersburg
Gold, silver, enamel, glass, portrait miniatures; 8.6 x 6.4 cm
Presented by Emperor Nicholas II to Empress Alexandra Feodorovna, Easter 1915
The India Early Minshall Collection, The Cleveland Museum of Art, Ohio (1963.673)

With the outbreak of the First World War, the designs of the
Imperial Easter Eggs reflected the conflict. Both eggs given in
1915 adopted the theme of the imperial family's work for the
Russian Red Cross. Empress Alexandra and her two eldest
daughters, Grand Duchesses Olga and Tatiana, enrolled as
nurses. This white enamel egg, decorated with a red cross
and mounted with portraits of the Grand Duchesses in their
uniforms, opens to show the Empress's cypher, the date 1915, and
a painted enamel miniature of the Resurrection, flanked by two
portraits of St Olga and St Tatiana, their name saints.

207
CONSTELLATION EGG, 1917– (unfinished)

St Petersburg
Glass, rock crystal; h. 18 cm
Intended to be presented by Emperor Nicholas II to Empress Alexandra Feodorovna,
Easter 1917
Fersman Mineralogical Museum, Moscow (PDK-2723)

Revolution and the First World War overtook the production
of this egg and it was never finished. The blue glass orb was to
be set with diamonds depicting the constellations at the time of
Tsarevich Alexei's birth. It was to be mounted with a rotary clock
and held aloft by silver cherubs clambering over the rock crystal
clouds. The design is derived from an 18th-century French clock
illustrating the conceit of love triumphing over time. The egg was
thus a defiant declaration, in the face of revolution and ultimately
impending death, of the indifference to time and circumstance of
the imperial family's love for each other.

THE IMPERIAL FABERGÉ EASTER EGGS

The first of the Imperial Easter Eggs was given in 1885 by Emperor Alexander III to Empress Maria Feodorovna. Following the Emperor's death in 1894 his son Emperor Nicholas II continued the tradition presenting two eggs each year, one each to his mother the Dowager Empress Maria Feodorovna and his wife Empress Alexandra Feodorovna.

Fifty-two eggs were conceived, but the last two of 1917 were not delivered, due to the First World War and encroaching Russian Revolution.

No Easter eggs were given in 1904 and 1905 because of the Russo-Japanese War.

PRESENTED BY EMPEROR ALEXANDER III TO EMPRESS MARIA FEODOROVNA:

1885	Hen Egg	The Fabergé Museum, St Petersburg
1886	Hen Egg with Sapphire Pendant	Missing
1887	Third Imperial Egg	Private Collection
1888	Cherub with Chariot Egg	Missing
1889	Nécessaire Egg	Missing
1890	Danish Palaces Egg	Matilda Geddings Gray Foundation
1891	Memory of Azov Egg	Moscow Kremlin Armoury
1892	Diamond Trellis Egg	McFerrin Collection
1893	Caucasus Egg	Matilda Geddings Gray Foundation
1894	Renaissance Egg	The Fabergé Museum, St Petersburg

PRESENTED BY EMPEROR NICHOLAS II TO EMPRESSES MARIA FEODOROVNA (MF)
AND ALEXANDRA FEODOROVNA (AF):

1895	Serpent Clock Egg	MF	Archives du palais de Monaco
1895	Rosebud Egg	AF	The Fabergé Museum, St Petersburg
1896	Alexander III Portraits Egg	MF	Hillwood Museum, Washington D.C.
1896	Revolving Miniatures Egg	AF	Virginia Museum of Fine Arts
1897	Mauve Enamel Egg	MF	Missing. 'Surprise', The Fabergé Museum
1897	Coronation Egg	AF	The Fabergé Museum, St Petersburg
1898	Pelican Egg	MF	Virginia Museum of Fine Arts
1898	Lilies of the Valley Egg	AF	The Fabergé Museum, St Petersburg
1899	Pansy Egg	MF	Private Collection
1899	Bouquet of Lilies Egg	AF	Moscow Kremlin Armoury
1900	Cockerel Egg	MF	The Fabergé Museum, St Petersburg
1900	Trans-Siberian Railway Egg	AF	Moscow Kremlin Armoury
1901	Gatchina Palace Egg	MF	The Walters Art Gallery, Baltimore
1901	Basket of Flowers Egg	AF	H.M. The Queen
1902	Empire Nephrite Egg	MF	Missing
1902	Clover Egg	AF	Moscow Kremlin Armoury
1903	Danish Jubilee Egg	MF	Missing

1903	Peter the Great Egg	AF	Virginia Museum of Fine Arts
1904	No Eggs		
1905	No Eggs		
1906	Swan Egg	MF	Private Collection
1906	Moscow Kremlin Egg	AF	Moscow Kremlin Armoury
1907	Cradle with Garlands Egg	MF	Private Collection
1907	Rose Trellis Egg	AF	The Walters Art Gallery, Baltimore
1908	Peacock Egg	MF	Private Collection
1908	Alexander Palace Egg	AF	Moscow Kremlin Armoury
1909	Alexander III Commemorative Egg	MF	Missing
1909	Standard Egg	AF	Moscow Kremlin Armoury
1910	Alexander III Equestrian Egg	MF	Moscow Kremlin Armoury
1910	Colonnade Egg	AF	H.M. The Queen
1911	Bay Tree Egg	MF	The Fabergé Museum, St Petersburg
1911	Fifteenth Anniversary Egg	AF	The Fabergé Museum, St Petersburg
1912	Napoleonic Egg	MF	Matilda Geddings Gray Foundation
1912	Tsarevich Egg	AF	Virginia Museum of Fine Arts
1913	Winter Egg	MF	Private Collection
1913	Romanov Tercentenary Egg	AF	Moscow Kremlin Armoury
1914	Catherine the Great Egg	MF	Hillwood Museum, Washington D.C.
1914	Mosaic Egg	AF	H.M. The Queen
1915	Red Cross with Imperial Portraits Egg	MF	Virginia Museum of Fine Arts
1915	Red Cross with Triptych Egg	AF	The Cleveland Museum of Arts
1916	Order of St George Egg	MF	The Fabergé Museum, St Petersburg
1916	Steel Military Egg	AF	Moscow Kremlin Armoury
1917	Karelian Birch egg		Not delivered. Missing
1917	Constellation Egg		Not delivered. Unfinished elements, Fersman Mineralogical Museum, Moscow

NOTES

INTRODUCTION
Kieran McCarthy

1 Bainbridge 1949, p. 82.
2 Letter from Empress Maria Feodorovna to Queen Alexandra, 21 April 1914. Hoover Institution, Stanford.
3 Royal Archives, Windsor Castle, GV/GVD: 1 December 1894.
4 Letter from Empress Maria Feodorovna to Queen Alexandra, 18 December 1906. Hoover Institution, Stanford.
5 'Franz Birbaum, *Memoirs*', *Fabergé: Imperial Jeweller*, ed. Géza Von Habsburg & Marina Lopato (St Petersburg 1993), p. 453.
6 *Victoria Sackville-West's Diary*, 1 June 1896, Lilly Library, Indiana University.
7 Bainbridge 1933, p. 170.
8 The Bainbridge Papers are held in The Fabergé Museum, St Petersburg.
9 Pearson 1926, p. 16.
10 Phillip Larkin, 'MCMXIV', *The Whitsun Weddings* (London 1964).
11 Keppel 1958, p. 4.
12 Leaska & Phillips 1991, p. 87.

FABERGÉ IN RUSSIA
Tatiana Muntian

1 *Iskusstvo i khudozhestvennaia promyshlennost'*, 1898, no. 3, p. 212.
2 *Otchet o Vserossiiskoi khudozhestvenno-promyshlennoi vystavkie 1882 goda v Moskvie, tom III: Raboty ekspertnykh'' kommissii* (St Petersburg 1883), p. 13.
3 Castellani, an erudite firm of jewellers in Rome who focused on archaeological revival jewellery; ibid.
4 Habsburg & Lopato 1993, p. 58.
5 Russian State Historical Archive (RGIA, St Petersburg), Record Group 472, Sub-Record Group 43 (511/2840), 1910–1917, file 130, p. 1.
6 Russian State Historical Archive (RGIA, St Petersburg), Record Group 472, Sub-Record Group 43 (511/2840), 1910–1917, file 130.
7 On this egg in the Danish Royal Collections, see Tatiana Muntyan, 'Symboles d'un empire disparu', in *Fabergé: Joaillier des Romanovs* (Brussels 2005), p. 35.

8 State Archive of the Russian Federation (GARF, Moscow), Record Group 652, Sub-Record Group 1, file 380, p. 16. This important document was first discovered by archivist Rifat Gafifullin. See Gafifullin, 'O roli arkhivnykh istochnikov v atributsii proizvedenii iskusstva', in *Ekspertiza i atributsiia proizvedenii izobrazitel'nogo iskusstva. Materialy* (Moscow 1996), p. 124.
9 State Archive of the Russian Federation (GARF, Moscow), Record Group 652, Sub-Record Group 1, file 380, p. 21.
10 Krog 2002, p. 189.
11 Birbaum 1993, p. 7.
12 'les fleurs de haute lignée telles que les orchidées, délicates et charmantes, palpitantes et frileuses; les fleurs exotiques, exilées à Paris', J.-K. Huysmans, *A rebours* (Paris 1920), p. 87.
13 Krog 2002, p. 189.
14 Tatiana Muntyan, 'Simvoly ischeznuvshei imperii', *Antikvariat. Predmety iskusstva i kollektsionirovaniia*, December 2013 (12), pp. 78–9.
15 Russian State Historical Archive (RGIA, St Petersburg) Record Group 468, Sub-Record Group 8, file 1056, 1910, p. 104.
16 Iusupov 1998, p. 325.
17 Shcherbatov 2000, p. 225.
18 Krog 2002, p. 184.
19 Shcherbatov 2000, p. 131.
20 Grand Duke Gavriil Konstantinovich, *V mramornom dvortse: memuary* (Moscow 2001), p. 57.
21 Krog 2002, p. 188.
22 Matil'da Kshesinskaia, *Vospominaniia* (Moscow 1992), pp. 128, 86.
23 Ibid., p. 219.
24 Russian State Historical Archive (RGIA, St Petersburg), Record Group 468, Sub-Record Group 8, file 1056, 1910, p. 105.
25 Oksana Petruchuk, 'Paskhal'noe ozherel'e. Vospominaniia Lidii Arturovny Mitkevich-Zholtko', in Tatiana Faberzhe et al, *Faberzhe i peterburgskie iuveliry* (St Petersburg 1997), pp. 542–7.
26 State Archive of the Russian Federation (GARF, Moscow), Record Group 601, Sub-Record Group 1, file 1406, p. 255.
27 State Archive of the Russian Federation (GARF, Moscow), Record Group 826, Sub-Record Group 1, file 45, p. 255.

28 Russian State Historical Archive (RGIA, St Petersburg), Record Group 468, Sub-Record Group 43 (511/2840), file 103, 1910–17, p. 2.
29 Tatiana F. Faberzhe and Valentin V. Skurlov, *Faberzhe — 'ministr iuvelirnogo iskusstva'. Iz istorii firmy* (Moscow 2006), p. 181.
30 Birbaum 1993, p. 27.
31 Tatiana Muntyan, *Faberzhe. Velikie iuveliry Rossii. Sokrovishcha Oruzheinoi palaty* (Moscow 2000), p. 7.
32 Oleg Agafonovich Faberzhe, *Blestki, perevod s shvedskogo E. Berlin* (Moscow 1994), p. 16.
33 Russian State Historical Archive (RGIA, St Petersburg), Record Group 472, Sub-Record Group 66, file 120 (1915–1917), p. 35.
34 Birbaum 1993, p. 31.
35 Iusupov 1998, p. 325.
36 Dmitrii Dmitrievich Ivanov, 'Kamennye zver'ki russkogo granil'nogo proizvodstva', *Sredi kollektsionerov*, 1922, no. 4, p. 21.
37 Habsburg & Lopato 1993, p. 121.
38 Epikur (pseud.), 'Koe-chto o dragotsennostiakh', *Stolitsa i usad'ba*, 1914, no. 2, p. 14.
39 Birbaum 1993, p. 30.
40 The studies of the dandelion seed heads were carried out jointly with Mikhail Ignatov, an employee of the Flora Department of the Botanical Garden of the Russian Academy of Sciences, using specialized equipment.
41 Konstantin Dmitrievich Bal'mont, *"Sedoi oduvanchik", Polnoe sobranie stikhov. Tom 6. Vtoroe izdanie* [*The Complete Poems*. Vol. 6, 2nd edition] (Moscow 1911), p. 52.
42 Birbaum 1993.

THE ST PETERSBURG WORKSHOPS
Ulla Tillander-Godenhielm

1 Léon Grinberg's notes on his interviews with Andrey Plotnitksy, a goldsmith working in the Henrik Wigström workshop, dated 28 September 1951. Hillwood Estate & Gardens, Washington D.C.
2 Two albums of watercolour drawings from the workshop of Henrik Wigström, which contain a total of *c.*1200 drawings of objects made in the workshop from 1911 to 1916, serve as an excellent tool for the exploration of Wigström's diverse production.

3 A considerable number of Fabergé's craftsmen settled in Finland after the 1917 Russian Revolution. They either set up workshops of their own or were employed by local goldsmiths.

4 Baron von Stieglitz's Central School of Technical Drawing was founded in 1876 and opened in 1879. The School had some 200 students at the end of the nineteenth century, and faculties included general artistic education, majolica, decorative painting and carving, minting, xylography and watercolours, porcelain painting, flower painting, weaving and printing crafts. For the benefit of his students, Baron von Stieglitz established a museum of applied arts. This was modelled on the South Kensington Museum in London, which became the Victoria and Albert Museum in 1899. The Stieglitz museum collections were made up of both fine antique works of art from all over the world as well as objects reflecting the latest trends in design in Europe and beyond.

5 An album of Alina Holmström's drawings has survived, and is now with A La Vieille Russie in New York. There are also two surviving albums of jewellery designs from the atelier of Albert Holmström, dating from 1909–15. A comparison between the designs in the two Holmström books and those in Alina's hand shows convincing likenesses.

MATERIALS AND METHODS
JOANNA WHALLEY

1 Pliny the Elder, *Natural History*, 37.9. Translated by J. Bostock and H.T. Riley (London 1855).

2 Bainbridge 1966, p. 55.

3 Ibid., p. 128.

4 E.V. Tsareva, M.F. Pirogova and Y.A. Spiridonov, 'Opacified and opaline enamels on precious metals', *Glass and Ceramics*, 2012, 68, 376–7; https://doi.org 10.1007/s10717-012-9394-4.

5 B. Kirmizi, P. Colomban and M. Blanc (eds), *Journal of Raman Spectroscopy*, 2010, 41(10), 1240; P. Colomban, 'Colouring Agents for Glass, Glaze and Enamel: Tracing Innovation and Exchange Routes', *Supplementary information for*

Raman Spectroscopy in Archaeology and Art History, The Royal Society of Chemistry, 2019, pp. 8–9; Analysis report: 15-104-LB XRF Fabergé cigarette case, Lucia Burgio, V&A, 2015; traces of lead and arsenic found in the XRF analysis of a cigarette case by Fabergé.

6 Personal communication, Fred Rich, Master Enameller, 17 Feb. 2021.

7 Bainbridge Papers, 5 August 1935.

8 Bainbridge Papers, 13 December 1935.

9 Bainbridge 1966, p. 58.

10 Stephen R. Dale, 'The Use of Platinum by Carl Fabergé, New Evidence from the Design Books of Holmström', *Platinum Metals Review*, 1993, 37, (3), 159.

FABERGÉ IN LONDON
KIERAN MCCARTHY

1 *Revue des arts décoratifs (Exposition Universelle, 1900, the Chefs-d'Oeuvre)*, ed. Victor Champier, 1902, pp. 232–3.

2 Thomas-Joseph Armand-Caillat, *Extrait du rapport présenté au nom du Jury classe 94* (1903), p. 330.

3 Letter from Eugène Fabergé to Henry Bainbridge, 21 June 1931.

4 Bainbridge 1933, p. 182.

5 Royal Archives, Windsor Castle, GV/GVD: 3 May 1903.

6 Letter from Otto Jarke of the Moscow branch to Allan Bowe, dated 2 January 1906. Russian State Archive of Historical Documents (DDDDD D 1468 2).

7 Fabergé circular, October 1906, held in the Bainbridge Papers, The Fabergé Museum, St Petersburg.

8 Bainbridge 1949, p. 28.

9 Maureen E. Montgomery, *'Gilded Prostitution': Status, Money and Transatlantic Marriages, 1870–1914* (Abingdon 2012).

10 Florence Hwfa Williams, *It Was Such Fun* (London 1935), p. 183.

11 *The Sunday Times*, London, 25 June 1911.

12 Bainbridge 1949, pp. 83–4.

13 Sonia Keppel, *Edwardian Daughter* (London 1958), p. 33.

14 *Stolitza y Usadba* [*Town & Country*], St Petersburg, 15 January 1914.

15 The Goldsmiths' Company Library Archives, RCN 2142, No. 7739. Q19, p. 29.

16 Bainbridge 1949, p. 98.

17 Bainbridge 1949, p. 84.

18 Väinö Joensuu, 'Kultainen joutsen ui akvamariini laineilla', Suomen Kuvalehti, No.18, Helsinki, 1935, interview with Agathon Fabergé.

19 *Daisy, Princess of Pless*, autobiography (London 1928), p. 107.

BOND STREET AND INTERNATIONAL LUXURY
ANNA FERRARI

The author wishes to thank Richard Edgcumbe for sharing information for this essay.

1 *Olivia's Shopping and How She Does It: A Prejudiced Guide to the London Shops* (London 1906), p. 24.

2 Crook 1999, p. 154.

3 The economist Thorstein Veblen coined this phrase in *The Theory of the Leisure Class* (1899) when writing about American society during the Gilded Age and it has since been applied to British Edwardian society.

4 Henry Benjamin Wheatley, *A Short History of Bond Street Old and New, from the Reign of King James II to the Coronation of King George V* (London 1911), p. 20.

5 Pasols 2012, p. 100.

6 Salomé & Dalon 2013, p. 17.

7 Phillips 2019, p. 134.

8 McCarthy 2017, p. 167.

9 Pierre Cartier undertook sales trips to Russia in 1908 and 1909, following the visit to the Paris branch of the Dowager Empress Maria Feodorovna. Nadelhoffer 1984, pp. 114–18.

10 Scarisbrick 1995, p. 156.

11 It became Chaumet when Jean-Valentin Morel's granddaughter married Joseph Chaumet, who took over the firm in 1885 and gave it his name.

12 McCarthy 2017, p. 108.

13 Nadelhoffer 1984, p. 70.

14 It first opened at 68 Bond Street before relocating to No. 127 (two blocks north of the jewellers Chaumet) by 1911. Kuchiki 2013, pp. 33–4.

15 Between 1910 and 1912 the V&A acquired several screens from Yamanaka, including E.3051–1910, E.3052–1910, E.3054–1910, E.1486–1912 and E.1488–1912. 'Yamanaka and Co.' registry file, V&A Archives, Blythe House.

16 Munn 1987, p. 44.

17 Nadelhoffer 1984, p. 93.

18 Sackville-West 2016, p. 137. Vita Sackville-West grew up among the Edwardian elite and her mother, Lady Sackville, was a collector of both Japanese works of art and Fabergé objects, purchasing three flower studies from the latter's London branch. McCarthy 2017, pp. 144–5.

THE BRITISH ROYAL FAMILY AND FABERGÉ
CAROLINE DE GUITAUT

1 McCarthy 2017, p. 25.

2 Empress Maria Feodorovna purchased a pair of cufflinks in the form of cicadas.

3 Notebook, RCIN 4819. For the brooch see De Guitaut and Patterson 2018, p. 414, cat. no. 257.

4 Bainbridge 1933, pp. 220–21.

5 RA/VIC/ADDA21/219/B/C.6.

6 Bainbridge 1949 (b), pp. 97–8.

7 Consuelo Vanderbilt Balsan, *The Glitter and the Gold* (London 1953), p. 90.

8 RA PP/GV/GVD, 1 December 1894.

9 RCINs 40413 and 13941.

10 RA/GV/ADD/COPY/119.

11 De Guitaut and Patterson 2018, p. 204.

12 Bainbridge 1949 (b), p. 109.

13 RCIN 9258.

14 RCIN 9238. Elephant automaton in the form of the badge of the Order of the Elephant; acquired by King George V, 1935.

15 RA/QMH/PRIV/CC13/97.

THE SPORT OF KINGS
KIERAN MCCARTHY

1 Hesketh Pearson, *The Whispering Gallery: Leaves from a Diplomat's Diary* (London, 2000).

2 Bainbridge 1949 (b), p. 89.

WAR, REVOLUTION AND EXILE
HANNE FAURBY

1 Muntyan 2018, p. 179. Costly jewellery was a way of preserving wealth during times of inflation. This gave rise to an increase in the number of expensive orders at Fabergé.

2 Muntyan 2018, p. 179; Fabergé, Kohler & Skurlov 2012, pp. 532–3.

3 Ivanov 2002, p. 621.

4 Ibid., p. 53.

5 Ibid., p. 603.

6 Ibid., p. 607.

7 Ibid., p. 615.

8 Bainbridge 1966, p. 34.

9 Bainbridge Papers, dated 27 April 1934, p. 3.

10 Bainbridge Papers, dated 22 June 1931, p. 1.

11 Its contents, according to Eugène Fabergé, amounted to about 1.25 million Swiss francs. Fabergé, Kohler & Skurlov 2012, pp. 543–4.

12 Lowes & McCanless 2001, p. 194.

13 Bainbridge Papers, dated 30 March 1931, p. 1.

14 Bainbridge Papers, dated 5 August 1935, p. 1.

15 The root cause of this disagreement cannot be firmly established. For further details see McCarthy 2017, p. 216.

16 Bainbridge 1966, p. 17.

17 Muntyan & Voronchenko 2009–15, p. 13.

18 Bainbridge 1966, p. 62.

19 Bainbridge Papers, dated 30 March 1931, p. 1; Fabergé, Kohler & Skurlov 2012, p. 527; Bainbridge 1966, p. 36.

THE LEGACY OF THE IMPERIAL EASTER EGGS
GÉZA VON HABSBURG

The author wishes to thank his colleagues Christel Ludewig McCanless, Annemiek Wintraecken, Alexander von Solodkoff, Kieran McCarthy and John Andrew as well as Jennifer McFerrin-Bohner and Christopher Forbes for kindly supplying information for this essay.

1 The bibliography on Fabergé's Imperial Easter Eggs is vast. Twenty Imperial Eggs were first illustrated in Bainbridge 1934 in a two-part article in *The Connoisseur* magazine. Sixteen Imperial Eggs were illustrated in Bainbridge 1949. A. Kenneth Snowman catalogued and illustrated 43 of the 50 Imperial Eggs accepted as genuine today (Snowman 1953). The invaluable catalogue by Tatiana Fabergé, Lynette Proler and Valentin Skurlov was an up-to-date history of the eggs with their archival sources (Fabergé, Proler & Skurlov 1997). Will Lowes and Christel Ludewig McCanless's *Fabergé Eggs: A Retrospective* is a meticulous, more recent compilation of all available information concerning the eggs (Lowes & McCanless 2001). At present the Fabergé Research Newsletter (www.fabergeresearch.com) is produced online by the two aforementioned authors, while Annemiek Wintraecken constantly adds the most recent information to *Mieks Fabergé Eggs* (www.wintraecken.nl/mieks/faberge/index-uk). For a popular version of the story of the Imperial Easter Eggs, see Faber 2008.

2 The Dresden Hen Egg from the Green Vault was sold at Habsburg Feldman, Geneva, 16 November 1988, lot 255. It was returned by the Saxon state to the Wettin family in 1924, together with other parts of the family's possessions, and kept at Moritzburg Castle by Prince Ernest of Saxony, the last king's youngest son and the author's uncle, until his death in 1971. It was published by Jean-Louis Sponsel, Der Führer durch das Grüne Gewölbe, 1921, p. 86 as 'Das goldene Ei aus dem Besitze Augusts des Starken' (followed by detailed description), Inv. Nr. VI, XIII.

3 For the two eighteenth-century Hen Eggs in Vienna and Copenhagen, see Habsburg 1986/7, cats 663 and 664.

4 For Fabergé's First Hen Egg, see Fabergé, Proler & Skurlov 1997, pp. 14–19, 92–3, cat. 1.

5 For Fabergé's Danish Palaces Egg, see ibid., pp. 102–5, cat. 6.

6 For Fabergé eggs with family portraits, see ibid., cats 11, 15, 16, 18, 19, 27, 31, 34, 35, 37, 40, 42, 44, 46, 47, 49 and 50.

7 For Fabergé eggs with family abodes, see ibid., cats 6, 9, 14, 23, 28, 32 and 34.

8 For Fabergé eggs containing means of family transport, see ibid., cats 7, 16, 22 and 36.

9 For the 1901 Basket of Wild Flowers Egg, see ibid., cat. 24.

10 For the 1906 Moscow Kremlin Egg, see ibid., cat. 30.

11 For the 1907 Cradle with Garlands Egg, see ibid., cat. 31.

12 For the 1908 Peacock Egg, see ibid., cat. 33; for the 1910 Standard Egg, see ibid., cat. 36; for the 1910 Alexander III Equestrian Egg, see ibid., cat. 37.

13 For the 1910 Colonnade Egg, see ibid., cat. 38.

14 For the 1911 Bay Tree Egg, see ibid., cat. 39.

15 For the 1915 Red Cross Egg with Icons, see ibid., cat. 48.

16 For the fate of the eggs after the departure of the Emperor, see Muntyan 1995, pp. 24–31; and Tatiana Muntyan, 'The Kremlin Collection', in Fabergé, Proler & Skurlov 1997, pp. 82–9. The sales of the Fabergé Easter Eggs by the Bolshevik Government are also described in Odom & Salmon 2009, part III, 8 and 11; and Semyonova & Ilyine 2013, chapter II, pp. 28–59 ('The Romanov Treasure Trail').

17 For the history of Wartski and of the firm in London, see Munn 2015, pp. 40–83; and McCarthy 2017, pp. 24–35.

18 For the 1897 Coronation Egg and the 1898 Lilies of the Valley Egg, see Fabergé, Proler & Skurlov 1997, cats 16 and 18.

19 For the 1895 Rosebud Egg, see ibid., cat. 12.

20 For the 1913 Winter Egg, see ibid., cat. 43.

21 Hammer 1936; Hammer 1987. Both of these books are autobiographical and unreliable. For other versions of the role of Armand Hammer in the Russian sales, see Weinberg 1989, part III; Blumay 1992; Epstein 1996; Géza von Habsburg et al., 'The Hammer Years' in Habsburg 1996, pp. 56–61.

22 For the 1896 Revolving Miniatures Egg and the 1912 Tsarevich Egg, see Fabergé, Proler & Skurlov 1997, cats 14 and 42.

23 For more information on these four well-known collectors, see Habsburg 1996, pp. 72–189.

24 For the 1914 Catherine the Great Egg, see Fabergé, Proler & Skurlov 1997, cat. 45.

25 Schaffer 1984, pp. 131–8; Paul Schaffer, 'Fabergé and America' in Habsburg & Lopato 1933, pp. 190–5.

26 *The Palace Collections of Egypt*, Sotheby's 10 March, 1954, lots 101–65.

27 For the 1898 Kelch Hen Egg, see Fabergé, Proler & Skurlov 1997, p. 72.

28 For the 1894 Renaissance Egg, see op. cit., cat. 10.

29 A first catalogue with thumbnail illustrations of the Forbes Collection was compiled by Alexander von Solodkoff (Solodkoff 1984); for a full, later catalogue, see Forbes & Tromeur-Brenner 1990.

30 For the 1902 Marlborough Egg, see Fabergé, Proler & Skurlov 1997, p. 81 (28).

31 For A La Vieille Russie, see Schaffer 1984, pp. 131–8; Paul Schaffer, 'Fabergé and America' in Habsburg & Lopato 1993, pp. 190–5.

32 For the 1897 Coronation Coach Egg and the 1898 Lilies of the Valley Egg, see Fabergé, Proler & Skurlov 1997, cats 16 and 18.

33 For the 1900 Cockerel Egg, see ibid., cat. 21.

34 For highlights from the Forbes Collection acquired by Viktor Vekselberg, see Habsburg 2004; for the full catalogue, see *Fabergé, Treasures of Imperial Russia. Fabergé Museum, St. Petersburg* (Milan 2017).

35 For the McFerrin Collection, see *From a Snowflake to an Iceberg* (Humble, TX 2013); McFerrin 2016.

36 For the 1902 Kelch Rocaille Egg, see Fabergé, Proler & Skurlov 1997, p. 72.

37 For the 1892 Diamond Trellis Egg, see ibid., cat. 8.

38 Auction prices for Fabergé Imperial Easter Eggs: 1947 sale, Bay Tree Egg £1,650; 1949 sale, Winter Egg £1,870; 1954 sale, Swan Egg £6,400; 1960 sale, Diamond Trellis Egg £2,400; 1961 sale, Order of St George Egg £11,000; 1964 sale, Egg with Clock £875 (unrecognized); 1973 sale, Cockerel Egg £82,666; 1985 sale, Cockerel Egg £1,375,000; 1992 sale, Cradle Egg £3,190,000; 1994 sale, Winter Egg £3,560,539; 2002 sale, Winter Egg £6,872,000. Other Fabergé Easter eggs at auction: 1934 sale, Reliquary Egg £110; 1954 sale, Kelch Hen Egg £4,410; 1965 sale, Marlborough Egg £17,855; 1989 sale, Kelch Pine Cone Egg £1,872,340; 1990 sale, Kelch Bonbonnière Egg (sold privately after sale for 'just under $1,000,000'); 1994 sale, Kelch Apple Blossom Egg £582,480; 1994 sale, Nobel Egg £149,520; 1996 sale, Nobel Egg £198,820; 1997 sale, Kelch Pine Cone Egg, unsold at £2,800,000; 2007 sale, Rothschild Clock Egg £9,980,000.

39 For the 1900 sale of the Pine Cone Egg and Nobel Egg, see ibid., pp. 73 and 81.

40 https://www.reuters.com/article/russia-faberge-egg/find-of-the-century-u-s-scrap-dealer-finds-20-million-faberge-egg-idINDEEA2J0E120140320.

41 For the London exhibition catalogue, see *Fabergé, 1846–1920* (London 1977).

42 For the Munich exhibition catalogue, see Habsburg 1986/7.

43 For the New York exhibition catalogue, see Habsburg 1996.

44 Moore 1989.

45 For more information on Victor Mayer, see Géza von Habsburg, *Fabergé gestern und heute* (Munich 2005); Herbert Mohr-Mayer, *Victor Mayer (1857-1946)* (Ubstadt-Weiher 2007); Anne-Barbara Kern, *Fabergé Ei-Objekte aus der Manufaktur Victor Mayer* (Stuttgart 2015).

46 Information listed by Annemiek Wintraecken on Google 'Mieks Fabergé Films' and 'And the Oscar goes to ...' (www.wintraecken.nl/mieks/faberge/index-uk).

SELECT BIBLIOGRAPHY

Bainbridge 1933
Henry C. Bainbridge, *Twice Seven* (London 1933)

Bainbridge 1934
Henry C. Bainbridge, *Russian Imperial Easter Gifts. The Work of Carl Fabergé*, Connoisseur, May–June, 1934, pp. 299–306 and 384–9

Bainbridge 1949 (a)
Henry C. Bainbridge, *Peter Carl Fabergé, Goldsmith & Jeweller to the Russian Imperial Court & Principal Crowned Heads of Europe* (London 1949)

Bainbridge 1949 (b)
Henry C. Bainbridge, *Peter Carl Fabergé, His Life and Work* (London 1949)

Bainbridge 1966
Henry Charles Bainbridge, *Peter Carl Fabergé, Goldsmith and Jeweller to the Russian Imperial Court, His Life and Work* (London 1966)

Birbaum 1993
Franz P. Birbaum, *Istoriia firmy Faberzhe po vospominaniiam glavnogo mastera firmy Frantsa P. Birbauma*, eds Tatiana F. Faberzhe and Valentin V. Skurlov (St Petersburg 1993); 'The 1919 Birbaum *Memoirs*', trans. H.S.H. Princess Natalia Heseltine-Galitzine, in Tatiana Fabergé, Eric-Alain Kohler & Valentin Skurlov (eds), *Fabergé: A Comprehensive Reference Book* (Geneva 2012), pp. 297–323

Blumay 1992
Carl Blumay, with Henry Edwards, *The Dark Side of Power: The Real Armand Hammer* (New York 1992)

Crook 1999
Joseph Mordaunt Crook, *The Rise of the Nouveaux Riches: Style and Status in Victorian and Edwardian Architecture* (London 1999)

De Guitaut 2003
Caroline de Guitaut, *Fabergé in the Royal Collection* (London 2003)

De Guitaut and Patterson 2018
Caroline de Guitaut and Stephen Patterson (eds), *Russia: Art, Royalty and the Romanovs* (London 2018)

Epstein 1996
Edward J. Epstein, *Dossier: The Secret History of Armand Hammer* (New York 1996)

Faber 2008
Toby Faber, *Fabergé's Eggs: The Extra-ordinary Story of the Masterpieces that Outlived an Empire* (London 2008)

Fabergé, Proler & Skurlov 1997
Tatiana Fabergé, Lynette Proler and Valentin Skurlov, *The Fabergé Imperial Easter Eggs* (London 1997)

Fabergé, Kohler & Skurlov 2012
Tatiana F. Fabergé, Eric-Alain Kohler and Valentin V. Skurlov, *Fabergé. A Comprehensive Reference Book* (Geneva 2012)

Forbes & Tromeur-Brenner 1990
Christopher Forbes and Robyn Tromeur-Brenner, *Fabergé: The Forbes Collection* (Connecticut 1990)

Habsburg 1986/7
Géza von Habsburg et al., *Fabergé, Hofjuwelier der Zaren* (Munich 1986; English edition Geneva 1987)

Habsburg 1996
Géza von Habsburg et al., *Fabergé in America* (New York 1996)

Habsburg 2000
Géza von Habsburg et al., *Fabergé, Imperial Craftsman and his World* (London 2000)

Habsburg 2004
Géza von Habsburg, *Fabergé: Treasures of Imperial Russia* (New York 2004)

Habsburg & Lopato 1993
Géza von Habsburg and Marina Lopato (eds), *Fabergé: Imperial Jeweller* (Petersburg & Washington D.C. 1993)

Hammer 1936
Armand Hammer, *The Quest of the Romanoff Treasure* (New York 1936)

Hammer 1987
Armand Hammer, *Hammer: Witness to History* (New York 1987)

Iusupov 1998
Kniaz` Feliks Iusupov, *Memuary. V dvukh knigakh. Tom II. V izgnanii. 1924–1925* (Moscow 1998); Prince Felix Youssoupoff, *Lost Splendour*, trans. Ann Green & Nicolas Katkoff (London 1953)

Ivanov 2002
Alexander Ivanov, *Unknown Fabergé* (Moscow 2002)

Keppel 1958
Sonia Keppel, *Edwardian Daughter* (London 1958)

Krog 2002
Ole Villumsen Krog, *Ruslands skatte – kejserlige gaver [Treasures of Russia – Imperial Gifts]*, exh. cat., Copenhagen, 2002

Kuchiki 2013
Yuriko Kuchiki, 'The Enemy Trader: The United States and the End of Yamanaka', *Impressions*, no. 34, 2013, pp. 32–53

Leaska & Phillips 1991
Mitchell Leaska and John Phillips (eds), *Violet to Vita: The Letters of Violet Trefusis to Vita Sackville-West, 1910–21* (London 1991)

Lowes & McCanless 2001
Will Lowes and Christel Ludewig McCanless, *Fabergé Eggs: A Retrospective Encyclopedia* (London & Maryland 2001)

McCarthy 2017
Kieran McCarthy, *Fabergé in London: The British Branch of the Imperial Russian Goldsmith* (Woodbridge 2017)

McFerrin 2016
Dorothy McFerrin at al., *Fabergé. The McFerrin Collection. The Opulence Continues* (Humble, TX 2016)

Moore 1989
Andrew Moore, *Theo Fabergé and the St. Petersburg Collection* (Oxford 1989)

Munn 1987
Geoffrey Munn, 'Fabergé and Japan', *The Antique Collector*, January 1987, pp. 37–45

Munn 2015
Geoffrey C. Munn, *Wartski, Thirteen Eggs and Other Things. The First One Hundred and Fifty Years* (Woodbridge 2015)

Muntyan 1995
Tatiana N. Muntyan, 'Fabergé im Kreml' in Alexander von Solodkoff, *Fabergé, Juwelier des Zarenhofes* (Berlin 1995)

Muntyan 2018
Tatiana Muntyan, *Fabergé Easter Gifts*, Federal State Institution of Culture, Moscow, and Kremlin State Historical and Cultural Museum and Heritage Site (Moscow 2018)

Muntyan & Voronchenko 2009–15
Tatiana Muntyan and Vladimir S. Voronchenko (eds), *Fabergé Masterpieces – From the Collection of the Link of Times Foundation* (New York 2009–15)

Nadelhoffer 1984
Hans Nadelhoffer, *Cartier* (London 1984)

Odom & Salmon 2009
Anne Odom and Wendy R. Salmon, *Treasures into Tractors. The Selling of Russia's Cultural Heritage, 1918–1938* (Washington DC 2009)

Ometov 1993
Boris Ometov, 'Fabergé's Houses in St. Petersburg', in Géza von Habsburg and Marina Lopato, *Fabergé, Imperial Jeweller* (Washington DC 1993)

Pasols 2012
Paul-Gérard Pasols, *Louis Vuitton: The Birth of Modern Luxury*, translated from the French by Lenora Ammon (New York 2012)

Pearson 1926
Hesketh Pearson, *The Whispering Gallery: Leaves from a Diplomat's Diary* (London 2000)

Phillips 2019
Clare Phillips, *Jewels & Jewellery* (London 2019)

Sackville-West 2016
Vita Sackville-West, *The Edwardians*, 1930 (New York 2016)

Salomé & Dalon 2013
Laurent Salomé and Laure Dalon (eds), *Cartier: Style and History*, exh. cat. (Paris 2013)

Scarisbrick 1995
Diana Scarisbrick, *Chaumet: Master Jewellers since 1780* (Paris 1995)

Schaffer 1984
Paul Schaffer, 'A La Vieille Russie', in Alexander von Solodkoff, *Masterpieces from the House of Fabergé* (New York 1984)

Semyonova & Ilyine 2013
Natalya Semyonova and Nicolas V. Ilyine (eds), *Selling Russia's Treasures* (New York & London 2013)

Shcherbatov 2000
Kniaz' Sergei Aleksandrovich Shcherbatov, *Khudozhnik v ushedshei Rossii* [*An Artist in Bygone Russia*] (Moscow 2000)

Snowman 1953
A. Kenneth Snowman, *The Art of Carl Fabergé* (London 1953)

Solodkoff 1984
Alexander von Solodkoff, *Masterpieces from the House of Fabergé* (New York 1984)

Weinberg 1989
Steve Weinberg, *Armand Hammer. The Untold Story. An Unauthorized Biography* (New York 1989)

ARCHIVES

Bainbridge Papers, 'The Link of Times' Foundation, Fabergé Museum, St Petersburg
Letters from Eugène Fabergé addressed to H.C. Bainbridge

Rothschild Archive
Letter from Rawle, Johnstone & Co. to Sir Leopold Rothschild, dated 7 February 1917

Marjorie Merriweather Post Foundation
Hillwood Estate and Gardens, Washington D.C.

THE CONTRIBUTORS

CAROLINE DE GUITAUT is Deputy Surveyor of The Queen's Works of Art at Royal Collection Trust. Curator of numerous Royal Collection exhibitions and author of accompanying catalogues, her publications on Russian decorative art include *Fabergé in the Royal Collection* (2003), *Royal Fabergé* (2011) and *Russia: Art, Royalty and the Romanovs* (2018). She is a Trustee of the Hermitage Foundation UK and the Royal Yacht Britannia Trust.

ANNA FERRARI is an independent curator specialising in late-nineteenth and twentieth-century art and design. She wrote her PhD thesis on the French modernist sculptor Henri Laurens and has previously worked at Kettle's Yard, Cambridge, and curated exhibitions at Barbican Art Gallery, the V&A and the Royal Academy of Art, London.

HANNE FAURBY is the Exhibition Project Curator of *Fabergé in London: Romance to Revolution.* She has researched and written on nineteenth- and twentieth-century decorative art including embroidery and jewellery by Arts and Crafts designer May Morris. Most recently she has contributed two articles for the *V&A Book of Colour in Design.*

GÉZA VON HABSBURG has a Ph.D. in History of Art from Fribourg University, Switzerland. He was Chairman of the auction house Christie's (Switzerland and Europe) for 18 years, has published or edited both books and catalogues on Russian art and Fabergé, and has organized five international exhibitions. He is on the Advisory Board of the Fabergé Museum, St Petersburg.

KIERAN MCCARTHY is a Freeman of the Worshipful Company of Goldsmiths, a Fellow of the Society of Antiquaries and a Director of Wartski, the London based court jewellers. He is a member of the Advisory Board of the Fabergé Museum in St Petersburg and has written and lectured widely on the imperial Russian goldsmith's work.

TATIANA MUNTIAN is a leading researcher at the Moscow Kremlin Museums. She was born in Yuzhno-Sakhalinsk, and graduated from Lomonosov Moscow State University with a degree in History and Theory of Art in 1984. Since 1987 she has been curator of the collection of artworks of the C. Fabergé firm and other Russian jewellery firms of the nineteenth and early twentieth century. She is the author of books and articles devoted to the history of Russian jewellery and is the curator of numerous Russian and international exhibition projects.

ULLA TILLANDER-GODENHIELM, Ph.D., is the great-granddaughter of the St Petersburg jeweller Alexander Tillander. She has been researching the *oeuvre* of Russian jewellers for many years. Her doctoral dissertation was on the award system of imperial Russia. Her work takes her around the world: lecturing, consulting for art exhibitions and contributing to exhibition catalogues. She has published several books on her specialty, the art of the jewellers of imperial St Petersburg.

JOANNA WHALLEY DipCons FGA DGA is a freelance metals conservator and gemologist. She led the Metals Conservation team at the Victoria and Albert Museum for many years and has lectured and published widely. She is a Freeman of the Worshipful Company of Goldsmiths and a Fellow of the Gemmological Association of Great Britain, and current roles include Deputy Chair and Trustee of the Society of Jewellery Historians.

ACKNOWLEDGEMENTS

In creating the exhibition and present publication, the curators are indebted to the sponsors, lenders, contributing authors, external collaborators and colleagues within the museum. The support, commitment and enthusiasm with which we have been met has made this project all the more special.

Our Sponsors
We are hugely obliged to our generous sponsors, in particular Pan Pacific and the Jewellery Gallery. With their support the exhibition has been possible.

Our Lenders
The major loans generously granted by H.M. The Queen and H.R.H. The Prince of Wales from the Royal Collection Trust are the spine of the exhibition. Thank you to all staff at the Royal Collection Trust and special thanks to Caroline de Guitaut. We are indebted to the generosity of the late Harry Woolf, who was a peerless and erudite collector of Fabergé, the Woolf family and Nita Sowerbutts; His Grace the Duke of Norfolk; the Devonshire and Castle Howard collections. Further gratitude is due to the Khalili Collection of Japanese Art; The Trustees of the Rothschild Archive, with special thanks to Melanie Aspey and Nathalie Attwood; May Calil and Tom Dingle; Lord and Lady Lovat; Mr and Mrs Goodson, Symbolic & Chase; Manchester Art Gallery; Chartwell, The National Trust Collections; The Hon. Mrs de Laszlo and Katherine Field at The Catalogue Raisonné of Works by Philip de László; Sir Timothy Cassel; Elizabeth Douglas at the Royal College of Physicians; Mr Stephen Perrott; and Mr Andre Ruzhnikov.

In Russia we have been overwhelmed by the support and generosity of the Kremlin Museums, with special thanks to Yelena Gagarina and Ekaterina Karavaev as well as Tatiana Muntian; The State Hermitage Museum; The Link of Times Foundation at the Fabergé Museum, with special thanks to Vladimir Vorenchenko and Mikhail Ovchinnikov; Fersman Mineralogical Museum, with special thanks to Dr Generalov; The Peterhof State Museum-Reserve; and the State Museum Reserve Pavlovsk.

From America we are grateful for the generous loans and huge support of the Artie & Dorothy McFerrin Collection at the Houston Museum of Natural Sciences; A La Vieille Russie in New York; the Cleveland Museum of Fine Art; and the Beilin-Makagon Art Foundation.

On the continent we are indebted to loans from Archives du Palais de Monaco; The Musée des Arts Décoratifs in Paris, facilitated by Evelyn Possèmè; and the Mirabaud Collection.

The exhibition and publication have benefited from generous loans and support from across the globe. Those who wish to remain anonymous and those potential lenders whose treasures we would have loved to have included and whose kindness and support have not gone unnoticed – we send our thanks to you and to the wider Fabergé community.

Our Collaborators
Special thanks are also due to the Cartier Foundation, in particular Anne Lamarque, Renée Frank, Pascale Le Peu. At Louis Vuitton Archive our special thanks go to Bleue-Marine Massard; and further thanks to Agata Baran at Truefitt and Hill; Mr Yamanaka and Masako Yamamoto at Yamanaka & Co. Ltd; and Roger Short, who helped bring the characters in our story to life.

Our thanks to the following for their invaluable assistance: the staff of Wartski, Nicholas, Margo and Hector Snowman, Thomas Holman, Giovanni Massa, Christel Tyran, Nathalie Rivière and Steven Vaughan; Leslie Chappell, Helen Culver-Smith, Mr and Mrs David Englefield, Thomas Faerber, Harry Fane, Simon Fuller, Stephen Harrison, Richard Hart, Emma Hawkins, John Hawkins, Mr and Mrs Victor Ilyukhin, Amin Jaffer, Karen Kettering, Jennie Lord, Hugo Mackenzie-Smith, Nathalie Marielloni, Jacqueline Meakin, Natalia Nikolaeva, Maxim Revyakin, The Earl of Rosslyn, Richard Ormond, Alexander Von Solodkoff, Laura Stuart, Alexander Tceitlina, Marie Tceitlina, David Thomas, Oliver Thomson, Eleanor Thompson, Martin Travis, Ivan Tverdiukov, Haydn Williams, Wilfred Zeisler. To those we have missed here, our apologies and please forgive us.

Our Authors and the Publication Team
A huge thanks to our contributing authors Tatiana Muntian, Ulla Tillander-Godenhielm, Joanna Whalley, Caroline de Guitaut, Anna Ferrari and Géza von Hapsburg. We are truly grateful to you for your valuable contributions which have brought our vision to life. Thanks are also due to our readers and editors Katherine Purcell, Denny Hemming, Kirstin Beattie and Coralie Hepburn; designer Daniela Rocha; production manager Emma Woodiwiss; commercial rights executive Fred Caws and commercial rights manager Andrew Tullis.

Our Colleagues
The curators would also like to acknowledge the instrumental roles of Richard Edgcumbe, who saw the potential for the show and who together with Anna Ferrari ensured the exhibition's acceptance on the V&A Public Programme. Thanks are also due to Jane Pritchard, Greg Irvine, Masami Yamada and Yoojin Choi. A huge thanks also to colleagues across the institution in particular the Press, Marketing and Development departments.

The Exhibition
A huge thank you to all our internal and external colleagues who have contributed in the shaping of the exhibition, from loans management to design and interpretation. Daniel Slater, Sarah Scott, Rebecca Lim, Joanna Norman, Brendan Cormier, Vanessa North, Nikki Caxton, Roo Gunzi, Sarah Jameson, Celia Pullen, Jessica Karlsen, Charlie King, Bryony Shepherd, Lenny Cherry, Asha McLoughlin, Katherine Young, Evonne Mackenzie, Juri Nishi, Heather Whitbread, Alicia Gonzalez-Lafita, Clair Battison, Katrina Redman, Sophie Manhire.

Thanks to Studio ZNA for their beautiful lighting design; music and sound design duo FATHER for their evocative soundscapes; process film production directed by Noémi Varga, produced by Alice Hughes for Pundersons Gardens and starring engine-turner David Wood-Heath and enameller Fred Rich.

With sincere thanks
Kieran McCarthy and Hanne Faurby

PICTURE CREDITS

References are to plate numbers, unless otherwise indicated.

© A La Vieille Russie, Inc. 73, 74, 79, 111, 117, 121, 162, 164

Alamy Stock Photo
© Album / Alamy Stock Photo 19, 184
© Artmedia / Alamy Stock Photo 122
BFA / Alamy Stock Photo. © Danjaq LLC 189
© Chronicle / Alamy Stock Photo 101, 169
© SPUTNIK / Alamy Stock Photo 16, 163
© The Print Collector / Alamy Stock Photo 166

© Archives Louis Vuitton Malletier 102

© Arkivi UG All Rights Reserved / Bridgeman Images 77

Courtesy of the Beilin-Makagon Art Foundation 15, 114, 115

© bpk / Staatliche Kunstsammlungen Dresden / Jürgen Karpinski 8

Bridgeman Images
© Christie's Images / Bridgeman Images 5, 105
© Look and Learn / Bridgeman Images 149
© Look and Learn / Valerie Jackson Harris Collection / Bridgeman Images 135 (right)
Courtesy of His Grace The Duke of Norfolk, Arundel Castle / Bridgeman Images 116
Private Collection / Photo © Christie's Images / Bridgeman Images 99

Vincent Wulveryck, Collection Cartier © Cartier 104

Courtesy of Sir Timothy Cassel 119

Courtesy of The Cleveland Museum of Art / The India Early Minshall Collection 13, 43, 173, 206

© The Devonshire Collections, Chatsworth 94

Courtesy of Fersman Mineralogical Museum, Moscow 87, 167, 174, 185, 207

Courtesy of Stephane Korb / Forbes Magazine 185

Historic England Archive 171

© "The Link of Times" Foundation, Fabergé Museum in St. Petersburg 9, 97, 177, 178, 179, 181, 182, 183, 186, 191

© MAD, Paris / Jean Tholance/Paris, musée des Arts décoratifs 100

Courtesy of the McFerrin Foundation, Houston 50, 71, 67, 78 (photography courtesy of HMNS / photographer: Mike Rathke), 193

Mirabaud Collection, Switzerland 49

© Geoffroy Moufflet / Archives du palais de Monaco / IAM 195

© Moscow Kremlin Museums 14 (Sushenok A.M.), 25 (Baranov. S.V.), 61, 62, 63, 69, 170 (Mironov S.Y.), 198, 201, 204

© 2021. Digital image, The Museum of Modern Art, New York/Scala, Florence 4

© National Portrait Gallery, London 139

Private Collection 21, 44 (photo © Matias Uusikylä), 180, 197, 200

Public domain 11, 55

Reproduced with the permission of The Trustees of The Rothschild Archive 109

Royal Collection Trust / All Rights Reserved 41, 70, 98, 110

Royal Collection Trust © Her Majesty Queen Elizabeth II 2021 39, 46, 64, 81, 88, 92, 93, 95, 124, 125, 126, 127, 128, 129, 130, 131, 132, 133, 134, 135 (left), 136, 138, 140, 141, 142, 143, 147, 148, 150, 152, 153, 154, 155, 156, 157, 158, 159, 160, 161, 194, 196, 202, 205, 256

Photograph © The State Hermitage Museum, 2021 12 (Vladimir Terebenim), 60 (Pavel Demidov), 75 (Alexander Koksharov)

Courtesy of Symbolic & Chase 123

Courtesy of Ulla Tillander-Godenhielm 20, 28, 30, 32

© The Victoria and Albert Museum, London 76, 103, 107

Courtesy of Rare Book and Manuscript Library, Yale University 66

Photo: Yamanaka & Co., Ltd. 106

Courtesy of Wartski, London pp. 2–3, 6, 8; pls 1, 2, 3, 6, 7, 8, 17, 18, 22, 23, 24, 26, 27, 29, 31, 33, 34, 35, 36, 37, 38, 40, 42, 45, 47, 48, 51, 53, 54, 56, 57, 58, 59, 65, 68, 72, 80, 82, 83, 84, 85, 86, 89, 90, 91, 96, 108, 112, 113, 118, 120 (National Trust), 137, 144, 145, 146, 151, 165, 168, 172, 175, 176, 187, 188, 190, 192, 199, 203

INDEX